SYLVIA PLATH
—— DAY BY DAY ——
Volume 2

SYLVIA PLATH

DAY BY DAY

Volume 2: 1955–1963

CARL ROLLYSON

UNIVERSITY PRESS OF MISSISSIPPI / JACKSON

The University Press of Mississippi is the scholarly publishing agency of the Mississippi Institutions of Higher Learning: Alcorn State University, Delta State University, Jackson State University, Mississippi State University, Mississippi University for Women, Mississippi Valley State University, University of Mississippi, and University of Southern Mississippi.

www.upress.state.ms.us

The University Press of Mississippi is a member of the Association of University Presses.

Library of Congress Cataloging-in-Publication Data

Names: Rollyson, Carl E. (Carl Edmund), author.
Title: Sylvia Plath day by day. Volume 2 : 1955–1963 / Carl Rollyson.
Description: Jackson : University Press of Mississippi, 2024. |
Includes bibliographical references and index.
Identifiers: LCCN 2024017647 (print) | LCCN 2024017648 (ebook) |
ISBN 9781496844286 (hardback) | ISBN 9781496851987 (epub) |
ISBN 9781496851970 (epub) | ISBN 9781496851963 (pdf) | ISBN 9781496851956 (pdf)
Subjects: LCSH: Plath, Sylvia. | Women poets, American—
20th century—Biography. | Poets, American—20th century—Biography.
Classification: LCC PS3566.L27 Z8496 2024 (print) |
LCC PS3566.L27(ebook) | DDC 811/.54 [B]—dc23/eng/20240510
LC record available at https://lccn.loc.gov/2024017647
LC ebook record available at https://lccn.loc.gov/2024017648

British Library Cataloging-in-Publication Data available

CONTENTS

SYLVIA PLATH
—— DAY BY DAY ——
Volume 2

INTRODUCTION

SINCE SYLVIA PLATH'S DEATH IN 1963, SHE HAS BECOME THE SUBJECT of an unceasing succession of books, biographies, and articles. She has been hailed as a groundbreaking poet for her starkly beautiful poems in *Ariel* (1965), and as a brilliant forerunner of the feminist coming of age novel in her semi-autobiographical *The Bell Jar* (1963). The literature about her has expressed a wide range of opinions about the causes of her suicide—often tied to the breakup of her marriage to Ted Hughes. Each new biography has offered new insight and new sources with which to measure Plath's life and influence. At this point, what is needed is a work that can offer a distillation of this data without the inherent bias of a narrative.

Biographical narratives, because they are designed as stories, inevitably discard many precious details and the feel of what it is like to live day by day. This is especially true in Sylvia Plath's case because she began writing diaries at the age of twelve, and for many of her days, months, and years, she kept calendars and journals full of details that no narrative biography can possibly include. This volume begins where volume 1 ended, on February 14, 1955, the day Plath wrote to her mother declaring that the Smith College faculty strongly supported her decision to study in England. That decision marked a turning point in her life that leads directly to the second volume of *Sylvia Plath Day by Day*.

Every effort has been made to do justice to her assiduous recording of her life in an effort to recover the diurnal Sylvia Plath, to write in the present tense about past events as if they are happening now. Many entries end without a period, with her activities marked off by commas, in order to suggest fragments of a life in progress. I have also retained, in most instances, Plath's misspellings. In effect, you are presented with the raw data, without commentary, so that *you* become the biographer. And where there are still gaps, where I cannot account for certain days, perhaps other researchers will come along to fill some of those voids, prodded by what I have included or overlooked.

I do provide brief signposts in italics that signal the important events and turning points in Plath's life. In a departure from volume 1, I include—at significant points—the words of others, including Ted Hughes, to provide some context for Plath's reactions in certain situations, or because the comments of others supply a date that she does not specify in her own writing.

My approach is inspired by Jay Leyda's *Melville Log* (1951), that bedrock of Melville biography. Leyda wanted to establish a groundwork for the biographies yet to come. Although Plath has many biographers, there is no reason to suppose that others will not appear in this and the next millennium so long as this world and its literature survives. Even with the most recent one-thousand-page biography, Heather Clark has acknowledged that because of the exigencies of a one-volume work, she had to cut more than three hundred pages. Her biography may have been the better for such deletions, but that is not to say that within those discarded pages there are not the kinds of vital details that this book attempts to recover.

I draw on excerpts from letters in the Harriet Rosenstein papers at Emory that appeared after publication of *The Letters of Sylvia Plath* and on letters that appear only in the Faber paperback edition of Plath's correspondence. As in volume 1, in my notes, I have identified letters Plath mentions but are either lost or in private hands. Missing from this book, as in all books about Plath, are details that might have been included in two journals that Ted Hughes said he destroyed and in other unfound calendars and diaries she probably wrote in for 1957–1958 and 1958–1959.

Sylvia Plath Day by Day is for readers of all kinds with a wide variety of interests in the woman and her work. The entries are suitable for dipping into and can be read in a minute or an hour, by the bedside or propped against another book or other suitable support during a meal. It is difficult to read multiple Plath biographies side by side, but this book by ranging over several sources stimulates points of comparison between biographies and other materials, including Plath's own diaries, journals, letters, stories, and poetry and other prose (other Plath biographies). My principle of selection has been to record the most striking events and comments that reveal Plath but also to minimize repetition, except when the repetition of certain sentiments and events seems important in characterizing her daily activities.

The details in her calendars, diaries, journals, and letters sometimes read like the minutes of her life giving us a granular Plath. More importantly, by accounting for her activities she also particularizes the culture of her time, what it was like for a young woman making her way in the 1950s, and a mature woman entering the 1960s.

What holds true for another book of this kind, *Marilyn Monroe Day by Day*, also holds true for this one: it is for anyone who delights in savoring all aspects of becoming and being a self. Reading about Sylvia Plath day by day yields many different Plaths and perhaps suggests new angles and perspectives.

SOURCES AND ABBREVIATIONS

ENTRIES FOR 1955–1956 RELY ON DIARIES AND CALENDARS IN THE Sylvia Plath papers in Special Collections, Lilly Library, Indiana University in Bloomington. Entries derived from Sylvia Plath's letters are from Peter K. Steinberg and Karen V. Kukil, eds., *The Letters of Sylvia Plath: Volume I. 1940–1956* (New York: Harper, 2017); and *The Letters of Sylvia Plath: Volume 2. 1956–1963* (New York: Harper, 2018). Entries derived from Plath's journals, 1950–1962, have been collected in Karen V. Kukil, ed., *The Unabridged Journals of Sylvia Plath: 1950–1962* (New York: Anchor Books, 2000). Letters to Plath and entries in the Letts Royal Office Tablet diary for 1962 are in the Sylvia Plath collection, Mortimer Rare Book Library, Smith College in Northampton, Massachusetts. Two pages from the Letts calendar have been removed and were missing when Ted Hughes sold the item to Smith College. These pages concern the marriage breakdown during the week Plath overheard a call from Assia Wevill and relate to the September 1962 trip to Ireland, during which Hughes abandoned Plath. Curly brackets (i.e., {}) identify other sources for entries, outlined below by their abbreviations. I have not corrected Plath's misspellings or her inconsistent capitalization. I have used the maiden names of Plath's friends, even if they married and acquired another last name. Peter K. Steinberg has been able to determine additional dates for drawings, poems, journal entries, and various notes: https://sylviaplathinfo.blogspot.com/2019/01/dating-sylvia-plaths-journals -part-ii.html; I have also drawn on his dating of Plath publications: https:// www.sylviaplath.info/publications.html. His extensive work on Plath is available in the Preservica Digital Preservation System at https://te992faff 27c68c1d.starter1ua.preservica.com/portal/en-US.

ADC: Amateur Dramatic Club, Cambridge University
AW: Andrew Wilson, *Mad Girl's Love Song: Sylvia Plath and Life Before Ted* (New York: Scribner, 2013)

Bells: Notation in Plath's Smith College calendar referring to sitting at a desk "on watch," recording entrants into Haven House and Lawrence House

BF: Anne Stevenson, *Bitter Fame: A Life of Sylvia Plath* (Boston: Houghton Mifflin, 1989)

BW: Plath's abbreviation in her calendars for waiting on tables, usually at breakfast, as part of her Smith College scholarship obligations

CAW: Julie Goodspeed-Chadwick and Peter K. Steinberg, eds., *The Collected Writings of Assia Wevill* (Baton Rouge: Louisiana State University Press, 2021)

CR1: Carl Rollyson, *American Isis: The Life and Art of Sylvia Plath* (New York: St. Martin's, 2013)

CR2: Carl Rollyson, *The Last Days of Sylvia Plath* (Jackson: University Press of Mississippi, 2020)

CR3: Carl Rollyson, *Sylvia Plath Day by Day, Volume 1* (Jackson: University Press of Mississippi, 2023)

CR4: Carl Rollyson, *The Making of Sylvia Plath*, forthcoming from Jackson: University Press of Mississippi

CSM: *Christian Science Monitor*

EB: Edward Butscher, *Sylvia Plath: Method and Madness* (New York: Seabury Press, 1976)

EF: Elaine Feinstein, *Ted Hughes: The Life of a Poet* (New York: W. W. Norton, 2001)

HC: Heather Clark, *Red Comet: The Short Life and Blazing Art of Sylvia Plath* (New York: Knopf, 2020)

HH: Diane Middlebrook, *Her Husband: Hughes and Plath—A Marriage* (New York: Viking, 2003)

HR: Harriet Rosenstein research files on Sylvia Plath, 1910–2018, Stuart A. Rose Manuscript, Archives, and Rare Book Library, Emory University, Atlanta, Georgia

JB: Jonathan Bate, *Ted Hughes: The Unauthorised Life* (Great Britain: William Collins, 2015)

LH: Aurelia Plath, ed., *Letters Home* (New York: Harper Perennial, 1992)

LP1: Peter K. Steinberg and Karen V. Kukil, eds., *The Letters of Sylvia Plath, Volume 1. 1940–1956* (New York: Harper, 2017)

LP2: Peter K. Steinberg and Karen V. Kukil, eds., *The Letters of Sylvia Plath, Volume 2. 1956–1963* (New York: Harper, 2018)

LWM1: Linda Wagner-Martin, *Sylvia Plath: A Biography* (New York: Simon & Schuster, 1987)

LWM2: Linda Wagner-Martin, *Sylvia Plath: A Literary Life, Second Edition* (London: Palgrave Macmillan, 2003)

PA: Paul Alexander, *Rough Magic: A Biography of Sylvia Plath* (New York: Da Capo Press, 1991)

PJ: Karen V. Kukil, ed., *The Unabridged Journals of Sylvia Plath: 1950–1962* (New York: Anchor Books, 2000)

PKS: Peter K. Steinberg, *Sylvia Plath* (New York: Chelsea House, 2004)

PM: Plath manuscripts, Special Collections, Lilly Library, Indiana University, Bloomington, Indiana, last updated 2022, http://webapp1.dlib.indiana .edu/findingaids/view?doc.view=entire_text&docId=InU-Li-VAC4841

RB: Dr. Ruth Beuscher, aka Ruth Tiffany Barnhouse

RH: Ronald Hayman, *The Death and Life of Sylvia Plath* (New York: Birch Lane, 1991)

SPD: Elizabeth Sigmund and Gail Crowther, *Sylvia Plath in Devon: A Year's Turning* (Gloucestershire, UK: Fonthill Media, 2014)

THL: Christopher Reid, ed., *Letters of Ted Hughes* (New York: Farrar, Straus & Giroux, 2007)

TMA: Gail Crowther, *Three-Martini Afternoons at the Ritz: The Rebellion of Sylvia Plath & Anne Sexton* (New York: Gallery Books, 2021)

PRINCIPAL PERSONAGES

A principal personage is anyone who appears in Plath's diary, journals, or correspondence several times.

Abels, Cyrilly: *Mademoiselle* editor who mentored Plath

Adamson, George: illustrator of Ted Hughes's children's book *Meet My Folks!*

Akutowicz, Edwin: met Plath in Cambridge and after a sexual encounter paid for the doctor's bill when Plath hemorrhaged; she maintained sporadic contact with him until she graduated from Smith

Alliston, Susan: married to Clement Moore, Warren Plath's friend and best man at his wedding; Alliston was involved in an affair with Ted Hughes and seemed obsessed with Sylvia as well

Alvarez, Al: editor of *The Observer* poetry page and a friend of Hughes and Plath; he figures importantly in her last diary, which Ted Hughes said he destroyed

Anderson, Jane: at McLean hospital during Plath's stay; dated Richard Norton; a character modeled on her appears in *The Bell Jar*

Arvin, Newton: Plath's American Literature professor at Smith for whom she also worked as a grader when she returned to teach; a distinguished biographer of Nathaniel Hawthorne, Herman Melville, and Henry Wadsworth Longfellow

Axworthy, Nancy: housekeeper of Court Green, the Plath and Hughes home; she usually came for three hours (9:45 to 12:45) in the morning

Baltzell, Jane: an American student at Cambridge who had a conflicted friendship with Plath, who regarded Baltzell as a kind of double

Barrett, A.: Plath's French tutor at Cambridge

Bennett, Grace: wife of Jim Bennett

Bennett, Jim: local repairman in North Tawton

Bennett, Joan: Plath enjoyed her "incisive" lectures on seventeenth century metaphysical poets at Cambridge

Benotti, Dorothy: Aurelia Plath's sister and Sylvia's aunt

Benotti, Nancy: Dorothy Benotti's daughter

Billyealds, Major and Mrs.: North Tawnton neighbors

Bires, Mrs.: Plath engaged her to mind the children at Court Green

Booth, Dr. Marion: Smith College psychiatrist who met with Plath on a regular basis in the spring semester of 1954

Brown, Marcia: Plath's Smith roommate who remained a close friend

Burton, Kathleen Marguerite Passmore: Cambridge University director of studies; Plath's supervisor for Tragedy and Practical Criticism

Cantor: Mrs. Plath's employer in Chatham (on Cape Cod), where Plath looked after the Cantor children; Mrs. Cantor remained a part of Plath's life, and her Christian Science beliefs intrigued and influenced Plath

Cartwright, Sheena: a nanny for Plath's children, she lived in Totnes in South Devon

Causley, Charles: a poet and friend of Plath and Hughes

Chase, Mary Ellen: professor of English at Smith College and one of Plath's mentors

Cheney, Don: an old Wellesley friend, Warren's classmate at Choate, and on a Fulbright in Rome, where Plath spent some time with him

Cleverdon, Douglas: BBC producer who broadcast Plath's "Three Women"

Compton, David: a Devon neighbor and writer married to Elizabeth, Plath's close friend

Compton, Elizabeth: Plath's devoted Devon neighbor and friend

Corkery, Brian: a Cambridge University student in history who dated Plath

Crockett, Wilbury: Plath's esteemed high school teacher

Daiches, David: important literary historian and critic whose lectures Plath attended during her early Fulbright days in England

Davies, Winifred: one of Plath's midwives

Davison, Peter: Harcourt Brace editor who took an interest in Plath's work and briefly became her lover

Drew, Elizabeth: distinguished literary critic and Smith professor

Farrar, Vicky: Ted Hughes's cousin

Farrar, Walter: Ted Hughes's millionaire uncle

Ferran, Dina: Fulbright scholar at Cambridge who befriended Plath

Fisher, Alfred: a Smith professor who took a special interest in Plath's poetry and tutored her

Fosters, Alan and Marion: literary-minded Irish family in North Tawton Plath socialized with

Frater, Ken: South African student at Cambridge who befriended Plath at the ADC

Frayn, Michael: on the *Varsity* staff at Cambridge and a friend of Plath's

Freeman, Ruth: childhood friend in Winthrop

Friedman, Ellie: Smith classmate and good friend

Gebauer, George: an Amherst student Plath dated

Gibian, Professor George: supervisor of Plath's senior thesis

Hamilton, Mrs.: a North Tawton neighbor

Haupt, Gary: a Yale student studying at Cambridge during Plath's time there

Hughes, Edith: mother of Ted Hughes

Hughes, Gerald: brother of Ted Hughes

Hughes, Joan: wife of Gerald Hughes

Hughes, Olwyn: sister of Ted Hughes

Hughes, William: father of Ted Hughes

Hughes-Stanton, Corbin: boyfriend of Susan Roe

Hutchins, Miss: one of the nannies Plath did not like

Huws, Daniel: a friend of Ted Hughes and later of Plath's

Huws, Helga: Daniel's German wife who befriended Plath

Jenkins, Alan: father of Susan Roe

Jenkins, Nancy Letitia: mother of Susan Roe

Jennings, Elizabeth: a Catholic poet who lived in a convent and whose company Plath enjoyed

Kane, Marvin: interviewed Plath for a BBC program and became a friend

Kazin, Alfred: prominent literary critic; Plath took his class at Smith, and he was instrumental in writing recommendations for her

Key, Percy: a Court Green neighbor, husband of Rose

Key, Rose: wife of Percy; her cottage was close to Court Green; she sometimes babysat the children

Krook, Dorothea: Cambridge University philosophy lecturer and Plath's mentor

Lameyer, Gordon: introduced himself while visiting Smith, dated Plath, and wrote to her while he was in the Navy; became her suitor

Lawner, Lynn: Wellesley undergraduate Plath met at a poetry contest; they exchanged letters

Licht, Dorrie: a Smith College classmate

Lythgoe, John: Cambridge University set designer for ADC

MacBeth, George: BBC producer of "The Poet's Corner"

McCurdy, Philip: a close Wellesley friend

Macnamara, Mrs. Kathleen: a North Tawton resident with room to spare for Plath's friends the Kanes

Macedo, Helder: Portuguese poet befriended by Plath and Hughes

Macedo, Suzette: teacher, Helder's wife, and friends with Plath and Assia Wevill

Mazillius, Charles: Plath's solicitor

Merwin, Dido: wife of W. S.; helped Plath and Hughes settle in London but turned against Plath

Merwin, W. S.: American poet and friend of Ted Hughes

Meshoulem, Isaac "Iko": economics student at Pembroke College, Cambridge University

Michie, James: Plath's editor at Heinemann

Moore, Clement: friend of Warren Plath and husband of Susan Alliston Moore

Moore, Leonard: father of Clement Moore

Myers, Lucas: a close friend of Ted Hughes who wrote two memoirs about Plath and Hughes

Nash, Ben: editor of *Granta*, which published Plath's work

Northam, John: Plath attended his lectures on drama at Cambridge University

O'Neill, Patsy: a Wellesley friend

Perego, Giovanni: Paris correspondent of *Paese Sera*; he became Plath's confidant while she was in Paris suffering over Richard Sassoon's departure

Phillips, Claiborne: Smith College student and Plath friend

Plath, Aurelia Schober: Sylvia's mother

Plath, Otto: Sylvia's father

Plath, Warren: Sylvia's brother

Pollard, Charlie: a Devon beekeeper

Prouty, Olive Higgins: popular novelist and one of Plath's benefactors

Redpath, Theodore: Plath attended his incisive, logical lectures at Cambridge but wanted a more personal connection since she saw him as a father figure

Redwood, Miss P. B.: Plath's riding instructor at Lower Corscombe Farm, Corscombe Lane, near Okehampton

Roberts, Margaret: a South African student at Cambridge University and a friend of Plath's

Roche, Clarissa: Paul Roche's wife, a friend of Plath's, who visited her at Court Green and also in London and wrote a memoir about her friendship with Plath

Roche, Paul: translator who befriended Plath at Smith College

Roe, Susan: a young nurse recommended by Winifred Davies; Susan helped to look after the children

Sassoon, Richard: a Yale undergraduate when Plath met him; they became romantically involved

Scott, Ira: a doctor Plath dated in Cambridge, Massachusetts

Secker-Walker, Lorna: a young mother who lived near 23 Fitzroy Road and visited there for tea

Shakin, Carl: Plath met him aboard a ship on the way to England and their romance briefly continued in London; he was an NYU engineer and nuclear physicist on the way to a Fulbright in Manchester

Sigmund, Elizabeth: see Compton, Elizabeth

Sillitoe, Alan: novelist and friend of Plath and Hughes

Strahan, Derek: a student of modern and medieval languages at Cambridge who dated Plath

Sweeney, John: head of the Woodberry Poetry Room at Harvard who recorded Plath reading her poetry

Taylor, Elsie: a Court Green neighbor

Tyrer, George: bank manager in North Tawton, near Court Green

Tyrer, Marjorie: wife of George Tyrer

Tyrer, Nicola: teenage daughter of George and Marjorie Tyrer

Wain, John: poet and critic; Plath contacted him when she moved to 23 Fitzroy Road in London

Watkins, Mr. and Mrs.: Court Green neighbors

Weare, Mrs.: she minded Plath's children

Webb, Dr. Hugh: Plath's physician during her second pregnancy

Webb, Joan: wife of Dr. Webb

Weller, Sue: a Smith classmate who spent time with Plath on long walks and playing tennis

Welsford, Enid: Plath attended Welsford's lectures on tragedy at Cambridge

Wertz, Dick: Yale graduate and Richard Sassoon's roommate studying at Cambridge when Plath arrived

Wetzel, Margaret (Maggie): Sylvia's sister-in-law, married Warren Plath in 1962

Wevill, Assia: wife of David Wevill and lover of Ted Hughes, and like Susan Alliston, obsessed with Plath

Wevill, David: poet and husband of Assia Wevill

Whitman, Will: a Wesleyan student Plath met at a poetry contest; he drove her back to Smith

Wyatt-Brown, Bertram: an American studying history at King's College, Cambridge; befriended Plath and dated Jane Baltzell

TIMELINE

1955

Even before Plath knew she would have a Fulbright scholarship, she decided on going abroad to study at Cambridge. Ever since high school, when she had discussed studying in England with her teacher, Wilbury Crockett, she was formulating a plan to become connected to the world, reaching out to a German pen pal and thinking in global terms.

February 14: "dear mother": about her acceptance at Cambridge: "whole english dept. here is behind me and against machine-made american grad degrees."

February 15: Returns to library books about John Ford[1]

8:00–1:00: Works on revisions of poems

10:00–11:00: German with Professor Sonnenfeld

1:15: *Smith Review* meeting

2:00: Meets Eleanor Duckett[2]

3:30: Meets with Professor Mary Ellen Chase

7:00: Sees Claude Rains in *Romeo and Juliet*

February 16, 8:00: Attends chapel

9:00–12:00: Studies Shakespeare and *Winesburg, Ohio* by Sherwood Anderson

12:00–1:00: Bells

2:00–6:00: *Smith Review* meeting

7:00–10:00: Studies German and *Romeo and Juliet*

10:30: A meeting with seniors

February 17, 8:00–10:00: Cleans room

10:00–11:00: Alfred Kazin's class, Gordon Lameyer calls from Cuba[3]

11:00–12:00: German

12:00–1:00: Shakespeare

2:00–3:00: Dresses

3:00–4:00: Meets with Professor Fisher about her poetry

"Alum house tea"

February 18, 8:00–10:00: German translation

 10:00–11:00: Alfred Kazin's class

 11:00–12:00: German class

 12:00–1:00: Shakespeare class

 2:00–6:00: Naps, sends poems to *Ladies Home Journal*

 7:00–10:00: A bull session with Alvina[4]

February 19, 8:00–10:00: Works on German translation

 10:00–11:00: Alfred Kazin's class

 11:00–12:00: German class

 12:00–1:00: Shakespeare class

 2:00–6:00: Naps

 7:00–10:00: Begins writing "The Princess and the Goblin," reads *Antony and Cleopatra*

 Memoranda: Works on Ford bibliography; German, *Tonio Kröger* by Thomas Mann "story and grammar" notes; and reads *Winesburg, Ohio*

February 20, 8:00–12:00: Reads *Romeo and Juliet* and *Othello* Dinner with Dorothy Wrinch Hubbard[5]

 2:00–5:30: Dr. Chang[6]

 7:00–12:00: "Finish Shakespeare reading"

February 21, 8:00–1:00: Finishes reading *Winesburg, Ohio*

 2:00–3:30: "read for Vogue"

 "scholarship office"

 3:30–6:00: Reads to Professor Gray[7]

February 22: Rally Day,[8] note to call Professor Sonnenfeld

 9:30: Attends chapel

 2:00–6:00: Works on first draft of piece for *Vogue*

 7:30: Rally Day Show with Sue

 "bull session"

February 23: 8:00–12:00: "Vogue essay?" German paper

 12:00–1:00: Bells

 2:00–6:00: Listens to music

 7:30–10:00: "German: Sonnenfeld"

February 24, 8:00–10:00: Cleans room and works on German translations

 10:00–11:00: Alfred Kazin's class

 11:00–12:00: German class

 12:00–1:00: Shakespeare class

 Bathes and dresses

 3:00: Works on poems with Professor Fisher

 7:00–10:00: Works on *Vogue* article, washes hair

February 25, 8:00–10:00: Works on German translations

 10:00–11:00: Alfred Kazin's class

11:00–12:00: German class

12:00–1:00: Shakespeare class

Bathes and dresses

4:00: Meets Richard Sassoon

7:00–10:00: At Rahar's for martinis[9]

February 26, 8:00–10:00: Works on German translations

10:00–11:00: Alfred Kazin's class

11:00–12:00: German class

12:00–1:00: Shakespeare class

Mails *Vogue* and *Mademoiselle* entries

2:00–6:00: Writes letters to Mary Ellen Chase, Ruth,[10] Richard Sassoon

February 27, 9:00–1:00: Reads *Babbitt* by Sinclair Lewis, works on German translations

2:00–5:30: Works on poems for Professor Fisher

6:00–10:00: Bull session with Sue Weller, writes "Sonnet to Shade" and "How shall winter"

February 28, 8:00–1:00: Writes sculpture poem, works on *Vogue* Prix de Paris essay

3:30–6:00: Reads to Professor Gray

7:30: "40b: 17th cen: Peterson"

March: Writes to editor of *Mademoiselle* praising the February issue and twentieth anniversary of the magazine. Singles out poems by Donald Hall and Dylan Thomas among others.

March 1, 8:00–10:00: Works on article for German class

10:00: German with Professor Sonnenfeld

11:00–1:00: Finishes reading *Babbitt*

2:00–6:00: At Amherst to see a performance of *Othello*

7:30: Returns on bus to Smith

Postcard to "Dear Mother": Reports on a forthcoming "rugged" week of schoolwork, a planned trip to NYC, and a symposium at Smith on the "Mid-Century Novel" with Alfred Kazin, Saul Bellow, and Brendan Gill, which *Mademoiselle* has asked her to report on.

March 2, 8:30: Chapel

9:00–12:00: Washes hair, studies for German exam

12:00–1:00: Bells

2:00–6:00: Writes "Ice Age"

5:00: Sees Harry Levin[11] in Sage Hall

7:30–10:00: Works on German with Professor Sonnenfeld

March 3, 10:00–11:00: Alfred Kazin's class

11:00–12:00: German class

12:00–1:00: Shakespeare class

1:30: *Smith Review* meeting

3:00: Meeting with Professor Fisher

4:00–6:00: Studies *Romeo and Juliet*

March 4, 8:00–10:00: Studies for German class

10:00–11:00: Alfred Kazin's class

11:00–12:00: German exam

12:00–1:00: Shakespeare class

2:00–6:00: Symposium on midcentury novel in Sage Hall, martinis at Rahar's

8:00–10:30: Dinner at Little Italy

March 5, 8:00–10:00: Writes up symposium for *Mademoiselle*

10:00–11:00: Cuts Alfred Kazin's class

11:00–12:00: German class

12:00–1:00: Shakespeare class

2:00–6:00: Naps

7:00–10:00: Goes to a Chekhov movie, *The Anna Cross*, with Gordon Lameyer

March 6, 8:00–1:00: Reads *Duchess of Malfi* by John Webster[12]

Dinner with Gordon Lameyer

2:00–3:00: Bells

3:00–6:00: Writes "Eye of Demon Lover"

7:00–10:00: Writes "Moonsong at Morning"

March 7, 8:00–1:00: Works on *Mademoiselle* assignment

2:00–3:30: Writes to Richard Sassoon

3:30–6:00: Reads to Professor Gray

[Eleanor] Duckett party

7:30: Attends Professor Hornbeak's lecture on eighteenth century

8:00: Hampshire bookshop

March 8, 8:00–10:00: Translates from the German Franz Kafka's *Metamorphosis*

10:00–11:00: German class

11:00–1:00: Writes "Second Winter"

2:00–6:00: Writes "Jilted Lover"

7:00–10:00: Washes hair, writes "Orange & Black"

March 9, 8:30: Chapel

9:00–12:00: Reads *The Great Gatsby* by F. Scott Fitzgerald and *Romeo and Juliet*

12:00–1:00: Bells

4:00: Meets Alfred Kazin in his office

7:30: Meets with Professor Sonnenfeld to work on German

March 10, 8:00–10:00: Cleans room and works on *Romeo and Juliet*

10:00–11:00: Alfred Kazin's class

11:00–12:00: German class

12:00–1:00: Shakespeare class

3:00: Meets with Professor Fisher about her poetry

4:00–6:00, 7:00–10:00: Reads Shakespeare and writes "Song for a Thaw"

"Dearest mother": Could use $25.00 for various expenses, needs $4,000 to cover two years at Cambridge, which she will manage somehow, getting on well with her work with Fisher and Kazin.

March 11, 8:00–10:00: Reads Shakespeare

10:00–11:00: Alfred Kazin's class

11:00–12:00: German class

12:00–1:00: Shakespeare class

4:00–6:00: Works on German translations

7:00–10:00: Walks with Sue Weller after the rain

March 12, 8:00–10:00: Reads *Hamlet*

10:00–11:00: Alfred Kazin's class

11:00–12:00: German class

12:00–1:00: Shakespeare class

2:00–6:00: "shop: Ruthie!"[13]

Writes "Million-Dollar Moth," martinis at Rahar's

7:00–10:00: Writes "Futility of Lexicon" and "Neophyte Notes"

March 13, 9:00–1:00: Tennis with Sue Weller, studies Shakespeare, works on German paper and on a topic for Kazin, dinner, writes to mother and Sassoon

2:00–5:30: Naps

7:00–10:00: Reads Blake and about F. Scott Fitzgerald

"Dearest Mother": Mentions writing poems about paintings she saw at the Whitney Museum, describes Ruthie's friend as "young and tedious," feels "very happy and optimistic" about her chances for a Fulbright, getting her work together for the Yale Younger Poets series, wants to bring Sue Weller home with her, a brilliant and athletic girl.

March 14, 8:00–1:00: Translates "Metamorphosis," banks and bookshop

11:30: Meets with Professor Gladys Anslow

2:15: Professor Page

2:30–3:30: Types poems

3:30–6:00: Reads to Professor Gray

7:30: "40b, 19th cen. Romantics: [Professor Helen Whitcomb] Randall"

March 15, 8:00–10:00: Translates "Metamorphosis"

10:00–11:00: Meets with Professor Sonnenfeld

11:00–1:00: Reads pieces for *Smith Review*

2:00–6:00: At the infirmary

7:00–10:00: Reads *Tender Is the Night* by F. Scott Fitzgerald

March 16, 8:30: Attends chapel

 9:00–12:00: Studies notes for Shakespeare class

 12:00–1:00: Bells

 2:00–6:00: "Mass meet: 4"

 7:30: Meets with Professor Sonnenfeld

 10:00: House meeting

March 17, 8:00–10:00: Reads Shakespeare criticism and cleans room

 10:00–11:00: Alfred Kazin's class

 11:00–12:00: German class

 12:00–1:00: Shakespeare class

 3:00–4:00: Meets with Professor Fisher about her poetry

 7:00–10:00: "critics and language"

Postcard to "Dear mother": After visit to infirmary feels better and ready for exams in German and Shakespeare and excited about forthcoming trip to NYC.

March 18, 8:00–10:00: Studies Shakespeare's plays

 10:00–11:00: Alfred Kazin's class

 11:00–12:00: German class

 12:00–1:00: Shakespeare class exam

 2:00–6:00: Meets with Professor Drew and picks up clothes

 7:00–10:00: Washes hair, finishes German paper

March 19, 8:00–10:00: Reads *Hamlet*, starts work on paper for Kazin

 10:00–11:00: Alfred Kazin's class

 11:00–12:00: German class

 12:00–1:00: Cuts Shakespeare class

 2:00–6:00: Meets Marty [Marcia Brown] and Mike [Plumer] at Rahar's for "beer & good talk"

 7:00–10:00: Meets Chris Buxton[14]

March 20, 8:00–10:00: Tennis with Sue Weller

 4:30: Meets with Professor Drew

 7:00–10:00: Writes to Claiborne Phillips, mother, Richard Sassoon

"Dear mother": Invigorating tennis with Sue, fun with Marcia Brown, her boyfriend Mike, and their friend Chris Buxton, who tells her about Cambridge, presenting an "enchanting picture of spring boating & may 'balls' & gardens there."

March 21, 9:30: "hair trim"

 1:15: *Smith Review* meeting

 2:00–3:30: "D. shower?"[15]

 4:30–6:00: Rahar's, martinis, gifts, and gaiety

 7:30: 40b: 19th: Victorian poetry with Professor Johnson

 10:00: House meeting

March 22, 8:00–10:00: Works on German translations

10:00–11:00: Meets with Professor Sonnenfeld

1:20: Alpha Phi Kappa[16] meeting

Coffee with Ellie Friedman

2:00–6:00: Meets with Professor Page, works on German translations, paper for Alfred Kazin, reads *Hamlet*

7:00–10:00: Writes "Real Sea"

March 23, 9:00–12:00: Attends chapel, reads *Hamlet*, works on German translations

12:00–1:00: Bells

2:00–6:00: Lunch at Rahar's with Peter Davison

Rahar's with Sue Weller for Dorrie Licht's wedding shower

7:30: Meets Professor Sonnenfeld, washes hair and packs

March 24, 8:00–10:00: Cleans room and studies German

10:00–11:00: Alfred Kazin's class

11:00–12:00: German class

12:00–1:00: Shakespeare class

Showers, shaves, dresses, washes hair, and packs

3:00: Meets with Professor Fisher about her poetry

5:00: "Joan Bennet[17]: Sage"

Drives to NYC, "late martini & club sandwich"

"Dearest Mother": Announces Smith has awarded her $1,000 fellowship for study abroad, looks forward to a respite from classes and "stoic limiting" reading and writing at home, wants to see Mrs. Prouty, Patsy O'Neill, Warren, and RB.

March 25, 10:00–11:00: Cuts Alfred Kazin's class

11:00–12:00: German class

12:00–1:00: Shakespeare class

Lunch with Claiborne Phillips on Third Avenue in NYC

3:00: Meets Richard Sassoon

7:00–10:00: Dinner at Le Champlain with Claiborne and her fiancé Avrom Handleman and goes to see *Tea and Sympathy* by Robert Anderson

March 26, 10:00–11:00: Alfred Kazin's class

11:00–12:00: German class

12:00–1:00: Shakespeare class

4:30: Dorrie Licht's wedding in Mt. Vernon, "wonderful reception . . . champagne & canapes," meets Patience Cleveland from Smith and Charlie Acker from Wellesley

Sees *Saint of Bleeker Street* "dynamic"[18]

March 27: "orange, wine & talk—Long, late dinner at 'Albert's' in Village—shish—kebabs—herring—Wine—parfait—lovely drive—sang"

5:45: Train to New Haven, then late supper at coffee shop with Sue Weller

10:30–12:00: Bells

"Dearest mother": Feeling as calm and serene as the Mona Lisa after NYC trip, wants Sue Weller to come stay with her at home during spring break, describes long walk in NYC, visiting the skating rink at Rockefeller Center, Dorrie's high society wedding, pleased about a promising letter from *Atlantic Monthly* expressing interest in her poems.

March 28: Sleeps late

11:00–1:00: Brunch

1:20: *Smith Review* meeting

3:30: Cleans room

7:30: "40b: 19th Victorian Prose: Durbin"

March 29, 8:00: Meets with Professor Sonnenfeld

12:45: BW

2:00–3:00: "16 Paradise"

4:00: Meets with Professor Mary Ellen Chase

5:15: "bus home! Wonderful talk with composer Stefan Wolpe"[19]

March 30, noon: A late breakfast, plays piano, washes and irons clothes

Dinner with Warren, drives to Cambridge, listens to records and relaxes

March 31: Sleeps until noon, late brunch, bikes over to the Crocketts for an afternoon of "good talk," types poems to send to *Harper's*, *New Yorker*, *Good Housekeeping*, phones Marcia Brown

Spring: *Smith Review* publishes "Dances Macabre" and "Superman and Paula Brown's New Snowsuit"

April 1: Browsing the books at Hathaway House in Wellesley, types two sections of "Circus in 3 Rings"

4:30: Meets Marty and her boyfriend Mike at the Coop in Cambridge and then a beer at Wursthaus

5:30: Picks up Warren in Cambridge for dinner in Wellesley

Types poems

April 3: Finishes typing poetry manuscripts, works on "Circus in 3 rings"

April 4: After brunch, plays the piano, talks to Sue Weller, sends "Smoky Blue Piano" to *Good Housekeeping* after getting "lovely rejections" from *Collier's*, reads magazines and *Writer's Yearbook* and about "color theory"

April 5: After a late brunch cleans the porch

11:00: Calls Sue Weller

Drives with Philip McCurdy to Cambridge to pick up Sue, tennis with Philip McCurdy, calls Mrs. Prouty and Mrs. Cantor

April 6, 9:30: Meets Ruth Freeman and shops for a wedding dress

Home for lunch

2:00–5:00: Naps

Family dinner and a "good talk" with Warren, visits family of Clement
Moore,[20] Edwin Akutowicz calls

April 7: Picks up Sue Weller in Cambridge

11:00: Drops off Warren at Harvard

A chicken salad lunch at Wursthaus, tennis with Sue Weller, afternoon
nap, dinner "en famille," reads *Saturday Evening Post* stories in bed

April 8: Shops with Sue Weller at Hathaway house, drives to Cambridge
to buy sherry

3:00: Naps

To Boston with Sue Weller and Gordon Lameyer to see Greta Garbo
in *Camille* "tears and catharsis—meringues"

April 9: Tennis with Sue Weller

"Late delicious cheese-chicken fricassee lunch," "more tennis at Fells
courts," a dinner and talk with Edwin Akutowicz in Lakeview, Massachu-
setts, with a "lovely fire, beer, talk and very dear time"

April 10: Breakfasts with Sue Weller, drives to Chatham for a picnic of
roast beef sandwiches, cake, sherry, and coffee at Chatham Lighthouse,
drives through Orleans, a good talk with Sue Weller, washes her hair

April 11: A late breakfast, tennis with Sue Ellen, types poems

3:00: Dental appointment

4:30: Listens to records and calls Mrs. Prouty

Irons cottons, reads *Poetry and the Age* by Randall Jarrell

To Claiborne Phillips: She is ready to leave Smith and feels she needs
a "new world to conquer and be conquered by." {HR}

April 12: Writes three sonnets: "Sonnet to Green Eyed Sailer," "Advice
to Artificer," "Sorcerer Bids Farewell to Seem"

4:30: Tea with Mrs. Prouty, sherry and cucumber sandwiches, "won-
derful talk"

After a late steak dinner packs clothes

April 13: Returns to Smith with Grammy and Grampy in the car

Unpacks and fixes up her room

3:00: Lawrence House opens for dinner

April 14, 10:00–11:00: Alfred Kazin's class

11:00–12:00: German class

12:00–1:00: Shakespeare class

3:00: Meets with Professor Fisher about her poetry

Coffee with Sue Weller and Dorrie Licht

7:00–10:00: Reads "Prize 1955 Stories"

April 15, 8:00–10:00: "get clothes month"

10:00–11:00: Alfred Kazin's class

11:00–12:00: German class

12:00–1:00: Shakespeare class

3:25: Train to Poetry Reading Contest[21]

6:15: A lamb chop dinner

8:00: "reading and party"

April 16: "breakfast in bed: recording made of reading poetry—talk with Nancy Lynch"

10:30: Forum with Marianne Moore, John Ciardi, Wallace Fowler

Lunch at Holyoke: "wonderful, intimate, with poets & critics at book shop"; drives back to Smith with Will Whitman and Lynne Lawner; early to bed—"magnificent rapport with poets"

"Dearest mother": Describes the poetry contestants, judges, the public reading, considers the girls "superior to the boys," enjoys reading her poetry in public.

April 17: Tennis with Sue Weller, writes a sonnet "in dark room of your eye," meets Edwin Akutowicz for beer and a talk at Rahar's, "Bucolic visit to Look park,"[22] a dinner of herring, sour cream, and lobsters salad at Wiggins,[23] a long talk with Sue Weller before bed

April 18, 8:00–1:00: Writes letters to Carol,[24] "Mrs. P.,"[25] Professor Horner,[26] and Richard Sassoon[27]

Writes "Colossal is cockcrow of spring"

1:20: Alpha Phi Kappa meeting

2:00–3:30: Writes invitations

3:30–6:00: Reads to Professor Gray

7:30: 40b, Professor Drew on "20th cen"

10:00: House meeting

"Dear Miss Horner": Thanks her for arranging poetry festival: "I don't know when I've looked back on a more delightful weekend!" Crossing her fingers for a Fulbright.

Christian Science Monitor publishes "April Aubade"

April 19, 8:00: Works on paper for Alfred Kazin's class

11:00–1:00: Writes "desert song"

2:00–6:00: Naps

7:00–10:00: Works on outline for Kazin paper

April 20, 12:00–1:00: Bells and "name tags for tea talk"

4:00–6:00: Alpha Kappa Phi tea in Dutch Room

April 21, 8:00–10:00: Starts typing Kazin paper

10:00–11:00: Alfred Kazin's class

11:00–12:00: German class

12:00–1:00: Shakespeare class

3:00–4:00: Meets with Professor Fisher about her poetry

4:00–6:00: Washes hair, does German homework

6:45–8:00: Bells

7:00–10:00: House meeting

"Dear mother": A tough week with work piling up, wins the English department Alpha award for creative writing, four weeks of study for the May comprehensives and reading for "three months of long leisurely living" catching up on her sleep. The *Atlantic Monthly* asks her to revise "Circus in Three Rings," and she has qualms about revisions: "a poem is like a rare little watch: alter the delicate juxtaposition of cogs, and it just may not tick."

"The Spectrum of Scott Fitzgerald: A Study of Color Imagery in *Tender is the Night*," typescript for English 417b {PM}

April 22, 8:00–10:00: Reads *King Lear*

 10:00–11:00: Discussion about John Dos Passos in Alfred Kazin's class

 11:00–12:00: German class

 12:00–1:00: Discussion of *King Lear* in Shakespeare class

 2:00–6:00: Shopping with Sue Weller, a "good talk" with Elly Friedman

 7:00–10:00: Cocktails with Sue Weller

April 23, 8:00–10:00: Rewrites "Circus in Three Rings"

 10:00–11:00: Alfred Kazin's class

 11:00–12:00: German class

 12:00–1:00: Shakespeare class

 2:00–6:00: Out with Richard Sassoon for a sandwich and wine picnic

7:00–10:00: "house, wonderful, lamb chop Dinner & reading aloud—good"

"Dear mother": Wishes her a happy birthday and announces she has won the $50 Glascock Poetry Prize and quotes John Ciardi, who calls her "a real discovery." He has also offered to help get her published.

April 24: Works on German sentences, writes letters to editor Edward Weeks at *Atlantic Monthly*, Mother, Warren, Gertrude Claytor,[28] long talks with Sue Weller about the summer, reads letters of Gerard Manley Hopkins

"Dearest mother": Worried about her mother's health and Aurelia's plan to work in the summer, explains how they can get by without taxing her mother's strength, hopeful about her submissions to the *Atlantic Monthly*.

"Dear Editor Weeks": Submits five poems, winners of the recent Glascock Poetry Prize, welcomes his suggestions.

Birthday greeting card to Warren: "Much love on your approaching majority," reports her poetry prize award and $50 prize, "fighting with Editor Weeks" about revisions of her poems.

April 25, 8:00–1:00: Meetings with Dr. Booth,[29] Professor Page,[30] and Miss Fitch[31]

 1:20: Alpha Kappa Phi election of officers

 2:00–3:30: "clarify constitution—dues & pins"

3:30–6:00: Reads to Professor Gray
Types poems for Professor Fisher
7:30: 40b American Literature with Professor Arvin
"Dear mother": She has put together a book of sixty poems titled "Circus in Three Rings." With so much work she has decided to drop German for the rest of the year "without credit" as she prepares for the next "rather crucial" four weeks. Expecting replies from several magazines and from the Fulbright program, asks her mother not to worry.

April 26: "Mother's birthday"
 8:00–10:00: Naps
 10:00–11:00: Meets with Professor Sonnenfeld
 11:00–1:00: Writes to Gordon Lameyer
 2:00–6:00: Naps, then a coffee and a walk in the rain with Sue Weller
 8:00–10:00: Washes hair, reads "Prelude to Poetry"
To Gordon Lameyer: Envies his convalesce from an injury because in front of her is the "thorny slope of comprehensives." Longs for three months of sun, sand, and tennis, hopes to have some travel adventures with Sue Weller, tired of waiting to hear about the Fulbright, describes the demands to change "Circus in Three Rings" as an "aesthetic rape."

April 27: Warren's birthday, finishes "Prelude to Poetry"
 9:00–12:00: "Longinus: on Sublime,[32] Sidney Lanier"[33]
 12:00–1:00: Bells
 2:00–5:00: *Smith Review* meeting and "pinning party"[34]

April 28: "Read Stevens & criticism: Longinus & Lanier," $100 Christopher Prize
 8:00–10:00: Cleans room
 10:00–11:00: Alfred Kazin's class
 12:00–1:00: Shakespeare
 2:00–3:00: "wrote: Onteora,[35] mother, Ruth"
 3:00–4:00: "Sassoon—to bank"
 7:00–10:00: Reads John Ciardi and Stevens critics
"Dearest mother": Pleased with winning the Christopher award, encloses latest issue of *Smith Review* [spring 1955] with a story, "Paula Brown's Snowsuit" and poem, "Danse Macabre," in it, sending the same to Mrs. Prouty, hopes both her mother and Warren can come to graduation.

To Marion Freeman: Preparing for comprehensive exams covering her work in English of the last four years.

April 29, 8:00–10:00: Longinus and Lanier
 10:00–11:00: Alfred Kazin's class
 12:00–1:00: Shakespeare class
Reads the *New Yorker*

2:00–6:00: Tea and walks in the rain

7:45: Babysits for Professor Gibian

April 30, 8:00–10:00: Tennis with Sue Weller

10:00–11:00: Alfred Kazin's class

Washes hair, sunbathes on the roof, reads "Shaping Spirit"

5:00: Walks with Richard Sassoon by the river, then a "wonderful" lamb chop dinner and martinis at Wiggins

11:00–12:00: "penalty Bells"

May 1, 10:00–1:00: Reads Stevens, Longinus, Lanier, "Prelude to Poetry"

1:00–5:30, 6:00–9:00: Reads "Science of Versification"

9:15–10:30: Bells

May 2, 8:00–1:00: "Stevens & stockings," "Critical: Coleridge & Wordsworth"

2:00–3:30: "correlation questions"[36]

3:30–6:00: "Mr Fisher—to Miss Page"

7:30: 40b, American Literature with Professor Arvin

"bull session"

"dearest mother": Hopes her mother is convalescing well from virus infection, describes a "wonderful" date with Richard Sassoon.

May 3, 8:00–10:00: "Stevens: poems"

10:00–11:00: Meets with Professor Sonnenfeld

11:00–1:00: "Coleridge & Wordsworth & aesthetics books"

1:30: "hair trim"

2:00–6:00: Washes hair, sees Elly and Pat and packs

7:00–10:00: Step sings[37] with Dorrie Licht

May 4: Attends chapel

11:38: Bus to Albany

5:20: 3:00 bus to Kingston

"To Boiceville NY: sun, green mountains,"[38] "To school with Bob [Thornell]," a drive through the Catskills and talk by a lake

May 5: "magnificent, stimulating Boiceville English Festival"

10:00: Reads stories and poems in Assembly

"With Dachine Rainer[39]—met M. Spillane,[40]" drives to Albany with Bob Thornell

6:15: A Greyhound bus from Albany to Springfield

10:40: Train to Northampton

11:07: Arrives in rain and hail, a hot bath after a "perfect day"

May 6: Professor Gray's birthday, sleeps until 10:30, late breakfast at Toto's, writes Sassoon, Mother, Pat, and Bob Thornell[41]

2:00–6:00: "Joyce Horner"

7:00–10:00: Reads "Theory of Beauty"

"Dearest mother": Writes a greeting card birthday poem about "what a very very / wonderful mother you are." Describes her exhilarating experience at an English Festival in Onteora Central School in the Catskills.

"Dear Miss Horner": Assures her of the "rich experience the Holyoke festival was for me."

May 7, 8:00–10:00: Sunbathes on the roof of Lawrence House, reads " 'Theory of Beauty'[42] & 'Necessary Angel,' " the latter a book by Wallace Stevens

> **10:00–11:00:** Alfred Kazin's class
>
> **12:00–1:00:** Shakespeare class
>
> **3:00:** A walk with Richard Sassoon by Paradise Pond
>
> **7:00–10:00:** Lobster Newburg dinner at Wiggins restaurant; they

attend a movie, *Paris Incident*[43]

> **May 8, 8:00–10:00:** "Breakfast trays & sweep"
>
> **2:00–6:00, 7:00–10:00:** "correlation question reading"
>
> **May 9, 8:00–1:00:** Banking, "Get Kazin paper," John Everets
>
> **2:00–3:30:** Notes on Coleridge and Wordsworth
>
> **3:30:** "Outline of study program"
>
> **May 10:** Reading period begins
>
> **8:30–10:30:** Works on correlation question
>
> **10:30–11:00:** Drinks coffee and sorts her mail
>
> **11:00–1:00, 2:00–6:00:** Studies Romantic poets
>
> **7:00:** Washes hair
>
> **May 11, 12:00–1:00:** Bells
>
> Reads notes for English 211, "Gibians—Wonderful"
>
> **2:00–6:00:** Out with Sue Weller, Phi Beta Kappa dinner
>
> **7:30:** "dinner & talk red carnations & silver—Rahars with Sue"
>
> **May 12, 8:00–11:00:** Cleans room, studies Chaucer's "Troilus," "House

of Fame," "Book of the Duchess," "Parliament of Fowls"

> **7:00–10:00:** A walk with Sue Weller to "green hills—picasso cows"
>
> **May 13:** "Finish Chaucer, 'Canterbury Tales' "
>
> **12:00–1:00:** Sunbathes and reads Chaucer
>
> **2:00–6:00:** Step singing, a walk with Gordon Lameyer
>
> **7:00–10:00:** By the river, drinking wine and talking, washes hair
>
> **May 14:** Washes hair, shaves, packs, including copies of T. S. Eliot

and Chaucer

> **1:41:** At Yale with Richard Sassoon
>
> **2:00–6:00:** Tête-à-tête at Calhoun College
>
> Beach party with steak and whiskey in blanket
>
> **7:00–10:00:** A brandy at George & Harry's[44]
>
> **May 15:** A late breakfast at George & Harry's with Richard Sassoon
>
> **10:45:** Takes train to Smith

1:40: Arrives in Northampton, met at the station by Gordon Lameyer

2:00–5:30: "Sun & Pall Mell"

7:00–10:00: Reads T. S. Eliot

May 16, 8:00–1:00, 2:00–6:00: Reads T. S. Eliot, W. B. Yeats, W. H. Auden, Dylan Thomas

7:00–10:00: Begins reading Milton

May 17, 8:00–1:00: Finishes Milton: *Paradise Lost, Paradise Regained, Samson Agonistes*

Coffee with Ellie Friedman

2:00–6:00, 7:00–10:00: Reads James Joyce, *Portrait of the Artist,* makes notes on Edmund Wilson's *Axel's Castle*

May 18, 8:30: "Award Chapel"

9:00–12:00: Reads Hawthorne, Melville, Henry James

7:00–10:00: Supper with Estella Kelsey[45] at Little Italy

May 19, 8:00–1:00: Cleans room, studies notes on Shakespeare's plays, reads a critical book on the playwright by A. C. Bradley

2:00–6:00, 7:00–10:00: Reads James Joyce's *Ulysses*

May 20, 8:00–1:00: Studies Wallace Stevens, Coleridge, and Wordsworth and the role of poet and the nature of poetry

2:00–6:00: Learns she has won a Fulbright and writes ten letters of thanks to her professors and to RB

7:00: "FULBRIGHT!" Calls her mother

May 21: Final exams begin

9:00–1:00: Studies Coleridge, Wordsworth, and Wallace Stevens

2:00–6:00: Studies Milton and Bradley's book on Shakespeare

7:00–10:00: Reads George Lyman Kittredge on Chaucer

Sends a telegram home with "more good news": *Atlantic Monthly* will publish her original version of "Circus in Three Rings" in the August issue.

"dearest of mothers": On the roof in "halter and shorts basking in the pure blue air under a tall waving tree of white dogwood and green leaves": "how wonderful & reassuring it was to talk to you yesterday!" Lists her writing awards that total $465.

May 22, 9:00–1:00: Studies notes from Professor Patch's class and Kittredge on Chaucer's *Troilus* and *Canterbury Tales*

2:00–5:30, 6:00–10:00: Studies Shakespeare, her notes, and a book on tragedy and comedy

To Lynne Lawner: Praises Lawner's poetry and is "walking on air" now that she has her Fulbright.

May 23, 9:00–1:00: "Major Figures Exam"

2:00–6:00: Studies Byron, Shelley, Keats

7:00–10:00: "Dequincy—etc."[46]

May 24, 8:00–1:00: "James, Melville, Hawthorne"

2:00–6:00: Fitzgerald, Hemingway, Lewis, Dreiser, Anderson, Woolf, Lawrence, Joyce

May 25, 9:00–1:00: "General Exam"

2:00–6:00: "pack: home ride w. Warren call airline"

"visit mother at hospital"

7:00–10:00: "poems for Smith club"

May 26: Deposits check in bank, writes to *Mademoiselle*, visits mother, washes hair, does her nails, visits Mrs. Lameyer; Smith Club supper: poetry readings, "Magnificent dinner—lots of fun"; packs, Richard Sassoon calls

May 27: Writes letters, makes calls

11:00: American flight to NYC

Dinner of clams, consommé, duckling, and wild rice

May 28: Late breakfast at Steuben's,[47] Radio City Music Hall with the Rockettes, singing "Leave Me or Love Me," a performance of *Bolero*, a Tom Collins at the Plaza Promenade,[48] Cafe Francais[49] and steak tartare at Hamburger Heaven[50]

May 29: A "lovely luncheon" outdoors at Rey & Pierre's on 52nd Street, chicken in wine with avocado and onion soup, then raspberry ice and white wine, a walk in Central Park, strawberries and cream at the Promenade, movies: *Wuthering Heights* and *La Ronde*

May 30: Lunch at Three Crowns, a "wonderful revolving smorgasbord" and strawberry shortcake, on the Central Park carousel, rowing with Richard Sassoon on the pond, midnight supper at Toffenetti's[51]

Picture postcard to "Dearest mother": mentions "weeping buckets" over *Wuthering Heights*.

May 31: A walk in the rain and coffee at Howard Johnson's

12:30: With Mrs. Chubb for lunch at the Colony Club on Park and 62nd Street[52]

Movie: *The Glass Slipper*

6:00: Dinner at Claiborne Phillips's apartment with Richard Sassoon

After dinner cocktails and a "good sleepy talk" saying goodbyes

June 1: Walking in New York down Broadway and in Central Park

12:00: A BLT lunch with Claiborne Phillips

Reads *Mademoiselle* and sleeps until supper

June 2: Late breakfast, lunch with Cyrilly Abels at the Drake Hotel, "wonderful talk & shopping"

5:05: Train to Northampton, unpacks

June 3, 9:00: Wins Clara French Prize for the top senior in English

Meets Jane Anderson

2:00: Outdoor Ivy Day[53] Rehearsal

Letters and errands

From Gordon Lameyer: "From you . . . I have found a language, a way of looking at life, a beauty in the terrible paradoxes. You have given me courage to work in the dark, energy to concentrate on my work, vision to clear the shelf of the masters who sit staring down on me with their chilling jeer, confidence to act in the Hamlet play of life. I have taken all you had to give—and you gave more than anyone." {CR1}

From Richard Sassoon: "O my darling sweet clever Sylvia! You will make the heavens answer someday . . . if ever I am there . . . and I shall be." {CR1}

June 4, 9:30: Outdoor Ivy Day, white dresses and red roses in the alumnae parade[54]

Home to Wellesley with Mrs. Lameyer

1:30: Senior Step Sing

June 5: To bed with a cold

Greeting card to Gordon Lameyer with short poem that "can be gay / But not mad" and "just a little risqué."

June 6: Commencement day, Richard Sassoon's birthday

10:00: Graduates *summa cum laude* {LWM1}

Meets Ellie Friedman on a "lovely blue day," listens to Adlai Stevenson, picnics at Quabbin Reservoir[55] with Grammy, Mum, and Mrs. Cantor, Patsy O'Neill visits

June 7: Deposits $450 in bank account, shops at Filene's and Alexander's for shower and wedding gifts for Ruth Freeman

3:30: Tea with Mrs. Prouty

June 8: Gordon Lameyer's birthday, writes letters to Professors Page, Fisher, Kazin,[56] Lynne Lawner

8:00: Shower for Ruth at the Belmont[57]

To Lynne Lawner: Describes graduation, her reaction to Commencement speaker Adlai Stevenson, concerns about her mother's operation on an ulcer, staying at home, and looking forward to her voyage on the *Queen Elizabeth*. She has had enough of travel for the moment after heady experiences in New York City.

June 9: Sends poems to *The Nation, Harper's, Harper's Bazaar, Ladies Home Journal,* talks on phone with Marcia Brown, Lynne Lawner, Mrs. Lameyer, RB, a visit from Kathy[58] and Stan[59]

June 10, 10:00: A good talk with RB, shopping, to Winthrop with presents for Ruth Freeman, shower rehearsal at church and a buffet supper for ten people with wine, cake, and salads

June 11: A late breakfast of egg, toast, coffee, talk with Betty Hall, arranges flowers, shops with Mrs Freeman, picks out a blue dress with pink and yellow embellishments

> **3:00:** "Ruthies wedding bouquet"
>
> Home with Warren
>
> **8:00:** Meets Edwin Akutowicz in Cambridge for supper and talk

June 12: Sleeps late, breakfasts, plays the piano, a call from Lynne Lawner, cooks a chicken dinner, writes to Richard Sassoon, RB, and Mrs. Chubb[60]

> **3:00–4:00:** Joan Cantor visits
>
> **6:00–12:00:** Types manuscript for Borestone Mountain literary competition

June 13: Finishes typing Borestone manuscript, cashes a check at the bank, has shoes heeled and dyed, picks up clothes at the cleaners, browses at Hathaway House bookstore, visits mother in hospital, reads Ayn Rand's *The Fountainhead*

June 14, 7:30: An evening with Patsy O'Neill and Mr. Crockett at Angelo Bertocci's home[61]

June 15: Phone installation, to the cleaners, picks up shoes, sunbathes in backyard

> **2:00–4:00:** At Nahant with Warren, swimming and walking
>
> **7:00–8:00:** A hospital visit to mother
>
> Early to bed

June 16: Sends "Smoky Blue Piano" to *Woman's Home Companion*, tennis and talk with Philip McCurdy, "hot sun"

June 17: Sunbathes in backyard, reads *Collier's* and "writer's books," washes hair

> **8:00:** A "wonderful reunion" with George Gebauer at Howard Johnson, a walk around Wellesley, a drive, a "long good talk"
>
> "The Magic Mirror: A Study of the Doubt in Two of Dostoevsky's Novels," carbon bound typescript {PM}

June 18, 9:30–11:00: "Dedication of Babson World globe[62] with Bill Cruikshank[63] and Pixie,"[64] sunbathes in backyard, says goodbye to Warren, visits mother at hospital, reads from "Black Prince,"[65] Gordon Lameyer visits

June 19: A "magnificent sunny day" at Crane's Beach in Ipswich with Gordon Lameyer, swimming, picnicking, and sunbathing, followed by martinis and a steak dinner, a lovely drive, and home with a "blazing burn"

June 20: Cleans house including Warren's room and bookcase, living room and bookcase, kitchen cupboards—all while listening to records and experiencing "ineffable nostalgia"

June 21: Washes hair, a hospital visit to mother with Grammy, then to the post office in Wellesley and shopping

1:00–5:00: At the post office for a passport application and then to the City Hall annex for a copy of her birth certificate

Bakes Tollhouse cookies

June 22, 9:30: To the bank to deposit $60 and withdraw $100 from checking account, then to the Cantors and shopping for suitcases in downtown Boston and buying two bathing suits, late lunch with Gordon Lameyer, "good talk" while playing records, writes letters[66] and works on her scrapbook, irons

June 23: Food shopping and letter writing[67] and to Ipswich with Gordon Lameyer, swimming, picnicking, long walks, another sunburn, listening to music on the drive home

June 24, 9:00–10:00: Food shopping

10:00: A hospital visit to mother, shopping, reads the *World Almanac*, visits from Gordon Lameyer and Mrs. Gaery,[68] draws bouquet of flowers for mother with the message: "WELCOME HOME!!!!!!"

June 25: Writes letters[69] and works on scrapbook

1:30–5:00: Tennis with Gordon Lameyer at Hunnewell Courts[70]

Cocktails with Lameyers, a drive in the country with Gordon

June 26: Calls Richard Sassoon "lovely," tennis with Gordon Lameyer at Hunnewell Courts, cooks steak dinner at home, back to the courts for doubles with "old Hungarian Nicholas & little Joe," talk with mother

June 27: Drives with Gordon Lameyer to Crane's Beach, sunbathes, reads the *New Yorker*, runs out of gas and hitchhikes to gas station, George Gebauer calls, Richard Sassoon calls, reads in bed

June 28: Writes letters to Grays, Powleys, Sue Weller, Bob Thornell, Robert Shea,[71] Academy of Poets, England,[72] mails manuscript to Borestone competition

2:00–5:00: Tennis and talk with Gordon Lameyer

To Harrison Eudy: Announces she has won an Academy of American Poets prize at Smith College, made possible with a bequest by Eudy's mother, a poet and fashion designer. Mentions two of his mother's poetry collections that will be an inspiration to her. Quotes from his mother's poems and regards her books as a "talisman."

June 29: Finishes writing letters to Mr. Eudy, Ruth Cohen,[73] C. Abbott,[74] I. V. Morris,[75] Gertrude Claytor,[76] Hans Plaat, Joyce Horner, Mrs. Wheeler,[77] mows lawn, weeds garden, shops all afternoon, goodbye visit with Gordon Lameyer

Dated passport {PM}

July 3: Breakfast of chicken livers and bacon, packs for a picnic, a "hot drive" to Ipswich, Crane's beach in the "hot sun" and "white sand," a lovely time playing in the water, home to a steak dinner and a "cool moony night"

July 4: Morning spent with Richard Sassoon around the house, a "chicken broiler dinner," a walk by Lake Waban in Wellesley, goodbye to Richard at the train station, home for cleanup

July 5: Sleeps later on a hot day with cantaloupe for breakfast, sends poems to the *Saturday Evening Post* and *New Orleans Poetry Journal*, and types "batches of poems" for *Atlantic Monthly* and *New Yorker*

July 6: Mails poems to *New Orleans Poetry Journal* and *Saturday Evening Post*, reads poetry magazines

5:00: Broiled chicken supper and martinis with Marcia Brown and her husband Mike at their "modern apartment," a "great talk," Sylvia drives home in the rain

To Edward Weeks: She is delighted he will publish her first version of "Circus in Three Rings."

To Warren: Combating the heat with iced coffee with "mountains of rejection slips" for work she is sending out again. "Poems are hell to sell." Details her domestic improvements while their mother improves from her surgery and also cooking, dating, tennis playing, swimming, shopping for her stay in England. Sassoon has visited and Aurelia seems to have found him okay. "You have no idea how happy our letters make mummy!"

July 7: Writes to Richard Sassoon, out to library, bank, and post office, polishes "Giant Steps," writes "Sea-Change," reads periodicals, a letter from Rhoda Dorsey.[78]

July 8: Bakes cookies, browses books in the library, writes "Zeitgeist at Zoo"

8:00: Attends a performance of *Desire under the Elms* with George Gebauer, and afterwards a "lovely moon lit walk by lake" and "good talk"

July 9: To Grammy's and a drive to the Cape with her mother, a lunch with iced champagne, a swim, a long walk to Wellfleet, a visit to the Cantors, and at Thumpertown Beach in Eastham a "warm seaweed swim w. kids," cocktails with Frank and Louise Schober

July 10: Grammy's fiftieth wedding anniversary, "Magnificent day in sun at Nauset light Beach," swims all day in the surf with life guard Tony Whitman, lobster dinner with champagne "& relatives"

July 11: Returns to Wellesley, at Nauset Light beach, long walk in Wellfleet, swims, cheeseburger with Tony Whitman, sunbathes, chicken and wine super, a drive home to find "stacks of mail"

July 12: Returns books to the library, calls Fran, writes Richard Sassoon, does the laundry, shops, washes hair and shaves

4:30: Typhoid, tetanus shots

Calls RB, cocktails with neighbors Betty and Ginny Aldrich

To her mother vacationing on Cape Cod: Sore arm from vaccines, brings her up to date on poetry submissions and letters from friends, mentions RB's new baby.

July 13: Does her nails, writes to Olive Higgins Prouty, Mary Ellen Chase,[79] writes the beginning of "Sestina"

 8:00: "Betty Aldrich: lovely eve of talk and Alexanders"

July 14: Finishes writing "Sestina"

 6:15: Dinner with Mrs. Prouty at Brookline Country Club: martinis, "filet mignon under trees—lovely talk"

July 15: Washes hair, shaves, does her nails, writes Mary Ellen Chase,[80] begins writing an article about Mrs. Prouty, writes to the Postscript poetry contest

 8:00: With George Gebauer to *Tales of Hoffman* and *Last Holiday* in Boston, ice cream afterwards at Howard Johnson

July 16, 12:45: Arrives in New Haven and on a hot day, a "great quarrel" with Richard Sassoon, tired after a steak dinner and cocktails, goes to bed early at the Taft Hotel

July 17: A "hot hellish day," but a "wonderful breakfast of melon eggs and bacon, toast and honey and an afternoon of gin and tonics"

 4:30: "tender make up"

 7:45: In Boston for "gourmet dinner" at Tivoli: crab, lamb chops, and wine

July 18, 8:52: Train from New Haven to Boston

 11:30: Arrives in Boston

 11:45: Train to Newtonville is late "tears in chapel of our Lady's of the Railways," arrives home and reflects on her journey, showers, washes hair, naps, eats a chicken dinner and writes letters[81]

July 19: Calls RB, does banking, laundry, shops, writes letters to Mrs. Prouty, Mary Ellen Chase, Ellie Friedman, Gertrude Claytor, Richard Sassoon,[82] sends poems to *Lyric*, writes Olive Higgins Prouty article for *Reader's Digest*

 "dearest mother": Occasionally gets the impulse to "call the cape and chat with you," mentions visits with family, friends, and dates.

July 20: Calls RB, begins "Platinum Summer," sends Prouty article to *Reader's Digest*

 6:15: Dinner and theater with Mrs. Lameyer, sees "wonderful performance of *Henry IV, Part 1* "under stars"

July 21: Returns books to library, works on "Platinum Summer"

 3:00–4:00: Appointment with RB, sees her new baby Christopher, they enjoy a lemonade together and "good talk"

 6:00: Supper at Dotty's, cocktails and steak "wonderful," talks with "Dot & Joe"

 Washes hair

July 22: Irons laundry, shaves, does her nails, at Betty Aldrich's, "dallied around on 'Platinum summer,'" out with George Gebauer on Beacon Street in Boston, sees *Svengali* at the MIT Chapel and auditorium, a walk in the public garden

July 23: A hot day, hand washing laundry

 4:00–5:00: Naps

 5:00–6:00: Dresses for dinner

 8:00: Cocktails with editor Peter Davison, "British and tweedy," dines at Chez Dreyfus in Cambridge, attends performance of *Henry IV* at the Brattle Theatre

July 24: To the Cape on a rainy day, sunbathes in the afternoon, after supper drive with Tony Whitman, including a visit to a "lovely home" on Inspiration Point, they walk around Provincetown, into an art shop, out to the lighthouse

July 25: Reads short stories all morning on a rainy day, roast beef with Tony Whitman, a "long gay whirl on Ferris wheel" surveying the "bright colored prize booths"

July 26: Breakfast with mother, lovely day at the beach at Nauset Light swimming with Tony Whitman, riding the waves on a raft, a "long walk along beach in sunset"

July 27: Late breakfast and long drive home to find an acceptance of "Lament" from the *New Orleans Poetry Journal* and of "2nd Winter" and "Apotheosis" from *Lyric*, calls Rhoda Dorsey

Plath spent the summer saying her goodbyes, which to her included ending (she thought) her relationship with Richard Sassoon and soon the sexual relationship with Peter Davison, as well. Gordon Lameyer remained in her thoughts but no longer as the kind of romantic ideal she envisioned.

July 28: To Gordon Lameyer: "I keep reading about this damn cecile rich only two years older than I, who is a yale younger poet and regularly in all the top mags." Having trouble with the plots of her stories. "I grow old. already my pre-departure homesickness has set in and I am growing ineffably nostalgic."

To Warren: Feels closer to her friends and family more than ever now that she is departing for England. But she needs to spread her wings and avoid suffocation in New England or even in New York, recommends a "socratic talk" with himself as part of the maturing process she also has to experience.

August: *Atlantic Monthly* publishes "Circus in Three Rings," *Mademoiselle* publishes "Two Lovers and a Beachcomber by the Real Sea"

August 3: To Gordon Lameyer: "I Must See You Before I Sail. I simply can't leave this country without seeing you." He is "woven so into the tissue of my life."

August 4: Works on "Platinum Summer," washes hair

 2:00: Injections for travel abroad

 4:30: Drives to Cambridge

6:00: Cocktails with Marcia Brown and her husband Mike

Meets Peter Davison in his new apartment

To Gordon Lameyer: Still hoping they will meet before she sails.

August 5: Washes hair, plays the piano

4:00: Drives to Cambridge

5:00: Drives to Martha's Vineyard with Peter Davison, meets his friends the poet Padraic Colum and his wife Mary, a book reviewer

Dinner at Landfall, a wharf restaurant, a ferry ride with an orange moon and "strange faceless people"

August 6: Sails with Peter Davison and Peter Jones, swims in Menemsha Pond and rowing, lunch at Barnhouse restaurant in Chilmark, swims at a nudist colony, at Vincent Cliffs[83] for Graf's party with champagne, peaches, lobster, a walk on the hills in a fog, *The Nation* publishes "Temper of Time"

August 7: Breakfast at Barnhouse, a swim and run with Peter Davison, a hearty lunch, the spray blows on the steamer crossing to the mainland, "lovely ride home" and dinner at Peter Davison's in the rain "and good love"

August 8: Finishes "Platinum Summer," washes hair, does the laundry, shops, calls RB

August 9: Retypes "Platinum Summer," sends it to *Collier's*, calls Marcia Brown and RB

12:00: Picks up suit at "Crawford & Hollidge in Wellesley

Writes to Sue Weller and Lynne Lawner

"dearest mother": "nothing but nice things to tell you," relating her dates and excursions, including a meeting with the Colums who speak "so familiarly of names that have been legends to me . . . the last two days have been a dream." She is intent on "selling to the slicks," expects to see Sassoon in Paris.

August 10, 6:15: Steak dinner and Rum Collins with Peter Davison, "reading from Cambridge diaries"

August 11: A "lovely" breakfast of fried eggs, Canadian bacon, toast, and strawberry jam, cleans house, listens to violin music "great weariness & nostalgia," reads in bed

To Gordon Lameyer: "my life has been so undisciplined and hedonistic this past summer that I will be glad to get back to a kind of strictness and routine this fall." Deplores her ignorance of politics and history and not much more about art. "I begin to wonder why intelligent people bother with me at all." Her writing has been focused on the "slicks." Wants him to "speed this female Ulysses on her way with a kind of creative blessing."

August 12: Sends "Smoky Blue Piano" to *Woman's Day*, picks up shoes and dress at Crawford and Hollidge in Wellesley, "long good talk" with Ellie Friedman over a steak dinner on the porch, experiments with hair styles

"dearest mother": Describes a hearty breakfast, which makes her feel "extremely creative, as if I could write a pulitzer Prize novel." Hopes to visit Betsy Powley in Germany, feeling "very rested and happy," learning how to deal with rejections of her writing after reading an article in *The Writer's 1955 Year Book*,[84] looks forward to dance lessons so she can tell the difference between a tango and a rhumba.

August 13: A "lovely" breakfast with Ellie

10:45: Appointment with RB: "good talk re social groups & difference bet. Desire & act—not 'Turning lids' on"

Meets Peter Davison for lunch, naps, attends performance of *Much Ado about Nothing* at the Brattle Theatre, "fun"

August 14: Breakfast with Peter Davison: omelette, toast and strawberry jam, coffee, peaches, and bacon followed by a "tête-à-tête" about the intricacies of a publishing job, reads poetry aloud, visits Emmy and Claudio Spies[85] for a gin and tonic, attracted by a "powerful red & green painting"

August 15: Does the laundry, works on "Lucky Break," writes to Mary Ellen Chase, Richard Sassoon[86]

2:00: Dance lesson at Fred Astaire studio with Richard Hansel, "handsome blond guy," tennis and a long "tête-à-tête" with Philip McCurdy

August 16: Picks up her formal, washes hair, does the laundry, tidies up the house, prepares to begin work on a new story about a tuberculosis sanitarium, "revising old one"

7:00–10:00: Drives to the Cape

August 17: A "long sunny day" at Nauset Light beach during high tide, in the evening out to Inspiration Point with Tony Whitman and his mother, the agent Constance Smith: "long, good talk" over a gin and tonic

August 18: "torrents of rain," a late breakfast, and "long slow soaking drive home"

8:00: Rewrites "rough first draft" of sanitarium story, "Gift of Love"

August 19: "TORRENTIAL RAINS"

8:45: Mrs. Cantor visits

11:00: Dance class with Mr. Hanzel

12:00: Lunch Marcia Brown at Harvard Coop "CANCELLED"

To Peter Davison's for a dinner with agents, "Rain and Long sleep Lovely time"

August 20, 9:00: Calls RB

10:00: A "wonderful talk re love and pigeonholes" with RB

12:00: Dance lesson with Mr. "Rick" Hanzel, "great rapport"

1:30: Meets Marcia Brown

4:00: A "friendly talk" with Peter Davison

Washes her hair and bakes date nut bars

August 21: Sunbathes while reading William Sheldon's *Psychology and the Promethean Will*, "Rick Hanzel—fantastic twilight," afternoon of "tall iced drinks & lovely dancing & serious talk," evening talk with Peter Davison, listening to Dylan Thomas records

August 22: Banking, food shopping, returns library books, to the cleaners for white dress, finishes typing "Xmas Heart," writes Gordon and agent at Russell & Volkening,[87] "sad blue day—Rick called"

August 23: Gordon Lameyer calls, shops for mushrooms, tomatoes, melon scoop, prepares supper

6:15: Peter Davison arrives for dinner, afterward a "Stiff walk to playground," a "final talk" and "good bye," "blue???"

August 24: Finishes typing "Christmas Heart," to the cleaners, writes letter to Sue Weller, Mrs. Freeman for dinner, "Rick—call?"

To Gordon Lameyer: Mentions all the recent flooding and driving through the rain: "I feel a kind of strong joy in battling the forces of nature." Her Cunard ticket has arrived. She still hopes to get to Tangier next summer and write about the American school there. Confesses both her joy and fear about studying abroad: "will I grow like my favorite isabel archer, through struggle and sorrow?"

August 25, 10:30: Shops in town at Filene's for winter coat, tweed suit, and luggage on a crisp clear day, sees Mrs. Cantor

2:00: Shots for trip abroad

8:15: Appointment with RB

August 26: A "wonderful breakfast"

12:00: Dance lesson at Fred Astaire Studio

"hot day of shopping," spaghetti dinner with Chianti and French bread, "long good talk" with Marcia Brown

August 27: Packs two hundred books and clothes, fixes bike, meets Jon Rosenthal for "vodka & good talk," washes hair, shaves, does her nails, packs for Washington

August 28, 7:00: Departs for Washington, six-hour drive with a Harvard undergraduate, Pat Coney, to NYC through "sunny green country," cheese blintzes with Sue Weller and Whitney, returns to Washington for spaghetti at Sue's, "exquisite night walk through quaint Georgetown"

August 29: "lovely late breakfast in bed," window shopping on Connecticut Avenue, sightseeing: White House, Washington Monument, National Gallery with Flemish and Florentine art, pizza and to the movies to see Katharine Hepburn in *Summertime*

August 30: Rents a "two-tone blue Ford" for a trip to Mount Vernon, tours eighteenth-century "formal gardens & stately home overlooking Potomac," "lunch at ye little hatchet Inn," visits the Lincoln Memorial, dinner

at Peter Pan, sends three picture postcards to Aurelia showing Mount Vernon, the National Gallery of Art works

August 31: Fresh peaches for breakfast, reads in bed, talks with Sue Weller for hours at the National Art Gallery, martinis at home, then supper at "Vics"

September 1, 9:45: Meets Dorrie Licht at Union Station, they walk by the Supreme Court, the Library of Congress, and the Capitol

12:00: Lunch with Dorrie Licht and Sue at Gung-Ho with wonderful talk in the East Garden Court of the National Gallery

4:30: Presents for Sue: A book and Harvey's brandy, evening talk with Sue and her friend George

"Dear mother": Describes her visit to Sue Weller in Washington, delighted with "pseudo Greek" buildings and quaint Georgetown, the Lincoln Memorial: "Such a colossus, in such clean, enormous simply carved white stone. I felt shivers of reverence, looking up into that craggy godlike face."

September 2: Late breakfast with Sue, peaches and coffee

12:00: To Baltimore by train

1:10: A "long pleasant" drive back to Wellesley with Gordon Lameyer

Near Meriden, Connecticut, they drink martinis with a chicken dinner and music, calls RB

September 3: Lunches with Gordon Lameyer, writes letters to Claytor, Bob Thornell, Lynne Lawner,[88] dinner at Robin Hood's Ten Acres[89] with Gordon: brandy and martinis with lobster newburg, "lovely dancing and energetic floor show"

September 4: Recuperates from "fatigue" in bed and reads *The Recognitions* by William Gaddis, washes hair, Berrys visit, dinner at the Sheraton Plaza with Gordon and his mother: martinis, roast duck, French pastries, says goodbye to Gordon

September 5: With Warren to Crane's beach, "white sand & blue sea," a swim in "icy water," cold chicken picnic lunch, they walk and talk, at home, sorts clothes and reads from *The Recognitions*

September 6: "RR Express—send off,"[90] calls Peter Davison, calls about dance lessons, shops in Boston and Wellesley, packs trunk and suitcases

September 7: Calls Patsy O'Neill, RB, Mr. Crockett, Alison Smith, shops in Wellesley, makes hair appointment at Joseph's, makes dinner date with Ira Scott, packs trunk

September 8: Washes hair, shaves, does her nails, makes out labels, reads and sunbathes in backyard

7:15: Dinner with Ira Scott

8:00: A "warm goodbye" talk with RB "wonderful rapport"

September 9: To the watchmakers, calls Mr. Crockett and Patsy O'Neill

3:15: A "hair trim" at Joseph's

4:00: Dental appointment

4:30: Meets Peter Davison for a sandwich

8:30–9:00: A wonderful evening of talk with Patsy O'Neill and Mr. Crockett

September 10: A lovely late breakfast with family, sunbathes in backyard, naps, dinner at Mrs. Prouty's in Brookline

6:30: With mother and Arden[91]

8:00: "cocktails & lamb dinner," a "wonderful present—$100 & book!"

September 11: A "late breakfast with "mother & warren," "goodbyes" over a champagne and roast beef dinner with her "dear family," to Connecticut with Warren to stay with the Moores for a sherry and supper in a "fantastic new modern house"

Photograph of Plath in front of Wellesley house {PM}

September 12: A late breakfast at the Moores, Warren drives Sylvia to New York City {PA}, to Alison Smith's on Park Avenue and 92nd Street in NYC, lunch with Louise Giesey, Alison, and Mrs. Smith

4:00: Receptions at 19th East 54th, "tea and bread and too many new intelligent people"

Sees Alison off at Penn Station, washes hair

Beginning with her meeting with literary agent Henry Volkening, Plath would meet an impressive array of professionals in publishing, government, and academia that shaped her into a transatlantic figure at a surprisingly young age, immersed in the culture and politics of her time, and in a position to meet with prominent figures who were shaping and guiding the contemporary world.

September 13: Shopping at Bloomingdale's, visits American Express office, walks to Rockefeller Plaza for lunch with Louise Giesey

3:45: Lunch with Henry Volkening, literary agent

7:00: Warren, Dorris, Clement Moore for dinner at an Italian restaurant, Asti's,[92] to the opera and walking in the city

September 14: *Queen Elizabeth* sails

1:30–4:00: Embarkations accompanied by Warren, Peter Davison, "farewell to Manhattan," kisses Warren goodbye {PA}

Aboard ship a "lovely dinner & funny Steward," walks on deck, drinks cider, dances, talks with "young prep school boys"

September 15: After a "late rich breakfast" talk on the aft deck with Pat Montgomery, lunch with a gin and tonic looking out on a blue sea, tea with Anthony Wedgwood Benn,[93] English cider with Gerry Fee, dinner and a "jolly sing on stairs," and a dance with Pete Valletutti

September 16: A "hot salt bath," breakfast, reads on deck, drinks hot bouillon, looks out on a "rain gray sea"

11:30: A Fulbright meeting with Mr. Koenig

Lunch on a rocking ship enjoying Toby's "wry humor," gin and tonic with Danny, movie after dinner: *Value for Money*, dances in winter garden with John Sessions "very sweet"

September 17: A "beautiful day in the world with Carl Shakin," sunning on the deck with "enormous good talk everywhere," afternoon tea, on the shelter deck with cocktails, dancing with John: "stars & good love"

September 18, 8:00: A bath

9:45: A day of talk on deck with Carl Shakin, "wonderful mystic rapport" as they hold hands across a table, watch a movie, eat a turkey dinner, "windy black night on deck No Carl"

September 19, 9:30: With Carl Shakin in the Smoke Room, meets with immigration officer, on deck in the sun to watch the ship arrive in the afternoon beauty of Cherbourg, with Carl in a green park watches children play with goldfish, and they bicycle through "quaint streets—enchanting"

September 20: Breakfast in Southampton, photographed by *Evening Standard* journalist, rides with Carl Shakin and Pete[94] through "D. H. Lawrence country" to Waterloo station in London, with Carl takes a bus to Regent's Park, tea and supper in Piccadilly, attends a performance of *Waiting for Godot*

September 21, 8:00: Breakfast

10:00: Round table discussion of economics and politics with an editor of *The Economist*

3:30: Tea for English majors with "famous celebrities" C. P. Snow[95] and David Daiches

8:00–9:30: At the English Speaking Union, Berkeley Square, champagne with Carl Shakin, Trafalgar Square

September 22, 8:00: Breakfast, Viennese cheesecake & café expresso, "pastries in park" while it rains, hot tea and gooseberry tart, visits bookshops on Charing Cross Road

6:00–7:30: "Robinson at U. of London"

7:45: At the cinema to see Alfred Hitchcock's *Shadow of a Doubt*[96] "lovely shashlik in Soho—Chez Auguste"[97]

September 23: Breakfast and more rain

10:00: "education panel . . . Mr. Ray & Mr. Christie (Oxford)"[98] A talk with Carl Shakin and Scott Hamilton[99]

3:00: At the British Museum, the Palace, Regent's Park

5:00–7:00: Meeting with American ambassador Aldrich[100]

8:00: "Count of Clermabard" at the Garrick

A late supper at Le Bon Gourmet

September 24: Moves to the YWCA in Great Russell Street, visits Charing Cross bookstores

10:30: John Clark for coffee and croissants at Hay Market Coffee House

A walk in St. James Park

2:30: Attends a performance of *Separate Tables* by Terrance Ratigan with tea between acts

Returns to the Fountain Coffee House again, watches a film, *Riffi*,[101] with Carl Shakin, Mayfair delicatessen for veal scallopini outdoors, washes hair, writes letters[102]

September 25: "sad search around lovely Gray London for Sunday breakfast," writes letters,[103] looks at the Crivelli, Botticelli and Bosch, Bruegel at the National Gallery

2:30: Meets John Clark[104]

Tea at Royal Festival Hall, a drive in the city of London in the bombed areas "red soldiers in black busbies,"[105] supper at the Penn Club, "nice talk with boys," writes Mrs. Prouty[106]

"Dearest mother": Describes the "whirlwind of the past days."

September 26: To the American Express office in Haymarket and to the post office for stamps, writes to her Cambridge tutor Irene Victoria Morris,[107] breakfast at Haymarket Coffee House with Ann, looks up Lesley Davison[108]

2:00: Coffee and "2 strange men"

5:30: Dinner with Ann in Soho, "Gourmet restaurant—fruit & sugar"

September 27, 10:00: Calls Lesley Davison, writes to Richard Sassoon, Sue Weller, Mrs. Cantor, Mr. Crockett, Dot & Joe[109]

12:30: "Regent St"

Lunch at Wigmore Street café with Smith[110]

To Gordon Lameyer: a postcard reporting her London activities.

September 28: Writes to her Cambridge tutor, Irene Victoria Morris,[111] about her arrival in Cambridge, lunch at *Kind Captain* with Ann, writes postcards, watches two films, *The King and I*[112] and *The Doves*,[113] "a Dickensian pub," sandwiches and rum with John Whiteside (an "old beau" of Sue Weller's) by the Thames riverbank: "talk and warmth moon & swans"

To Elinor Friedman: A postcard mentioning how London is great and her "tragic shipboard romance" with a man married only two months ago (Carl Shakin). In France, she discovers, men know how to look at women.

September 29: "turn in 'Salad days' ticket," a walk in the morning sun

9:45: A "lovely warm time," talking and making love with John,[114] reading stories until the afternoon, then "superb spaghetti," hot chocolate, and pastry at "bamboo & black corduroy" booths in the "bohemian" Sa Tortuga in Chelsea,[115] a "long slow walk home," supper at the Penn Club

September 30: Posts letter to Irene Victoria Morris,[116] makes a UK call from the American Express office, to the post office, American Express office, calls Irene Victoria Morris

10:00: "dark room—talk"

"warm soapy bath," cold apple turnovers with whipped cream, long walk down Kings Road, at "Le Rêve," a "date & cream sandwich & hot chocolate at 'Sa Tortuga,'" packs

October: *New Orleans Poetry Journal* publishes "Lament"

October 1: Packs, calls taxi, takes train to Cambridge, tour of Cambridge with Jean Pollard[117] and David,[118] "Chapel—Bridge of Sighs[119]—Market—tea—Boats on Cam[120]—Dick Wertz"

October 2: Unpacks books, late breakfast, coffee in Whitstead[121] garden with Elizabeth Kimber,[122] unpacks books and settles into room, "lonely time—dinner: coffee & talk in room with South African girls!, Jean Pollard, House Mother Mrs. Milne"

"Dearest mother": Dreams of Aurelia and Warren every night "conspiring to get rid of me forever. Which I suppose is an indirect way of saying that basically I miss you both." Describes beautiful Cambridge, her room, what she is eating and drinking, her eagerness to return to her writing, and eagerness to meet British men.

October 3: Shops, has bike fixed, sews skirts, does laundry, writes to Gertrude Claytor and Sue Weller,[123] a "wonderful gray rain day," to Lloyd's Bank, the post office, and bookstore, coffee after lunch with Margaret Roberts,[124] "breezy ride to town" on vespa motor scooter, at "copper kettle—good talk"

October 4: Morning coffee with Barry Edward Sales[125] and Lois Marshall,[126] shops for furniture and "tea things," punting on the Cam with Dick Wertz, writes to Gertrude Claytor and Sue Weller[127]

October 5, 2:00: Sees Dr. Bevan,[128] picks up bike

5:50: Meets with Miss Burton about her schedule

"Dearest mother": Describes delightful shopping in markets and bookstores, decorating her room, opening a bank account at Lloyd's, making new friends, checking out Cambridge clubs and literary magazines, coffee in Evelyn Sladdin's[129] room, talk with Isabel Murray[130] and Jane Baltzell.

October 6: "table arrives," "buy notebooks and books!"

4:30: Conservative tea in Old Hall

5:15: Meeting with Miss Cohen, school principal

To John Lehmann, editor of *London Magazine*, enclosing a selection of poems he might find "suitable for publication."

October 7: Lectures begin

9:00: Robert Theodore Holmes Redpath, Trinity College lecturer on tragedy

10:00: F. R Leavis[131]

11:00: Muriel Bradbrook, lecturer on the history of tragedy
Shopping

7:15: "college feast: gown"

October 8, 11:00: Basil Willey lecture

Talk with Gary Haupt[132] and Dick Wertz, "survey of Westminster w. Dick"

2:00: "Royal visit rehearsal"[133]

Tea with Margaret Roberts, washes hair, finishes reading *Six Characters in Search of an Author* by Luigi Pirandello,[134] begins reading I. A. Richards's *Practical Criticism*[135]

October 9, 9:00: Breakfast, "write mother recopy notes"

1:00: Tea with Christine Abbott[136]

2:30: ADC (Amateur Dramatic Club) meeting in Park Lane "smoke & tour of state & club"

A walk back to Newnham College[137] "in mellow afternoon," steak, rum, and brandy for dinner at Scotch House with Jane Baltzell and Isabel Murray

"Dearest mother": Making her room feel like home, lectures start soon and all is "poised on the threshold, expectant, tantalizing, about to begin." She will study topics for two years that she will write about in six exams at the end of that time. Topics are tragedy, classic French playwrights, the English moralists, and reading in philosophy and literary criticism beginning with Aristotle and ending with D. H. Lawrence. She will "slowly spread pathways and bridge over the whistling voids of my ignorance." She will attend lectures by F. R. Leavis (a "malevolently humorous little man"), Basil Willey, and David Daiches. Notes the absence of central heating in her "cool" room. She is looking forward to learning more about politics, although she has already written off the Conservatives and the vague Liberals. That leaves the socialists and the communists to investigate.

October 10, 9:00–11:00: Nurses a cold and writes John[138]

11:00: Joan Bennett lecture on seventeenth-century poetry

12:00: Meets Margaret Roberts at *Varsity*[139]

2:30: To Fenner's for an X-ray

5:00: David Daiches

8:30: At the Labour dance meets Mallory Wober of King's College and "other nice men"

October 11: Copies note, buys tickets to a performance of *The White Devil* by John Webster[140]

10:00: Dorothea Krook philosophy lecture

11:00: Muriel Bradbrook lecture

4:30: Meets with Miss Burton about practical criticism

7:00: Dinner with Jane Baltzell and Robert Yates

Auditioning for the Amateur Dramatic Club was one of the highlights of Plath's first days at Cambridge. She excelled as an actress, enjoyed the attention

on stage and off of various Cambridge males, and quickly took the measure of both social life and academics. She developed a reputation as an outgoing, even brash American, but she seems not to have minded that response from both English men and women, whom she deemed rather timid and insular, even as they deplored her American provinciality.

October 12, 9:00: Redpath lecture

 10:00: Leavis lecture

 11:00: Enid Elder Hancock Welsford lecture on tragedy

 To "Sick-bay (ghastly macabre)" with sinus infection

 2:00–5:00: ADC audition

 5:00: David Daiches lecture

October 13: Visits Dr. Bevan

 11:00: Basil Willey lecture

 12:00: Meets with Miss Burton

 2:00–5:00: ADC audition, reads from Rosalind's speeches in *As You Like It* and performs as Camille in *Camino Real* by Tennessee Williams[141]

 4:30: Tea with Mallory Wober

 8:30: "members list—ADC"

Thanks Mallory Wober for enclosing a map to get to their tea. "However did you guess that I have no sense of direction?"

October 14, 8:00: "coffee & sherry," "Corneille & Racine," "Call French tutor"

 9:00: Redpath

 10:00: Leavis

 11:00: Bradbrook

 2:30: ADC meeting—parts to play

 5:30: "Dearest mother": Socialized medicine works well for the very ill and the healthy, but she misses the Smith infirmary with its cocaine sprays and penicillin. She is only able to obtain aspirin, and the paper shortage results in no kleenex and "ghastly" meals: "white fish paste and white potato, stewed fruit and custard of uncooked dough, with nothing to drink to wash it down!" No fresh vegetables or fruit. But she is saved by kind Dr. Bevan who prescribes nose drops. "Seeing young men make tea is still a source of silent mirth to me!" She is elated to have been chosen for the ADC, with the part of Mrs. Phoebe Clinket in *Three Hours after Marriage,* a Restoration play by Alexander Pope, John Gay, and John Arbuthnot.[142]

October 15, 11:00: Basil Willey lecture

 2:30–4:00: ADC rehearsal

Margaret Roberts for sherry, chicken curry with Ken Frater[143] at Taj Mahal on a starry night, washes hair

October 16, 9:00: Breakfast

10:00–1:00: Works on French and play part

2:30–7:00: ADC: "club room Dick Mansfield"[144]

4:00: Tea at Pembroke College meets Graeme McDonald, Camille Prior[145]

8:00–11:00: ADC stage work

October 17, 9:00: Breakfast

11:00: Joan Bennett lecture

12:00: "Northam (Botany)"

2:00–5:30: French tutoring

5:30: At ADC for a makeup demonstration

Tea and honey in Grantchester[146] with Ken Frater

8:00–11:00: Stage work at ADC

Coffee at Eros Cafe on a clear, cold night, walks home with Tony Smith

October 18, 10:00: Dorothea Krook lecture

11:00: Muriel Bradford lecture

12:00: Meets Miss Barrett

1:00–3:00: ADC

4:30: Meets with Miss Burton

8:00–10:00: Works on French and her "play part"

"dearest licensed mother!!!": Congratulates her mother on obtaining a driver's license: "never too late for any of us to learn," pleased with her young French tutor and the drama she is reading, loves her ADC role as a "mad poetess."

To Gordon Lameyer: Describes Cambridge as the "dearest city in the world," her dismal health care experience, her ADC success, and what she is studying.

October 19, 9:00: Redpath lecture

10:00: Leavis lecture

11:00: Welsford lecture

12:00: "Burton: supervision: Corneille"

2:00–7:00: On the stage at ADC

Supper with Dick Gilling[147]

8:00: "ADC—club room"

To Mallory Wober: "I think if you appeared in person sometimes to arrange crucial items such as hour and place it might be several hundred percent simpler. unless I take to using carrier pigeons."

October 20, 11:00: Willey lecture

11:40: Royal visit[148]

12:00: "Burton—supervision"

2:00–4:00: "ADC—clubroom"

4:00–7:00: Works on French translations

Dinner with Ken Frater in union

8:00–11:00: On the stage at ADC
Washes hair

October 21, 9:00: Redpath lecture

 10:00: Leavis lecture

 11:00: Bradbrook lecture

 12:00–1:00: Sherry and lunch with Brian Corkery[149]

 2:30–4:00: ADC

 6:00: Dress rehearsal for ADC

 8:00–10:00: "ferocious rain"

To Mallory Wober: Can't meet him because of dress rehearsal for play. Thinks "life here seems like a carousel which accelerates considerably each day!"

October 22, 9:00–11:00: "Police & P.O."

 11:00: Willey lecture

 12:00: Lunch with Ken Frater

 1:00–3:00: ADC

 4:00–6:00: John Oddey[150]

 6:30: Sherry party with Martin Duckett[151] in Pembroke College

"ADC plays 8 supper at Scotch House—Ken [Frater]"

To Mallory Wober saying she will "do my best to get free of these dramatic tyrants" to meet him for dinner and a concert.

October 23: "rainy day by fire," dinner with Mike Lotz at Kohinoor

 7:00: Supper with Mallory Wober followed by piano playing and sherry

 8:00: ADC party, a visit to King's College concert, and a great Indian supper at Taj "mangoes etc."

October 24, 9:00–11:00: Writes Corneille paper

 11:00: Bennett lecture

 To launderette

 12:00–1:00: Works on Corneille translation

 2:00–7:00: "Market Hill"[152]

At the university library, "(Ski meet: 8:30)"

 8:00–11:00: Reads Corneille

"Dearest mother": Describes the reception for the Queen and the Duke. Their "radiance" appeals to her. Reports the play has been a success, a surprise visit from Myron Lotz, "bored by his heavy, prosaic complacency," admires the robust Mallory Wober, a contrast to the "pale, delicately-made englishman," and describes their dates and her biking five to ten miles a day to classes, to town, and to her dates.

October 25, 9:00–1:00: Notes work on Corneille paper and to buy *Rouge et Noire*

10:00: Krook lecture

11:00: Bradbrook lecture

12:00: Meets with Miss Barrett

4:30: Meets with Miss Burton about practical criticism

8:00–11:00: "finish french plays"

October 26: Corneille and Racine paper due

9:00: Redpath lecture

10:00: Leavis lecture

11:00: Welsford lecture

12:00–1:00: Tea at Copper Kettle

8:30: Overseas reception at Dorothy Cafe

"Four Tragedies of Corneille: The Conflict of Good with Good" type-script with supervisor's comments {PM}

October 27: "23rd Birthday!" Writes letters[153]

9:00–11:00: Shops "lovely yellow & gold day yellow flowers"

11:00: Willey lecture

12:00: "Burton"

2:00–6:00: In Grantchester with Ken Frater for tea

8:00–10:00: A play reading at David Wilson's with Peter Jackson, Charles Stallard "etc."

To Elinor Friedman: "cambridge is heaven." Describes the cold wild wind that "comes straight off the russian steppes." Wants to meet as many men as possible, noting the "women here are ghastly: two types: the fair-skinned twittering birds who adore beagling and darjeeling tea and the large, intellectual cowish type with monastically bobbed hair, impossible elephantine ankles and a horrified moo when within 10 feet of a man." Sums up her heady round of activities.

October 28: "cold, frosty day," shopping for sherry, fruit, and books

9:00: Redpath lecture

10:00: Leavis lecture

11:00: Bradbrook lecture

12:00–1:00: Tea with Richard Mansfield, ADC director

4:30: Tea with John Lythgoe

6:00: Sherry with Brian Corkery at Pembroke College

8:00–10:00: Dinner at Copper Kettle with Richard Mansfield

October 29, 9:00–11:00: On a "wonderful clear blue & gold day" shops at Market Hill and Heffer's[154]

11:00: Willey lecture

2:00–6:00: Writes letters to Mrs. Prouty, Mary Ellen Chase, David Freeman, and Mother

8:45: "Brian!"[155]

"New Faces" and "Little World of Don Camille,"[156] dinner at Bombay restaurant

"dearest mother": Delighted with birthday gifts and letters from home, describes her dates and ADC activities, mentions meeting Nathaniel LaMar "that boy from exeter and harvard who wrote the story 'creole love song' in the atlantic!" He is a "lovely light-skinned negro, and I look most forward to talking to him about writing, etc."[157]

To Mallory Wober: Looking forward to meeting his friends, "your piano, your polished table, your crocodile, and, of course, your highness himself."

To Mrs. Prouty: Describes her room, shopping, social life, ADC, lecturers: "caustic F. R. Leavis, wry Basil Willey, and vital David Daiches." She has been treated "like a queen" with so many invitations to dinner and tea and cultural events and outings.

To David Freeman: Admires his Renaissance Man activities: "fencing, italian, mountain climbing, and the rest." Describes her ADC experience, lectures with professors "whose books have lined my shelves for years," and adventures punting and bicycling, and reports on the Queen's visit, "trekking through green meadows to granchester for tea." [HR]

October 30, 12:00: Sherry with Mallory Wober

2:00–5:00: Visits Martin Deckett[158] to read plays

5:00: ADC meeting, play reading, sherry by a fire with Richard Mansfield

October 31, 9:00–11:00: Shopping for copies of Ben Jonson and John Dryden

11:00: Bennett lecture

12:00: Northam lecture

4:00: Wonderful tea with Nathaniel LaMar at the Copper Kettle, a rapport with this "strange young texas boy"

Coffee and bread at Alexandra House, coffee with Yvonne Zeffert[159] in Piele Hall

November 1, 10:00: Krook lecture

11:00: Bennett lecture

12:00: Meets with Miss Barrett

2:00–4:00: "to Downing & Pembroke"

4:30: Meeting about practical criticism with Miss Burton

8:30: Meets Dick Gilling

November 2, 9:00: "Redpath (Nat LaMar)"

10:00: Leavis lecture

11:00: Welsford

3:15–4:15: "Matriculation" ADC

8:00: With Richard Mansfield to see *The Cabinet of Dr. Caligari* and a Chaplin film

November 3, 9:00–11:00: Reads Dryden

11:00: Willey lecture

12:00: Supervision meeting with Miss Burton "Lady Tansley & apples"[160]

4:00: Tea with John Lythgoe and a motorbike ride with him to Grantchester

Accompanies Nat LaMar to a Louis MacNeice[161] reading at the English Club

8:00: Nat LaMar "bohemian eve at Alexandra"

November 4, 9:00: Redpath lecture

10:00: Leavis lecture

11:00: Bradbrook lecture

1:00: Lunch with Nat LaMar at the Arts Theater

2:00–7:00: Martin Deckett and dinner

8:00–11:00: Attends a repertory production of *I Am a Camera*[162]

November 5: Reads French, Ibsen's *Rosmersholm* and *Hedda Gabler*

6:15: Sherry and dinner with Brian Corkery at the Garden

With Mark and Joyce at a dance[163]

November 6: "wet, mild gray day: yellow apples," reads *Andromache* and Stendhal's *Le Rouge et le Noir*

2:00–5:00: At the Marlowe Society

7:45: Attends a reading of *King Lear* with Jeremy Trafford at St. John's College

November 7, 9:00–11:00: Reads *Le Rouge et le Noir* and Otway[164]

11:00: Bennett lecture

12:00: Northam lecture

4:30: Derrick A. Moore[165]

5:30: Sherry and "lots of piano" with Mallory Wober playing Beethoven and Schubert

8:00–11:00: "good talk" and a dinner at the Taj

"Dearest mother": "I am slowly learning by experience the kind of life I want most to live here." Describes Nat LaMar: "very much like me, enthusiastic, demonstrative, and perhaps trusting and credulous to the point of naivté." Describes her social activities and moviegoing. Two of her poems, "Epitaph in Three Parts" and "Three Caryatids Without a Portico," have been accepted by Cambridge "little magazines."

November 8, 9:00–10:00: Reads Dryden[166] and Otway

10:00: Krook lecture

11:00: Bradbrook lecture

12:00: Meets with Miss Barrett

2:00–4:00: "study poems"

4:30: Burton on practical criticism

November 9, 9:00: Redpath lecture

 10:00: Leavis lecture

 11:00: Welsford lecture

 12:00–1:00: Finishes reading Dryden and Otway

 2:00–7:00: Reads Romantic drama

 8:00: "Romantics"

November 10, 9:00–11:00: Reads Romantics

 11:00: Willey lecture

 12:00: "Burton—supervision"

 2:00–4:00: Tea with Richard Mansfield

 4:45: Tea with John Lythgoe

November 11, 9:00: Redpath lecture

 10:00: Leavis lecture

 11:00: Bradbrook lecture

 12:00–1:00: Shopping

 2:00–7:00: Sherry and good turkey and wine with David Buck,[167] at Christ's College

 8:00: "University Arms! Eartha Kitt & rapport"[168]

November 12, 9:00–11:00: Cleans room

 11:00: Willey lecture

 1:00: Shops for bread and cake, lunch with David Buck at Eagle

 3:00: Punting with Mallory Wober on Cam

 9:15: "great nostalgia weltschmerz"

November 13: "amazing day"

 1:00: With Mallory Wober in his room playing recordings of *Emperor Concerto* and "Greensleeves" and also playing ballads on his piano

 2:00–7:00: A tour of King's College Chapel with John Lythgoe and Mallory Wober

 "enormous long tea & talk"

 "From 4–10 (!)—steak dinner at Taj Mahal with Mallory"

 Even with numerous dates and the intimacy Plath shared with Mallory Wober, Richard Sassoon remained in her thoughts and desires, and would continue to entrance her even after her first meeting with Ted Hughes.

November 14, 9:00–11:00: Returns library book, shops for food, cashes £5

 11:00: Bennett lecture

 12:00: Northam lecture

 4:30: Tea with John Lythgoe, "Discussion of Europe, etc."

 8:00: Reads *Phèdre* by Jean Racine

 "dearest mother": "I enjoy everything . . . which you write about."
Every night she relaxes with a pot of hot milk and crackers by her gas fire

and reads the *New Yorker* for the "fun in it." Feels she has been inadequately prepared for classes that call on a knowledge of sixteenth-, seventeenth-, and eighteenth-century literature. But that is what she must do: fill in the gaps of her knowledge. She believes people are "still infinitely more important" to her than books, which is why she will never be an "academic scholar." This explains why she spends so much of her days socializing. She hopes to get a scholarship that will allow her to "live without academic obligations." She misses her friends who have shared her life, but she believes that she can "slice into the depths of people more quickly and more rewardingly than if I were superficial and formal." She is supplementing the school's starchy diet with a pyramid of fruit in her room. She misses Sassoon who is at the Sorbonne. The English boys are "babies compared to him."

November 15, 9:00–10:00: Studies French

 10:00: Krook lecture

 11:00: Bradbrook lecture

 12:00: Meets with Miss Barrett

 4:30: Meets with Miss Burton about practical criticism

 8:00–10:00: Reads *Faust*

November 16, 9:00: Redpath lecture

 10:00: Leavis lecture

 11:00: Welsford lecture

 2:00–7:00: Reads Romantics

To Mallory Wober: "Now, Mallory (I like to say that name out loud, because it has just the right number of syllables to give it so many kinds of dramatic expression)." She wants him to ask her to "demonstrate some time." Proposes a meeting so they can sort out "an extremely complex conflict, with large philosophical issues woven into apparently simple social phenomena," which involves him, wants him to remind her to read to him from e. e. cummings, Edith Sitwell, and Dylan Thomas.

November 17, 9:00–11:00: Reads *Faust*

 11:00: Willey lecture

 12:00: A supervision meeting with Miss Burton

 "afternoon of great decision"

 2:00–7:00: "Mallory-David—ADC"

 8:00: David Buck: "7 dinner 'Piecemeal,'" sherry, wine, and good show

To Mallory Wober: "Like Alice-in-Wonderland, I have gone through the looking-glass, and now, (translated to the land of the Jabberwock)."

November 18, 9:00: Redpath lecture

 10:00: Leavis lecture

 11:00: Bradbrook lecture

 Shops for food

2:30: Meets David Buck

4:30: Tea with Nathaniel LaMar "great talk"

6:30: Attends a performance of *The Glass Menagerie* with Mallory Wober "picnic supper & mangoes & lovely walk and talk"

November 19, 9:00–11:00: Shopping in the rain and the cold

11:00: Willey lecture

2:00: A lovely tea in her room with Mallory Wober "warm black & crimson"

"cold supper & Scarlatti at Mallorys"

8:15: In the Clare Music Room at ADC

November 20, 10:45: Meets David Buck at Christ's College

11:30–1:00: At ADC, lunch in the Arts Theater with David Buck

2:15–5:00: ADC and talk with Mallory, "music & love"[169]

8:15: ADC

November 21, 11:00: Bennett lecture

12:00: Northam lecture

4:00: Tea with Mallory Wober

5:00–6:30: "EFGHIJ—crowd"

6:30: David Buck

8:15–10:30: "KLMNOPRSTUVWXYZ—stage"

"Dearest mother": Plans to meditate on her life, "gathering my selves into myself again" after classes end December 3. She continues to enjoy her ADC work. Also plans excursions to London and Paris. Calls Nat LaMar a "wonderful sort of psychic brother" whom she will meet in Paris a few weeks after the end of December classes. "I think I shall start a salon in Paris!"

To Mallory Wober: Asks if she could come to "listen to music & you & calm my most hectic & tormented psyche," becoming a "sedate femme du salon," signs herself "Your ramping jade."

Plath's mention of becoming a femme du salon reveals how she longed for a close circle of friends and admirers who would in some respects compensate for the home she had left. Children, too, fit in her scheme of family and her yearning to watch the growth and development that she could no longer experience with her brother.

November 22, 9:00–10:00: Writes letters[170]

10:00: Krook lecture

11:00: Bradbrook lecture

12:00: Meets with Miss Barrett

2:00–3:00: "FGHJ"

3:00–3:30: "N"

3:30–5:00: "YZ"

4:30: Meets with Miss Burton

6:30: First dress rehearsal

Supper with David Buck

"Dearest mother": Feeling "occasional waves of deep homesickness" as the holidays approach. She misses her wonderful family. Resents not being able to watch Warren "becoming a man." Wants to write Christmas letters to all who have been dear to her. Expresses her desire to move out of academics and into the "world of growth & suffering where the real books are people's minds and souls," which means finding friends and being able to say, like Yeats, 'It was my glory that I had such friends' when I finally leave the world." And she wants to be a "fine creator of childrens' souls. Preferably my own children, where intense love could be involved."

To Richard Sassoon: "In the beginning was the word and the word was sassoon."

November 23, 9:00: Redpath lecture

10:00: Leavis lecture

11:00: Welsford lecture

Reads Ibsen's *Brand* and *When We Dead Awaken*

2:00–7:00: A run through of Ben Johnson's *Bartholomew Fair*[171]

A steak dinner with John Lythgoe

6:30: Second dress rehearsal

To Mallory Wober: "you surprise me by joy."[172]

November 24, 9:00–1:00: Shops and reads *Brand*

12:00: Meets with Miss Burton

2:00–6:00: Run through of *Bartholomew Fair*

Dinner with David Buck at Lucy's

8:00: Performance of *Bartholomew Fair*

To Mallory Wober: Writes from rehearsal about the "line between reality (which is life) and the illusion of it (which is acting)." Compares herself to Camille, languishing "amid my withered yellow dahlias."

To Mallory Wober (during the play): Says it is like "having a blood transfusion (only much more magnificent) to receive your just-before-curtain-time note." She feels like a prima donna.

To Mallory Wober (during the play): In the "bedlam of sword fights, spilt oranges, musty gingerbread, hobby horses, cut purses, revolving pink elephants, floating iridescent soap bubbles, shrill mad men with tousled red hair, ballad mongers and delicately askew orange & blue rooftops."

November 25, 9:00: Redpath lecture

10:00: Leavis lecture

11:00: Bradbrook lecture

12:00–1:00: Does laundry and shops

2:00–7:00: A "wonderful" afternoon tea with Mallory Wober

8:00: Performance of *Bartholomew Fair*

November 26: Reads *Troilus and Cressida*, writes Ibsen paper

2:00–7:00: Reads *Brand* and *When We Dead Awaken*

8:00: Performance of *Bartholomew Fair*

"Dearest mother": Describes the play: She has "only one brief scene of dashing across the stage & shaking a creature and bellowing about the hardships of the common whores, it is good experience." She has enjoyed the theater experiences. "I want to be out on the stage too, and create in any way, no matter how small." Expresses her delight in Mallory Wober who sends her daily notes and shows up at her room with a small Hammond organ. They spend the day "singing our favorite hymns (he introduced me to a wonderful one with words by john bunyan beginning: 'he who would true valor see') and christmas carols he also played bach and scarlatti, and as we ate tea on the floor by the fire, we heard tchaikovsky's magnificent 1st piano concerto & beethoven's." His "coal-black hair, elegant strong bone structure, scarlet cheeks, blazing black eyes, with a wonderful feeling of leashed strength" is how she pictures Dmitri Karamazov. She finds an "aesthetic delight in just looking at him."

To Mallory Wober: "The room was still full of music & your presence lingered in my mind like the smile of the cheshire cat which comforted my favorite alice-in-w."

November 27: Works on practical criticism and Ibsen paper

12:00: Sherry with Mallory Wober who plays "Greensleeves" and Bach on the organ, "good strong love," "tea and cake"

"MALLORY: exquisite candlelight advent carol service at King's Chapel," a steak dinner at Alexandra

November 28, 9:00–11:00: Purchases malt bread, grapes, bananas, and matches

11:00: Bennett lecture

12:00: Northam lecture

2:00–7:00: Writes Ibsen paper

8:00: Performance of *Bartholomew Fair*

To Mallory Wober: "all I want to do is sleep like the enchanted princess for 100 years. tonight I must give birth to my paper which has cost me labor pangs all day. tomorrow I type it."

November 29, 10:00: Krook lecture

11:00: Bradbrook lecture

12:00: Meets with Miss Barrett

4:30: Meets Miss Burton

8:00: Performance of *Bartholomew Fair*

November 30, 9:00: Redpath lecture

10:00: Leavis lecture

11:00: Welsford lecture

2:00: Marlowe auditions

3:00: Meets Mallory Wober

8:00: Performance of *Bartholomew Fair*

December: Photograph of Aurelia and Warren and photograph of Sylvia and Warren made into Christmas card {PM}

December 1, 9:00–12:00: "sick day"

12:00: Supervision meeting with Miss Burton

"MALLORY—Bach on organ—records—steak dinner & good talk at home"

8:00: Performance of *Bartholomew Fair*

December 2, 9:00: Redpath lecture

10:00: Leavis lecture

11:00: Bradbrook lecture, "Mallory"

4:30: Meets Nat LaMar at Pembroke College

8:00: Performance of *Bartholomew Fair*

December 3: Shops for fruit, flowers, tea, bread, cakes, Christmas presents, "Mallory—afternoon: Bach & tea and good talk," David Buck visits, "meat pre supper—lovely rapport"

8:00: Performance of *Bartholomew Fair*

December 4: Richard Sassoon arrives, morning walk through Cambridge and lunch at ADC {HC}

4:30: Tea with Wertz and Sassoon, "sherry & long sad talk—'you can't go home again'"

December 5: To the bank and travel agent, shopping for Christmas gifts, "orgy of buying"

5:30: Meets with Miss Burton

5:45: Sherry with David Buck and dinner at Bombay

"Mallory—scrapbook"

"Dearest mother": Reports on her "rugged week," including coping with a sinus cold and fever. Mallory has been her "rock of Gibraltar" and an "absolute joy."

December 6: Shops for "dinner provisions," sends Christmas gifts from post office

9:00–1:00: Reads French

3:00: Meets with Miss Barrett

4:30: Meets John Keogh

6:00: Dinner with Mallory Wober

December 7: Shops for tea

9:00–1:00: Reads nursery rhymes

4:30: Meets Nat LaMar and Mallory Wober for tea
Bach and "good talk"

December 8, 11:00–1:00: Begins writing a story

2:00–4:00: John Lythgoe for tea, a motorcycle ride
Mallory for dinner at Scotch House, then to the movies to watch *The Country Girl*

December 9, 9:00–1:00: "French Fulbright story," writes Christmas letters

4:30: Mallory for tea, dancing, talk, dinner at the Taj Mahal
End of term, fills out Fulbright renewal papers {PA}

December 10: Washes hair, horseback riding with Dick Wertz

2:00–4:00: Runaway horse incident[173]

4:00: "Mallory—ride with organ"

7:00–10:00: Supper at Copper Kettle "goodbye"

"Dearest mother!": Thrilled with Christmas box, including the silver wrapped cookies, explains how much the holidays and family mean to her but also her happiness in Cambridge: "I haven't had such a healthy 'co-ed' life since high school, really." Looking forward to meeting Mallory Wober's Jewish family in London, describes herself as an "ethical culturist" and "close to the Jewish beliefs in many ways," looks forward to seeing the wonders of Paris with Nat LaMar and Richard Sassoon.

Christmas was a very special time for Plath. She associated the holiday with her cherished family life and friendships. To be away from home was a trial—manageable in her heady days at Cambridge. But later, especially during the last Christmas after the breakup with Ted Hughes, the absence of family and friends became unbearable, especially when she had thought she was building a future that began, in earnest, during these exciting Cambridge days that fulfilled her vow that she would seek new experiences and places that would enrich her life and work. The cold she mentions in her letters should be treated with the utmost seriousness. She was prone to winter sinus infections, the flu, and the common cold, and, like other Americans, found the lack of central heating in England very uncomfortable. The colder she became the more menacing the climate seemed to her. She welcomed "rough situations," as she told Warren, and yet the bleak days of winter took their toll.

December 11: Sleeps until noon, reads "Bérénice" by Edgar Allan Poe, writes Christmas letters

"Dearest Grammy & Grammy": Wishes them a merry Christmas and recalls their many wonderful holidays together, describes wearing the ski pants they sent and the episode of the runaway horse in Cambridge scaring the pedestrians: "Such an adventure! I am still black & blue!"

"Dearest mother": Wishes her a merry Christmas and to feel, "in spirit at least, that I am with you!" Describes the "associations" that go with the gifts she has sent.

To Richard Sassoon: Confesses to a "certain great sorrow in me now. . . . I must stop identifying with the seasons, because this English winter will be the death of me."

To Warren: Reminds him of their shared Christmases, tells him about the rewards of working hard while also treasuring the moment and small things like the sound of rain, a "flicker on the grass," urges him to travel in Europe and to adapt to "all kinds of rough situations."

December 12, 9:00–12:00: Translates Giraudoux

12:00: Meets with Miss Barrett

Shops for books, to the post office with Christmas letters to Gordon Lameyer, Mary Ellen Chase, Mrs. Freeman, Mrs. Cantor, Sue Weller

8:00–12:00: Writes letters

To Elly Friedman: Mentions recuperating from the flu and playing a whore in *Bartholomew Fair*, confesses she feels Mallory Wober is too young for her [he is nineteen] and Sassoon has "shrunk, like Gregor samsa,[174] to an insect, to my utter horror. BANG." Describes her rollicking ride through Cambridge on a horse that has left her black and blue but also energized and passionate.

To Gordon Lameyer: Brings him up to date on her hectic Cambridge life, which is frustratingly hard to capture in letters, describes her well-appointed room and wishes he could visit, the heady ADC experience was cut short by the flu, and now she has to catch up with her reading. She explains her discovery of the symbolic Ibsen and his portrayal of the artist's need. To "sacrifice life to his creation and the deadly retribution he must pay, laying waste to the creative lives around him yet having to follow his call." She wants to escape the suffocation of having to learn so much and to enjoy the "periodic bull sessions" with Nat LaMar who went to Exeter with Warren and so feels like a brother, and days with vital Mallory Wober about whom she feels maternal.

December 13, 9:45: Haircut, banking

12:30: Meets John Lythgoe

Writes Christmas letters, steak supper at Gourmand, "rum at pub"

To Mallory Wober: "I'm not half as much of a stoic as I think I am, but I must admit that outside the circle of my scorching gas fire and gaily colored mounds of books, the gray, wet, sodden atmosphere is rather ominous." Perhaps she will "borrow" him for a short story. Misses home and calls herself "a kind of feminine ulysses, wandering between the Scylla of Big Ben and the charybdis of the Eiffel Tower."

To Olive Higgins Prouty: Calls her a "second mother" with whom she can talk "perhaps even more frankly!" Reports on her activities, "trying out different kinds of life." Her concern is overstimulation and lack of preparation: "I have constantly to remind myself that this wider reading background is partly what I came for, and I must go on reading and enjoying slowly, and not want to devour the University Library at one desperate gulp."

Near the end of her first term at Cambridge, Plath took stock of her social and academic life, much of which had invigorated her. She enjoyed being in the center of the action, which her dates and dramatic roles fostered. She envisioned herself as part of a salon, a like-minded gathering of a literary/artistic ensemble that would remain a vital conceit and conception of herself.

December 14: Finishes Christmas letters while it rains

4:30: Tea with Dick Wertz

ADC dinner at Café Royal in Regent Street

"dearest mother": Completed twenty Christmas letters and ten cards to teachers, family and friends, telling them how much they mean to her. "I really felt I was communicating in a deep sense with all those I wrote to, and let them know it." She is going to try to carve out an hour a day for her own writing, which has been difficult to do with all the other demands on her time. She looks forward to her mother's summer visit to Cambridge.

To Jon K. Rosenthal: "I haven't stopped running like Alice trying to keep in the same place." Describes Cambridge, her adventures in London, but is looking to Paris for that "intense emotional rapport which I simply don't feel for the delicately boned frosty-eyed, terribly proper English." Her best friends are "Jewish or negro."[175]

To Marcia Brown: Describes decorating her room and cooking in it. "I love having 'salons' at tea and dinners for two." Enjoys the international flavor of the cafés and her new friends, the ADC plays, and her excitement about going to Paris.

Plath regarded her continuing contact with Dr. Beuscher as a steadying influence. They shared a common text that Beuscher recommended: Psychology and the Promethean Will. *Setting that book beside Plath's letters and journal entries reveals that she was following the program of behavior endorsed by the book's author, William Sheldon.*[176]

December 15: Shops, goes to post office and launderette, sees Miss Morris about her Fulbright

9:00–1:00: Writes to RB, goes to the tailor for her coat

2:00–7:00: Writes to RB

8:00–10:00: "Fulbright statement"

To Mallory Wober: Tells him about writing her Christmas letters. "I never realized quite so intensely what wonderful people I have known."

She chose cards that suited their interests. She likes him with and without a beard. It is the "essential you" she values quite aside from externals. Looks forward to her London visit on the way to Paris.

December 16, 9:00–1:00: At the launderette and shopping

 2:00–4:00: Naps

 8:00–10:00: Packs, washes hair, does her nails

December 17: Reviews French

 1:30: Meets John Lythgoe

 2:00: Attends wedding in Grantchester with "much champagne & sandwiches"

 Takes the train to London—"rainy, sleep," "Salad Days': John Lythgoe: effervescent dancy musical—motor cycle—Regent Street stars—hot chocolate at Moulin Rouge"

December 18: Walks with John Lythgoe around St. John's Wood and Maida Vale—"blue house," delicious dinner of lamb chops, mushrooms, "garlic & merry down"

 3:00: In Golders Green to meet Mallory Wober's family, organ and piano accompaniment to tea and talk, photographs, a talkative dinner with his aunts, "hot roasted chestnuts," to Trafalgar Square and Regent Street with Mallory

 "Alan Patillo piano & cats"[177]

 To Mallory Wober: Recites "Three Little Pigs" and adds: "THIS little pig seems to have had his cake and eaten it too . . . from Piglet, Esq."

December 19: "Fr. Book," mails letters, a "long late breakfast" with John Lythgoe by the fire on a "frosty white morning," with the sun looking like an orange globe, shops at Foyle's, attends a performance of *Richard III* in Leicester Square, "Depression: vegetable & fruit street," hot chestnuts, steak supper, "Wine & good bedtime talk"

 To Mallory Wober: Delights in her time with his family and their outings: "all this is Christmas-wrapped in my heart."

December 20: "nightmare trip with Jane,"[178] "channel boat to Calais—white basins: brandy Hotel Des 2 Continents 25 Rue Jacob," walks to Richard Sassoon's for supper of meat and wine with him and Jane, walks by "rainy" Palace Des Invalides talking with Nat LaMar, "Key incident— stayed over with Swiss girls"

Although Richard Sassoon is mentioned only sporadically in Plath's diary and not at all in letters home, he accompanied her through most of her time in Paris and Nice. As she grew closer to him, he began to withdraw—perhaps not yet obvious to her. Indeed, he seemed to offer the cosmopolitan alternative to the effete Englishman she had dated and the parochial American males who could not speak to her wide-ranging interests. But he shied away from commitment, later

suggesting he had to make his way first by serving in the army and establishing himself before he could consider marriage to Plath.

December 21: Returns to her room, talks with Nat and sleeps until one, walks with Sassoon along "grey Seine," passing Notre-Dame and book stalls, eats an enormous lunch of escargots, steak, tart, wine, naps at hotel, a walk, a cognac at a bar, good talk in French over steak tartare and chocolate at "snack house"

December 22: Croissants and coffee in bed, to the Louvre with Sassoon to see *Winged Victory*, the *Mona Lisa*, *Pietà d'Avignon*, and other works of art, to the American Express office, a meal of onion soup, wine, a club sandwich at "Pampam," "Carnet de Major Thomson," at the Café Deux Magos[179] for "cafe de flor: orange pressé"

December 23: Croissants and coffee in bed, visits Ile de la Cité: "15th cen. Stained glass windows: jewel box: rose windows: pastels gilded flour de lis," lunch at the "Palais de Justice," Marche de Fleurs, Ile de St. Louis: scene at hotel: "blue room," visits Rue de la Paix and Place de Vendome

To Malory Wober: Enjoying the sites and employing her "stammering French."

December 24: A lovely breakfast in a blue velvet room at the Hotel de la Harpe, lunch on the "Boul. Mich: sardines herring, steak and red wine," to the post office, long talk with Sassoon about the future, in the rain to see "Las Chambre & Le Loupe," the Arc de Triomphe, Place de las Concorde, "Madelaine—lights," "oysters & refreshing white wine (vind'alsace) & ham—good talk"

December 25: With Richard Sassoon, a long morning of croissants and coffee in bed with the sun shining through white lace curtains, hears the organ in Notre-Dame, observes the "colored windows—flowers: crowds: gray seine: park & bell," a Cinzano at a café in St. Severin, coq au vin on Montmartre, "white Sacre Coeur: quaint steep streets: pigalle & whores,"[180] buys nuts, oranges, figurines, takes the Metro back to hotel "joues children"

December 26: Café au lait in a café, a café on Rue Jacob for lunch: "good spaghetti & wine," conversation with a Puerto Rican girl, "pansy & wise guy: arguments," goes to see Danny Kaye in *Monsieur Le Maire* [Inspector General], walks about Bout, Monmartre, observing nude ads and "hundreds of tiny oysters & lemon shops," "fruit & great talk"

December 27: Croissants, coffee, and oranges in bed, walks across Ile de la Cité on a gray white afternoon with scattered showers, five letters await her at the American Express office, a supper of fruit salad, cold fish, mayonnaise, pastry, wine at Pam-Pam, and a walk up the lighted Champs-Elysées in the rain "brilliant stores & cinemas," takes the Metro home and reads in bed

December 28: Croissants and coffee in bed noting the "blue sky & white Utrillo buildings," to the Tuileries: "wonderful children everywhere w. new toys & games swings, sailboats puppet show," "Orange rice: impressionist: Lac d'Annecy: bluegreen Cezanne," attends an Emlyn Williams play, *Monsieur qui Attend*, at Pam-Pam

December 29: A gray day, croissants and coffee in bed, buys theater ticket, eggs, bacon, bread, and wine at the Odeon Cafe, at the hotel writes letter, rains, supper across the street observing "mad beggar clown & bread & can of soup: castrated cat"

To Mallory Wober: Describes the view from her hotel window and what it is like in this "conglomerate oriental quarter" as well as her other walks in Paris. Gets his letters from American Express office that make her feel "so far away from everything and everybody now: time has no meaning anymore, because all here is so new and strange and terrible and wonderful all at once." She doesn't mind him seeing Bernice[181]: "There is nothing that makes a girl appreciate the true worth of a man more than if she thinks there is another girl in the picture, and I would be only too happy to be of service to you in this situation."

December 30: Croissants and coffee in bed "long languor & talk," walks along the Seine by the bookstalls, browsing "gay watercolors," to American Express office to pick up Christmas cards, walks along the Tuileries to shish kebab supper with Nat LaMar. Sassoon has been a "godsend," taking her to places like the Place Pigalle, where women cannot go unattended by males, with his French sorting out any difficulties she has. Attends performance of *Jeanne d'Arc*

"Dearest mother": A travelogue as she prepares to leave for Nice in the hope of finding the sun.

December 31: Packs for Nice after breakfast: "cold meat at Gare de Lyon," "Excitement of night departure—Moonlight, stars, white roads & Quarries, shades of gray, black & white, rhythm of train wells rushing on, wine & cold ham en route"

On the train: "Off into the night, with the blackness of a strange land knifing past. . . . feeling the incomparable rhythmic language of the wheels, clacking out nursery rhymes, summing up the moments of the mind like the chant of a broken record: saying over and over: god is dead, god is dead. going, going, going. and the pure bliss of this, the erotic rocking of the coach. France splits open like a ripe fig in the mind; we are raping the land, we are not stopping," compares the look of the night landscape to painting by Van Gogh and cubist paintings of blocks of buildings, sleeps with the weight of Sassoon on her breast

1956

Undated: "Zeitgeist at the Zoo," "The Widow Mangada," "B. and K. at the Claridges," "Guess where it's heaven to be a girl," "Poppy Day at Cambridge" {PM}; photographs of Plath and Ted Hughes, Plath and Warren, in Paris {PM}; underlinings in Elizabeth Drew, *Poetic Patterns. A Note on Versification* {PM}

Winter: *Chequer* publishes "Epitaph in Three Parts" and " 'Three Caryatids Without a Portico' by Hugh Robus. A Study in Sculptural Dimensions"; *Lyric* publishes "Apotheosis" and "Second Winter"

January 1: Watches a "clear" Mediterranean "pink sunrise" over a breakfast of café au lait, bacon and eggs and croissants, gazes at the Côte d'Azur: "blue—red sun—pink & yellow arabesque villas—bizarre palms, cacti," Nice: "limbed virile ville," passing by a "white cemetery" and a "magnificent view of snow capped mountains," at a flower and vegetable market

"Dearest mother": Writing on the express train to Nice and describing her arrival.

To Mallory Wober: "all is unbelievably new, colorful & lovely."

January 2: Coffee and croissants for breakfast and balcony view of the hills, walks around Nice, noting the "azure ocean gulls," a cinnamon in a café on Rue Victor Hugo with "sexy young people dancing," naps at the warm hotel, supper and wine at a good restaurant, washes hair and reads in bed, describes the sea and the town in her journal. {PJ}

January 3: A nice day begins with café au lait in bed, walks around Nice, a "wonderful gentle martini w. Italian olives" on the Promenade des Anglais looking at orange trees, the ocean, and "fascinating resort types," motor scooter ride to Juan les Pins, steak dinner and wine, a stop for coffee and rum at a café

January 4: Jam, bread, butter and café au lait in bed, errands: "new motor bike—frightful scene at garage—gas spot—insults: tears," lovely lunch in the hot sun on the promenade: fish soup, apple tarts, shopping, evening ride on scooter to Villefrance "steep hills, sparkling lights," "good dinner" at restaurant Victoria

January 5: "exquisite blue day," motorcycles "along blue inlets to Villefrance, Beaulieu around Cap Ferrat," in the casino at Monte Carlo: roulette, croupiers, green tables, music and good dinner in Menton at an Italian restaurant with Americans, "scarlet flowers," rides back to hotel at night seeing Christmas trees

Telegram to Mallory Wober announcing day of her arrival in London.

January 6: A lovely breakfast in bed: bread, butter, apricots, motorcycles through green hills to Vence, passing orange and olive trees, white doves,

"quiet pink houses in the sun," "Epiphany visit to St Chapelle de Rosario—weeping—vision of Love white wine—stormy ride back azure waves casino—gambling—roulette: plush—orange juice"

January 7: Finishes *Autobiography of Alice B. Toklas* in bed, to the telegraph office, white wine and ham sandwich and pastries for lunch, naps at hotel, dinner of steak, wine, and apples

Postcard to "Dearest mother": Describes her adventures on a Lambretta motor scooter.

Postcard to "Dear mother": Visits Matisse chapel, closed, but opened by the mother superior who entreats her not to cry and to enter: "I just knelt in the heart of the sun & the colors of sky, sea & sun in the pure white heart of the chapel. 'vous êtes si gentille' I stammered. The nun smiled 'C'est la miséricorde de Dieu.' It was."

January 8: Returns to Paris on the train watching the dawn over the Mediterranean with passengers "French prof : Italian ship fitter : Corsican pansy host : ugly baby Chantelle & solicitous parents : gay lung chap from Marseilles," reads Jean Cocteau's *Machine Infernal*[182] with Sassoon, tea in railway car as they enter snowy Paris: "blue velvet room : great dinner at 'seroil'; good farewell love"

January 9: At the American Express office to pick up mail, to London after a hectic breakfast at Hotel de la Harpe, rushes for the boat train in the snow and wet, meets Pat Mackenzie, a Canadian, on the "green rough boat crossing" from Dieppe to New Haven and "white cliffs," elderly American woman: "Dagenham bag," "Pipers: train to London—spanish & Vietnamese boys : animated hot French : wearily to Cambridge bath"

January 10: Sleeps late and has breakfast on the gas fire in her room, surprise visit from Mallory Wober, unpacks, they have a serious talk, prawn pilau at Taj Mahal, to Market Hill for daffodils and tulips, purchasing grapes and oranges, cleans room, first British supper and chat with Jane Baltzell, washes hair, calculates finances

"Dearest of mothers": "My New Year mood is so different from the rather lonely, weary, depressed and slightly fearful state in which I left Cambridge a mere three weeks ago." She is grateful for the *New Yorker* issues her mother sends "full of poems and good stories and all the tidbits of Americana I love so well." Describes her delight in the thirteen-hour return trip to Cambridge with a cross section of French society: "everybody joined in together," and she learns to play a new card game, Belote.[183]

January 11: Deposits check at bank, pays bills at Heffer's bookshop, laundry, pays bills, finishes rough draft of her Fulbright statement

To Richard Sassoon: Describes the rough crossing from France to England.

To Rosalind Pugh Swaim: Describes Christmas in Paris, New Year in French Riviera, motorbiking in Nice and Italy.[184]

January 12: Sees Miss Morris about her Fulbright, rewrites and types her Fulbright renewal application, "bumped away at poem," reads *New Yorker* issues, "hot milk & evening stars"

January 13: On a "crisp clear day" with "white frost" bikes to laundry, buys nuts, soap, "dyeing problems," visits John Lythgoe and Brian Corkery, begins an article about Cambridge

January 14: "write CSM article & Vence article," finishes typing seven-page article on Cambridge and begins another article about Paris

7:00: With Brian Corkery for supper and "magnificent movie" *Die Letzte Brüke* about "German—Jugoslav partisan battles"

"nurse Helga—Chekhov story: 'illegitimate child' "

To Richard Sassoon: Waits for "those sudden moments of incandescence: unexpected, but once one knows them, one can live life in the light of their past and the hope of their future."

January 15: Finishes writing Paris and Nice article for CSM, does pen and ink sketches of Cambridge gable, chimney pots, palms, wicker chairs, and a man reading on the Promenade, begins reading Shirley Jackson's novel *Bird's Nest*,[185] washes hair

January 16: Banking, shopping, to the post office, types story for *Granta*[186] in the morning, cards to Dotty, Aunt Helen, and Richard Sassoon,[187] sees daffodils in Market Hill shop windows, a "gay, crisp sunny feeling," Ben Lyon, "coffee—Yvette's," finishes *Bird's Nest* about four split personalities

"dearest of mothers": June 10 is the ideal time for her mother to visit since term will have just ended: "your trip plans make me glow with joy." Discusses her travel plans, wants to study German again after seeing a German movie, misses her girlfriends: "close girl friends are difficult here because of the intensely individual & concentrated nature of our separate studies," but she does like Jane Baltzel.

To Mallory Wober: Tells him about the German movie that deeply moved her "even to tears & a certain home-sickness."

Plath decided she would devote her second term to disciplined study and forego her interest in dramatics in favor of also spending more time on her own creative writing. But this time was also marked by her distress over her failed relationship with Richard Sassoon.

January 17: Begins second term at Cambridge {PA}, a stewed tomato breakfast, writes an outline for Vence story, with Sally and Richard on a blue day, runs across the lawn with Jane Baltzell, shops around Market Hill for daffodils, coffee at Copper Kettle with John Lythgoe, reads Strindberg's *Dance of Death* and *Gustavus Vasa*

"dearest mother": Complains about overcharging on the currency exchange rate, wants to send RB $50, regrets having to give up ADC because of her "ever-expanding reading list," frets about not writing enough: "I would really like to get something in the new yorker before I die I do so admire that polished, rich brilliant style." Mentions her "flashes of delight" and Sassoon's saying "the important thing is to love this world." She needs the "spiritual calm" of writing. Looking for a mature man, not the young ones she tends to mother. Sassoon is the only man she has loved but she fears for his "particular nervous, intense fluctuating health."

January 18: Reads Raymond Williams on Strindberg and *Prometheus Bound*, "to toura—sun: apples & oranges"

12:45: Meets Miss Burton

Lunch with Mallory Wober, windy and sunny on the bridge by the mill race, "merrydown cider ducks & sandwiches," an afternoon of "lazy talk—Nat: nostalgia—frosty moon"

January 19, 10:00: Redpath lecture on tragedy

11:00: Willey on the moralists

2:00–5:00: Works on Vence story

4:00–7:00: Reads Strindberg's *Dream Play*

8:00–10:00: Reads Strindberg's "Swanwhite," "Simoom"

January 20: Northam lecture on modern drama

10:00–1:00: Works on Vence story

4:30: Meets Iko Meshoulam for tea

"Israeli-Arab talk"

8:00–10:00: "wild wind whipping rain"

"Dearest Grammy and Grampy": Happy to get their "lovely letter." She feels much closer to home with the photograph of her mother they have sent. Excited about her mother's visit and grateful to have such loving grandparents, describes her friends, feels she is building up creativity inside her as she has decided to start "a rather more serous and solitary life this term."

January 21, 9:00–1:00: Works on Vence story

2:00–7:00: Reads Strindberg

8:00–10:00: Begins paper

To Gordon Lameyer: "It is a brilliant, frigid morning, and I sit by a whistling gas fire, burning on one side, with fingers polar cold, warming up on the keys before I begin my daily stint of two to three hours of writing. New Year's Greetings from the frosty fens." Delights in his gift of Richard Wilbur's *Misanthrope*, describes her three weeks in France. She is more "desirous of writing prose, good short stories, now, than poetry, which isn't wide enough for all the people and places I am beginning to have at my fingertips."

January 22, 9:00–1:00: Works on Strindberg paper

4:00: Meets Nat LaMar for coffee and a "wonderful stimulating afternoon"

David Tinnin "possibility of teaching jobs—also abroad"

"Strindberg: Tragic Concept and Dramatic Form," typescript with supervisor's comments {PM}

January 23, 9:00–10:00: Finish typing paper

10:00: Krook lecture

11:00–1:00: "snowy, rainy sickest"

2:00–5:00: Reads Aeschylus

5:00: David Daiches lectures on the modern novel

8:00–10:00: "moon on snow flat crusty whiteness"

January 24: Meets with Miss Burton

10:00: Redpath lecture on tragedy

11:00–1:00: Coffee with Nat LaMar

2:00–7:00: On a "bright crisp sunny day" at the library working on Vence story

8:00–10:00: "2nd rewrite of Story"

Even as Plath was drawn to Richard Sassoon, her letters reflect an awareness that they are not quite right for one another and that another sort of man is what she requires—one who will not measure himself against her, as Sassoon seems to do, but is all himself while capable of allowing her to be all herself. Sassoon acted as though he had something to prove, and while Plath could feel the same way, she believed there might be a man out there who felt he had to prove nothing, and such a man would be the proof of what she was looking for.

January 25, 10:00: Welsford lecture on tragedy

11:00: Leavis lecture on criticism

2:00–5:00: Writes two poems

5:00: Daiches on the modern novel

"Dearest mother": Pleased with the long letter, urges her mother to report on Grammy's illness. It is much quieter now that she has quit ADC and is not constantly visited by the ADC boys, "most of them were so emotionally immature that they shocked me; I felt so much like a wise old mother." She requires the "absolution of the printed word." Describes reading eighteen Strindberg plays and finds the reading and writing combined gives her a "peace in myself which I never had when I was running around to the theater and going out all the time last term." She has not found the right man. "I shudder to think how many men would accept only a small part of me as the whole, and be quite content." Brilliant and intuitive Sassoon has come closest to her ideal, but "he pays for this with spells of black depression and shaky health which would mean living in daily uncertainty."

Calls him a "holy person." He does not look "at all like the kind of man I could be fond of; but he is, and that's that." She consoles herself with Nat LaMar who is very much like herself.

January 26, 9:00–10:00: Reads Aeschylus

> **10:00:** Redpath lecture
>
> **11:00:** Willey lecture
>
> **2:30:** "Reynolds—classics"
>
> **4:00–7:00:** Supper at Whitstead
>
> **8:15–10:00:** With Mallory Wober attends ADC production of *Crime and Punishment*
>
> "Mallory moon—sad—destructive—lonely"

January 27, 9:00: Northam lecture on French plays and Stendhal

> **10:00–1:00:** Shops
>
> **2:00–4:00:** Coffee with Nat
>
> **8:00–10:00:** Sees *Odd Man Out*[188] with Jane Baltzell "Irish rebel—art scenes"
>
> Bikes home "catharsis-tears," washes hair

January 28, 9:00–1:00: To the post office in "rain, smoky fog" to send poems to New York

> Reads Chekhov's *Uncle Vanya*
>
> **2:00–7:00, 8:00–10:00:** A "long drowsy day" of reading Chekhov's *Ivanov, Cherry Orchard*

To Richard Sassoon: "I would sit around and read and write and brush my teeth, knowing in you there were the seeds of an angel, my kind of angel, with fire and swords and blazing power, why is it I find out so slowly what women are made for?"

January 29, 10:00–1:00: "Read Magarshack on Tchekov"

> **2:00–7:00:** A visit with Chris Levenson[189]
>
> **8:00–10:00:** Translates Racine's tragedy *Bajazet*
>
> "Tremendous sense of Guilt & pressure"

"Dearest mother": Describes her heavy schedule of reading, lectures, and translation leaving little time to write. "do hope someday I meet a stimulating, intelligent man with whom I can create a good life, because I am definitely not meant for a single life." Excited to be living on the edge of the Continent: "I actually feel smothered at the idea of going back to the States!" She would consider returning only if she had a husband. "I really think I would do anything to stay here." Considering Saxton and Guggenheim fellowships to prolong her stay abroad. She does not want to be a "career woman," but waiting for someone she can honestly marry is "so hard."

January 30, 9:00: Redpath lecture

11:00: French with Miss Barret, discussion of two Racine plays

12:00–1:00: Shopping at Heffer's

2:00–5:00: "Russians"

Dick Wertz visit

5:00: David Daiches lecture on Virginia Woolf's *Mrs. Dalloway*

"'Month in Country'—rain in gutter"

January 31, 9:00: Meets Miss Burton

12:00: Krook lecture on moralists

2:00–7:00: Aeschylus

"weak, passive"

8:00–10:00: "sleepy day"

"mock appendix attack—ambulance—Addenbrook hospital—night-mare—80 bed ward—rain & snow & icy wind—wash hair bath"

February 1, 9:00: Redpath lecture

10:00: Welsford lecture on tragedy

11:00: Leavis on criticism

12:00–1:00: Finishes reading Aeschylus

2:30: Reynolds lecture on classics[190]

4:00: Feels a cold misery and yet has an epiphany at tea with Christopher Levenson in spite of bad reviews of two of her poems in the Cambridge paper *Broadsheet*

5:00: David Daiches lecture

8:15: Film Society showing of *L'age d'Or*[191]

"Mallory frosty stars"

February 2, 9:00–10:00: "miserable cold still"

"frost bitter"

11:00: Willey lecture

12:00–1:00: Visit with Mallory Wober

2:00–7:00, 8:00–10:00: Final draft of "Matisse Chapel" story

"Dearest mother": Feels sad she is not there to help her ailing grandmother and will send cards and notes "if it would make her days brighter, for my love for her is daily, and I think of her with such tenderness." It is so cold that she cannot live without a hot water bottle, ski socks, sweater, and flannel pajamas. Even with "fur lined gloves I feel an intense pain in my fingers and never have experienced such cold." Relates her appendicitis scare and trip to hospital but the result is only a cold and "colic," she is told. Mentions poor reviews of her two poems in *Broadsheet*. She would like to take a short trip with Warren when he arrives in Germany in the summer.

"Dearest grammy": Mentions the operation and wishes she was home to help her convalesce. "I remember the many times you have taken care of me, and made tempting broths and run downstairs for me during sinus

colds—! . . . If you hold this card open to the light, you will see all the bright, jewel-like colors on one of the stained glass windows of my favorite chapel in Paris—I wanted to share the beauty of it with you." Draws a bouquet of daffodils on back of envelope.

February 3: "heat off Pembroke frigid"

9:00: Northam lecture

10:00–1:00: Meets Nat LaMar for coffee: "Wonderful warm talk—Kumquats"

Shops and goes to the post office

4:30: Tea and theological discussion with Dick Wertz in Westminster

8:00–10:00: "students—chapel service"

Sends Vence story to the *New Yorker*[192]

February 4, 9:00–1:00: Begins Aeschylus paper and writes business letters

2:00–7:00: A visit with John Lythgoe

8:00–10:00: Freddy Mayer[193]

February 5: "Lovely dreamy movie morning"

10:30–1:00: At the Film Society to see *La Belle et la Bête*[194]

"Debussy: 'Images'—Red Shoes ballet," writes Chekhov paper

4:30: Cocktails with D. Lehmkuhl[195] "jettisoned for Chris & coffee & warm rapport"

8:00–10:00: Reads *Dr. Faustus*, *The White Devil*, and Ronsard

Washes hair

"The Question of Tragedy in Chekhov's Plays. 'Studies in Frustration' or an 'Affirmation of Life?'" typescript {PM}

February 6: Types Chekhov paper

9:00: Redpath lecture

10:00–1:00: Works on Aeschylus paper

5:00: Daiches lecture on James Joyce's *The Dubliners*

"hot milk and roast chestnuts by fireside"

8:00: "early to bed"

"Dearest of mothers": Happy to have her mother's optimistic letter on a "wet, rainy morning!" Cheered by Grammy's improvement: "In the last two years we have certainly had our number of great tests (first my breakdown, then your operation, then grammy's) and we have yet been extraordinarily lucky that they were timed in such a way that we could meet them. I am most grateful and glad that I banged up all at once (although I am naturally sorry for all the trouble I caused everyone else), for I can't tell you how my whole attitude to life has changed! I would have run into trouble sooner or later with my very rigid, brittle, almost hysterical tensions which split me down the middle, between inclination and inhibition, ideal and reality. My whole session with RB is responsible for making me a rich, well-balanced, humorous,

easy-going person, with a joy in the daily life, including all its imperfections: sinus, weariness, frustration, and all those other niggling things that we all have to bear. I am occasionally depressed now, or discouraged, especially when I wonder about the future, but instead of fearing these low spots as the beginning of a bottomless whirlpool, I know I have already faced The Worst (total negation of self) and that, having lived through that blackness, like Peer Gynt lived through his fight with the Boyg, I can enjoy life simply for what it is: a continuous job, but most worth it. My existence now rests on solid ground; I may be depressed now and then, but never desperate. I know how to wait."

February 7: Meets with Miss Burton

10:00–12:00: Reads Aeschylus criticism

12:00: Krook lecture

2:00–6:00: "thoughts of Chris—most beautiful & sad letter"

6:45: Sherry with Miss Morris "from Richard High table—amusing—lavender haired Betty Berenson—18th cen."

8:00: "china cocks—rent & housing problems—dry Edith: sultry Hezrahi—Brisker"

"Romantic German don—season ticket—life miserable—suicidal: linen closet—wrote paper late—tired: conscience pangs note from dear Chris—"

To Mallory Wober: "in a very grubby mood this week. . . . But let me make like Greta Garbo huh? 'I vant to be alone.' Or just fall in bed & sleep for a week."

February 8: "rainy . . . cold—weary—sherry & sudden joy"

9:00: Redpath lecture

10:00: Welsford lecture

11:00: Leavis lecture

12:00–1:00: Haircut

2:30: "Reynolds—Read Aeschylus paper"

5:00: Daiches lecture

8:00: Meets Mallory Wober

February 9, 9:00–11:00: "windy, blustery day" snow flurries, shops, banks, does the laundry

11:00: Willey lecture

12:00–1:00: Shops

2:00–7:00: "tired yet happy coffee & good talk" about Yeats and Synge with Iko Meshoulem[196]

February 10: Writes letters to Jon Rosenthal, Mrs. Prouty, Gordon Lameyer, Sue Weller[197]

9:00: Northam lecture

10:00–1:00: Shops for fruit

"Chris: Downing[198]: lovely afternoon—snow"

2:00–7:00: "coffee & warm love"

Dinner at Taj Mahal

8:00: Attends production of *Philoctetes* and *Shoemaker's Wife*, with John Lythgoe

"Dearest mother": Ecstatic because Sue Weller will be coming to England on a Marshall scholarship and is anticipating visits from several friends.

To Ellie Friedman: Proposes they travel together this summer and outlines her planned trips, including one with "hunky" Gordon Lameyer in Germany, relates her trip to France, the "dear, sweet boys (mostly Jewish and negro) . . . But none I could marry."

February 11, 9:00–1:00: Reads Yeats plays

Writes letters to Mrs. Prouty, Gordon Lameyer, Jane Anderson

2:00–7:00: Coffee and supper with Nat LaMar, at coffee house with Chris Levenson for chicken sandwiches and cheese

"Nostalgia: Richard,[199] future, no career superficial, slight poetry—selfishness"

February 12, 10:00–1:00: Writes Irish paper and reads *Le Cid*

2:00–7:00: Reads The White Devil, The Duchess of Malfi, and Ronsard

7:45: Meets Chris Levenson on a snow night with talk by the fire and a "poetry reading—African—Gary[200]"

February 13, 9:00: Redpath lecture

10:00–1:00: Writes paper on tragedy in Yeats and Synge in "weariness and desperation"

Cuts French tutoring session

5:00: David Daiches lecture, "Jeremy Trafford—wild"[201]

Cocktails at New Court in St. Johns College "multitudes of martinis"

8:00: "stone stairs—bridge of sighs—blur of liquor—to IKO [Meshoulam] & consolation by fireside—'Four Seasons' Vivaldi"

"The Drama of Yeats and Synge. (A Few Miscellaneous Notes and Observations Only.)" typescript with supervisor's comments {PM}

February 14: "Complete reversal of desperate & depressed mood—good supervision: clear cold sun—shopping for cake & cookies & nuts"

2:00–7:00: Tired but happy to receive CSM check

A brief coffee session with Chris Levenson, reads his literary correspondence

8:00: "bedtime doubts of future again"

"Dearest mother": Reports $16.50 payment for her CSM article about Cambridge and a pen and ink drawing of "gables and chimney pots from our little bathroom at Whitstead!" This the highest payment she has received for publication in that newspaper.

February 15: Redpath lecture

10:00: Welsford lecture

11:00: Leavis lecture

"cold—inferior feelings re writing & thinking," finishes *Bacchae* and reading literary criticism

2:30: Reynolds lecture

5:00: Daiches lecture

"old doubts superficiality in expression (words) & inexperience"

February 16, 9:00–11:00: To the post office; purchases typewriter ribbon

11:00: Willey lecture

12:05: "Med exam: long talk with Doctor re dentistry, thyroid, medicine, etc"

Types "Side Hall Girl," begins reading Eugene O'Neill's plays

8:00: Supper in her room, "terrible tearful frustration & desire for R or C."[202]

February 17, 9:00: Northam lecture

10:00–1:00: Hot bath, eats fresh oranges, dresses, begins a rough draft of a poem "re bathtub"

2:00–7:00: "Chris: Taxis: train to London: excitement: White smoke & sowfields & bright orange sun—shish kebab & wine in Soho—'Darkling Child'—WS Merwin"[203]

8:00: Walking home along the Thames in the "cold dark" listening to Big Ben

Plath seemed to be looking for some kind of intervention in her life, a male who could break through her worries about the future and with whom she could share it, while not being quite able to give up on Sassoon. She regarded herself as a kind of Eugene O'Neill character who was on stage, wearing a mask, performing a self separate from the anxieties she could acknowledge only in the most general terms to her mother.

February 18: Bath

2:00–7:00: Shops, reads O'Neill, sees Chris Levenson

8:00: A party, "hypnotizing:[204] talk with Win[205] re Jane Trask & Richard & Lois & love etc puppy dog abandon—frosty walk home frozen tears & suffering," thinks of Richard Sassoon: "You are in my guts and I am acting because you are alive. And meanwhile you are probably sleeping exhausted and happy in the arms of some brilliant whore, or maybe even the Swiss girl who wants to marry you." {PJ}

"Hello again, dearest mother": "Occasionally, I am chastened and a little sad, partly because of the uncertainty of the coming years, and the cold whispers of fear when I think of the enormous question mark after next year (which is still not finally financed)." Notes her interest in politics and in getting work as a journalist.

To Gordon Lameyer: Hopes he can look in on her family to see how they are doing, especially her mother who has been teaching and nursing Sylvia's grandmother recovering from stomach cancer. Expresses interest in exploring a "bit of Europe" with him.

"I am Nina in 'Strange Interlude'; I do want to have husband, lover, father and son, all at once. . . . And I cry so to be held by a man; some man, who is a father." {PJ}

February 19: "lovely chastened walk with Chris to Grantchester—gray skies flat white snow landscape—brown undertones of earth & leaves— green water: snow in hair—feeling of distance," long teatime talk with John Lythgoe, "Effort at articulation of love & life—painful communion—need for simple warmth of human kindness," reads *Macbeth*

To Jon K. Rosenthal: Regrets just missing him when she was in Paris. Describes Nice: "I can't believe people really live all year round in pink, yellow and orange houses under palms and lemon trees."

February 20, 9:00: Redpath lecture

10:00–1:00: Walks to town in early morning while the shops are shut

2:00–5:00: "wrote short poems re swan & winter landscape with rooks"

5:00: Daiches lecture "very depressed & antagonistic & hollow"

Finishes reading O'Neill's plays

8:00: Broods over hot milk, "close to blackness again"

To Aurelia: "How happy I am to hear that you are home & going along so well!"

"Dear Doctor": "I am feeling very sick. I have a heart in my stomach which throbs and mocks. Suddenly the simple rituals of the day balk like a stubborn horse. It gets impossible to look people in the eye: corruption may break out again? Who knows. Small talk becomes desperate . . . read two letters from mother which cheered me a bit: she is so courageous, managing Grammy and the house, and building up a new life hoping for Europe." {PJ}

February 21: *New Yorker* rejection of story, "The Matisse Chapel": "blow bang—yet somehow new stoic courage: must be dry, demanding—weariness & scratchy throat—, yet more outgoing"

9:00: Meets with Miss Burton

10:00–12:00: Returns books to university library

12:00: Krook lecture

2:00–7:00: Reads *The Trojan Women*

8:00: At *Bacchae* performance with Jane "blue gauze scrim, red Dionysus—fine weird music & lightning flashes—coffee & talk after with R. McClaren & Dark Dick"[206]

The "black-and-white doom of the printed rejection." {PJ}

February 22: Picks up bike, "snow spitting day—raw wind—new resolution to be accessible and sweet"

 9:00: Redpath lecture

 10:00: Welsford lecture

 11:00: Leavis lecture

 12:00–1:00: Banks and shops

 2:30: Reynolds lecture

 Meets Chris Levenson for coffee and talk

 5:00: Daiches lecture

 "guitars & hot wine & gin punch": party with Derek Strahan at Queens[207]

 8:00: "lovely revelation—simple ballads by fire"

February 23, 9:00–11:00: A late breakfast, a miserable cold, bikes in the snow and "raw wind"

 11:00: Willey lecture, shops, coffee at Alexandra house with John Lythgoe—"bright wise guy, hence tempting—"

 2:00–4:30: "dear Nat—talk & coffee with Derek Strahan"

 Tea with cakes and scones with Gary Haupt at Pembroke College, good talk with Chris Levenson and Keith Middlemass[208] over a fire and sherry, evening at home nursing a cold with wine, finishes "Channel Crossing & best poem yet—so to bed"

 "Dearest mother": Confesses to writing a "self-pitying" letter and that every now and then she likes to be "babied," especially now with her miserable cold and sleeplessness. "I am so sick of having a cold every month. . . . I was simply not made for this kind of weather." Misses the tender care of the Smith infirmary. "Here the people have such an absurd inertia. They go around dying with flu and just plodding on and on. . . . I am sick of being constantly shivering & biking in siberian winds. . . . I sometimes despair of ever finding anyone who is so strong in soul and so utterly honest and careful of me." She misses her "strong constellation" of friends at home.

February 24, 9:00: Northam lecture "miserablest of days"

 10:00–1:00: "awful wet cold—drugs—far off—no sleep—Great Depression"

 2:00–7:00: "impotent—salted nuts—blue drench of moonlight"

 A visit from Chris Levenson warms her

 8:00: "human strength—flow of life"

Plath's first meeting with Ted Hughes comes right in the midst of one of her depressions. She is still in love with Richard Sassoon but anguished about his reluctance to commit himself to her. While Hughes seems to be the answer to her lifelong quest for a strong, creative man who would honor her own commitment to writing, she has to overcome doubts about his brutality. Her reference to

"fatherly Dr. Davy" reflects how much she was drawn toward figures of author-
ity who could be protective and understanding. Hughes did not quite fit this
category of solicitude and inspiration, but perhaps he could be shaped into a
facsimile thereof. Letters to her mother and her talk with Dr. Davy also suggest
she had her suicide attempt in mind as she sensed she was about to enter a new
phase of her life, even as she missed the infirmary comforts of Smith College.

February 25, 9:15: Consults Dr. Fender who recommends Dr. Davy, a
psychiatrist

10:00–1:00: Long talk with fatherly Dr. Davy

"Dearest mother": Potent nose drops are helping as does a psychiatrist
who listens to an account of her past. Looking forward to tonight's party to
celebrate *St. Botolph's Review*, with poetry that is "really brilliant" and prose
that is "taut, reportorial and expert."

2:00–7:00: Dinner with Nat LaMar, reads Racine criticism, Hamish
Stewart takes her to the *St. Botolph's* party, "got drunk," meets Ted Hughes,
"mad passionate abandon," "misty moon—climbed spikes to Queens"[209]

2:30 a.m.: Returns to her room at Whitstead, escorted by Hamish
Stewart {PA}

3:00: Falls into bed {PA}

"I was too intense with one boy after another. . . . Richard [Sassoon]
knows that joy, that tragic joy. And he is gone and I should probably be glad.
I long so for someone to blast over Richard." Visits a psychiatrist: "Wanted
to burst out in tears and say father, father father, comfort me." {PJ}

February 26: "exhausted & chastened after orgy"

10:00–1:00: "weary & gray—chills—simply spent—desperate re
work—obsessed re Ted—dark giant—lust & anger—nap"

2:00–6:00: A comforting time with Chris Levenson by the fire drink-
ing coffee

6:45: Dinner of sherry and steak at the Blue Boar with Mallory Wober,
feeling "stiff, formal—tired"

A visit and talk with Derek Strahan and Jane Baltzell and then to bed
with hot milk

Describes meeting Ted Hughes: "The one man since I've lived who
could blast Richard." Reports Hamish Stewart's claim that Hughes is the
"biggest seducer in Cambridge." {PJ}

February 27, 9:00: Redpath lecture on *Antony and Cleopatra*

10:00–1:00: In bed working on Ronsard and Racine paper

2:00–5:00: "cold cancelled all—sleet till noon—wrote 'pursuit' "[210]

A brief visit from Chris Levenson "felt stubborn, spoiled self—Awed?"

5:00: Daiches lecture

8:00: Radiant panther[211]

"feeling worthless and slack, yet stubborn," writes "Pursuit," dedicated to Ted Hughes, imagining a "black marauder" who will have "the death of me," mother's letter is full of maxims, some of which strike home, such as "be gentle on yourself"

February 28, 9:00: Meets with Miss Burton, finishes writing "Pursuit"

10:00–12:00: Begins Ronsard

12:00: Krook lecture

"stayed home . . . Velvet & gold slippers—bread & cheese & soup lunch"

2:00–7:00: Tea with Maryan Jeffrey,[212] a "good talk" for two hours, Iko Meshoulam drops in, cooks a steak and salad supper, reads *Oedipus Rex at Colonus* and *Antigone* "struck by cold dark fate & ruin"

February 29, 9:00: Redpath lecture on a "windy warm day"

10:00: Welsford lecture, "tired, yet stoic"

11:00: Leavis lecture, "wonderful humanist," shops, cleans room

2:30: Reynolds lecture

5:00: Daiches lecture

8:00: With Iko Meshoulam to light opera, *Sir John in Love*

Coffee at Alexandra

Plath's dual focus on Sassoon and Hughes is articulated almost in the manner of the Eugene O'Neill plays she was reading at Cambridge, works that experiment with masks as facets of unreconciled selves. Watching Cocteau's films stimulated a similar dissociation of sensibility in Plath. Her command to Sassoon—"Break your image"—is cinematic, as are her phantasmagorical dreams. Her references at this time to stoicism suggest a tension between the passion she is writing about in Racine's plays and the logical, ethical effort to maintain an equilibrium that would prevent her making irrational choices. The appearance of Gordon Lameyer in her dreams and her letters to him seem part of her quest to hold onto a stabilizing force.

March 1, 9:00–11:00: Finishes Ronsard

11:00: Willey lecture

2:00–6:00: With Chris Levenson

6:00: Meets Stephen Spender at tea, sandwiches at Anchor with Luke Myers

8:00: Derek Strahan, "Cocteau's *Orphee—death & heurtebise*"[213] "magnificent—Jean Marais: Richard"

To Richard Sassoon: "I made your image wear different masks, and I played with it nightly and in my dreams. I took your mask and put it on other faces which looked as if they might know you when I had been drinking. I performed acts of faith to show off: I climbed a tall spiked gate over a moat at the dead hour of three in the morning under the moon, and the men marveled, for the spikes went through my hands and I did not

bleed. . . . Break your image and wrench it from me. I need you to tell me in very definite concrete words that you are unavailable, that you do not want me to come to you in Paris."

March 2, 9:00: Northam lecture

 10:00–1:00: Reads Ronsard

 2:00: Meets Miss Barrett to discuss Ronsard

 4:00–6:00: Reads Racine, "whiskey at Miller's & still & sugarloaf"

 6:30: Sandwiches with Hamish Stewart, watches Frank Sinatra in *Man with the Golden Arm* "great Sinatra—jazz—OK time"

March 3, 9:00–1:00: Finishes reading for Racine paper, washes hair, shops on a rainy day

 2:00–7:00: A "lovely bouquet of spring flowers from John Lythgoe—stoic work"

 8:00: Begins Racine paper, "behind as usual—defiant—sort throat nightmares & sleepless thoughts re Jane, Miss Burton, Gordon & Europe"

"Passion as Destiny in Racine's Plays," typescript with supervisor's comments {PM}

"Dearest mother": Preparing for a "stoic weekend of solid work. . . . I do want to tell you how much your letters mean to me . . . how very much I have admired you: for your work, your teaching, your strength and your creation of our exquisite home in Wellesley and your seeing that Warren and I went to the Best colleges in the United States (best for each of us, respectively, I'm sure of it!) All this is your work, your encouragement, your produce, and as a family, we have weathered the blackest of situations, fighting for growth & new life: perhaps I most especially admire your resilience and flexibility." Trying to be more social and resisting the impulse to measure all men against Sassoon, mentions meeting Ted Hughes: the "only man I've met yet here who'd be strong enough to be equal with."

March 4: Has a blowup with Jane Baltzell who wrote in books she borrowed from Plath: "rehash of gripes—catharsis at last"

 10:00–1:00: Rewrites Racine paper

 2:00–7:00: Reads Marlowe and Chapman

"France, St. Botolph's, etc. relief selfishness in Paris—also ruthlessness re Mallory—disturbing—danger of repeating ourselves 'two American girls who write' "[214]

 8:00: "tired but dogged"

To Gordon Lameyer: She has been dreaming about him: "I can make all my vacation plans revolve around you, and would like very very much to do so."

March 5, 9:00: Redpath lecture on Ibsen's *Ghosts*

 10:00–1:00: Reads Marlowe and Chapman

2:30: Meets Miss Barrett to discuss Charles Baudelaire's *Les Fleurs du Mal*

4:00–5:00: "dull girls—revelation—I could sight read much—ravished Huxley[215]—frogs like little green Christs"

8:00: Reads Marlowe and Chapman "wearily—tense sleep so tired"

CSM publishes "Leaves from a Cambridge Notebook" [part 1]

March 6, 9:00: Meets with Miss Burton

10:00–12:00: Cleans room letting in fresh air

12:00: Krook lecture on "Electra: Sophocles, Euripides, Eumenides—Aeschylus"

2:00–7:00: Shops for oranges, mackintosh apples, honey, and cheese

Receives a letter from Richard Sassoon saying he is joining the army, "Richard's letters—crying—revelation—1st saintly letter, 2nd disgusted him"

8:00: "wrote him long letter re eternal love & weakness in wish for immediate love & joy in this world—decided to go to Paris whether he'll see me or not"

"Dearest mother": "I deprived myself of all my 'father figures' in the form of my professors at Smith, and my mothers in the form of you, RB, Mrs. Prouty, Mrs. Cantor, and my woman professors." With the "opinionated" Dorothea Krook, however, she can "grapple" and is "angling" to get Krook as her supervisor.

To Richard Sassoon: Tells him her poems are "all for you. . . . I know now how deeply, fearfully and totally I love you, beyond all compromise, beyond all the mental reservations I've had about you, even to this day."

To Elinor Friedman Klein: "coming like rhett butler from his slam-bang hedonist life through love that is holy, sassoon, not saying 'I don't give a damn' and leaving her on the stairs holding a piece of red dirt, but saying: 'two years of army (it may kill him) and I must make a fortune and only then found a family, and always in the holy skies our love is and will be: someday; meanwhile, I must be noble and give you your freedom.'"

"I am in great pain. . . . I retype the letter I wrote in answer to his [Sassoon's] which he may never read, and will probably never answer, because he seems to want a clean break." Goes shopping: "gives me a sense of 'things' somehow: taste color and touch, and a certain power and plenitude. . . . Come my coach. Goodnight, goodnight."[216] {PJ}

CSM publishes "Leaves from a Cambridge Notebook" [Part 2]

March 7, 9:00: "wonderful morning coffee with Redpath"

10:00: Welsford lecture

11:00: Leavis lecture

12:00–1:00: At the Anchor with Jane,[217] D. Wilson,[218] and Brian Adams[219]

2:30: "Reynolds stimulating talk re tragedy-crammed Greek plays"

"Mike Lotz visit—success basketball & Medicine"

8:00: "read Ronsard sleepily"

March 8, 9:00–10:00: Coffee with Gary Haupt

11:00: Willey lectures

12:00: Krook lecture

1:45–3:15: Reads Ronsard

3:15: Meets with Miss Barrett about Ronsard

4:30–7:00: Finishes reading *The Man Who Died*[220]

Chicken and wine dinner with Gary Haupt

8:00: A sherry and early to bed

The calming influence of Gary Haupt, describes the morning coffee on March 7 with Redpath: "practically ripped him up to beg him to be my father; to live with the rich, chastened wise mind of an older man." {PJ}

March 9, 9:00: Oversleeps and misses Northam lecture

10:00–1:00: Does laundry, shops on a "lovely clear sunny mild day"

Bikes across the green

2:00–7:00: "Fen's to laundry—travel agency—bank—P.O."

Reads Blake and the *Times*, types out poems

7:45: Meets Hamish Stewart for "whiskey & arguments & stars & kissed—ah me"

"Dearest of mothers": "It is a beauteous morning. . . . I felt especially desirous of just hugging you and sharing this lovely morning, so, in substitute, I am writing this letter." Regards "Channel Crossing" as a "turning away from the small, coy love lyric (I am most scornful of the small preciousness of much of my past work) and bringing the larger, social world of other people into my poems. . . . Oh, mother if only you knew how I am forging a soul! . . . all pales to nothing at the voice of his [Richard's] soul, which speaks to me in such words as the gods would envy. I shall perhaps read you his last letter when you come; it is my entrance into the taj mahal of eternity." Sassoon wants to conquer the world before he returns to her, and yet "until someone can create worlds with me the way Richard can, I am essentially unavailable."

"I need a healthy overturning of the apple-cart" and wishing to put off the "academic-critical-teaching live" in favor of a novel about love and suicide using her letters to Sassoon. {PJ}

March 10, 9:15: At Fenner's to see Dr. Davy: "Talked too much re passionate forces—last visit"

To the college library

11:00–1:00: "lovely crisp weather—sun through white & gold hyacinths & crocuses"

Hears that Ted Hughes is in town "panther tormented day with fevered fury"

8:00: Reads *Duchess of Malfi* and *The White Devil*

"Anti-climactic visit from John[221] tired—uncreative—felt 'Left out'—re Granta—be stoic for week"

A "huge joy" gallops through her when she learns that "Lucas and Ted threw stones at your window last night." Sits "spider-like" waiting for Ted to call on her, but she is not a "Penelope waiting for Ulysses." {PJ}

March 11: "continuation of Ted travesty"[222]

10:00–1:00: "fresh news from Philippe re mud & name last night—Chris Levenson—same news—finished "Atheists & Revenger's tragedies"

4:00: Tea with Keith Middlemas at Pembroke College

Gary Haupt and Valeria Stevens[223] "(Society girl? CTBlackwell)[224] & Peter Andrews[225]—sweet—good talk re Cocteau, point-to-point—sherry"

8:00: Reads criticism

"Another day of hell. He is on the prowl." Chris Levenson knocks on the door to say he saw Luke and Ted on the street "this very morning." She is sure "they will not come." But she learns they have mistaken her window and throw mud at Phillipa's instead. She imagines them rolling in the mud "treating me like that whore, coming like the soldiers to Blanche DuBois. . . . They refused to face me in daylight. I am not worth it. I must be when if they ever come. They will not come" She wants to "rave out in the streets and confront that big panther, to make the daylight whittle him to lifesize." {PJ}

March 12, 9:00: A fine Redpath lecture on "Two Antigones"

Tired with "coffee nerves"

10:00–1:00: Writes paper on Webster and Tourneur

2:00–4:00: Meets with Miss Burton "frustrated interview—good—Anchor roast beef & cheese & coffee"

5:00: Daiches lecture, buys sandwiches with Jane Baltzell

6:45: With John Lythgoe at a performance of *Troilus and Cressida*

"Luke—visit—crash excellent pangs—grant"

"Ted has girl![226] Thrysites, Pandar—tired—stoic"

March 13, 9:00: Meets with Miss Burton and learns her Fulbright has been renewed

10:00–12:00: Shops

"Gordy's fairytale letter"[227]

12:00: Krook lecture "Richard's love—on love"

Lunch with Gary Haupt and Nat LaMar

2:00–4:00: Tea with Redpath at Matthew Cafe

Coffee with Luke Myers "nice guy," "Marian Frisch—marvelous"[228]

8:00: Copper Kettle "rapport & Communion"

"Amazing—emotionally exhausting & exhilarating day—Nat, Gordy, Luke & Marian—feeling of joy & love everywhere"

Lucas (Luke) Myers asks her to "visit him and Hughes in London on her way to Paris" {PA}

"Dearest darling beautiful saintly mother!!!": Exuberant over Fulbright renewal. Plans to go around Cambridge sketching. Dorothea Krook is her new supervisor: "The one woman I admire at Cambridge! I should grow amazingly by fighting her logically through Aristotle, Plato, through the British philosophers, up to D. H. Lawrence!"

March 14, 9:00: "cut classes, felt sad re Redpath—eye hurt—lovely carcason[229] postcard from Sassoon"

> **10:00:** Welsford lecture
>
> **11:00:** Leavis lecture
>
> **2:30:** Reynolds lecture
>
> **5:00:** Daiches on "Modern Novelists—hero"
>
> Supper at Anchor with Gary Haupt
>
> **8:00:** With Gary Haupt attends Vienna Choir Boys concert: "angel voices & candlelight & amazing tenderness"

March 15, 9:00–1:00: Shopping

> **1:00:** Lunch with Gary Haupt "mill race talk"[230]
>
> **3:15:** Meets with Miss Barrett
>
> **4:30–7:00:** Sherry and poems at Lucas Myers's
>
> **8:00:** Myers takes her to performance of *Juno and the Paycock*
>
> Visits Bertram Wyatt-Brown "anticlimactic somehow"

March 16, 9:00–1:00: "lovely springish day"

> Lunch at the Anchor "sun on crocuses & fens"
>
> **2:00–7:00:** Walks with Nat LaMar to Grantchester "talk—jealously re J.[231] & flock of men—tea and nap at Gary's"
>
> **6:45:** Races home to dinner
>
> **8:00:** A visit and talk with Chris Levenson

March 17, 9:00–1:00: Breakfast with Gary Haupt

> In Addenbrooks Casualty ward to see Dr. Bevan about "eye trauma"[232]
>
> **2:00–7:00:** With Gary Haupt "anesthetic & probes—picnic at Whitstead with Liebfraumilch"
>
> Sherry and "night love"
>
> **8:00:** "Thurber at Gary's—vigil & eyedrops"

March 18: A weary day after a sleepless night recuperating from eye operation, walks to Grantchester with Gary Haupt, after a good Sunday dinner, goes to sleep exhausted by ten

"Dearest mother": Describes the cinder that had to be removed from her eye, administered eye drops all night as Gary Haupt reads James Thurber to her, asks her mother to act as literary agent and send out her work, lists magazine addresses of the "slicks": *McCall's, Woman's Home Companion,*

Woman's Day, Everywoman's: "Amusingly enough, all the scholarly boys I know here think of me as a 2nd Virginia Woolf!"

To Gordon Lameyer: Discusses traveling together in Germany and other places as "friends."

Ted Hughes to Lucas Myers: "Dear Luke": "If you see Sylvia Plath, ask her if she's coming up to London, give her my address. Get her somehow, free lodgings for her as for you." {THL}

March 19: Visits George Blakey at Trinity College[233]

10:30: Bikes to Addenbrooks for eye checkup

11:30: Meets Gary Haupt at Pembroke College for a walk, they quarrel

Mails poems to *Encounter*, lunch at Arts, "bank triumph," a "lovely walk along Backs[234] w. George" notices the crocuses

2:00–4:00: At Trinity Chapel "goldish Italian & dining"

4:00: Tea with George Blakey "hall w. Hen VII?"

"Pastry and talk," sherry and talk with Gary and George

8:00: Washes hair

March 20, 9:00–9:30: Haircut, banking, biking, shops and buys "three lush cashmere sweaters—red, turquoise & forest green," a "fine lunch" of nuts and apples

4:00: Tea with Ikdiko Hayes and an "excellent long talk" till supper with Jennifer Platt[235] and Ikdiko on "writing, men, etc."

"Learned much re rumor 'assault & battery' of Botolph's—irony!" A visit from Lucas Myers extending an invitation from Ted Hughes, "Smoke & quiet—reversal: Jane & Nat in Italy"

"Dearest mother": Spending Easter vacation in Paris and Rome and shopping for new clothes. "For all the golden 'atmosphere' of England, there is an oppressive ugliness about even the upper middle class homes, an ancient, threadbare dirtiness which at first shocked me; our little White House is a gem of light and color compared to the dwellings here."

March 21, 9:45: Final eye appointment

10:00–1:00: Writes and posts letters to Marty [Brown] Plumer, Ira Scott, Carole O' Brien, Mrs. Claytor[236]

2:00–7:00: At the cleaners, Jane Anderson visits

Cards to Dorrie Licht, Betsy Whittemore, Ruth Moynihan, Barbara McKenna[237]

8:00: "weary—to bed early"

"Dearest grammy": Hopes the returning spring coincides with feeling better. "If you only knew how much I think of you & miss you! My Love to dear grampy, too."

"Dear Jane": Looking forward to Jane Anderson's visit. "I, too, have felt the handicap of having a record in a mental hospital, and probably was

the only Fulbright student to have a letter of recommendation written by her psychiatrist! . . . Each month of reliable living & growing, I think, is a solid step away from McLean. . . . There is much fighting and inner struggling going on all the time, a kind of forging of the soul through conflict, and, often, pain, but behind it all, there is this Chaucerian affirmation which holds fast." Her perspective now included "arabs & jews arguing here, south african communists who are going back to fight the totalitarian white government that keeps the colored people in appalling chains."

March 22, 9:00–1:00: At the laundromat, mails poems to Professor Fisher at Smith, buys light blue sweater and three pairs of pottery earrings

2:00–7:00: Works on wardrobe, sewing, and washing and packing

8:00: Drives with Margaret[238] for supper and cider at "green man" Washes hair

March 23: A "morning of spring sunlight"

9:00–1:00: Meets George Blakey and his friend Anthony Gray for lunch at the Anchor

A good talk with Murray Wigsten about jobs

3:15: "fine tea" on train to London, "felt most cosmopolitan"

Meets Emmet Larkin,[239] at 18 Rugby Street, talks with Lucas Myers and Ted Hughes about James Martin[240] and Ireland

7:00: Wine and eggs "wild wandering night with Ted—record? Panther, acting same, disturbing"

5:00 a.m.: "wounded and shaken from ruthlessness of Ted who called me wrong name."[241]{PJ}

March 24: On the way to Paris exhausted, sore

5:00: "coffee & steadying by Emmet"[242]

A drive through Canterbury with a "bright lovely but superficial English girl Janet," Emmet's girlfriend, good lunch on the boat, a "bumpy agonizing ride through country to Paris," arrives at hotel exhausted, disappointed that Sassoon has left Paris {LWM1}, meets "by sheer accident" a kindly Italian Communist journalist Giovanni Perego, "very dear & cultured dinner"

March 25: After a good night's sleep arrives at Richard Sassoon's apartment and is told he will not return until after Easter, writes him a note "through tears," wanders until she finds the restaurant where they ate her first night in Paris, feeling "growing pride & affirmation at independence," walks along the Seine to Notre-Dame and the bookstalls, feels good and has supper with Giovanni Perego and his friends "OK"

March 26: "feverish sleep: nightmare of man trying to cut up crust of bread & being kicked & beaten," coffee and croissants in bed on a "lovely sunny day," searches for hotels "without luck," meets Dmitri on the Seine and talks "pose—best when serious: 'Il faut être sinister,'" pen

and ink sketches of Le Pont Neuf, visits American Express office, crab salad at Pam-Pam, long walk with R. Diderot[243] to the Jardin des Plantes, naps, dinner with an Oxford University student, Tony Gray, and his sister, washes hair

At the Hotel Béarn, thinking of the "sleepless holocaust night with Ted. . . . Overcome by a disastrous impulse to run to Sassoon as formerly; I took myself in leash & washed my battered face, smeared with a purple bruise from Ted and my neck raw and wounded too, and decided to walk out toward Richard's and search for food on the way." But Sassoon is gone leaving no messages. "I was really amazed at my situation; never before had a man gone off to leave me to cry after." Sitting in the sun with a meal she revives and feels "downright happy." Starts sketching. Worries that she has already been typed as "Ted's mistress or something equally absurd." {PJ}

c. Late March: Ted to Sylvia: "Sylvia": Getting to know her smooth body: "The memory of it goes through me like brandy." He will be in London until April 14 and wishes to see her there or in Cambridge if she does not come to him. {THL}

March 26–28: "Dearest mother": Writes a cheerful letter not mentioning the exhausting night with Ted Hughes. "Perhaps the hardest & yet best thing for me is that Sassoon isn't here. . . . I am on my own. As you may imagine, this is very different from being escorted everywhere as I was at Christmas but I am getting most proud of my ability to maneuver alone!" Describes long walks around Paris and what she is wearing.

March 27: Croissants and café au lait in bed, well rested, drawing rooftops, talking with Giovanni Perego, walks across a "sparkly Seine" to the Tuileries and sketches a kiosk, meets Tony and Sally Gray for lemonade and cookies, a taxi to the Eiffel Tower, with views of Sacré-Coeur, walks to Champs-Elysées, Rue Royal, Elise Madeleine, and "luxurious shops" to the American Express office, to the Rue de la Paix and Place Vendome again, "Sat amidst children in Tuileries—dressed in velvet for play—hurried to Comedie Champs Elysees for Anouilh's Ornifle—lonely moon—bare streets—hard time"

"my greatest flaw is the smug satisfaction that I am intuitively right because I change and grow and then my new vision always seems right because it has increased insight; the process of enlightenment is, however, continuous, so I must realize that even my certainties at the moment will be chastened and altered and mellowed by time." Cries and curses Sassoon for leaving her. {PJ}

March 28: Weary at breakfast, types letter to mother, steak, onion soup, and wine at Pam-Pam, to American Express office, a walk by the Seine, sketches kiosk in the sun, a talk with a "precocious boy—fantastic meeting

with Gary [Haupt]," Cognac and dinner with Gary, to a surrealist film, *Reves a Vendre*[244]

Gives her mother the "gay side" in a letter. Grateful for the solid presence of Gary Haupt since she is tired of warding off men who try to pick her up. {PJ}

March 29: "lovely elated day," eats croissants in bed

Meets Gary Haupt and walks to Ile de la Cité, sitting on a beach sketching "tabac du Justice amidst traffic," large lunch and wine at Pam-Pam, to the Tuileries to watch the children playing, purchases an "enormous brilliant blue balloon," an orange pressé at Sérail "followed by Tristesse re Richard," tearful about Richard and feeling sorry for herself. {PJ}

March 30: Breakfast in bed, walks to the Seine with Gary Haupt, meets Tony Gray on Pont Royal, a lemonade in the Tuileries, climbs "crooked streets to Montmartre—Sacre Coeur in sun—silhouette," white wine and a "delectable veal" meal at Suberg du Coucou, "violets—afternoon of faun—twilight—love-making—tea on quai," sees *To Catch a Thief*,[245] "Color Riviera Champs Elysees & Place founts"

"A strange day passing through ecstasy unto certain sorrow and the raining of questions sad and lonely on the dark rooftops." An artist does her silhouette. "I shall not go to London to descend on Ted; he has not written; he can come to me, and call me Sylvia not Shirley. And I shall be chaste and subdued this term and mystify those gossipmongers by work and seriousness!" {PJ}

March 31: A cold day, very weary at breakfast, drowses in bed, a "long pedantic talk" with Gary Haupt, twelve pages of notes on Paris life using Giovanni's typewriter, walks to "Motte-Picquet for assiette anglaise,[246] white wine & coffee—felt much better, Sassoon's road passed," more white wine and talk in a café with a Fulbrighter, Ted Cohen, and his wife Pearl, "lovely dinner" of lobster, rice, and wine with Gary Haupt at gay "Don Camillo," singing "Blanche Neige, la suite"[247]

Describes Dmitri, a Greek who follows her on her walk, as "all pose."[248] He tells her in French, you have to be even sinister. Leaves a note for Tony Gray at his hotel. "I felt I should let as many people as possible know where I was to compensate for missing Sassoon." A pleasant dinner later on after Tony and his sister call at her hotel. {PJ}

April 1: "no breakfast—accidental fast," "Gary—very bad day—dry croissons," café au lait at Café Deux Magots, "brief visit" to the Musée de Cluny to see the "delicate tapestries & jeweled reliquaries but unicorn being repaired"

2:30: Machine à Ecrire Ravioli lunch and a "colorful play" play at Comédie-Française

"shadow brother & desire for guilt," a "goodbye for good" to Gary Haupt—"rest—shock: nasty sour grapes letter—steak & wine at Boul Mich,"[249] sees *The Third Man*, a "fine film" after waiting in the cold

"resolutions": "Don't drink much . . . Be chaste . . . Be friendly & more subdued . . . Work on inner life—to enrich . . . Don't blab too much . . . Keep troubles to self . . . Bear mean gossip & snubbing & pass beyond it—be nice & positive to all . . . Don't criticize anybody . . . be nice but not too enthusiastic . . . Be stoic when necessary & write—you have seen a lot, felt deeply & your problems are universal enough to be made meaningful—WRITE" {PJ}

April 2: "surrealist waking—knock on door—run downstairs hoping for phone call: smiling Leontine: 'Je a'ai pas frappé'[250]—false alarm," dozes after breakfast on a "lazy morning," lunch at Pam-Pam "amid militant Dutch women," walks in the sun to the "white pillared Musée d'Art Moderne" for a "flaming revelation: Nicolas de Stael—vivid—pattern, color, force & subtle greens," "amazing encounter" with Carl Shakin[251] and Joan, watches a "handsome painter" on a bridge, in tears seeks comfort from Giovanni Perego, "lovely homey in time supper at Epicerie"

April 3: Awakes from a "heavy wine-weighted sleep" to an early breakfast on a "cold windy bright morning," a "moment of elation" on the Rue de la Paiz gazing at the "brilliant shop windows," the Peugeot shoes, no letters, wonders what to do—nothing heard from Gordon Lameyer, Richard not there, "Cologne in Place Vendom like giant green erection, obelisk in Concorde—raping arc de Triomphe," good roast pork and wine dinner at Pam-Pam, reads in the sun near Notre-Dame, "bought glace à trois," returns to her room and meditates, "made to have tragic life—but have comic Face—idea for story in am"

"Dear mother": "I am a bit desolate with all mail in England & no word from you."

April 4: Finishes reading *Turn of the Screw* in bed with her croissants and coffee, encounters Gordon Lameyer at the American Express office, lunch at Pam-Pam and learns that American Express had forwarded to Cambridge all his letters to her, they walk together in the cold rain and then have a steak dinner at Pam-Pam, attend Cocteau's ballet *Phèdre*, talks with Giovanni, "sadness at fate—longing for R [Richard Sassoon]"

April 5: Croissants, "weary" after "warm talk" with Giovanni Perego last night, ham and egg and red wine with Gordon Lameyer at a bistro, spends afternoon typing notes, talks with Perego about "3 fatal choices—sadism," to Notre-Dame and Sainte-Chapelle with Gordon, hamburger and a milkshake, washes hair, packs, "evening of peace, poetry, warmth w. Giovanni"

"Dearest mother": "most brave & desolate without Richard."

"I cannot wait for Richard longer, it has been two weeks, and he must have felt my strong will; London is Ted or too expensive." No longer has much interest in journeying to Germany with Gordon Lameyer. Quotes Verlaine: "Il pleure dans mon cœur / Comme il pleut sur la ville."[252] Gordon, with Sassoon crying in her heart, has become an irritation bringing out in her "a worse kind of self." But she does not know what else to do. She imagines ripping past Shirley and showing Ted her "tender and wise" side. "I lust for him, and in my mind I am ripped to bits by the words he welds and wields." {PJ}

April 6: With Gordon Lameyer departs for Munich: "Last misty view of Sacré Coeur from train—terrible sick sorrow re Richard—temptation to jump—wonderful lunch of beef & veal & cheese," in Munich, a beer and cold meats at Rathskeller served by a friendly waitress, "amazing rapport after all"

April 7: Enjoys the soft bed and hot bath, polishes her shoes, after an elegant breakfast boards the train for Venice, through a snow storm, tunnels, and steep rocky slopes "quaint Dolomites on Austro-Hungarian border," through the Berner Pass and "pink & purple snow peaks in sunset," a veal cutlet in Verona, Chianti on the train, sleepy and cold arriving in "starry Venice," on the Grand Canal in a waterbus sees the reflections of the bridges, St. Mark's, and a clock tower

April 8: The bells of St. Mark's wake her up, after coffee and buns walks in the square watching the fluttering pigeons, the "gilded mosaic" in St. Mark's, the marble floor mosaics, climbs the clock tower, walks in the squares and over bridges, a lunch at Colombia, a gondola ride, a bright walk and a "lovely veal & wine & pineapple" dinner

April 9: Departs from chilly Venice, through Bologna to Rome, arriving in the blazing sun at a modern train station, takes a trolley around the fountains, meets Jane Baltzell on the Spanish steps in the sun, meets Don Cheney[253] in the "cold marble halls" of Hotel Sestina, a gourmet dinner at Ile de Amici: croutons, a "rich fish soup," veal, mushroom, and wine

Ted to Sylvia: "Sylvia": Expects to see her Friday [April 13] at 8:00 p.m., writes a poem that ends: "Wherever you haunt the earth, you are shape and bright / as the true ghost of my loss." {THL}

April 10: In Rome, awakes and meditates until 10:00 about her future in the early bright flood of sunlight, breakfast of "bitter good coffee" in a silver urn with bread and orange jam, on the Spanish steps in the sun and the dolphin fountain, fresh flower stands, the Keats and Shelley memorial, a "moving walk" to Place Venezia, eats a bag of fruit in the forum in the sun, gazing at the "broken white grandeur on bright green of the Palatine hill, the palms and grottos," climbs the Colosseum, eating oranges and bananas in the sun "while speculating on Christians & wild beasts"

7:30: Steak, wine, and cheesecake with Gordon, Jim, and Don Cheney at "red plush & marble tabled Caffe Greco"

Sophian publishes "Prologue to Spring" and "Second Winter"

Still conflicted about what to do with Ted Hughes, and distraught at Richard Sassoon's absence, Plath, who had not been looking forward to traveling with Gordon Lameyer, no longer finds his company tolerable, and after much tension between them, she is happy to see him depart. The mention of "dull Jim" reflects how much Plath misses Sassoon's sophistication.

April 11: Sleeps poorly, nightmares and in pain, treats herself with codeine, naps until noon, out with Gordon to see an art exhibition: "Nostalgia of Infinite," talk with Jane's friend regarding Ischia and writing

7:30: With Gordon "barbs—too much wine for lunch," visits Navona and Bernini fountains of the four rivers, brandy and dinner at Don Cheney's

April 12, 9:00: Breakfast with Don and "dull Jim" for a "good caffe latte & buttery croissons"

What she sees: Raphael's *Galatea*, Sistine Chapel ("dynamic Last Judgment—powerful Christ & dark demons & damned—St, Bartholomew & sin etc."), a "Michelangelo head," Vatican museum, Laocoon "grotesques," St. Peter's fountain and "huge oppressive enormity of St. Peter's," a "devastating encounter" with Gordon, "Joy at leaving Rome & Gordon," lunch at Blue Grotto

April 13: What she sees: Michelangelo's *Pieta*, "Bellini's last," walks along Tiber with Don Cheney: chicken sandwiches & coffee at Caffe Greco, Gordon Lameyer takes her to the airport {PA}

1:10: Plane from Rome to London

4:35: Arrives in London to white clouds and rain, meets a "delightful S. African," Michael Butcher, on the bus for a great talk and steak and wine supper at Shepherds, exhilarated in a taxi on her to way to Ted Hughes, fortified with a brandy and carrying her bags

April 14: "Bloody exhausting night of love-making" and "terrible dreams," longing for "magnificence of Ted—lovely horizontal talk," sad on the train back to Cambridge, arriving late and crying when she reads Sassoon's letters {HC}

April 15: "Best day in World" with breakfast of eggs and feeling triumphant in a daffodil garden with "big hulking Ted" walking to Grantchester meadows enjoying the greenery and sun, lunch at Luke's: wine, roe, steak, carrots, soup, and Italian brandy she brings with her, afternoon of "good violent love," reads poems, "Isis in search—power of horoscope," a meal at the Anchor, "dawn of tenderness. Miracle"

April 16: A "wakeful tense night like taut wire," hears the morning bird song and the "blue light & hot milk—up shakily for coffee," writes six-page

article about Paris for *Varsity*, goes to its office and enjoys the "nice guys" in a "subdued & modulated" way, tea and sandwiches with Ted, they walk happily among the daffodils, shopping, listening to Beethoven, eating a trout & peas supper, "plunging depression serious talk—read Hopkins & orange juice"

"Ted: you have accepted his being: you were desperate for this and you know what you must pay: utter vigilance in Cambridge." He has replaced the "void" in her guts about Richard. Suspects that Ted "has no love for you" but considers herself "lucky to have been stabbed by him. "Let him go. Have the guts." She would cook, play, and read for him but work for "Krook, Varsity & home." She is in the "temporary sun of his ruthless force." {PJ}

April 17: Sends poems off to *Atlantic Monthly*, *Harper's*, and *Poetry*, "still tired and spent," calls this a "bad learning day," Ted is late and she feels as if he's slept with "5 girls since I last saw him," shops, for supper: "pilau & mango chutney at Taj—brothel talk—cold Grey night by starlit river—revelation of his lack of care—revulsion sad walk by self in cold"

"Dearest of mothers": Writes in sorrow about the loss of her grandmother and how she feels "so cut off" and concerned for Aurelia, wants her mother to come and will arrange everything for her visit. "The most shattering thing is that in the last two months I have fallen terribly in love, which can only lead to great hurt: I met the strongest man in the world, ex-Cambridge, brilliant poet whose work I loved before I met him, a large hulking healthy Adam, half French, half Irish, with a voice like the thunder of God; a singer, story-teller, lion and world-wanderer & vagabond who will never stop."

To Edward Weeks at *Atlantic Monthly*: Submits a batch of poems "writing from a gabled attic near the Backs of the River Cam."

To Karl Shapiro, editor of *Poetry*: Submits poems and mentions her previous publications in several magazines and journals.

April 18: "incredible feel of own faith & integrity that will come through—Ted cannot ever annihilate me—I can see his flaws—egoism, bombast & lack of care for others are worst," begins "Mad Queen's Song" feels "good joy in word power growing," shops, Ted bangs and breaks a bottle creating chaos "like naughty irrepressible boy," "contest of wills" between them

To Richard Sassoon: "now the forces are gathering against me"—her grandmother dying slowly like her father did, and in the interval since he brutally broke off their relationship "something very terrifying" has happened to her. {PJ}

April 19: "good day," see Dr. Bevan about torn ligaments, finishes "Mad Queen's Song," "fine lunch" of kidneys, steak, eggs, cheese and wine" with

Ted, bus to Cherryhinton, a trek though green oats, observing "skipping hares, flint, forest & love under coo pigeons," Prawn pilau and mango and fine talk at the Taj Mahal regarding horoscopes, "Elated buoyant stroll through starlit Grantchester, cows and blue wash of moonlight"

"Dearest mother": Thinking of grammy and sending love across the seas, extolls Ted whose voice is "rarer than Dylan Thomas booming through walls and doors." This "violent Adam" tells her about horoscopes, farming, hunting, fishing in all "health and hugeness. . . . I am strong enough and can make him grow . . . In this sick small insular inbred land."

April 20: A "wonderful day" walking through fen and farmland, begins poem "Under crunch of my man's boot," receives a "fantastic invitation" to London to meet Bulganin[254] and Khrushchev, sherry with Ted in the garden, home cooked steak, coffee with Chris Levenson

9:30: Visits *Varsity* office, complimented on her article about travel in France

"river & moon & love & joy"

April 21: Completes "Ode for Ted," finishes "Poem for Pan 'under crunch of my man's boot'" and feels it is her "best yet." Elated, plays piano in the sun, mails four poems to the *New Yorker*, feels let down after Ted leaves Cambridge for work in London, "'Firesong' . . . tremendous creative surge"

"Dearest of mothers": Encloses two poems extolling Ted as a nature god and her feature article and two sketches for *Varsity*: "I feel like Marguerite Higgins, only better!"[255] She has been assigned to cover Bulganin's and Khrushchev's reception at Claridge Hotel.

Varsity publishes "An American in Paris"

April 22: A "pleasant breakfast" with Isabel[256] and Jean,[257] "lovely mirth," finishes "Firesong"

"Slightly tense," writes to Ted, Emmet, Michael[258]

2:15: Meeting at *Varsity* and wanders about with Michael Frayn[259]

Begins *Gorgias*,[260] "balanced plans for summer & thought of Bulganin & Ted"

As Plath's commitment to Hughes strengthened, she began to enclose him in the family circle that meant so much to her, and that she hoped he would participate in with her.

April 23: "surge of noble love and giving," finishes *Gorgias*, reads the *Symposium*, sunbathes on Evelyn's[261] roof—sees Barry,[262] "all golden & luminous in sun—feeling of Eden," remains tense, hard to concentrate thinking about mother's coming visit, a trip to Spain next year, her "astounding" love for Ted, "inner dialogues—whole future gathering—accelerating—taut balance"

"Dearest mother": Arranging plans for her mother's arrival: "Think of your trip here as a trip to the heart of strength in your daughter who loves you more dearly than words can say."

To Warren: "in face of blackness and cruelty and unreason, Chaucer's world sprouts green in everlasting cycles of birth leaps like the corn-god out of the husks of death." Feels she is writing her best poetry. She is in love with the "only man in the world who is my match." Wants him to convince their mother that the trip to England is something she deserves and is the "right thing." She loves him beyond words and hopes he will be able to visit her, plans to publish her first book and to continue her sketching.

April 24: Bathes and shaves

10:30: Krook lecture, "sparkling talk on Gorgias"

Happily shops and dresses

2:30: To London, for "hammer & sickle tea" at Lyon's, vodka and black caviar at reception for the Russians, with Eden[263] and Attlee[264] present, talks with the mayor of Northampton, Walthamstow, meets "Lovely Nigerians," Russian officers over cold chicken and "much vodka—growing joy," shakes hands with a "kind, smiling" Bulganin, then off in a taxi to see Ted and to bed "strangeness still—Ted in black far gone 'bloody mind'"

April 25: "joyous day" in London with Ted, "drunk in bed . . . frenzy of love" talk about going to Spain, "lazy brunch . . . back to bed, still in dreams from hell," returns to Cambridge sleepy on train with "Gawain & green knight"

April 26: "lazy breakfast—Mother's birthday" on a "cold gray day"

11:00: Krook lecture on *Gorgias*

1:00: Lunch with Ted

2:00–4:00: Plays piano, reads poems, "warm love"

4:00: Tea with Derrick Moore

"Circus: 3 girls on silver balls boxing chimps dark ring, red stakes—elephants"

8:00: Prawn pilau—"Africa & great Terrible sorrow at utter callousness"

"Dearest mother": "If anyone asked me what time of my life was most invaluable, I would say those 6 terrible months at McLean: for by re-forging my soul, I am a woman now the like of which I could never have dreamed of." Describes the reception for the Russians and meeting Bulganin and her introduction to Soviet Ambassador Malik. Her supervisor Dorothea Krook reminds her of RB.

April 27: Warren's birthday

9:00–1:00: "strangely sick at heart & stomach—pampered self at home in slacks & blue jersey"

Writes "The Glutton," a "good, small, hard, caked poem"

2:00–7:00: Peels shrimp all afternoon with Ted, a "lovely time" cooking shrimp Newberg, fresh trout, sherry, visit from Bob Byerly[265] and Michael France[266]

8:00: "fierce goodby to Ted"

April 28, 9:00: "good comradely breakfast"

10:00: Krook lecture, writes letters, interviews Margaret Roberts[267] for *Varsity*

11:00–1:00: Writes two-page article

Meets Michael Butcher[268] for "sherry & two fatal merry downs at Mill," "pang at vision of dear Ted"

8:00: "delectable lamb chops & comraderie at Miller's & wine—disastrous detach at Alexandra House—dozes of kisses & Keith—proctors & home to drop like rock"

April 29: Sylvia's grandmother dies {EB}

"tumultuous 30 hour day—woke 6–clear & sad at 6 to write 'Strumpet Song'"

2:15: A "warm meeting" at Varsity with Campbell Page,[269] a visit from Keith Middlemass

4:30: Waits an hour for Ben Nash[270] "fine guy—comfort re nasty letter from TED"

6:00: Meets Chris Levenson "Gargantuan poems—Kebab at Gardenia—miraculous switch & promise of life together—tender"

"Dearest most wonderful of mothers": Encloses her *Varsity* article about Paris, describes reception for Khrushchev and Bulganin. "Ted reads in his strong voice, is my best critic, as I am his." She reports a similar dialectic with Dorothea Krook and that "my voice is taking shape, coming strong; Ted says he never read poems by a woman like mine: they are strong and full and rich, not quailing and whining like Teasdale, or simple lyrics like Millay: they are working sweating heaving poems."

April 30, 9:00–10:00: "difficult tense day—dozens of swords bristling overhead"

10:00: Krook lecture, writes to Fulbright commission

11:00–1:00: Writes eight-page article about Smith

Bikes to *Varsity* office, tea with "queer Walter Elthis"[271]

6:45: "Proctor—Clare—tears & daffodils"

7:00: With Ted at the Anchor

"to Alexandra: painted playroom—relaxing, fire, love—talk re Spain"

8:00: "new faith—steak & sweetly home"

May 1, 6:00: Writes paper

9:00–10:00: Weary

10:00: "triumph of discussion" with Krook about her paper "good rapport"

12:00: At the Anchor for sandwiches and red wine with Ted

2:00–7:00: Punting with Ted up the river to Grantchester, observing a woodpecker, a baby owl, tea in an orchard: honey, cake and sandwiches, "learned to punt back" observing cows in rain squall

8:00: Return with Ted to Alexandra and in a lavender, black, and white striped room, with "fine relaxed tenderness & love—pilau at Taj"

Plath often mentions, and sometimes even brags, about fighting with Hughes. Exactly what this means is not clear. More than just arguments? Sometimes she reports that they came to blows. She seems to have equated this fighting with both an assertion of self and a kind of contest that made the combatants worthy of themselves and their relationship. She seemed to think such fights the only way to work through what they meant to one another.

May 2, 9:00–10:00: "Rough tough fighting yet good day"

Varsity meeting hostile rejection of her long article about Smith, returns to her room to rewrite

2:00–7:00: Shops for fruit in hot sun: "dear TED—tense tea w. Derrick [Moore]"

Liver, mushrooms, and wine with Ben Nash in "lovely Kings room"[272]

8:00: Rushes to "my ted—thorny crying time of fight to ultimate victory for day"

May 3: "lovely gray day—hot bath—TED," a walk through Newnham gardens to *Varsity* office, enjoys the "silent exquisite cool" of St. Edward's church, shops for steak, mushrooms, and wine, lunch at Anchor, "Novel project: Am. Girl in Cambridge series of short stories," writes Bulganin article for CSM while Ted reads *Catcher in the Rye*, after steak, mushrooms, and wine "miraculous Love, Spain plans"

"Dearest of mothers": "I have passed through the husk, the mask of cruelty, ruthlessness, callousness, in Ted and come into the essence and truth of his best right being: he is the tenderest, kindest, most faithful man I have ever known in my life."

May 4, 9:00–1:00: Meets with Miss Morris

With Ted at Mill bridge "loaded with fairy stories & legends"

2:00–7:00: Sausages and sandwiches at the the Mill

A bus to "green end—hitch to Stratford—love amid cows, daisies & stinging nettles," they hitchhike back to town

8:00: Kebabs at Gardenia " 'Summer Manoevers': & sad, sick identification"

"Dearest mother": After tensely waiting "long distance," she receives the news of her grandmother's death with a "sense of rest and peace at last." With Ted she has "consecrated" the day to Grammy, wants her brother to meet Ted, a man worthy of Warren, hopes to write a novel, sold separately as stories about an American girl in Cambridge, finds she is better able to work with Ted in the room. "I can tell you, if you will sit tight on it, that

within a year, after I graduate, I can think of nothing I'd rather do than be
married to Ted."

May 5, 9:00–10:00 Writes long letter to RB

10:00: "derivative poem 'Bucolics'"

11:00–1:00: With Ted and Iko Meshoulem talking about vacation

A "lovely punt ride" up the Cam with Betty and Duane Aldrich visit-
ing from Wellesley

2:00–7:00: Tea in Orchard at Grantchester, "proud & happy with Ted"

8:00: "warm time together at Whitstead"

At the Red Lion Hotel over a "divine melon, roast duck, Chablis &
cognac," she has the "guts to face Ted in honest brave statement of concern
for next year"

*It was characteristic of Plath to plan ahead and of Hughes to dally. A Cam-
bridge graduate, he had yet to settle on employment or a way of life. He had
no ambition, so far as can be discerned, to see himself seriously published as
a poet. He had no commitment to living in England and was considering
emigrating to Australia to join his older brother Gerald. So it would have
been entirely Plath's responsibility, as she saw it, to shape him up and suggest
a course of action for them as a couple and as poets. As she devoted herself
to Hughes, other friends—such as Nat LaMar—sensed her withdrawal from
them and may have resented Ted's advent as much as Hughes's friends resented
her. Hughes had purposefully delayed any life-changing decisions and seemed
adrift, and seems to have welcomed Plath's proactive personality, which pro-
vided a structure and sense of destiny. But even as Plath diminished her at-
tention to others, Hughes continued to consort with his companions, perhaps
as a way to remain his own man and to indulge his craving for the good
fellowship and admiration of his friends, even though Plath would come to
see their adulation as part of the hermetic seal of his circle, which she had
broken and which they would seek to repair by their cosseting of him and
disapproval of her.*[273]

May 6, 9:00–10:00: A "nice if tense & last breakfast of melon, ham,
honeycomb" with Nat La Mar, Keith Middlemass, back to Ted "sun in
yard—quick port, rice, wine"

10:30: "Hot sun—green eden day"

2:15: Good meeting at the *Varsity* office with Barry, Tim, Duncan Slater

Rushes back to meet Ted, drinks wine discussing the future, Spain,
"life together—vision of this face of Ted: my one man," sausage, cheese,
and coffee at the Anchor "cool heavenly eve of easy talk"

"Dearest mother": Describes an idyllic day with the Aldriches and
"how touching Ted was. . . . Ted says himself that I have saved him from
being ruthless, cynical, cruel and a warped hermit because he never thought

there could be a girl like me and I feel that I too have new power by pouring all my love and care in one direction to someone strong enough to take me in my fullest joy."

May 7: "worked like a stoic all day"

9:00–1:00: Reading Plato's *Republic*, "whooshing" about a Wellesley wedding

2:00–7:00: A "cool, bloody day"

8:00: "tortured self till 3 a.m. writing about 17 pages in coma on justice & callicles"[274]

May 8, 9:45: Meets with Dorothea Krook about two papers, "exhausted after late typing—yet wonderful supervision," they talk about the Trinity

1:00: Lunch with Ted at the Anchor "holy ghost," wine and sandwiches, Arthur Rackham drawings, "fine afternoon passing from flash of resentment at Ted's drunkenness last night & blonde one to afternoon of excellent love & talk & plans re spain"

Supper of "lovely" kebab and cheese and rice at Gardenia "sweet dear Ted: god I love him"

By sometime in May, Plath seems to have committed herself to marrying Ted Hughes, a decision that came shortly after expressing her qualms about him. She seemed keen to settle the differences between them in marriage, which he appeared to want as well.

May 9: "blowy gray rainy day"

9:00: To the laundromat, shopping for fruit, meat, and other provisions, ironing shirts, preparing a tomato and cucumber salad lunch with "dear Ted," "lovely talk" in the rain about DeQuincey and Howard Nemerov," writes article about Isis on "male/female situation," steak, mushroom, and strawberry dinner, "scolding from witch Abbot"[275]

"Dear mother": Extols her sessions with Dorothea Krook, sharing personal as well as intellectual experiences: "Had the most moving discussion of the idea of the Trinity with her, a revelation to me of the blind stupid ignorance I had in not even 'listening' to such conceptions." Dreams of bringing Ted back to Wellesley for a barbecue party before they begin their "world-wandering," expects to begin writing a novel when they head to Spain.

May 10: "Rehabilitation day: exeat[276] from Miss Morris," "confidence with Mrs. Milne,"[277] "magnificent" two hours with Mary Ellen Chase at the Garden House Hotel about possibly teaching at Smith, Sylvia's work at Newnham, and writing for the *New Yorker*, tea and sandwiches at the Copper Kettle with Ted, "afternoon of best love yet: created wedding plans great joy & planning"

8:00: A kebab supper at Gardenia

"Dearest mother": Describes her "I-thou" feeling with Ted.[278] His talk of fairy tales takes her back to childhood.[279] He is agreeable to visiting the US with her next June.

May 11: A happy, hot morning, gets play tickets, bathes and dresses for trip to Fulbright reception in London, "met dear Ted—ride w. funny stimulating Jonathan Miller,[280]

Makes love at Rugby Street flat, cleans greasy kitchen

5:30–7:30: Fulbright reception, a "nightmare rush," drinks several sherries, speaks with Duke of Edinburgh, "blackout—sick drunk—Ted's care & solace through bad night"

May 12: Recovers from hangover, a "good morning of talk & love," lunch with Lucas and Valerie,[281] talk of Buddhism, reads Ted's poems, draws witches, wine, bread, and butter, a rush to get play tickets, a "sleepy train ride" back to Cambridge through "incredibly green country," milk and crackers at Whitstead, kebab dinner at Gardenia, "Sliver of new moon & Venus" on Garret Hostel Bridge, in the orange street light a tree appears in "beaten gold—strange codeine weariness"

Varsity publishes "Smith College in Retrospect"

May 13: Up early with a wonderful sense of well-being in the sun, a "radiant day," "fine talk" with Jean Pollard, begins *Open Society*,[282] "good Sunday dinner"

2:15: A pleasant short *Varsity* meeting

Sunbathes in bathing suit, "lovely time" with Ted at tea, reads over "Sunday at the Minton's" "great cathartic talk" about her mother, steak at New Bengal, runs home, a new moon

May 14: Shops for drugs, soap, other practical things, finishes reading *Open Society* and rereads *The Republic*, stays up to 4:00 writing a paper on three objections to Plato's conception of the state until she hears birds chirping, "tense, tire—electric wires in blood" watching the "green milky dawn," then falling "dead asleep"

"Some Preliminary Notes on Plato and Popper: Concerning The Republic," typescript {PM}

May 15: Awakes taut and ready for supervision with Krook, reading paper and arguing, sunbathes and writes Elly Friedman,[283] meets Ted at the Anchor for a "nice roast beef lunch," lies in the afternoon sun on the banks of the Cam reading Ted's poetry, "quick pork dinner with strawberries & ice cream," In "hysterics" over the mirror scene in a Marx Brothers film,[284] "God-like 'Shane' w. Alan Ladd," floats home after eating cheese and biscuits "fine day"

May 16: Tired, takes hot bath, shops, meets "dear Ted" for tea, after supper makes love at Whitstead, "sunny wonderful tea" with Mary Ellen Chase, Miss Duckett, Jane Baltzell, and Isabel Murray, steak and mushroom dinner at Alexandra House with Ted "tired & problematic"

Isis publishes "Cambridge Letter"

May 17: Tired and quiet but a "lovely day" with a "good letter" from mother, begins poem, "Wreath for a bridal," "fine lunch" at Newnham, "sleepy afternoon" with Ted, "talked out women & engagement & came to new feeling," eats "honey and sweets, spaghetti, alley walk with quaint back-yards & perspectives—stars & moon & leaves & utter opening of sense & love to still world"

May 18: Tired, works on "Wreath for a bridal," article in *Isis* published verbatim, "good," happy day with Ted in the cold and rain, to library, "two great hours of love" at Shiela's,[285] "cooked herring, pear, rice, straw-berries & ice cream—sleep & drowsy dear love rainy night-lie deeper & more rich"

"Dearest mother": Sending out Ted's poems to American magazines, requests three-cent stamps from her mother, describes meeting Duke of Edinburgh at Fulbright reception. Ted says he is chaperoning Sylvia and the Duke replies, "the idle rich." They plan to marry in Wellesley in June, already planning for seven children.

"Smith College in Retrospect," *Varsity* {PM}

May 19: An "active day" doing laundry, banking, working on articles for *Varsity*, dashing to Garden House Hotel for "divine lunch" of cold meats and Chablis with Mary Ellen Chase, "home to mourn Ted," then "with Ted to Vogue shop & Robert Sayle for bathing suit try on,"[286] a "lovely" supper of fish soup and "fireside rest"

May 20: Cleans room, "to fens w. cows to sketch Ted," lunch at Arts Theater, "nice" *Varsity* meeting about her article on fashion, runs home to "dear Ted" and a "lovely afternoon of love," reads German poetry with peanut butter crackers and milk, kebab supper at Gardenia on a "languid green night," bikes home

May 21: Spends a sunny day typing Ted's poems, writes letters to the Saxton fund, Jane Anderson, RB,[287] lunch at Newnham, "bad lambchop" dinner at King's Wood, sad after Ted leaves, envies "stupid, married people in snug homes"

May 22: Mails Ted's poems, bathing suit shots at Robert Sayle's shop in Cambridge, "trauma at Josh Taylor's re missed appointment—Vogue battle—formal in garden—back to Josh Taylor—tears & final capitula-tion,"[288] a steak supper, "quiet love—strawberries & icecream—ironed shirts—weary, sad, Plato"

Ted to Olwyn Hughes: Ted's life is "peaking" in the company of a "first rate American poetess" he wants his sister to meet. She believes in his work and knows the top American journals to which she is sending his work. {CR1}

May 23: Awakes to a misty green morning

10:00: Cancels meeting with Dorothea Krook because of sore throat

Reads *Phaedo* in the "hot sun under lilacs by poppies," sandwich lunch with Ted, feverish nap while Ted reads, kidney, rice, bean supper, "relaxed in balance of fever," hot bath before bed

May 24: Writes "Two sisters of Persephone"—"best poem yet," sunbathes until lunch, washes hair, "Ted & wrong Love & hard talk—another step front—criticism of selves—sense of growing through hardness & hurt," Chilean brandy and a "delectable port with carrots, salad, strawberries and ice cream," "fond goodbye after another conquering"

May 25: "excellent supervision w. Dr. Krook" discussing Plato's "vision & flaws," nature of poetry and philosophy, meets Ted at the Anchor for a "fine spaghetti dinner" and an afternoon of "dear love" accompanied by Beethoven, at a *Varsity* gathering: sweetbreads, mushrooms, and burgundy and cognac, full moon on the way home

May 26: Fights though a "good day" in spite of "wet twitchy cold," fine supervision with Dorothea Krook, meets Ted at the Anchor for a roast beef lunch, shops, at Whitstead "good love & Beethoven, at Alexandra House fish, soup, asparagus, and potato supper, "cake & tender time—Venus in clear blue green sky"

"Dearest mother": Encloses her *Varsity* article appearing as a "cover-girl!" Explains the mixup about taking pictures at Joshua Taylor's when she is told she had the dates for the photo shoot wrong and it has been cancelled, but the store director relents after she shows her article, "the best free advertising. . . . I am really getting to be a determined newspaper woman." Describes her enraptured times with Ted, writing and reading and sending out his poems. "He has just never bothered to try to publish (outside the Cambridge magazines)."

Varsity publishes "Sylvia Plath Tours the Stores and Forecasts May Week Fashions"

May 27: Sunbathes in the morning to "bake" the cold out of her head, writes to Mrs. Prouty[289] and Patsy O'Neill

2:15: An "uneventful" *Varsity* meeting

3:00: Meets Peter Durlacher[290] for a "good little talk"

With Ted, sketching in the sun at "garden allotments—grass & chicken coop—unpleasant encounter with Iko—kebab and tearful talk re public opinion"

To Patricia O'Neil: A full report on life in Cambridge expressing the hope that Patricia can attend the wedding she has planned for Wellesley in June 1957.

May 28: Reads papers at the *Varsity* office, restores herself in the sun after a night of "terrible dreams," shops on a hot day for dinner, lunch at Whitstead with Jane Baltzell and Isabel Murray, talk with Ted in the sun,

"fine afternoon of love" in Alexandra House, "delicious leisurely steak dinner" with mushrooms, melon, and ice cream

"Dearest mother": Happy to hear that the Aldriches have given Aurelia a good report about Ted, discusses a list of bridesmaids and people to invite to the wedding, goes over the itinerary of her mother's visit and says: "We both can't wait to see you when you come!"

May 29: A "rainy blowy day," meets Ted at Pembroke college, coffee at Copper Kettle, a morning at Taylor's picking out a wool suit for Ted, a long walk to shops for food, "much fun" and a hot pilau lunch at Taj Mahal, an "afternoon of love" at Whitstead, tuna fish salad supper with fried potatoes as it rains outside

May 30: Spends the morning "perversely caught in throes of nightmare poem, 'Aerialist,'" "afternoon of love with Ted & desperate putting off of work," supper: steak, wine, cheese, crackers, strawberries, and ice cream, stays up until 1:00 reading Aristotle, "visions of keen love for Ted"

May 31: Wakes up exhausted, finishes reading Aristotle, writes paper

10:00: "good supervision" with Dr. Krook

Cleans room, "Ted and 'Waiting for Godot'—flatter than London," drinks wine with Lucas Myers at Alexandra House, "jealous wrath among cows & buttercups," "make up—love & soup & sandwich supper"

Summer: *Delta* publishes "Winter Words," *Chequer* publishes "Prologue to Spring"

June 1: Writes poem in the morning, "This dream budded bright," "Dream with Clam-diggers," "brief hot afternoon at Shiela's, got pork, peas, wine for supper," "lovely twilight walk by river to willowed island—warm rapport"

June 2: Writes "Ella Mason & Her Eleven Cats" all morning, dashes to a good lunch and sultry walk with Ted to art exhibit in All Saints Passage, "Leaves of willow & Clare gardens after shopping," "tough unrapport fought through steak & mushroom supper merrydown[291] at Jane's party—great love on park bench"

June 3: Writes twenty-four lines of "Gerd the Gypsy—crystal gazer" all morning, dashes to lunch and a "placid pleasant" *Varsity* meeting "messing around with ideas—of evergreen death & decay of all else,"[292] soup & cheese supper, "good lovemaking," "peace and calm & love w. Ted"

Plath's meeting with Jane Anderson, according to Anderson, include Plath's admission that she knew Ted was a "very sadistic man," but that she could manage him. But Anderson detected a "pressured" Plath and implied she was acting hastily.[293]

June 4: An "unpleasant" talk with Miss Burton on a "strange sour day: blowy with rain," hectic shopping, short visit with Jane Anderson, nasty

letter from Gary Haupt, "Ambiguous ominous interview" with Mary Ellen Chase about *Varsity* "& peering on backs," great steak and wine lunch with "dear Ted," tea at Madingley Manor House with Crystals, "lovely eve w. peaceful Ted"

June 5: "strange quirked rushed day"

 9:00: Meets Ted at Catholic church

 Does the laundry and over tea reads Ted's "good vampire poem," finishes rewriting "Crystal Gazer," "ambitious" Mrs. Zeeman,[294] afternoon of reading and typing with Ted, reads Dostoevsky story "re Akulka," "nightmare of 3 interruptions at Alexandra, yet good love," port with Mary Ellen Chase and an "eerie quiz," "moon phobia," chicken omelet at Taj Mahal

June 6: Enjoys a happy morning with letters from mother and Patsy O'Neill, writes to Warren,[295] begins work on Aristotle but turns again to her poem "Crystal Gazer," writes until Ted comes for good pork and potato supper with wine, gives up Michael Frayn's party and rows into "black bitter quarrel re bad hurt & treatment," writes Aristotle paper until cock crow at 4:00

June 7: Writes "Tinker Jack Traffics with Tidy Wives" on a rainy day, two-hour session with Dr. Krook about Aristotle, hot bath, Ted arrives with red roses for a "sleepy afternoon of love," "Fine kebab & Footlights Revue"

June 8: "gusty rainy day" spent writing "The Village Idiot Who Watched the Weather," "lovely rainy afternoon with Ted," Chris Levenson drops in for tea, supper of haddock, potatoes, and peas, reads Chaucer

The plan had been to marry in Wellesley but the couple decided they could not wait another year and that they would have to conceal their marriage for fear that Plath would lose her Fulbright. Ted did not even inform his parents of the impending wedding, and Aurelia only learned of the decision after she arrived in England.

June 13: Meets her mother at "Seven Seas," lunch at Clifford Inn in London, talk and supper at Schmidt's with Ted "decision to get married—Thomas & Moon—brandy toast"

June 14: A big breakfast with Ted and mother, to St. Paul's "red coated Grenadiers," in the rain, mother ill on trip to the Tower

 8:00: To The Criterion to see *Waltz of Toreadors*[296]

June 15: Breakfast with mother, morning walk to American Express office, gets plane tickets, lunch with Ted at Clifford's,[297] to Westminster Sanctuary, "red tape re marriage License," trek with Ted to see Reverend Wilson by Dickens house

 7:30: Attends an excellent performance by Sybil Thorndike in T. S. Eliot's *Family Reunion*

 A walk with Ted to Green Park by the Thames

June 16: Sylvia and Ted purchase two gold wedding rings {PA}

1:30: "MARRIED TED HUGHES LONDON"

The marriage performed at St. George the Martyr in Queens Square in the rain, wears a pink dress and a pink rose, "mother off—grubby Rugby Street," Aurelia returns to stay at Garden House Hotel in Cambridge {PA}

From Aurelia: "To my complete surprise, three days after landing at Southampton on June 13, 1956, I found myself the sole family attendant at Sylvia's and Ted's secret wedding in the Church of St. George the Martyr, London." {LH}

June 18: To Elinor Friedman: Welcomes her to England. Perpetuates the fiction that she will be married to Ted next June. Ted leaves for Yorkshire to store some of his personal belongings. {PA}

To Warren: Announces her marriage but swears him to secrecy, saying there will be another wedding in Wellesley next June and a huge "folk festival" kind of reception.

June 21: Sylvia, Ted, and Aurelia board the train for London {PA}

June 22: Sylvia, Ted, and Aurelia fly to Paris[298] {PA}

June 24: "woke early after cataclysmic day yesterday[299]—felt drugged & slow," meets mother, "much happier slightly drunk for puppet show," describes "jewel colored" Sainte-Chapelle, a "thunderous" organ and a flag procession at Notre-Dame, bad supper in a bad restaurant, home to bed, washes her hair after "wearing soporific day"

June 25: Sleeps until noon after "colossal" breakfast of croissants, butter, jam, coffee, and chocolate, steak tartare and chicken for lunch, to American Express office, a citron and orange pressé, sleeps and feels rested, writes "bad poem 'Spiteful Crone' ghostly night—'O'Kelly's Angel'"[300]

June 26: Sleeps until noon, hot chocolate and croissants for breakfast, "magnificent blue & sunny day," gourmet dinner at "dark cool" Franco oriented on Rue Mazarin: hot borsch, escallope de veau with mushrooms and sour cream, "ambrosial strawberry tart," visits American consulate, writes "Miss Drake Proceeds to Supper" in the sun by the Seine {PJ, PKS}, draws her shoes {PJ, PKS}, milk, cheese, bread, and fruit supper at home

c. June 26: Draws kiosk {PJ, PKS}

June 27: Up late, after croissants and chocolate ambles over to American Express—no mail, "weary," an orange pressé at "sunny café de la Paix," watches "ugly, queer people go by," tiring search for a restaurant, "chic kebab & wine at Serail," home after an exhausting day

Postcard to Elinor Friedman: hoping for a reunion dinner.

June 28: Meets mother for cold roast beef sandwiches on Rue de Rivoli, takes snapshots in Tuileries, the metro to Montmartre and Sacré Coeur,

purchases pottery in little shop, "supper & too much red wine with Luke—drunken singing on banks of Seine"

June 29: Gets up quickly to "see mother off," after chocolate and crossaints, trip to American Express office with Ted and mother, finds a rejection from *Ladies Home Journal,* coffee at a café, "good lunch" with white wine and cold port at Pam-Pam, writes and reads *McCall's* in Tuileries, "depressing" borscht and veal supper with Luke at "bitter Franco Oriental"

June 30: "stormy" morning with Jeff[301] and Luke barging in, "reconciliation till afternoon," lunch of chicken and steak with Luke at a cheap restaurant, sunbathes on the Seine, feeling dizzy, and then returns home with a load of fresh cold cherries and peaches from Buci Markets, rushes to Theatre Champs-Elysées for "execrable" Jean Babilée ballet[302]

July 1: Sleeps late, "alternating love, Luke, cherries, hot chocolate"

3:00: Out to a "little cheap restaurant" for chateaubriand, red wine, port, and yogurt, to a patisserie and shopping near a "rainy gray green Seine," finishes reading *Two Gentlemen of Verona,* in bed, "love, exhausted," sleeps, washes hair, a ham sandwich, "ted cut hair, pleasant day"

July 2: "Absolutely wicked, futile day," letter from Olwyn postponing money,[303] rejection letter, letter from Sassoon, no tickets at American Express office, finds Spanish Embassy is closed after "exhausting walk," Galerie Lafayette[304] closed, "peacock & white parrots, cheeseburger and mozambo,"[305] walk to Orestes, "sick w. d. sad day"

July 3: A hot business morning, starting with coffee and croissants, to the Metro in the "cool gray air," at Spanish Embassy "postponed visa," at American Express cancels old tickets, hectic introduction to shopping at Galerie Lafayette, "black trunks for Ted white sandals for me—marvelous," "triple chateaubriad & haricot verts dinner at R. Jean—strange nice Amer. Rest . . . Supper: 'Shrike,'" "her shrike-face / pecked open those locked lids . . . The last re-berried blood dropped / from his trapped heart." {PJ, PKS}

July 4: Sends Ted's poems to *Virginia Quarterly Review,* hers to *Yale Review* and *Partisan Review,* croissants and coffee in bed, types letters to Mrs. Prouty,[306] mother, Ted on errands, good wine and steak dinner at Chez Jean, packs for trip to Spain

July 5, 9:00: Tired after a trip to the Spanish Embassy, "lay about—love—tender Chateaubriand at Chez Jean," changes money, "missed Olwyn," buys wine, milk, bread, cheese, fruit, etc. for the train, a beer at the Austerlitz station

9:15: Train to Spain with "chattering French" makes it a "torturous trip"

July 6: A wet gray dawn traveling in "marvelous" train car with Spanish soldiers drinking from a leather wine flask, sharing food, watching the

"blazing yellow fields" and the "sheep, bulls, goats, donkeys, storks, rocks, pines, white mesas—Escoria"

6:00 p.m.: Arrival in Madrid {PA}

c. July 6: "Parcae": various descriptions of women knitting "black landscapes shuttle through their heads . . . knitting webs of fate. . . . Constant reflections are spinning it out of their heads through their fingertips." {PJ, PKS}

July 7: Tired in Madrid, coffee and fried bread on the way to the American Express office, walks along "wide hot streets" with "splendid" shops, an "elegant" lunch of veal, mushrooms, beans and tomatoes, wine, and ice cream, naps, draws the tower opposite their room, showers, "fine cheap supper," out on the "eerie hot night streets—every body out"

"Dearest of mothers!": Describes the twenty-four-hour train trip to Madrid, settling into a comfortable apartment with a private bathroom and shower—a new, exciting experience for Ted. The "whole secret for both of us, I think, is being utterly in love with each other, which frees our writing from being a merely egoistic mirror, but rather a powerful canvas on which other people live and move."

July 8: Still exhausted, "lovely" breakfast of coffee, rolls, marmalade in bathing suits on the blue and yellow tile balcony with green plants, making love, showering, baking in the sun, dressed in the evening for bullfight at Ventas, "six lovely doomed black bulls" subjected to the brutality of picadors—"blood sheeting out of holes," a "fat picador gored in thigh"[307]

Postcard to "Dearest mother": Enjoys the dry heat and violent colors, the train trip through a "primitive unspoilt dreamland."

c. July 8: From Ted to his parents: "Dear Mom and Dad": "I am certainly going to marry Sylvia[308] . . . Don't be frightened of Sylvia being a drag. It's obvious from what's happened since I met her that she is anything but. She is a very fine cook, and a much more certain money-earner than myself." Mentions she has been offered a job to teach at Smith. {THL}

July 9: A grumpy search for breakfast, second cup of coffee helps, buys bus tickets and fruit, and black heels at department store sale, a light brown linen suit, a black tie, a "cheap good meal" of white beans, greens, rice, tomato sauce, and fried bananas, a cold beer on Alcala, early to bed

July 10: Café con leche at bar, buys tie for Ted, to the Prado to see Bosch's *Garden of Earthly Delights, Hay Wain, Table of Seven Deadly Sins,* "excellent grotesques—good Cranach, Fleming paintings, El Greco," eight-hour ride to Alicante with "hot, dusty, vivid Spanish scenery": re purple earth, yellow wheat, "rock-white town—cold beer at stops," eats plums and watermelon, dozing and bouncing along to loud music, "queer noisy hotel" in cheap resort, a seaport with "garish palms" and paella

July 11: Coffee and buns at a sidewalk bar, an early bus to Benidorm "fantastic Senora Ortiz," a "dream house" with a garden and fig trees, balcony, terrace overlooking the oceans with "blue sheen of peacock feathers," a beach picnic on a cloudy day, "Alicante fight—long hostile walk"

July 12: A "rushed morning," with "scalding café con leche at bus stop," ride through desert red hills to Benidorm, settled in a house, buys beach towel, shops for a picnic lunch, swims and explores the beach, "exhausted supper, Ted sick—early to bed"

July 13: A "miserable day": sunstroke, sick stomach, Ted sunburned, a fever, no water in the morning, then "finally" "hot good mugs of café con leche" on balcony, shopping, "delirious fever sleep all afternoon," cold potato salad and ham on "twilit" balcony watching the moon and stars and lights of sardine boats, Ted hypnotizes her to sleep

July 14: Wakes refreshed on a fine day, early morning walk to the sea, café con leche on balcony, early shopping, discovery of fruits, vegetables, and "sparkling fresh fish" for lunch on balcony with tomato and onion salad, bread and cheese, writes mother and Warren, to the beach for a swim

"Dearest, dearest mother!": "our summer dwelling has surpassed my wildest, most exotic dreams. . . . Closer to the sea than grammy's place in Winthrop. . . . Day and night we hear the blessed roar of the waves on shore." Planning to do a series of sketches, plans to write about local color for women's magazine while Ted works on children's fables.

"Dearest Warren": "It is utter heaven here." Hopes he can join them, describes Ted as the "male counterpart of myself."

July 15: Exhausting bout of diarrhea, a swim, an argument with landlord about new guests and their access to the terrace, "emotional furor—drew house from beach—sick & miserably unsettled," makes "delicious" potato, onion, and eggs tortilla for supper, then a moonlit walk around town hearing crickets, "two strange animals," music, and "lighted elegant houses," describes Widow Magada's house and the view, the native women, the market, the stores, the sardine boats, the widow dressed "comme il faut," and the problems cooking and getting hot water. {PJ}

July 16: In bed, exhausted with "period cramps," coffee in the garden, makes the bed, swims in "clear lovely green water," tomato and onion salad and fried sardine lunch, "long weary siesta till 7," marketing in the cool of the day for oil, wine, garlic, bananas, "merluza[309] & potato salad cold summer" looking at the moonlight on the water

July 17: Bananas, sugar, coffee for breakfast on balcony on a "fresh clear day," Widow Mangada delivers "shattering news" that she is renting whole house to one person, "tears & great self-examining," hike to find the Mayor, "intuition about attractive road into mountains," discovery of a house in

a cornfield that they rent for "7,000—dazed?" A "happy potato tortilla," supper with a silver moon on the water

July 18: A "pleasanter" morning with the Widow, "all out in open," coffee on balcony, washes hair, sunbathes and swims in "clear green breakers," potato salad, wine, and "tough cow" supper, a walk in the moonlit village streets, "castle platform—silver waves & weariness"

"Dearest Warren": Leaving the fickle Widow Mangada for a larger place, still hopes he can come.

July 19: Hot on moving day with a "sense of joy & freedom," coffee in the garden, to the post office and bank, packing, breakfast of eggs, potatoes, and herring, a departure "on good terms" with the Widow, enjoying the delightful, cool "airy new home," naps, swims, supper by candlelight

July 20: "up early after cockroach night," bananas and coffee for breakfast, potato salad lunch, exhausted and bothered by flies, siesta while workers hammer, a walk after supper into the mountains through almond groves, moon and clouds on sea, "very tired"

July 21, 7:00: Rises early, café con leche and bananas, a "superb" early morning at the market purchasing fish, purple and yellow squash, rabbits and chickens, home to look over recipes and stock pantry, squash and potato cake lunch, writes an outline of a novel about Cambridge, "summer projects—siesta—fine—love-making—to market for wine & oil—Ted's lovely fables re tortoise hyena & fox"

July 22: Wakes early after "restless night," early café con leche and types Benidorm diary, works on rough draft of black bull story, "queer lunch of black zucchini[310] & tomatoes & deviled eggs—lovemaking & restless weariness," a "hypnotic" sleep, awakening refreshed, coffee, inspired to write a story about a hypnotizing husband

Benidorm: Sunday morning: Overjoyed at the new quiet place to write, so much better than noisy seaside filth of the Widow Mangada's establishment with no privacy. {PJ}

July 23: "bad evening after Ted's letter home," a walk under a "wild, full, moon," toward the mountains, "sour wrongness continuing through morning of shopping—tears, synthesis & good dear love—day of recovering," at the beach swimming in the "blue violent sea & reddish orange hills," translates French before bed—"our fable," describes Marcia Brown's arrival with her husband Tom and the camaraderie of wine-drinking Spaniards on a train

July 24: A "good day," beginning with a "fresh morning" and coffee, early to market, cooks beans, writes first pages of story about hypnotizing husband, "deep restful hypnotized nap," "reviving coffee & shower," writes some of black bull story, potato and onion supper, reads over Ted's

"wonderful bee & elephant fables," notices the fig leaves and blue ridge of hills while working on a French translation

July 25: Wakes up tired after a late night, to the market for fish and vegetables, no petrol, "tomato & egg mush lunch," afternoon siesta on the beach "in big green waves," "long talk with Spanish Mayor & farmer w. Olives, almonds, grapes, goats, rabbits, etc—American childhood," "hearty" fish and potato supper before going to bed

"Dearest mother": Describes the Widow Mangada and the move to ampler accommodations, which has allowed them to write diligently. She has been translating Stendhal's *The Red and the Black*. "My life has been like the plot of a movie these past years: a psychological, romance & travel thriller. Such a plot."

July 26: To the market, types first draft of bullfight story, Spanish lesson at the beach, good swim, search for petrol, shower, coffee, bean salad, and tomatoes with deviled egg and "cow" supper, works on French translation watching from a rocking chair the starlight, the moon, the vines, to bed

July 27: "sour mild beginning of morning," boils and washes sheets and towels while Ted markets, begins typing second draft of bullfight story, "crying nostalgia at lunch—furious re Olwyn's letter disturbed re Warren," swims and sunbathes while Ted conducts a language lesson, fish pie, "relieved decision to leave Spain early"[311]

July 28: A "tired day," stays home to wash her hair, floors, bathroom, and kitchen, on her knees all morning, a "restless" siesta in a dark room while Ted goes to Spanish lesson, coffee and a shower, "rocked out on geranium-scented porch after dinner," weary and to bed

July 29: Good breakfast of fried bread and coffee, writes bullfight story all morning and deals with Ted's corrections and advice to "cut drastically," potato and fried onions for lunch, off to the blue sea and mountains, "Lovely green swim & water playing," reads French, works on Stendhal, fish and cold beet salad for dinner, rocks on "starry, grape arbor porch"

July 30: Wakes to a sultry day with hot coffee and bananas, cooks potatoes, cleans up house, and shortens introduction to bullfight story, toasts sardines and tomato sandwiches, sandstorm on the beach, "enervating sun," showers, coffee in a "short pleasant rest in green lit room," a fish cake supper

"Dearest Warren": Mentions finances, disappointment that Olwyn has not sent Ted the $150 she owes him: "she is evidently extravagant, always overspending, and extracting money from her is a painful job of nagging." Expects to see Warren in Paris, where they will see all the sights.

July 31: Revises black bull story, feels "discontented" writing "first real prose after 3 years" while Ted has Spanish lesson, goes to the beach for a swim and a talk with herself alone, eats a poisonous red sausage, very sick sitting in the "cool moonlight" from three to four

August: Ted to Olwyn Hughes: "Sylvia is as fine a literary critic as I have met, and she thinks about my ordinary prose narrative style just as you do. But my fables she cries over and laughs all together and they are obviously very successful with her. Now if these would sell." {THL}

August 1: A terrible racking day after a sleepless, fevered night, aches and pains, diarrhea, feeling weak, faints, Ted reads Dylan Thomas to her, makes vegetable broth, brings watermelon and wet cloths for a "better night"

August 2: A day of "grateful recovery" free of pain and fever but still stomach cramps and fatigue. Tomato and egg tortilla for lunch, naps with Ted, "lovely" fish and bread in milk and butter for supper, finishes typing black bull story, cannot sleep

"Dearest mother": Happy to hear about her mother's visit with relatives in Austria, reports on Warren who promises to send $50 to make up for Olwyn's failure to send Ted money, looks forward to visiting Ted's home and to seeing the "Brontë moors," still plans to meet Warren in Paris, grateful for Ted's nursing her during her sickness. "There is actually nothing so exhausting as traveling." Still expecting a marriage ceremony in Wellesley, struggling with bull fight story, so different from Ted's: "his vision is really photographic, while mine is inclined to be an impressionist blur."

August 3: "ideas for a humorous" story about Widow Mangada, a "lovely translucent purple dream of witchcraft—good love," completely recovered except for cramps, a "depressing sultry siesta—turning point in facing toward England, rocks on porch with the scent of white flowers"

August 4: Milkman delivers sour milk, writes "bad poem on 'full moon,'" "good pep talk" with Ted about writing exercises, tuna salad for lunch, begins reading *A Winter's Tale* aloud, on the sunny blue beach, "sick in water: potato & creamed tuna supper," climbs mountains on a cloudy day to look at the "fairy-light" of Benidorm, steals almonds

"CONCERNING WAVES" {PJ}

August 5: "good love—green leafy grotto of grape leaves," begins work on Widow Mangada story, siesta after lunch, a hike around the bay into "wild lonely hills," over orange iron rocks and "huge rough white spray—rock salt" and the "heaving sea . . . exhausted," candlelight and wine supper, continues reading *A Winter's Tale*

August 6: "good love" on a cloudy white morning with coffee con leche and bananas, works until 1:00 on Widow Mangada story, over lunch Ted reads his fable of O'Kelly's Angel, cicadas on a damp, sultry, day, "tearful episode with landlady about leaving early—reconciliation"

August 7: Dust storm and "weird wind," concerns about plot in Widow Mangada story, not eventful enough, repetitious, reworks for "subtle inwardness," finishes rough draft, into town with Ted in the blowing dust for candles, a "tough lamb" mashed potatoes dinner with wine by candlelight

August 8: Finishes draft of Widow Mangada story on "another hot windy day," "active morning creative feeling—Ted's suggested plot re sisters," Ted rewrites "O'Kelly's Angel," a "tiring afternoon typing" in the heat

August 9: Works all morning on revisions of Widow Mangada and black bull stories, "depressing restless afternoon" unable to write poetry, "sad and sick view of uncertainties," but a "lovely cool pungent rocking on vinyl porch"

August 10: "loving morning" on a "bright eager day" with an idea for "Fabulous Roommate" story, washes nightgowns, makes notes for the story, sunbathes, swims in the afternoon, studies French, eats swordfish, rocks on porch

"Dearest of mothers": "What a life you are leading! Each new postcard and letter sounds like a fairytale. . . . Coming into my own, writing about 5 hours daily. Ted is a master at thinking up plots, my hardest task, and a perfect critic." Thanks Aurelia for sending $100, contemplating a teaching job if something can be found for Ted too, modeling her life with Ted based on people like the Beuschers.

To Elinor Friedman: "All is like a miracle," describing her time in Spain.

August 11: Spends part of a bright clear day in a futile talk with the landlord, types a long Fulbright letter, lunch and "good love," meets Swiss wife, walks in the hills, dinner of rabbit at Villa Joyosa, outdoor movies, fireworks, cognac

August 12: Wakes up exhausted after staying up until 2:00 on porch, early lunch on beach, a Mad Hatter regatta with double pontoon sailboats, "depressing meeting w. War," writes an outline of "Remember Stick Man story—moody over Olwyn," lovemaking at night

August 13: Still upset over Olwyn and money, late to the market, sketch of alley cats in "hot noon sun," "cooling dip" by sardine boats, lunch of tuna salad, exhausted, rests on the beach, sunbathes, "renewed surge of joy & love at sight of Ted—games underwater," a coffee, reads *Timon of Athens*, a later supper, "weary"

"BENIDORM: Bait Diggers." {PJ}

Benidorm—two girls playing with diving equipment in the waves. {PJ}

August 14: "auspicious good day," hitchhikes to Alicante with Spaniard going to the Villa Joyosa, walks through almond groves in the heat, picked up by "bleached blond French couple" with a black poodle, "good interview & gallant young teachers at Vox," where Ted wants to teach, rides back in a "sturdy station wagon" with "stout Germans & feverish little girl," a "lovely swim," observes an ant colony and a goatherd's hut, a dog and fig tree, hears the goat's milk hissing into a pail, rocks away watching the moon in the pines on "geranium porch," dresses to be "bright and wifely" on the way to Alicante, describes the trip on beach: "Ted finding ant-track; half an hour spent playing god." {PJ}

August 15: Shops early, spends morning in the sun doing "rather sloppy sketch of Carrero del Gats" watching the sun on "purple flowered vines & steps"

August 16: A "queer sultry oppressing day," fusses over beginning pages of "Remember the Stick Man," draws sardine boats, "spoilt maliciously by wine in bag," slips off to buy chocolate and a wine flask for Ted, draws "Birthday wrappings"

August 17: "TED'S BIRTHDAY: 26," buys cake, shops for chicken or rabbit and things for stew, "lovely day," "pinky Pooh chocolate breakfast—enormous sopping," makes a good drawing of sardine boat on bayside, buys moray eel and octopus, "creamed tuna & bean lunch," a "deep siesta," cooks delectable rabbit stew with wine, rocks on porch, reads Dylan Thomas, "blotted out memory of maliciously blurred drawing yesterday"

Describes life along the seashore, preparing rabbit for dinner, adds wine to kettle at Ted's insistence, presents him with "Hemingway leather wine flask," describes "Mr. and Mrs. Ted Hughes Writing Table." {PJ}

August 18: "excellent day," keenly aware of "sights & thoughts," on a "fine hot morning" sketching market fruit stands, "good love making," a "potato lunch—beach description of Castle hill," a "salty swim," begins a poem "You might as well string up," after hot chocolate to bed

Describes the clustering of houses in Benidorm. {PJ}

August 19: A "hot sultry day—unease of parting already present," spends the morning finishing poem, "Epitaph for Fire & Flower," swims in "green surf" after tomato and egg lunch, draws cliff pueblos on bayside all afternoon, begins reading *Love's Labour's Lost*, packs suitcases

August 20: Morning shopping on last day in Benidorm, draws Carrera del Gats again,

washes hair and towels, makes sandwiches and boils eggs

August 21, 7:45: bus to Valencia and Barcelona, "sour mile—flies—sweat," waiting for bus but "lovely sandwiches, eggs, grapes," picnic in Valencia, "comfortable" train to Barcelona, tired on arrival, "heavy cases," "Lovely horchatas[312] in strange moonlight—lousy hotel & flies"

August 22: "lovely sunny morning" in park with zoo, makes huge sandwich, watches mandrills, crocodiles, otters, eagles, a mountain lion

3:00: Barcelona train on way to Paris, "elegant steak & wine dinner" in an "elaborate restaurant by a cascade," "nightmare train ride" cramped, arriving late

August 23, 8:45: Exhausted on arrival after breakfast on train: "dirty, raw-nerved" but a "lovely gray early Seine," eats sandwiches on a barge boat with fishermen, a "good wash, love, nap—fresh & fine supper at Café de Beaux Arts—Seine & moon"

August 24: Warren arrives for breakfast in the early morning in the "midst of good love"; amazed at the "new dimension of life" in Paris; Warren talks with Ted who reads his O'Kelly piece; lunch at Orestes, "nap & love," good supper, a walk along the Seine to the Place de la Concord, tired and to bed after watching "fine" *Potemkin* and Harold Lloyd

August 25: A long wait at American Express for tickets, a walk through Tuileries "bare of children," reads *All's Well That Ends Well* and the new *Mademoiselle*, "Excited & inspired . . . Stories to work on next month," hysterically funny Charlie Chaplin in *The Gold Rush*, on the Champs-Elysées

"Dearest of mothers": Describes the last five days and exhausting travel, the final week in Benidorm with Ted alongside her as she sketches, looks forward to the "wuthering-heights" visit to Ted's home, listens to Warren explain his thesis and language work.

August 26: A late breakfast with Warren and Ted, visits unicorn tapestries at Cluny: "delicate birds, flowers, and animals—carved woods chests—jeweled reliquaries," Axel Hoffer's attic room and snapshots,[313] a nap, to Notre-Dame and "milky green undersea light from windows," to Sainte-Chapelle "jewel box colored" then supper at a Greek restaurant and cognac at a sidewalk café

8:00 a.m.: Describes Paris: fishermen, bookstalls, run-in at a fruit stand when they try to pick their own fruit—told they are not allowed to choose. {PJ}

Describes Hotel Deux Continents. {PJ}

"Sketchbook of a Spanish Summer"[314]: Describes the more palatable and pleasurable sides of her working holiday

August 27: A "weary rainy day—repressed feelings of sprouting autumnal creativity—sick of exteriorized extraverted life of travel," to the American Express office, dashes out in the rain to "expensive steak dinner," at the Musée d'Arts "exquisite figurines . . . weary nap," farewell dinner, a walk along the Seine near Notre-Dame

August 28: A "rainy day of farewells"

6:30: Sees Warren off to the Rotterdam train, "bad warm coffee" at train station, "depressing gray wait" for the trains saying goodbye for "another year," subway to Galerie Lafayette, rain clears and at Chez Jean for a "reviving" breakfast at hotel and a long walk to Olwyn's in Rue Mahar, "Ted's cold—hypnotized sleep—heavy rain—made picnics, good-lit clearing—love for Paris"

August 29: Channel crossing nightmare, vomiting on a "black blowy night," "sickening dawn train to London," a "siege of sinus" waiting for a bus that travels though "green farms" to Leeds, passing "sooty air black collieries—numb to death," a Halifax bus to Ted's home in Heptonstall

Plath invested her first visit to Yorkshire, and to the Hughes home, with the romance of her reading. She thinks of Ted's world as a creation of literature, enhanced by her weariness over the worries of travel and exhilarated by her projected new home in England. The reality of life in Yorkshire, although it did resemble scenes from Wuthering Heights, *nonetheless nonplussed Plath, who shifted from periods of exhilaration to enervation, and from elation to depression.*

August 30: A day of recovery, "morning view of green moors" and "grey sheep," a late brunch, long talks with Ted's parents, a visit to "Mad Barbara with Alice, jovial Uncle Walt, talking with him and Ted in the town pub and then brandy and more talk by the fire at home"

August 31: Drives with Ted and Walt over steep green hills and down valleys to Haworth, a "lovely" ham sandwich picnic in "sunny pink heather," a long walk to Wuthering Heights watching "wooly gray black-faced sheep" in "lonely winds," begins drawing, a "fine tea" at Haworth, "Walt's humor"

September 1: Tired but elated over $50 check from *Atlantic Monthly* for publication of "Pursuit," resulting in "sudden symbolic rightness—renewed faith," a late breakfast, gets settled, types up poems for submission, letters, and walks down to Hebden Bridge over "steep green hills, a river, and a "fine walk" in the woods with Ted, who shoots a rabbit in the land of stone walls, brooks, ferns, a sow farm, and "wild sunset & wind"

September 2: A "rainy Wuthering day," misty with moving sheep, types letters, poems for herself and Ted to send out to several publications, reads *Wuthering Heights* by the fire and listens to the rain

"Dearest mother": She is now part of a "Brontë clan." Describes the view, the "most magnificent landscape in the world . . . wild and lonely and a perfect place to work and read."

September 3: "tiresome business day" taking care of four-page article, including drawings, on Benidorm for CSM, a frustrating time in the Hughes kitchen finding the right ingredients, a bus to Halifax for typing supplies and to send out poems, a "sick feeling" after eating pork fat, Ted sick after supper, continues reading *Wuthering Heights*

September 4: "very bad day" but good breakfast, reading *New Yorker* stories and "getting back into atmosphere at losing husband to mother's son," Mrs. Hughes cooks "starchy meat pies again," "no good love since Paris a growing sense of suffocation & loneliness," a long hike in Hardcastle Crags watching playful kitten, "fury at Ted's lack of understanding—hid in ferns & watched rabbits—got it out—tears—hard walk—steak—still sad"

September 5: "grim warped blocked day—mind caught in cog somewhere," works on two "slight poems" but "depressed and sterile," walks in rain with Ted in "green glooms of heather by ruined mill," but then

home to the fireside anecdotes with his parents and listening to Beethoven's Emperor Concerto

Plath wrote often, but in fits and starts, while Hughes seemed hardly ever to slacken his pace or trouble himself with writer's block. Plath has not yet regained the confidence that had resulted in her publication of stories in Seventeen *and* Mademoiselle.

September 6: Plays piano on a pleasant morning, struggles with "two bad poems," a "slight recurrence of sick, sterile fear in face of his great creativeness," a walk after the rain to "green lichen grown graveyard," reads and sadly ponders the old stones

September 7: An "indoor day," begins work on "secret story, slight & subversive: 'Hardcastle Crags,'" works on Marcie stories, a "wonderful" tour of the Wilfred farm, "black & brown silk blind puppies in hay loft—two calves—little hot pink-eared pig," and a "huge wallowing bristly pink blorting sow—fine"

September 8: Writes ten-page sketch, "Hardcastle Crags," shops in Hebden for food, "sickly smiling people," types "O'Kelly's Angel" for "two hours from dictation," a rabbit stew supper from "Ted's shot," a "good dark windy walk," with lights and clouds and "whistling telephone poles—weary to bed"

September 9: "lovely day—best yet," a good breakfast with coffee, fried egg and bacon, begins a short poem "November Graveyard," enjoys a Sunday roast with Yorkshire pudding, apple tart, and cream, finishes typing Ted's "O'Kelly's Angel" from dictation

3:00–5:00: "wonderful moon walk—pink light—wet bogs—rabbits—heather—green undersea light—love-mist—twilight," and evening of stories and laughter with Ted's parents

September 10: "strangely depressing day," although a good morning typing out second draft of "Hardcastle Crags," tired after "sooty wooden" bus trip to Halifax, visiting the Bishop Farrar Memorial,[315] exhausted, lays down, makes a jelly omelette, evening spent with Ted's Aunt Hilda and cousin Vicky, "much dear love of Ted in preparation for morrow"

September 11, 6:00: Up early to make Ted's breakfast out of a "wifely sense of deep love and well-wishing," back to bed, sleeps until noon, long afternoon tea and talk with Ted's mother, "greater understanding & love," fish and milk supper, explanation of families' histories regarding Hilda, Albert, Tom, Walter, et al., makes date-nut bread, washes clothes and hair, "good fireside talk w. Ted's dear father—so to bed"

"Dearest mother": Happy to receive her "wonderful fat letter." She casts Ted's creativity positively saying it makes her "feel very feminine and admiring." Writes out engagement announcement.

Mrs. Prouty had been disturbed by Plath's earlier letters about Hughes, suspecting that his rather violent nature, as Mrs. Prouty interpreted it, would not

wear well in the marriage, and that Plath was deceiving herself into believing she could change Hughes for the better.

September 12: Ted returns tired from a day in London; they talk warmly in bed in the "joy" of his arrival; makes a "good breakfast, types "Hardcastle Crags" and "Black Bull," works "like fury downstairs" while Ted sleeps "curled & tousled," in the afternoon works on "Widow Mangada" while Ted reads by the fire

Mrs. Prouty writes: "So often a girl has to go through a disturbing period when visiting her fiancés people—& many an engagement goes onto the rocks after such an upsetting test."[316] She has worried about Ted, but Aurelia has assured her that he is a "most gentle and understanding person." {HC}

September 13: A "good hearty late breakfast," finishes typing "Widow Mangada" on a rainy foggy day, types six Lucas Myers poems to send off, visits Uncle Walt who is not home, so they visit Hilda's "prim bright flat" with Vicky's designs and have "high tea—chicken cakes—very bad TV play—Hilda's song-walk in mist"

September 14: Spends a futile day on the moor searching for exact location of Wuthering Heights, starting out eagerly on a bright noon, a "thin blue sky, purple thistle, black-faced sheep—miraculous witty piglets," they make love in "heat" among "squealing seas of march grass," with a "growing weariness" a "dragging walk," a "cold wait" for a bus home

September 15: A "good day of work" after a hearty breakfast of poached eggs and honey, types twenty-page first draft of "Remember the Stick Man," which has to be polished and shortened, makes soup and sandwich lunch, finishes typing Ted's fable "The Callum-Markers," writes to BBC and Cambridge Appointments Board, serves tuna, rice, and cheese for supper, evening walk in the rain, a "weary cosy" evening and a "resolve not to work so hard"

September 16: Writes first draft of "Obstacle Course" poem on a bright sunny day, grouse for dinner, types Ted's story "Bartholomew Pygge Esq" all afternoon in the "warm sun," tired, coffee with a snack, supper with Vicky, disappointed after realizing they have not won the football pool, a moonlight walk

September 17: "good love," dash to the bus station for trip to Manchester, "active shopping day," mails Ted's stories to *New Yorker*, her stories to *Mademoiselle*, spaghetti supper and "lovely moonlit walk in blue mist"

September 18: "strange oppressed day—smothered choking feeling of frustration & uncertain future just out of reach," a flare-up over "stifled baking," a "cold, nightmare rest on bed in horrid imagining of rivalry & sickening voodoo forces," a walk with Ted, "love of him & good warmth during Beethoven's 'Eroica' which assuaged & life out of all blackness," bakes date-nut bars, washes, then dries hair by the fire, "good love w. Dear Ted"

c. September 19–20: Notes for "rich-flavored dialect story set in York-
shire (Wuthering Heights background)" dealing with "second sight," ghosts
{PJ, PKS}

September 19: Finishes typing rough draft of "Remember the Stick
Man," reads *New Yorker* stories, waits for Ellie Friedman to arrive for "long
gossip" about Smith, notices the "old stone & woodwork" at Sutcliffe Inn,
at the pub listening to "wild tales—blue moon mist," at Clifford's Inn,
"antiques, embroidery & home"

*The future, in England or America, as a writer, or perhaps a professor who
wrote, with employment at Smith, churned together in Plath's mind as she
realized she was at a pivotal point. She worried about Ted also teaching at
Smith among all those young women who might have designs on him. Af-
ter all, one of Plath's own professors, Alfred Fisher, had bedded and married
Smith students.*[317]

September 20: "oppressed beginning of day," worry about the future
and "personal pulls," breakfast in the garden with Ellie, "herds of pink
baby pigs," an afternoon walk and "lovely tea with Ellie at Sutcliffe's," with
the same old rapport during a "happy" walk on a moonlit night, "resolve
against Smith for Ted"

September 21: "nasty beginning of a day—Mrs. Hughes blundering in
on love," a "sour bitterness" and feeling of oppression and a sense of rivalry
with the women in the house, "cut off" from proper privacy, a rabbit stew
and a "lively evening" with Ellie Friedman, an idea for a story "The Big Act"

"Dearest lovely mother": Eager to return to Cambridge. Decides it is
too dangerous to have Ted teach at Smith, given the "irresponsible flirting"
and professors' affairs with students. Delighted with Ellie Friedman's visit.

September 22: "another bad day—wild strong good love in the morn-
ing," concerned about weak narrative, " 'All The Dead Dears'—depressed at
criticism—dull dead feeling," a walk with Ellie and John, "Tears & cows—
rivalry w. sloppy dominating intruding mother—tears, sickness, final relief &
blame on intolerable situation"

September 23: A better day as depression lifts, looking forward to Cam-
bridge, "hearty" breakfast, a long walk down to Hardcastle Crags with Ellie
and her friend John, dinner at Sutcliffe's, emotionally exhausted, finishes
New Yorker stories, reads *Member of the Wedding*, "still tense"

September 24: An "arduous athletic day," packs for a picnic in the "early
mist," takes a bus through green hills to Brontë Museum, looks at the wa-
tercourse and "minute" books,[318] hikes out to the falls and through "rusty
bracken" to Wuthering Heights picnic and sketching, an "exhausting bog
trek" through a pink "fairy wood," sees a black rabbit, "joy with Ted," tea
in the "black depths" of Hardcastle Crags, "starry dream—tired hike home"

Notes on visit to Haworth: "Mr. Nichols study, Charlotte's needlework," "bread service the rings," "charlottes wedding wreath," drawing of Brontë books in "microscopic script," contents of Charlotte's room, Charlotte's slippers, shawl, "scribbled drawing on wall," "wooden oblong cradle," "toys—discovered under floor boards." {PJ, PKS}

September 25: Prepares for London trip, washes hair, bathes, packs, a spaghetti supper

September 26: An early bus on a "sunny green" morning to Halifax, then on to London, eager to get there talking all the way with Ted, optimistic and excited, a stop for tea, meets poet Peter Redgrove in Chiswick "frigid modern house," "Ted's reading—ghastly peter"[319]

September 27: Up early, "stiff breakfast," to Fulbright appointment about grant, a "fine time" at Ted's BBC audition reading Yeats superbly, "prospects good—jealous Redgrove," lunch at Schmidt's, train and bus return to the Hughes home, happy with fish and chips

September 28: "furiously wild windy day—spats of rain," tired after yesterday's trip, types Ted's poems, rewrites "All the Dead Dears," a steak and onion supper, listens to Beethoven's Fourth and Seventh symphonies in the dark by the fire, proofs Ted's "fable book"

"Dearest mummy": Thanks her for family snapshots, "living in Mrs. Hughes' small messy kitchen is such a bother, with her being a bad cook." Dreams of modern American appliances, mentions concentrating on a novel about Cambridge, imagines with Ted's BBC experience and fame they can tour America.

September 29: "wild blowy day," types Ted's poems to send to *Nation* and *Poetry*, windy walk to Hebden Bridge, takes snapshots, orange sky, a "lovely" evening listening to Beethoven in "starred dark by coal fire," reads Hemingway in bed

September 30: "tense day," packs, begins a story "Dream Man," a creamed tuna supper, more Beethoven by the coal fire, and a "long windy walk with dear Ted along dark farms, cow fields" and Hardcastle Crags "dear love"

To Peter Davison: Brings him up to date on her writing projects and time at Cambridge, France, and in Yorkshire, looks forward to his advice about her writing, introduces Ted, a "brilliant writer," asks for advice on where to send the children's beast fable book and one for adults he is working on. "You have no idea how hungry I am for home; British writing is dead; so are the magazines. I find myself no literary exile, but a staunch American girl."

October: *Smith Alumnae Quarterly* publishes "B. and K. and the Claridge"

The couple split up, as Sylvia returns to Cambridge, thinking she had to conceal her marriage in order to retain her Fulbright. Ted remained in Yorkshire with trips to London for BBC work.

October 1: "miserable numb intense rainy day," coffee, bus and train to Leeds with Ted, a "sweet goodbye," returns to her room at Cambridge, "hypnotic unpacking—scripting of rubbish"

8:30: "Dearest Teddy": Arrival in Cambridge, the "trip back was hell." Comments on reading, including Adrienne Rich, "getting richer but duller." Big news: *Poetry* has accepted six of her poems. "So there is a god after all. . . . I want to share everything with you."

October 2: To the post office, laundry, bank, food shopping, dazed after a busy day and the "abrasive effect of crowds," a visit to Dr. Kaplan, a new bike tire, a watch to repair, clothes to the cleaners, types poems to send to *Atlantic Monthly* and *The Nation*, gruesome supper at Newnham, washes hair, reads the *New Yorker*

"Dearest darling mother": Rejoices in *Poetry*'s acceptance of her poems, now in the "market for a new lyrical woman!" encloses "Epitaph for Fire and Flower," which celebrates her union with Ted: "they ride nightlong / In their heartbeats' blazing wake."

October 1–2: Ted to Sylvia: "Dear Sylvia Puss-Kish Ponky": "The way I miss you is stupid. I have wandered about today like somebody with a half-completed brain-operation. . . . You keep watch on our marriage Sylvia as well as I shall and there is no reason we shouldn't be as happy as we have said we shall be." {THL}

October 3: A busy day of letter writing, laundromat, ironing, post office, "monitoring Dina[320]—restless wakeful lonely night," reads *New Yorker*, writes short poem "Monologue at 3 a.m."

"Dear Editor Weeks": "Best of all, here there is the leisure to write for quiet, uninterrupted mornings (as there would never be, at an American graduate school, I think, with the crammed class schedule and frequent exams)."

"Dearest Teddy": "I find myself walking straight, talking incessantly to you and myself, and painfully abused by the crowds of people—the motion, chatter and nip and tuck of cars."

Ted to Sylvia: "Dearest darling Sylvia": "I sit around in a daze of shock, I feel there are some things I can no longer do, or only half do, or do awkwardly and without pleasure—this feeling is vivid & constant." {THL}

October 4: A later breakfast, a walk into town with Dina Ferran, buys "Augustine & St. Paul," writes a poem, "Street Song," restlessly begins reading Augustine's *Confessions* and Paul's epistles, an evening talk with Marie Therese from Malay and Miss Abbott, misses Ted terribly

"Dearest Teddy-ponk": "I feel completely paralyzed, away from you."

Ted to Sylvia: "Dearest Sylvia kish and puss and ponk": "Since you went I have done nothing." {THL}

Ted to Sylvia: "Dear Sylvia": "I love you I love you, I love you I love you your Ted." {THL}

October 5: Reads Paul's epistles, Chaucer, skims poems in *New Yorker*, writes poem "Touch & Go," walks in "blind dark" after dinner, begins Chaucer's "Book of the Duchess"

"Dearest love Teddy": Miss Abbott says, " 'It's wonderful to see someone who's life is so happy,' I murmured darkly about passing through the forge of sorrow, the valley of tears." Reading Augustine and St. Paul: "I am standing at the crack, the hinge, the abyss, the suspension bridge between Greek and Christian thought. It awes me. . . . I honestly believe that by some mystic uniting we have become one flesh. . . . I love you so it is simply murdering me." He represents the "whole male principle," father, brother, husband, son.

October 6: "day of slight recovery," an "encouraging" letter from Peter Davison, begins "bad story on St. Botolph'—after silent sick lunch," hikes to Grantchester meadows, sits in the long grass by the river and draws two cows, draws thistle and dandelion at home, reads more of *Confessions* "inability to appreciate struggle for belief," finishes "Book of the Duchess," talks with "friendly" Jess,[321] Janeen,[322] and Dina

"dearest darling teddy": Peter Davison's letter "like a plumb-cake of helps, hints and interest for both of us," explains the interest in Ted's work, takes his advice to read Chaucer aloud, comments on his fables and poems.

October 6–8: Ted to Sylvia: "Dearest Sylvia, Saturday night, and no letter from my ponk. Is she dead? Has half the world dropped? . . . Love to you my kish and my puss and my dearest Sylvia my wife & love." {THL}

October 7–8: "Dearest love Teddy": "blasted by your absence . . . terrible nightmares." Calms herself by drawing cows in Granchester. Reading a book on abnormal psychology about manic-depressive geniuses.[323]

October 7: Completes "The Wishing Box" {HC}

October 8: Buys fruit, sherry, class list, calendar, "misty—moist morning—lovely letters from mother & Ted," types "The Wishing Box," goes "stolidly" to market and faces "stares, persecution complex," visits cows on way home,[324] begins "Invisible Man," a "queer sense of victory over prose style," a talk with Jane Baltzell

"Dearest of mothers": Exploding with pride over Ted's Yeats BBC program, expects he will get more work on the radio: "what wife shares her husband's dearest career as I do? except maybe Marie Curie?"[325]

October 9: Exhausted after sleepless night hearing owls hooting like "lost souls," sherry and cheese, types beginning of "Invisible Man," a visit from "scared silly Terry, Wertz friend," a "long broody observing" walking along green Backs and the "splendor of Clare gardens—unbelievable green radiance—fresh boys," draws Mill Bridge by "hissing swans," rests, talks with Jane Baltzell about writing, reads the *New Yorker*

"O my darling Teddy": "Your words on my poems are so right, as ever; you know." Discusses the plots and themes of her stories with him, his stories and her story "Invisible Man," plans for others, and admits: "the Idea Of Novel scares me."

October 9 or 10: "My dearest Sylvia": Suggests a plot for a story, comments on her poems. {THL}

October 10, 10:14: "Pightle—Miss Burton," a "misty tired day" listening to "faculty babble" during appointments with Miss Burton, Miss Morris, works on "Invisible Man," types revisions until after midnight, "very excited about it"

"O dear darling Teddy-one": Revels in her London rendezvous with Ted, which she keeps a secret from everyone, speaks of her "actress-side" that helps her bend others to her will, lists their submissions to various publications. "I kneel on the couch in the pitch black and throw all my force and love in the direction, as nearly as I can discern, of your bed in Yorkshire. I am living until Friday in a kind of chill controlled hysteria."

October 11, 11:15: Restless, cerise day anticipating London weekend with Ted, types final draft of "The Wishing Box," sketches in the "lovely green day"

7:15: College Feast, nice note from Ben, "encounter w. Iko & Keith Nash accepting Prescott story for Granta"[326]

Ted to Sylvia: "Dearest Sylvia": Suggests ideas for a poem and a plot for a story, details his business in London, and asks her to bring to London what she has written. {THL}

October 12: Busy day preparing for London visit

4:15: Taxi

4:42: Train to London

6:02: Arrives Kings Cross station, "nightmare of wait for 2 hours at bus station"[327]

A kind taxi driver takes her to a "tearful reunion" with Ted

October 13: "lovely lazy morning with teddy," first "deep sleep" in two weeks, "all knots dissolved, good dear love," breakfast then back to bed, naps, reads stories, eats fruit at Schmidt's for lunch, "bright sunny days— new polished potential feeling" in the afternoon, browsing in Charing Cross bookstores, buys the *Painted Caravan*[328] at Watkins's book shop in Cecil Court, twilight in Russell Square, pâté, fruit, early to bed

October 14: "morning of twilight—orange poinsettias on red curtain" with the sun shining through them, "up at 12—no breakfast," tramping through "ugly teeth-gritting streets near Liverpool station," coffee, sandwich goodbye, "renewal of force, though tired," finishes reading *Confessions*, begins typing Ted's story "How Donkey Became"

October 15: "strange rich dreams" of four-leaf clovers, a "red-plush" French hotel "Paradiso," rain, writes a "dream-poem" on gulls and ducks, "Luminous Vein," a sense of "light & radiance," a "stoic day" typing from 9 a.m. to 10 p.m. Ted's sixty-one-page book of nine fables, reads "Tarot pack book re fool & juggler"

11:00: Ted to Sylvia: "My dearest Sylvia": "This is just a short note with no plot. Tomorrow I shall give two. For my darling wife, for my Sylvia, for my ponk, my kish, my puss, and from her big toe up by quarter inches to the tip of her longest hair, kisses, and lickings and love." {THL}

October 16: Library books due, sends Lucas Myers's poem to *Poetry*, "still gray day," "blessed Krook—firm lucid cadence," buys "sherry—fight with Cork," mails Ted's fable book to London, writes to Ted, mother, and Ellie Friedman,[329] a restless afternoon of rewriting "Invisible Man—bare depression at Jane & Isabel—outside feeling—dogged resolution to go on reading," reads about tarot[330] and has a hot milk

"Dearest mother": Typing a book manuscript for Ted after he had taken aboard her suggestions for revision, speaks of the transformative power of her love for Ted.

"Dearest Teddy": Feels a "great calm" after their London weekend, praises Dorothea Krook's lectures "clear and cadenced as a piece of exquisite music."

October 17: Library books due, "intense day" of reading Augustine, begins paper before supper on a "blue frosty moonlit night," up until 2:00 a.m., "tense, cold-prickly eyed—typing into owl hoots by fire—hot milk"

"dearest love ted": *Mademoiselle* rejects three of her stories, "a black day." Imagines a future when editors will be writing "coy notes" asking them to contribute, washes down the "acidic rant" of August with sherry, happy that her mother is socializing, studies her tarot pack, feels very " 'kind' to the cards, sort of."

"Some Observations on *The City of God*," typescript with supervisor's comments {PM}

October 18, 9:00–11:00: Types "madly on low"

11:00: Dr. Krook "Christian view of physical act of love in marriage long good discussion," they discuss marriage in "church sacrament," the paper encyclical on virginity, "redemptive, transcending humanist view—foreknowledge—inspiration of free well, etc.," "drowsy dull afternoon"

5:45: Meets Judy and Stan Kahrl at English Speaking Union party, supper with Mr. and Mrs. John Press, "great literary name dropping—poets contests & to bed"

"Dearest darling ted": Tells him about her paper objecting to "Christian view of the origin nature and continuance of evil; god's foreknowledge

and man's free will, and the low debased view of physical love between man and women even in 'blameless wedlock.'"

Ted to Sylvia: "My dearest Sylvia": Advises her to write out her dreams each morning and not to worry about rejections of her work. "Do as you are doing, sending out your latest. If you keep up your writing you will see, after a few weeks, where you can improve the rejected ones, or whether they are better let lie." Makes suggestions about how to do her reading of the Elizabethans, including study of Johnson's *Lives of the Poets*: "You will never understand a poet of the past unless you know thoroughly and can imagine the exact cast of popular temperament. . . . There. That's a page of dogma. . . . I dreamed about you continually last night, in all kinds of places and confusions. We shall meet next week. A week since we met! I wish this was that or was next week, Sylvia. I wish this year were over and our wedding in America were over and I were just laying you down on the bed. All all all all all love Your Ted." {THL}

October 19: Works in the morning on "Spinster" poem, tea at King's, where she has a "golden-leaved view" of the river, a "nice time" with Ben Nash, finishes typing "Invisible Man"

"dearest love teddy": Describes meeting new American arrivals at English Speaking Union party, feeling aloof amid gossip about the marital affairs of English poets while telling them about Hughes. Mentions entering his first book of poetry in the *Harper's* contest. "I'm sure you'll win this; I feel very queer about it."

October 20: "strange horrid dream of sleeping w. Ira[331]—guilt at useless superfluous laxness—ruin," a "rainy siege" shopping at the market, banking, and to the university library. Begins typing "All the Dead Dears," goes to see *Le jour Se Leve* and *Time out of War* with Ben Nash, "cool lovely blue fen moon—sick for missing Ted"

"dearest love teddy": Looks forward to celebrating her twenty-fifth year with Ted in London, assesses the *New Yorker* stories she is reading, plans to send them three of her own, believes in the divine madness of artists. "I feel, in taking you to america, I am bringing, as it were, the grail to a place where it will be reverenced properly. time it may take; but in america, your voice will, increasingly, be heard. and loved."

Granta publishes "The Day Mr. Prescott Died"

October 21: "upset day," walks out on a "shining green" morning along the river after a rain, sits under a willow and writes a description, finishes typing "All the Dead Dears" and ten of her poems and Ted's to submit to BBC, "terrible upset, her battle & growing revelation of wrongness of our separation—frenzied tear stained letter begging him to come to Camb"

"dearest ted": "feeling hellish" watching kissing couples . . . I get these electric shocks of knowing how I miss you."

"Darling teddy": Changes her mind: She could concentrate more on her work if he was with her rather than, as she supposed, cut off from him. "I do not want to be away from you for 6 of the best months of our lives!"

Writes ideas for a novel, an anatomy of different forms of starfish. {PJ}

October 22: Dreams of Winthrop, the Cantors, "Levitation to sun—dr Krook as occult witch—trying to rise with Ted—tabu magic," writes two poems, "Sheen & Speck" and "Evergreens," considers revealing her marriage

"dearest mother": Cannot bear to be away from Ted, discovers three married women with Fulbrights, believes Dr. Krook will support the announcement of her marriage and believes she is wasting energy without him, decides against a second marriage and all the expense involved in favor of a big reception in Wellesley, seeks her mother's approval for this change of plans.

"dearest teddy": Dreams of them living with Dr. Krook, "both of us being a kind of sorcerer's apprentice" to discover her power. In a dream about the Cantors they all levitate above the clouds.[332]

October 20–22: Ted to Sylvia: "My dearest Sylvia": Two letters from her today: "The first melancholy sad, the second its antithesis. . . . I don't know what you're doing tonight—Saturday at eight to make me suddenly nightmarishly depressed. I kept trying to think of reasons why I should feel so miserable. Then a dog started howling of all things. . . . All my love every minute. . . . Oh Sylvia. Where are you? I could crush you into my pores. I've never passed such days. A soulless existence, in that I live purely the presence of this shape and weight,—all my sense is utterly with you." Suggests another plot for a story. {THL}

October 22: Detailed comments on her poem {THL}

It had been a trial living apart from Ted, which Sylvia thought was necessary because her marriage might contravene the rules of a Fulbright fellowship, and she might be able to pursue her studies more easily and with more concentration by herself, but the couple decided that they could no longer stand their separation and resolved to openly announce their union.

October 23: Ted to Sylvia: "to spend our first year—which is longer than most marriages last anyway—apart, seems mad." {THL}

"DAY OF TRAUMA, DECISION & JOY desperate hope for Ted's call," attends Krook lecture, speaks with Judy Kahrl,[333] awaits Ted's call, sends a "desperate telegram," no answer and sends a second telegram, no lunch, Ted calls to say they will "hash this out," mails his manuscript, CSM accepts her Benidorm article and sketches, awaits the "miracle" of Ted's arrival and their decision to make the marriage public and live together, after a steak dinner, "warm love & release—weary love"

"dearest mother": Describes the sketches in CSM, "ted is coming to live & work in cambridge for the rest of the year."

To Peter Davison: Encloses Ted's children's fables for publication with Atlantic Press or to be passed on to other publishers, reports she is writing stories and preparing to write a novel. "I feel somehow like a feminine Samson with hair cut, if such is possible—being so far away from editors & publishing houses!"

October 24: An "oppressive hectic dream" about Joan Cantor, feels pressured to study Chaucer's "Demon Queen," writes a short "Sonnet After Squall," begins "On the Plethora of Dryads"

"On the Elevation of Reason: Some Notes concerning the Cambridge Platonists, Whichcote and Smith," typescript with supervisor's comments {PM}

October 25: Awakes suddenly, reads C. S. Lewis on the Fall, a "stimulating" supervision with Wendy Christie[334] and Dorothea Krook, confides in them about her marriage, "dear Ted waiting—powerful love," to the Taj Mahal for a late lunch, "exhausting" session with the Ouija board and "poem accepting prophecies"

October 26: Finishes writing "On the Plethora of Dryads" in a "clear mood," shops, an "afternoon of love" with Ted, another exhausting session at the ouija board talking with the dead, pork and wine for supper, drowsing by the fire, talk with Ann Hopkins,[335] Grace,[336] and to bed

October 27: A "queer dream" about Warren who sends a "strange" birthday card saying "join me in sin," "good talk" with Ann Hopkins, "terrible afternoon of sorrow & anguish" over Ben Nash, "microcosm of nightmare of lax faithfulness"

Ted gives her a pack of tarot cards as a present {PA}

7:30: Loves her red velvet dress birthday gift and her dinner of sherry, smoked salmon, pheasant, and Chablis, "great rapport & centering"

October 28: A "lazy" day, writes a draft of a poem, "Vanity Fair," soup and cheese sandwiches for lunch, works more on poem, a "sharp" headache, begins slowly on Hooker's "Ecclesiastical Polity," "rich" supper of rice, tuna, and cheese with red wine, "embracing warm talk—fresh walk after rain—stars & fallen leaves"

"Dearest mother": Delighted with her birthday gifts and cards. Describes sessions at the ouija board and their contacts with spirits.

October 29: Reads Hooker in the library, attends Krook lecture, shops for sherry, soups, meat, mushrooms in a downpour, "queer fight" with Ted over their "lurid pasts," writes Hooker paper, a "rich" spaghetti and red wine dinner, a walk out with Ted to deliver her completed paper on Hooker

October 30: The blow of a *New Yorker* rejection, but she "defiantly" mails to the magazine her stories, "Invisible Man," "Wishing Box," and "All the

Dead Dears" as well as two of Ted's, works all day at the library, breaks for lunch with Ted, visits a house at 55 Eltisley Avenue, kebab at Gardenia, "very tired—early bed"

October 31, 8:15: Train to London with Ted

11:00: At the Fulbright office to meet with Dr. Gaines, "Handsome, genial man," pleased with her reception and announcement of the marriage, a "lousy afternoon in pub—utter waste—tearful dinner at Schmidt's—hectic sick train ride back w. Ted," supper and lovemaking, "sense of tension insecurity & longing for love expressed"

Winter 1956–57: *Chequer* publishes "Epitaph for Fire and Flower," "On the Difficulty of Conjuring a Dryad," "Miss Drake Proceeds to Supper," "November Graveyard"

November 1: "rough day—Dr. Krook & talk of difficulties of position," rushes to see Miss Morris, telling her about the marriage that was received very well, she cannot eat, waits for Ted, sherry party at Judy and Stan's [Kahrl] "love weary—period—Taj Mahal supper—home exhausted to bed"

"Dearest mother": Deplores Britain's bombing of Egypt and "smug commercial colonialism. . . . What joy there must be in Moscow at this flagrant nationalism and capitalism! This aggression by force, which has always been the cry of the Western Allies against totalitarians."

"Some Notes on Hooker's *Ecclesiastical Polity* (Books 1–3)," typescript with supervisor's comments {PM}

Plath remained a pacifist and anti-imperialist and publicly denounced the attack on the Egyptian-held Suez Canal.

November 2: "grueling worst day—rain, wind" but a "good supervision" with Dr. Krook, reads C. S. Lewis, lunches with Ted, types his job application for teaching at American air base, "stiff talk" with Miss Cohen, more rain, fish and chips and beer

November 3: "exhausting aftermath day," stays home, writes a "bad political poem," boldly introduces Ted to Miss Burton, with Ted buys books, soup lunch at Whitstead, bikes to town for book, a "lazy" afternoon of reading *McCall's*, supper in their new house

November 4: Wakens from "furious jealous dream about Janean[337] & T," a hot bath after breakfast, an uneasy day, tea with Miss Morris and Ted in "gray satin & red velvet suit," an "itchy" afternoon at the new Eltisley house because of "intolerable chairs & bad light," exhausted and nagged with an urge to paint the house and conquer it, "Ted's dear understanding," washes hair and to bed

November 5: "Horrible day—sick to stomach over heart-rending notes & cry for help from Hungarians"[338] as the British invade Suez, walks with Ted in the "golden green Clare gardens," feels a "division bet. Ted & work,"

afternoon in the Botanical Gardens watching ducks and arriving at a peace "of sorts"

CSM publishes "Sketchbook of a Spanish Summer" [Part 1]

November 6: "Better day although infuriated w. bathroom conflicts," Ted's poems accepted by *Atlantic Monthly* and *Poetry*, class with Krook, a "crisp invigorating day," types Ted's poems for submission to several journals, "awe-inspiring court-organ suicide from Kings chapel—lantern light," fish and chips with Ted, "love & relaxing deep at home"

"Dearest mother": "I am so emotionally exhausted after this week, and the Hungarian and Suez affairs have depressed me terribly from Hungary yesterday before the Russians took over I was almost physically sick."

CSM publishes "Sketchbook of a Spanish Summer" [Part 2]

November 7: "tedious tense day," reads Hobbes's *Leviathan* all day, talks with Ted about Auden, Frost, "jealousy, feeling of division—tightrope walking steps—wish for wisdom of Eve," steak dinner and back to Hobbes

November 8: Clear autumn day, reading Hobbes for a paper, "blow in stomach by nasty ADC letter—hashing out logic & reply w. dear Ted," finishes and delivers paper at twilight, a hamburger and cheese sandwich supper, "good love; bad spoiled day: stars"

November 9: *The Nation* rejects her poems, works "stubbornly at bad poem" until a stimulating talk about Hobbes with Krook, a soup lunch with Ted, shops in rain for fruit and meat, buys sofa and paint, for their first dinner in their new house: roast beef, mashed potatoes, peas, raspberries, "good love—very tired"

November 10: Sneezes and experiences excruciating back pain, X-rays reveal slipped disc, prescribed codeine, Poppy Day with Ted, costumed crow floats, a "Greek & Trojan battle on Backs," lunch at the Eagle, supper at Taj Mahal, "grim rainy evening & pain"

Granta publishes "Ella Mason and Her Eleven Cats"

November 11: A "stoic day of work—bad twitchy Cold, back pains," calls Miss Morris and learns the Newnham council has agreed she can stay on, writes "Poppy Day at Cambridge" article and sends to *New Yorker*, more drugs and misery but back is improving as her cold gets worse, "miserable nadir"

November 12: More sneezing and twitching, writes business letters, trouble concentrating, reads "Paddy Chayevsky's plays—Tearful, exhausted," pork, rice, and peas supper, takes codeine, reads in bed "all drugged & sorry"

"Dear Ted's mother & dad": Brags about Ted's acceptances. "I am very proud." Speaks of her articles in CSM. In spite of her cold and slipped disk, "I really feel blissful I can continue on my Fulbright studying at prim Newnham as Mrs. Sylvia Hughes."

November 13: Recovering from cold, sends off three stories to *Mademoiselle*, arranges Ted's poems in book form, begins reading Hume, a good steak, bread and butter meal, "queer feeling of jealousy v S. O.[339] dissipated it—washed hair"

"Dearest mother": Describes her medical woes, her rejections, her eagerness to get to America with Ted, furnishing their new home.

To Edward Weeks: Encloses three stories, "That Widow Mangada," "The Black Bull," and "Afternoon in Hardcastle Crags."

November 14: "Lousy soporific day" by the fire "sense of perverse inertia in Ted & self good love"

November 15: "much better day," calls Dr. Krook, plows into Hume, writes jingles for *New Yorker*, reads new issue of *The Nation* with Ted's poem "Wind" in it, soup at Alexandra house, "argument & home OK"

November 16: An "exhausting" busy day, CSM articles arrive, to the laundromat, then Boots,[340] dashes back to Newnham for lunch of cheese, eggs, peas, strawberries, buys lampshades, makes a roast beef dinner for Ted and Olwyn, "very tired—home to bed"

To Lucas Myers: Describes ouija board sessions summoning a spirit, Jumbo, who calls Sylvia a "vixen." {THL}

November 17: Works all morning on poem, "Black Rook in Rainy Weather," afternoon reading, talks with Ted and Olwyn, walks out on a "frosty gray invigorating air" shopping for books with Ted, fish and chips dinner, ouija board prediction of "football pool fortune," "poetry & story predictions"

November 18: A "queer 'locked in' day," a late breakfast, dashes with Ted and Olwyn off to the train station, finishes rewriting "Black Rook in Rainy Weather," writes "Soliloquy of the Solipsist," reads more Hume, "strange stubborn balk at work, tuna cheese & rice supper at Whitstead—weary & changeling distance from Ted—up till one in trance," writing poem "April Rhapsodies"

November 19: "much better day—clear crisp," writes poems "Letter to a Purist" and "On the Extra," returns to an "obsessive state of writing poem under pressure to put off work," Ted has good news about a job at a boy's school, lovemaking, pork and peas and a stiff "cider reception for Mr. Gaines," hears the carillon in the "blue on mist—Senate House Passage[341]—the moon over church"

November 20: Rushes breathlessly to Dr. Krook's lecture, mails six poems to the *New Yorker*, "stoic unbroken day" of typing Ted's poem for the *Harper's* first book contest

November 21: a "weary day," writes two poems: "Item" and "Megrims," depressed about Ted's *Harper's* rejection, finishes reading Hume, begins Mill,

weary of "academic pressure in new hour," fish in milk for supper with "dear Ted—very darling understanding—tired"

"Dearest mother": Trudging through academic obligations, writing "several good poems" and preparing a submission to the Yale Younger Poets series, typing Ted's poems, mentions a visit from Olwyn, a "changeling" and "quite selfish," although "I do like her."

November 22: "tired day—very depressed," an empty mailbox, dashes off a "bad little paper on Hume," meets a "very rugged & handsome" Ted for Mexican liver at Alexandra House, has a talk with Sue Weller, scrubs floors at her new home, washes a "mountain" of dishes, pork for dinner, "love—exhausted"

November 23: Writes "Monarch Mind" poem, types contents of Ted's book all morning, sends his poems to the *New Yorker*, *Yale Review*, *Sewanee Review* and hers to the Boreston Contest, reads Bentham, "still tired"

November 24: "steadier day of work," finishes reading Bentham, "more peaceful & stoic than usual, reading with Ted," a steak, tomato, and string bean supper, reads about politics with "great & vivid interest"

November 26: "bad tempered, exhausted day," waits for delivery of forty light-blue bricks for a bookcase, shops for wine and groceries, fatigued, can't read, "far sad love for Teddy trapped feeling in weary work," makes a "good" mushroom, onion, and egg omelette, "strong love w. dear Teddy"

November 27: "nightmare day," a vivid dream of war on Ganges, atrocities, types Ted's poems, an hour late for lecture, "bad surrealistic dream—feeling of ghost mess," and sick "in spite of a bright clear day—frantic depressed wild," sawed wood for the bookcase, "salvation" in Professor Redpath's tea, "perspective regained," and "renewed joy" with Ted, works on a paper until 4:30 a.m.

"The Utilitarianism of Bentham and Mill: Some Comparisons and Contrasts," typescript with changes and notes {PM}

November 28: "exhausted—caffeine tense numb day," yet a fine meeting with Dr. Krook about Bentham and Mill, soup lunch at home, admires the bookcase, drowses, "dear Teddy & tales of school" where he teaches

November 29: "much better day—clear, blue, frosty, sunny, invigoration," a joyous trip into town to the butcher, Market Hill, browsing at Heffer's, reads Basil Willey on Matthew Arnold, "dear Ted," still feels "tired & subdued," a steak, mushroom, and string bean supper with red wine, "good love," to bed

Thursday morning:[342] "Dearest mother": Describes their new home, Ted's painting of the walls light blue, which she matches by painting the firebricks of the bookcase, describes how Ted has mastered the attention of his wayward pupils.

Thursday also: "Dearest mother": Encourages her mother to use her as an example when talking to Dick Clark, a family friend suffering depression: "get him to talk, break down whatever sick reserve & terror he has & even get him to let go and cry. . . . Get him to go easy on himself; show him that people will love & respect him without ever asking what marks he has gotten. I remember I was terrified that if I wasn't successful writing that no one would find me interesting or valuable. . . . Above all, don't try to be rosy; start from what he thinks is the situation. . . . He will trust you if you treat his problems as real ones."

November 30: The *Morning Press* (Bloomsburg, PA) publishes "Second Winter"

December: From Ted to "Dear Sylvia's Mother & Warren": "I am applying pressure to get Sylvia started on her novel." {THL}

December 1: The *Morning Press* (Bloomsburg, PA) publishes "Apotheosis"

December 4: "Dearest mother": Encloses a tribute to Wilbury Crockett who first encouraged her to stay at Cambridge.

"Literature Versus Dogma," typescript {PM}

December 7: End of term

"Chaucer: The Most Versatile of Fourteenth Century English Poets," typescript with supervisor's comments {PM}

December 9: Aurelia and Warren phone Sylvia and Ted.

December 10: "Dearest mother": Homesick after speaking on the phone with her mother and brother last night, plans on writing for women's magazines to help with expenses of traveling to the States.

"Dear Ted's mother & dad": "I am so proud of Ted & his job—those little boys must just love him; he has got them writing little ballads, & acting little plays." Looks forward to a Christmas visit.

December 12: To Peter Davison: Hopes that perhaps Ted could get a job teaching writing courses at Harvard.

To Marion Freeman: Thanks her for "generous" wedding gift: "I can't wait to bring Ted home in June!"

December 15: To Ellie Friedman: "We work, we thrive."

To Marcia Brown: Describes meeting and marrying Ted Hughes: "He was very simply the only man I've ever met whom I never could boss; he'd bash my head in." They have settled into a grimy home they are fixing up. "If only you could imagine how grim England is in winter!"

Hopes "staunchly British" Ted will see that America is a better place to bring up children.[343]

December 17: To Robert Gorham Davis: Announces her return to Wellesley in June with her husband and that they will both be looking

for teaching positions, wishes to know if it is possible to apply for a teaching position.

December 20: "Dearest mother": Enjoying the presents, including $25 from Mrs. Prouty, works on the "scabrous" kitchen. "Oh, how I secretly hope that Ted finds America the wonderland I feel it is and wants eventually to settle there. . . . Our manuscripts all hang fire."

To Warren: Proud of his Phi Beta Kappa award, hopes he gets a Fulbright, describes her living arrangements: "I sometimes feel like taking a hatchet & going out like the old foolish knights to slay the Cold."[344] Looks forward to their reunion.

1957

Undated: "The Device of the Dream Vision in Chaucer and a Few Comparisons," typescript with notes and changes, and "Apotheosis" {PM}

January: *Poetry* publishes "Wreath for a Bridal," "Dream with Clam-Digger," "Strumpet Song," "Metamorphosis," "Two Sister of Persephone," "Epitaph for Fire and Flower"

Atlantic Monthly publishes "Pursuit"

January 2: "Dearest darling mother": "the next three months are the grimmest, but at least I have the house all fixed up & the heating relatively good; heat & food are the two things I refuse to economize on." Reveling in all the presents from home and in her home improvements, asks her mother to be a sponsor for Ted since he does not yet have a job in the States and has to prove he won't be a "charge" on America.

January 3: Describes a walk in Grantchester. {PJ}

January 9: "Ted's Nimbus acceptance—long visit with lugubrious" Sue Weller, "pleasant Pan interlude" with Ted and sherry "making out football pools," a casserole supper and lazy evening writing letters

"Dearest darling mother": The "planets point to a magnificent successful year for us both, & we will work to make it come true."

January 10: Describes the "heart of town." {PJ}

January 14: "Dearest mother": Mulls over various schools where they might teach

January 15: Sees Miss Morris

January 18: Welsford lecture on Spenser

January 19: Meat delivery from the butcher

"Dearest mother": "Your lovely plump pink letter came this morning & I read it aloud to Ted over coffee. We both enjoy every word you write so much." Enjoys cooking for Ted and wonders about the cost of living in the US. For Ted teaching is temporary; he wants only to write.

January 21: Coleridge essay due

From Ted to "Dear Sylvia's Mother and Warren": "Sylvia and I write pretty constantly." Describes their writing day, her "dazzling and disturbing" poems, "Sylvia reads out your long fascinating letters. I'm getting a very definite idea of America—of your America from them. . . . Sylvia by the way is becoming the most superlative cook I ever encountered. She adds one Ace dish each week." {THL}

January 22, 12:00: Dr. Krook on the moralists

1:15: Lunch at Newnham

4:15: Supervision meeting with Dr. Krook

"Some Notes on Coleridge *AIDS to Reflection*," typescripts with notes and changes {PM}

January 23, 12:00: Lecture on Chaucer

4:00: [Valerie Joan] Pitt for practical criticism

5:00: [John Caldwell] Hodgart lecture

January 24, 10:00: Welsford lecture on Spenser

3:30: Supervisory meeting about Chaucer

January 26: *Granta* publishes "The Wishing Box"

January 28, 11:00: Coffee with Mary Ellen Chase

"Dearest mother": Expects Mary Ellen Chase will give a "reliable picture of teaching prospects." Sick of "living on grants & being a perpetual student."

January 29: "Dearest mother": Relieved to hear Chase says no need for doctorates. Smith would prefer she concentrate on her writing and publications.

January 31: "Some Notes on Chaucer's *Canterbury Tales*," typescript with supervisor's comments {PM}

February 1: "huge blustery mild grey day—great pushing hand of wind," *Atlantic* rejection a blow, weary after staying up until 2:30 last night to finish a paper on *The Canterbury Tales*

February 3: "Dearest mother": Explains that Ted has made a "huge chart of the English writers & their dates" and "stuck it up all over one wall of the bedroom" for her to study.

February 4: "Chaucer's *Troilus and Criseyde*," typescript with supervisor's comments; "Some Observations on Locke's *Essays Concerning Human Understanding*," typescript with supervisor's comments {PM}

February 8: "Dearest mother": Describes her walk in Grantchester: "I felt myself building up a core of peace inside and was glad to be alone, taking it all in." Still trying to win the football pools using a ouija board, encloses "The Lady and the Earthenware Head."

February 16: "Dearest mother": Concerned that Mary Ellen Chase is not doing all she could to secure jobs for her and Ted.

February 18: To Smith Vocational Office: "Any suggestions regarding the sort of job that might be open to me when I return would be most welcome."

"D. H. Lawrence: The Tree of Knowledge Versus The Tree of Life," typescript with supervisor's comments {PM}

February 23: Telegram for Ted Hughes: "OUR CONGRATULATIONS THAT HAWK IN THE RAIN JUDGED WINNING VOLUME POETRY CENTER FIRST PUBLICATION AWARD. LETTER WILL FOLLOW." {PA}

Ted to Olwyn Hughes: "Sylvia has not stopped dancing since—it is music for a month." {THL}

February 24: "Dearest mother": Ecstatic over telegram announcing *Hawk in the Rain* has won the Poetry Center First Publication Prize, including publication by Harper's, notes that it is the "anniversary of the fatal party where I met Ted! . . . Genius will out! . . . I am more happy than if it was my book published! . . . There is no question of rivalry, but only mutual joy." She hopes the award would contribute to her "long-range project of making Ted love America."

To Smith Vocational Office: Seeking a position "in or near New England" teaching freshman English for herself and her husband.

Ted to Gerald and Joan Hughes and family: Mentions Sylvia has been pleased with their letters: "she's the most superstitious fanciful apprehensive diffident creature in the world, and what she's met so far of this family has bewildered her a bit. . . . Sylvia is my luck completely." {THL}

February 25: Outlines a plot for a novel about an American girl who "comes to Cambridge to find herself." Goes through various inadequate lovers until she finds her "big, blasting dangerous love." The marriage to Ted has fulfilled her quest to find herself, the husband who will help her raise "a batch of brilliant healthy children!" {PJ}

February 26, 7:30: Awake since 3:30 with Ted sneezing and her mind teeming with questions about their success. "Grim argument over silly question." Ted criticizes her Earthenware Head poem. "Bad time for criticism." {PJ}

To John Lehmann, the *London Magazine*: Encloses several poems and mentions her publications elsewhere.

February 27: "Dear Ted's mother & dad!": "Isn't he wonderful!" His winning the first book contest occurs almost exactly a year after she met him. Mentions her "intuitive vision" that he could be a "great poet." The only surprise is that it has come so soon.

February 28: "Dearest Warren": Announces Ted's award. "What a wonderful family we are!"

March 2: To Michael Frayn: Thanks him for comments on her stories "Invisible Man" and "Wishing Box."

March 4: "I am stymied, stuck, at a stasis. Some paralysis of the head has got me frozen." Her novel is "atrocious." Her exams oppress her. Her dilemma: how to write about the "voyage of a girl through destruction, hatred and despair to seek and to find the meaning of the redemptive power of love. But the horror is that cheapness and slick-love would be the result of the thing badly written. Well-written, sex could be noble & gut-shaking." {PJ}

"Henryson as a 'Scottish Chaucerian,'" typescript with supervisor's comments {PM}

March 7: "Dearest mother": A newsy letter about the latest acceptances of her poems and Ted's.

To Lucas Myers: Invites him to Cambridge: "I find myself rebelling against writing midnight supervision papers instead of on a novel." Offers to type his poems.

"On Chaucer's *House of Fame*," typescript with supervisor's comments {PM}

March 9: *Granta* publishes "Resolve," "Two Lovers and a Beachcomber by the Real Sea," "Dream with Clam-Digger"

March 11: Considers approaches to her novel: "Vivid direct descriptions. First person: perhaps I can get away with third." Looking for inspiration in Joyce Cary's *The Horse's Mouth*,[345] works on dialogue scene of her novel

March 12: "Dearest mother!": "Hold on to your hat for some wonderful news: I have just been offered a teaching job for next year! AT SMITH!"

March 13: To Robert Gorham Davis: Asks for a list of books used for teaching Freshman English.

March 14: "'Damn Braces. Bless Relaxes.' Blake and Lawrence: Brief Comparison and Contrast" {PM}

March 15: To Edith and William Hughes: "Isn't the letter from the Poetry Center nice? And just imagine how wonderful it will be for Ted to have a party given for him in New York this summer." Mentions her job at Smith and the possibility that Ted might teach there too.

10:00: "Dearest darling mother": Groggy after a night of typing her last paper of the term, complains that "old maid" Marianne Moore wants to eliminate three poems "rich with sexual imagery," mentions letters from faculty welcoming her back to Smith.[346]

March 18: "Dearest mother": "I can't wait to see Ted's impact on the world of poetry." Ted has written to Poetry Center justifying two of the poems Marianne Moore wants to eliminate.

March 19: "Dearest mother": Ted has received his *Harper's* contract, which allows him to negotiate directly with a British publisher like Faber & Faber. "My best baking product is apful kuchen [apple cake]: I have got

it as close to grammy's as possible & feel so nostalgic whenever I make it. What fun we'll have cooking for Ted & Warren!"

March 26: "Dearest mother": "Ted and I both were exhausted and blackly depressed this weekend as an aftermath of little sleep & a term's accumulation of fatigue and last-minute slaving by both of us, Ted on his [school] play, me on my papers & articles. . . . I never want Ted to have to undergo a year of strain like this again. I don't care if he only gets a part time free-lance job this next year, I want him to write above all." They have decided to take out two of the poems in Ted's book that Marianne Moore objected to.

March 29: Olive Higgins Prouty replies to a letter from Sylvia announcing good news: "There is no end to the thrilling things happening. It frightens me a little. I am very proud of you, Sylvia. I love to tell your story. Someone remarked to me after reading your poem in The Atlantic, 'How intense.' Sometime write me a little poem that isn't intense. A lamp turned too high might shatter its chimney. Please just glow sometimes." {CR1}

Spring: *Gemini* publishes "Spinster" and "Vanity Fair"

April 1: "Dearest mother": Ted is right in his astrological prediction that it would be a "fine day." *Poetry* has accepted four of her longest poems.

To editor of *Accent*: Enclosing several poems and listing where her work has appeared.

April 8: "Dearest mother": Writing at least two hours a day and "plodding" on her novel. "I have a feeling in flashes that I can make it a bestseller." Mentions reciting Chaucer to the cows in Grantchester.

April 9: To Elinor Friedman: Gritting her teeth over "behemoth exams covering 2000 years of tragedy, morality, etc.etc. in 5 days of 6 hours a day writing." Mentions Ted's award and expectations of his June 29 reception in Wellesley.

To Marcia Brown: Mentions how everyone is "raving" about Ted's book, her new job at Smith, looking forward to using modern American appliances, medical care, and dentistry. "I am become an american jingo."

April 13: "Dearest darling adorable mother": More rejections of her work and Ted's, but she is cheered by the editor of *Sewanee Review* who calls her a "spectacular talent" and they are now getting recognition from British publications. "We are going to catapult to fame, I predict."

April 15: In the morning sketching a bank of daffodils and bluebells, lunch at home, resolves to study in library every afternoon, translates *Les Fleurs du Mal*

3:30–6:00: An egg supper, finishes reading Baudelaire, tired but "feeling much more courageous about exams"

April 17, 6:40: Train to London

9:00: Ted's medical exam

3:00: Return to Oxford Street

April 18, 9:00: Oxford Street: "formal interview"

12:00: Lunch with Julian Jen[347]

April 20: "Dearest mother": Describes return from London trip to obtain Ted's visa. Tests show he is in excellent health, with recent good notices for his work on BBC, anxious about her "looming" exams, prefers reading at the library to avoid interruptions.

April 21: To D. S. Carne-Ross, BBC producer: Asks for an audition by reading her own poems on *Poet's Voice*. Encloses poems and mentions important publications.

April 23: Sends a happy birthday poem to her mother: "an invincible mother / (I defy you to show me another!)"

To Warren: Praises his work in science, looks forward to a holiday to the "moors, to the sea, & home." The plan is to spend two years in America and then a year in Italy.

April 28: "Dearest mother": Spending days and nights in the library studying for exams that are a month away: "2000 years up to Eliot, concentrating on Corneille, Racine, Ibsen, Strindberg, Webster, Marlowe, Tourneur, Yeats, Eliot. Ted hypnotizes her to relax, dries the dishes, walks out in the country with her, the "dearest person imaginable." Looks forward to early June, a visit to Ted's parents, the sea voyage to America, sharing her home with Ted.

To Gerald & Joan Hughes: "I'm really convinced that in case of any such horror as H-bomb warfare, our two families: you both, Ted, me, Olwyn, my brother Warren & appropriate mates, could re-people the world to its own advantage. O for an island. We want to get wealthy & buy one someday." Looks forward to showing Ted Cape Cod and exploring the rest of the country.

May: Ted to Gerald, Joan, Ashley and Brendon Hughes: "You have no idea what a happy life Sylvia and I lead or perhaps you have. We work and walk about, and repair each other's writings. She is one of the best critics I ever met and understands my imagination perfectly, and I think I understand hers. It's amazing how we strike sparks. And when we're fed up of that we walk out into the country and sit for hours watching things. . . . America is waiting with arms open." Mentions the planned party for him at the New York Poetry Center . . . "This is very different from the life I led a year or more ago." {THL}

May 4: *Granta* publishes "Mad Girl's Love Song" and "Soliloquy of the Solipsist"

May 5: "Dear Ted's mother & dad": "I am still here in the kitchen watching my Yorkshire pudding bake in the oven to go along with our Sunday

roast and looking so forward to our coming up to stay in Yorkshire around June 5th until we sail the 19th. . . . You have no idea how forward I look to living at the Beacon again. I catch myself daydreaming about the moors, with the mad-eyed moor sheep, & then the wonderful view from your livingroom windows over the green fields which always makes me think of living on top of the world."

May 7: "Dearest darling mother!": Pleased that Warren has won a Fulbright, spends her time in the "factory-stacked library," praises her mother's openness to experience and that the family is surmounting its Puritan "scraping to get money" that resulted in guilty pleasures, mentions a party in which the couple is treated as the "literary paragons of Cambridge." Both have just appeared in *Granta*.

To Henry Rago: Pleased with the acceptance of four of her poems for *Poetry*, provides information for his Notes on Contributors.

To Warren: Delighted about his Fulbright and hopes he will visit her and Ted during their summer at the Cape, mentions her novel, now titled "Hill of Leopards," expects the book to be controversial exposing a "lot of people and places." The novel explores the "positive acceptance of conflict uncertainty, & pain as the soil for true knowledge and life."

May 10: "Dearest mother": Faber & Faber has accepted *The Hawk in the Rain* with T. S. Eliot's commendation. "I am so proud."

May 12: "Dear mother": Encloses an assortment of Cambridge magazines with her poems and Ted's: "It seems the greatest living poets think Ted is wonderful & under these auspices, his book might even make a little money!"

May 16: To Lynne Lawner: Answers Lawner's letter, describes preparations for grueling Cambridge exams, asks to hear news about Nat LaMar, who she hears has finished a draft of his novel. She hopes to see him again and that Lynne might visit the Plath home after they arrive on June 26. Recommends Dorothea Krook and F. R. Leavis for Lawner's study at Cambridge. "You will invariably feel like Isabel Archer in Gardencourt before starting on the voyage to a soul through the various overcivilized corruptions of Europe." Few British men know how to treat an intelligent woman and remain fixed on the "eternal feminine." Wants to know about Lawner's work.

May 18: *Granta* publishes "Black Rook in Rainy Weather"

May 19: "Dearest mother": Believes Richard Wilbur does not write about big subjects: war, birth, love. "I am delighted at the way Ted looks forward to America: more & more in every way. . . . In the first 2 or 3 years of our marriage we would like at least 2 books each accepted: one poetry book for each of us, a novel for me & a children's book for Ted."

May 24: "Dearest mother": Congratulates her for promotion to associate professor: "you have long deserved it." Planning on America as home

base. "We both couldn't bear living in England for myriad reasons." Wants her mother to proofread their work, calculates that they have earned about $500 for their poems.

May 27–31: Cambridge exams

May 27, 9:00–12:00: French

 1:30–4:30: Essay

May 28, 9:00–12:30: "Crit & Comp"

 1:30–4:30: "Moralists"

May 29, 1:30–4:30: "Tragedy"

"Dearest mother": "I have honestly never undergone such physical torture as writing furiously from 6 to 7 hours a day (for the last two days) with my unpracticed pen-hand: every night I come home and lie in a hot tub massaging it back to action." Ted says her typing has made her a victim of evolution. Describes her various reactions to the questions and what she made of them. She is a finalist for the Yale Younger Poets series. "Ted has been a saint: making breakfast & heating water for a daily tub, meeting me at 4:30 after exams & last night (I was very exhausted & aching) served me with steak mushrooms & wine on a tray in bed, doing the dishes afterwards."

May 31: "Chaucer"

Summer: *Gemini* publishes "All the Dead Dears" and a "Review of *Stones of Troy* by C. A. Trypanis"

June: *Antioch Review* publishes "Black Rook in Rainy Weather"

June 1–4: Packing up trunks, crating books, settling debts

June 5: "To Yorkshire"

June 8: "Dearest mother": Toasting her toes in front of the coal fire, reading Henry James while Ted tackles Chaucer, and Olwyn sleeps late after arriving from Paris, relieved to have left her filthy Cambridge house: "Both of us are delighted to leave the mean mealy-mouthed literary world of England." Seeks guidance from her mother about cooking.

June 16: Ted awakens Sylvia with a "huge vase of pink roses," Ted's Uncle Walt gives them fifty pounds {PA}, Sylvia and Ted celebrate their wedding anniversary with a walk on the Yorkshire moors

June 17: "Dearest mother": Can't remember when she wasn't married to Ted: "our horoscopes read, when Leo & Scorpio marry, they feel they've known each other forever in a former life." Reading the syllabus for teaching at Smith, looking forward to a two-week visit at home, a summer of writing in their rented Cape cottage. The title of her novel has changed to "Falcon Yard." She expects to have her second novel finished by the age of twenty-seven and to begin having the first of three or four children.

June 19, 7:00 a.m.: "To London"

c. June 19–20: Describes the day in Piccadilly Circus, Soho bars, double decker busses, cruising cars, "blond tarts on corners, in doorways" {PJ, PKS}

June 20, 10:40: Boat train from Waterloo station

　　1:00: Boards *Queen Elizabeth*

　　5:00: Sailing to America

"Dearest mother": Writes from Waterloo station: "Our deep Cambridge fatigue is all gone & we are healthy & fine. . . . Coming home with Ted will be like discovering a new country & seeing it all through his eyes."

"Dear Ted's mother & dad!": "The chicken picnic yesterday was lovely & lasted us till London where we got a very nice hotel with bacon & egg breakfast in bed near the station." Will write more from America.

June 20–25: Aboard ship: Describes food, table decorations, passengers, including "Jews, coarse—tan-faced. Two bright negresses in gaudy colors," "ribald Scotswoman," records bits of dialogue, cramped sleeping "sense of waking deep in a coffin . . . sense of the great whales moving, rising, shedding scuds of water from their great bulks and rising to view." {PJ, PKS}

Plath's stay in the Hughes home, shortly before the couple embarked for the United States, had resulted in a flare-up with Olwyn who accused Sylvia of trying to displace her in the family's affections. In effect, Plath was put on notice—that her attachment to Ted could never equal the claim Olwyn had on her brother. Sylvia walked out of the Hughes home when the tensions became unbearable and expected Ted to defend her. He made excuses for her to Olwyn, but in his correspondence at least, he was saying Sylvia could not help herself. He was already creating a kind of deterministic view of her fate foretold in what he called her "miserable past."

June 20–23: Ted to Olwyn Hughes: "The days at home were ill-starred. Don't criticise Sylvia too badly about the way she got up and came after me. After her exams etc I suppose she felt nervy—she did, that was obvious. But the Beacon is too small for five or six people—especially if one of them has an obsession about resting. And everyone was walking in and out & up and down continually. She admires you more than any englishwoman she's ever met. Her immediate 'face' when she meets someone is too open & too nice—'smarmy' as you said—but that's the American stereotype she clutches at when she is in fact panic-stricken. Or perhaps—and I think this is more like it—her poise & brain just vanish in a kind of vacuous receptivity—only this american stereotype manner then keeps her going at all. She says stupid things then that mortify her afterwards. Her second thought—her retrospect, is penetrating, sceptical, and subtle." He says Sylvia has had a "miserable past." Describes his depression aboard ship: "black and absolute. It was difficult even to speak." An Errol Flynn movie lightens the mood. {THL}

June 25: "Land NYC"

June 29: Arrival in Wellesley, Aurelia hosts a catered party for Sylvia and Ted in the backyard of 26 Elmwood Road. Over seventy guests attend, including Gordon Lameyer and his mother, Philip McCurdy, the Crocketts, the Cantors, the Freemans, Ellie Friedman, Marcia and Mike Plummer, and Peter Davison. {PA}

Aurelia remembers a radiant Sylvia greeting her guests and introducing her husband to them. {LH}

c. June 30: Ted to Olwyn Hughes: Describes the Wellesley home and surroundings, the opulent food, the excessive friendliness, the splendid houses, the kindliness of people. {THL}

July: *Poetry* publishes "The Snowman on the Moor," "Sow," "Ella Mason and Her Eleven Cats," "On the Difficulty of Conjuring up a Dryad"

July 1: To Lynne Lawner: "Everything seemed immensely sparkling & shiny & fast-paced & loud after my bucolic existence on the Backs and the Bronte moors." Describes a customs inspector suspiciously going through a book crate. She told him she was going to be a college teacher. "Yeah," he said looking her up and down, "you're too young to get a job like that." Advises Lawner on what she knows about Cambridge.

July 8: "Dearest mother," from Elmwood Road: "It is absolute heaven here: peace, quiet, and Space to put our things: no clamor of neighbors & odds & ends to do." Looks forward to her visit after just hosting one from Warren.

July 9: To David Freeman: Thanks him for the "super salt & pepper shakers—<u>how did you know</u>? They are <u>exactly</u> our taste, very pure & classic-lined of natural material and <u>beautiful</u>, with those shining line insets. Ted & I will use them forever and have never seen any so fine. It means so much to have someone instinctively <u>know</u> one's taste—both of us like simple, modern functional & beautiful things—and your gift will go perfectly with our stainless steel set & rough linen."[348] {HR}

July 12: To Elinor Friedman, from Elmwood Road: To the Cape to-morrow, taking with them necessities: "typewriter & that enormous and magnificent American frying pan which we will be perching on the edge of and eating out of." Describes renting an apartment in Northampton.

July 13, 10:30: Dental appointment, Warren drives Sylvia and Ted from Wellesley to their rented writing cottage in Eastham "in the family car, their bicycles strapped to the car's roof" {PA}

Aurelia paid for a few months at the Cape before Sylvia was scheduled to begin teaching at Smith. Hughes felt uncomfortable accepting Aurelia's largesse, and Sylvia had trouble settling down to write the novel that continued to elude her.

July 15: "The virginal page . . . the painful, botched rape of the first page. Bad dreams": "diabolically real: Haven house, the feet of Smith girls past the

room, which becomes a prison . . . no private exits. . . . Why these dreams? These last exorcisings of the horrors and fears beginning when my father died and the bottom fell out. I am just now restored. I have been restored for over a year, and still the dreams aren't quite sure of it. They aren't for I'm not. And I suppose never will be. . . . All I need to do is work, break open the deep mines of experience and imagination, let the words come and speak it all, sounding themselves and tasting themselves." {PJ}

July 17: Regards her earlier fiction as "slick," relies on Ted and her work to get her going again. {PJ}

July 18: "No more dreams of queen and king for a day with valets bringing in racks of white suits, jackets, etc. for Ted & ballgowns and tiaras for me." Works on story drawing on events leading to her suicide attempt and to "earthy RB." {PJ}

"Dearest mother": Enjoys baking in Mrs. Spaulding's[349] oven at the Cape, getting back to writing is "awkward and painful," but it is the "prime condition" of their happiness. Writing in the morning, swimming in the afternoon, reading in the evening: "You could have done nothing more wonderful than giving us these seven weeks."

c. July 18: "Spaulding's Trailer": Describes the contents. Sketch of a story "The Great Big Nothing" and a "vivid character study" of the Spauldings. {PJ}

July 20: "We dream: and my dreams get better," as big game hunter Ted saves her from a tiger-man, conceives of her Cambridge novel of "American innocence on the saturated spot of history." {PJ}

July 21: "Dearest mother & Warren": Beginning to make progress on a story, with "two more acting themselves out in my head," as well as continuing with her novel, announces the *New Yorker* has accepted Ted's poem "The Thought Fox," declares she will do all the cooking during their visit: "Mrs. Spaulding is very dear & brought over a little quahog pie & blueberry muffins."

To Marcia Brown: Describes her rental in Northampton, meeting Daniel Aaron who is very reassuring about her teaching, mentions all of Ted's great success: "And he just sits, unshaved, his hair every which way, munching raw steaks & writing more. Very wonderful."

July 22: Dear Ted's mother & dad": "I've never seen Ted looking so well." Touts his successes: "Everyone who has met him, admires & likes him, and I'm sure that this year will establish him as the brightest young writer in America. . . . Ted and I are thriving, but miss you both, and the lovely moors and curlews and great windy days."

July 25: Mentions work on "Trouble-Making Mother" as "close to my experience," admonishes herself: "The artist's life nourishes itself on the particular, the concrete" as she has trouble writing poems. The heroine of

the story is Judith Greenwood, a precursor of Esther Greenwood in *The Bell Jar*. The *Saturday Evening Post* rejects the story. {HC}

July 29: Thinks of novel and cautions herself against sentimentality: "take a lesson from Hemingway. . . . I am back to a certain stoic stance: to begin again and write and read in the afternoons and evenings and to hell with the beach for a while." Works on a cake story about a young woman absorbed in her husband's success and worried about sacrificing her own personality but who comes around eventually to make peace with her homemaking by baking and welcoming him home, knowing "she will stick with him, and that he has truly come back to her." {PJ}

July 30: To her mother: "Ted and I loved every minute of your stay and it was great fun planning for it. . . . I am once more reading in the evenings: Faulkner this week, whom I find very difficult, and must get used to. Could you possibly get the Viking Portable Faulkner on your discount and send it down soon?"

July–August: Detailed description of pinecone, describes the Spaulding's trailer, corn vases {PJ, PKS}

c. August 1957–c. July 19, 1958: Notes for stories: "Mama McFague & The Corn Vase Girl," "A House for Mama McFague"

August 4: "Dearest mother": We have both been a bit blue this week after your departure and a bunch of rejections," Ted's ear infection, doctor's bills.

August 6: "dearest mother": A rundown of writing projects.

August 9: "That's my trouble. I see it very clear now: bridging the gap between a bright published adolescent which died at 20 and a potentially talented & mature adult who begins writing about 25." Describes last two "black lethal" weeks when she could not write and worried that she was pregnant and that would wreck her writing and teaching plans. Finally the "hot drench" and "red stain dreamed for" arrives and she is relieved. But then her book is not chosen for the Yale Younger Poets series and the "misery of knowing half of the poems, published ones, weren't any longer, or in two years would definitely not be, passable in myself because of their bland ladylike archness or slightness." {PJ}

August 20: Visits Rock Harbor on the bay side of Cape Cod {PKS}

August 21: Reads Henry James, looks forward to the "blissful concreteness" of her teaching job, notes for a story. {PJ}

August 27: Ted to Gerald, Joan, Ashley, and Brendon Hughes: "We sat, we got brown on the beaches, we idled, for 3 weeks. Then we had a black week, in which Sylvia lay helpless with sheer depression, and I went about with a melon grafted onto the side of my head—a corpulent drumming devil in the likeness of an abscess & swelling—the abscess right in my ear. This black week broke last Sunday the 3rd or 4th when we rode five miles

to the nearest Doctor. It was strange because a long tedious spell of 98°
per day broke with it. The rain fell as I have never seen it. Thunder was
continuous. I saw 3 trees that lightning had just struck within 20 yards of
the road. Anyway the Doctor's magic was good. The ear had cleared up by
Tuesday, Sylvia cleared up, and suddenly we have begun to write like angels
and apply our brains like the bits of electric drills." {THL}

August 28: Notes for story about a "weak-willed girl." {PJ}

c. September 1 1957–August 31, 1958: Descriptions of Whelan's garage
{PJ, PKS}

September 5: "Dearest mother": likes her "light and airy" Northampton
apartment, describes setting up her new home, lists the expenses of moving
in, she is "manager of the exchequer."

September 6: Ted doesn't know how to use the percolator and makes a
mess of it. "Story: woman with poet husband who writes about love, pas-
sion—she, after glow of vanity & joy, finds out he isn't writing about her
(as her friends think) but about Dream Woman Muse." {PJ}

September 12: In terrible pain after moving furniture, feels she is going
to vomit as Ted holds her head over the toilet bowl, recovers and thinks of
a D. H. Lawrence–inspired poem, "Crucifixes," works on different versions
of story about Haworth and walking to Wuthering Heights, an "insecure"
American wife of a British writer and a character based on Ellie Friedman. {PJ}

"Dearest mother": Settled now and the apartment is "lovely," draws
a picture of the botched job the dentist did on her teeth.

September 14: *Daily Hampshire Gazette*: "Ex-Gazette Writer Returns as
Smith Faculty Member" {PA}

September 18: Publication day of *The Hawk in the Rain*: the owner of
a local bookshop sends the couple two bottles of champagne. They share
one bottle by candlelight and save the other for the end of Sylvia's first
teaching week. {HC}

September 23: "Dearest mother": In two days she will teach her first class.
Follows her mother's advice and goes on "morale boosting" clothes shopping.

September 24: Trouble sleeping before her first class {HC}

September 25: Sylvia's first class at Smith[350]

Autumn: *New Mexico Quarterly* publishes "On the Plethora of Dryads,"
Accent publishes "Recantation" and "Tinker Jack and the Tidy Wives"

Ted to Olwyn Hughes: "Sylvia is creaking under her burdens. This,
for her, except insofar as it is a trial of character by ordeal, is a year lost. She
works every hour." {THL}

October 1: "Letter to a demon," a "soul-annihilating fear . . . The groan-
ing inner voice: you can't teach, can't do anything. Can't write, can't think."
But she vows to fight this feeling that she must be a "paragon," and to work
day by day to do the best she can. Vows to maintain a "stoic face." {PJ}

October 6: In the *New York Times Book Review*, W. S. Merwin hails the publication of *The Hawk in the Rain*. {EF}

October 27: To Lynne Lawner at Cambridge: "You are not unusual: you are, as you say, freezing, sick, and uncertain. Well, so was I." Offers advice about how to negotiate her way through Cambridge and about her academic program, mentions she has been going through a "black spell."

November: *Grecourt Review* publishes "All the Dead Dears"

The city/country dichotomy that bedeviled Plath and Hughes would be repeated when they returned to England. Added to their funk was a factor Plath never seems to have acknowledged in her letters: Hughes did not like the American way of life and felt out of sorts and out of place, although unlike Plath he did not write as much about his depressions, and she tried to conceal her own so as not to alarm him.

November 3: "Dearest mother": She cannot be frank with her colleagues, saying "how I begrudge not sitting and working at my real trade, writing, which would certainly improve rapidly if I gave it the nervous energy I squander on my classes . . . we can't stand city living, and don't enjoy suburbs where neighbors children and radios impinge on the air. We are really country people, and there must be a sunny hilltop place we could buy sometime in the next 10 years."

November 5: To Warren: "I've been in a black mood and haven't felt like writing anybody." Exhausted correcting sixty-six papers, worried about her teaching, "deathly nervous," quotes at length from positive reviews of Ted's book. "We're really terrifically excited about all this."

"Dear Ted's mother and dad": Thinking of her "heavenly time" at their home, describes her hectic teaching schedule, Ted's splendid performance at the Poetry Center, sales of 1,000 copies so far of his book, wonderful reviews, loves their gift of mother-of-pearl earrings for her birthday, their plans for Boston the next year, deciding the "academic life is probably not for us," her $100 prize from *Poetry*.

Tuesday night: "Time to take myself in hand. . . . Keep quiet with Ted about worries," checking her tendency to share her miseries. "I must learn to be very calm & happy: to let him have his time & not be selfish & spoil it." She will tough out her teaching and not quit as she did with waitressing and babysitting. {PJ}

November 7: *The Sophian* publishes "Hughes Depicts Cambridge Scene" [interview], and reports that Deborah Coolidge, one of Sylvia's students, hung herself on November 6 by Paradise Pond. Sylvia says nothing about the suicide in class. "She just forged on ahead," remembered Ellen Nodelman, one of Sylvia's students. {HC}

November 28: To Warren: Correcting seventy term papers, expects to be invited to teach next year but has decided against it, even with the prospect

of a promotion. Academic life is "Death to writing." Plans on moving to Beacon Hill on the "slummy side," records her poetry for Harvard's Woodberry Poetry Room, meets the Merwins, he "rather unpleasant in many ways." Devours the literary gossip about Robert Lowell, expects a hard life but one better than "tame campus poets." Describes a sumptuous Thanksgiving with Aunt Dot, looks forward to completing a book of poems, stories, and work on a novel.

December 8: "Dearest mother": Relieved that her mother has recovered from a hospital stay, preparing for her second semester of teaching, amazed that she has remained healthy through the rigors of teaching. "Ted, at last, is writing wonderful poems again" after a "dry spell."

December 15: "lethargic and feverish," cancels the rest of her classes—five days' worth," drives home with Ted to Wellesley, treated for viral pneumonia {PA}

December 16: To Warren: "I am counting the days until June 1st."

To Lucas Myers: Congratulates him on the appearance of his poems in *Poetry*, teaching uses the "wrong kind of energy," hopes he will come home from England.

c. Mid-December: To Elinor Friedman: "I am looking to June 1st & my restored humanity with stoic but starved mien." Hopes to see her in Wellesley.

To Gerald and Joan Hughes: "Managed to cook a lot now, though, which I love—so Ted & I regale fellow-writers & teachers on wine or tea, casseroles & spaghetti sups, pineapple upside down cakes—my one main way of being creative, unless making up classes on DH Lawrence & Dostoevsky could be called remotely that."

Postscript to a letter Ted writes: "Isn't he magnificent!!!"

December 24: Recovers enough, after antibiotics, to join family in trimming Christmas tree {PA}

1958

Undated: "Dialogue Over a Ouija Board: A Verse Dialogue," "Snake-charmer," "Yadwigha on a Red Couch Among Lilies: A Sestina for the Douanier,"[351] "Above the Oxbow," "Stone Boy with Dolphin," "Sweetie Pie and the Gutter Men," "Beach Plum on Cape Cod," typescripts {PM}

January 4: The "ice-ache" of winter: "It will take months to get my inner world peopled, and the people moving. How else to do it but plunge out of this safe scheduled time-clock wage-check world into my own voids. . . . I dream too much of fame, posturings, a novel published, not people gesturing, speaking, growing & cracking into print." Notes for "Jack & Jill story"

and *Falcon Yard* and how to reconstruct her childhood, and the experiences leading to Cambridge.[352] {PJ}

January 6: To Warren: Preparing to teach *Crime and Punishment*, suffering a cold and "battle fatigue," she has told a "very sorry and surprised" department chair she will not return next year, expects to enjoy her last semester of teaching now that she has announced her decision. Ted has secured a teaching position at the University of Massachusetts at Amherst, so they will be able to save some money toward their year in Boston.

January 7: Annoyed by faculty members like Albert Fisher and George Gibian coaxing her to remain at Smith. {PJ}

January 8: "How I can go, meeting & exorcising my own ghosts here!" {PJ}

January 12: Watches *Citizen Kane*, walks with Ted observing the detritus of Christmas, works on her novel. {PJ}

January 13: "Dearest mother": "I am still inclined to be rather depressed, a kind of backwash of convalescence, I guess, but should have a chance to rest up after this week while preparing for the 2nd semester before the exams come in." Describes a meeting with one of her "problem" students. "I do feel I am building up a pretty good relation with most of my students and am feeling some rather well-placed conceit as one of the more favored of the freshman English teachers. They are really good girls."

January 14: Sylvia's book-length poetry manuscript is rejected. She types Ted's poems.

January 20: "Dearest mother": Watches a "wonderful" Hitchcock movie, *The Lady Vanishes*, "which had me jumping at shadows behind doors for a few days," plans to leave Smith on June 1.

Works on her novel: "A girl wedded to the statue of a dream, cinderella in her ring of flames, mail-clad in her unassaultable ego, meets a man who with a kiss breaks her statue, makes man-sleepings weaker than kisses, and changes forever the rhythm of her ways." {PJ}

January 21: "Jealous one I am, green-eyed, spite-seething," reads the six women poets in the "new poets of england and america. . . . I wonder if, shut in a room, I could write for a year. I panic: no experience! Yet what couldn't I dredge up from my mind? Hospitals & mad women. Shock treatment & insulin trances. Tonsils & teeth out. Petting, parking, a mismanaged loss of virginity and the accident ward, various abortive loves in New York, Paris, Nice. I make up forgotten details. Faces and violence. Bites and wry words. Try these." Describes dinner with Newton Arvin and guests.[353] {PJ}

January 22: After meetings with faculty members: "Desperate, intense: why do I find groups impossible? Do I even want them?" {PJ}

January 26: "All my diaries are spattered with undone imperatives, directives. . . . My miserable tense knotted sleepless nights now, no sleep till

dawning & then a formless drugged morning, must go." Notes for story, "The Fringe-Dweller" about a woman who thinks she is coming into her own but is "her own tomb." {PJ}

February 2: "Dear Ted's mother & dad": Loves getting their letters and "hearing about every little thing from the candy melting together in the candy jars at the little shop and what kind of weather is blowing over the moors." Describes Ted's teaching job, recovering from pneumonia.

February 3: Dreams she is late for Newton Arvin's class,[354] records her dreams, listens to Arvin's "pleasant" lecture. {PJ}

February 4: More dreams. "Six weeks more of snow & sleet. O keep healthy. . . . No reason why I shouldn't surpass at least the facile Isabella Gardner & even the lesbian & fanciful & jeweled Elizabeth Bishop in America. . . . After this book-year, after next-Europe-year, a baby-year? Four years of marriage childless is enough for us? Yes, I think I shall have guts by then." {PJ}

Tuesday night: After a dinner party: "So it is over, the stretched smiles & wearying wonder: why don't they go home?" Describes the guests. "I deserve a year, two years, to live my own self into being: which, in less than 4 months, I'll take." {PJ}

February 5: "Weary, wicked, unprepared on Joyce for tomorrow, steeped in hot tub, scrubbing of skin scum & greenly soaking, hot, the kinks & cranks out of my system." Off to Arvin's lecture after the "sweat and fury of the bed." Watches the students' "spoiled faces, sweet faces, ugly faces," feels some nostalgia for her "lost Smith-teacher self."{PJ}

February 7: To Edith and William Hughes: "Hello! You should see what a wonderful teacher Ted makes!" Expresses fondness for her own students.

February 8, 1:00 a.m.: Describes the Roches, Paul: "adonis-boy looks lost, seedy, coarse-pored with skin too-bright orange & seamed as if grease-paint were cracking"; Clarissa: "blonde & sullen, her hair down, sheened metallic gilt in the dim light."[355] On their way to see film of *Pickwick Papers*. "Anyhow, the new sense of power & maturity growing in me from coping with this job, & cooking & keeping house, puts me far from the nervous insecure miserable idiot I was last September." {PJ}

February 9: "Dear Olwyn": "We both love getting your letters, which are serving as a kind of magnetic chain linking us to Europe where, as Ted & I remind each other, we intend to be the year after next, preferably in Rome or environs, preferably on luxurious grants, preferably not having to work for our pizza." Mentions Smith's advantages in terms of teaching time, "lively young faculty," so that one part of her feels "sad to leave." She has begun to enjoy shocking her students, but she can afford to be generous with her comments now that she is leaving. Reports that Ted is good at

teaching but also pleased to know he had only twelve more weeks to teach, describes the good poems and tales he is writing.

Heavy cleaning, keeps the "filth of life at a distance." Describes herself and Ted at home. Thinks about a coming-of-age story for the *New Yorker*. "How all this life would vanish, evaporate, if I didn't clutch at it, cling to it, while I still remember some twinge or glory. . . . 'Get hold of a thing & shove your head into it,' Ted says just now." {PJ}

February 10: Wonders if poet Anthony Hecht's comment on her "energetic-girl-coming-to-campus-when-you-don't-have classes" is "calculated mockery." Prepares for class, so does Ted. {PJ}

In marrying Ted Hughes, Plath believed she was rising to the challenge of his great talent and personality. She could not understand why so many of his friends were so much smaller than him in terms of their talent and ambitions, and they, in turn, resented the way she had taken him away from them to the diminishment of themselves.[356] From their point of view, however, Plath superintended Hughes and hobbled him in some ways. She seemed too possessive, and in America she was hyper alert to any sign that he had strayed from the orbit of their marriage's creative nimbus. With someone as charismatic as Hughes, it was no wonder that Plath sometimes chafed at the competition for his attention, even though, as her letters show, she took immense pride in his success and star power. To Hughes, Smith seemed entirely too circumscribed for his wife's genius. Her decision to quit teaching was her own, yet undoubtedly his own contempt for campus poets and the life of kept professors influenced her own conviction that she had to be more daring and do without the sinecure of a teaching position.

February 16: "Dearest mother": Thanks her for Valentine's Day gift of "lovely box of petit fours." Ted's teaching is going well. She is teaching *Portrait of the Artist as a Young Man*.

"Dearest Warren": Encloses reviews of Ted's book "ranging from eulogy to venom." Getting better at teaching, but it makes her "too conscious and analytical" and fatigued. Ted's teaching and writing going well.

"How Ted got his friends I don't know—they are so small & wistful & half-drowned compared to him—Danny Weissbort & Than Minton & Dan Huws & David Ross all writing meek miserable adoring letters from London, all self-conscious, grubbing, sorrowing with no knit forces & disciplines—their demons formless and pale like grubs under turned stones and their genii asleep on the dark side of the cold moon." {PJ}

February 17: Awaiting a visit from the Roches, apartment clean, anticipating the "absolute free willingness unleashed which wine brings." {PJ}

Plath regarded Jane Baltzell as a double, so it is not surprising that she would write to Baltzell to compare their experiences teaching and what they made of the world after leaving Cambridge.

February 18: To Jane Baltzell teaching at University of New Mexico: "I'd be most glad to hear from you & what shapes forms & colors life has taken since those last hot black-gowned days in the exam rooms opposite Trinity." Beginning to teach the drama she read at Cambridge. Smith a wonderful place to teach: "It is with a double-self very regretful that I resigned, although there was this pressure, as in a high-grade aluminum cooker, for me to stay on. And on." But teaching interferes with writing. Feels "much more partisan about Cambridge than I ever did about Smith: it seems one of those primitively mystic places, saturated with spirits of the past and whatever." Remembers the misery of it, the "sodden slovenly weather" but she still endows it with the "light of gone, very gone youth, or whatever."

Tuesday morning: On the way to Arvin's lecture, relishes the thought of her clean and fragrant apartment and the party last night: good company with "Paul & blond witchy dear Clarissa, her red mouth opening & curling lie petal led flower or a fleshly sea anemone, & Paul gilded as always, but not quite so seedy . . . Rossetti-like, cherubic, curling, his pale jacket & pale buff sweater setting off his gilt and gaudy head." Very pleasant to hear how good a teacher she is. {PJ}

Tuesday noon: Decides to title her book of poems, "The Earthenware Head": "Somehow this new title spells for me the release from the old crystal-brittle & sugar-faceted voice of 'Circus in Three Rings' and 'Two Lovers & a Beachcomber,' those two elaborate metaphysical conceits for triple-ringed life—birth love & deaths and for love and philosophy, sense & spirit." {PJ}

February 20, Thursday morning: Tries not to despair over so much teaching, paper grading, and department meeting. Longs to be "away from Smith. Away from my past, away from this glass-fronted, girl-studded and collegiate town." {PJ}

February 21, Friday night: "Simply the fact that I write and am able to hold a pen, proves, I suppose, the ability to go on living." Describes her day: "A day in a life—such gray grit, and I feel apart from myself, split, a shadow, and yet when I think of what I have taught & what I will teach, the titles have still a radiant glow & the excitement & not the dead weary plod of today. . . . I am married to a man whom I miraculously love as much as life & I have an excellent job & profession (this one year), so the cocoon of childhood and adolescence is broken[357]—I have two university degrees & now will turn to my own profession & devote a year to steady apprenticeship, and to the symbolic counterpart, our children. Sometimes I shiver in a preview of the pain & the terror of childbirth, but it will come & I live through it." {PJ}

February 22, Saturday night: "A scattered dull day . . . Do we always grind through the present, doomed to throw a gold haze of fond retrospect over the past." {PJ}

February 23, Sunday night: Reads *Lady Chatterley's Lover*, and thinks of *Women in Love* and *Sons and Lovers*: "why do I feel I would have known & loved Lawrence—how many women must feel this & be wrong!" She envisions "taking my place beside RB & Doris Krook in theirs—neither psychologist-priestess nor philosopher-teacher but a blending of both rich vocations in my own worded world." {PJ}

February 24, Monday night: Thinks of the anniversary of meeting Ted Hughes at the *St. Botolph's* party and the consequences. {PJ}

February 27, Thursday morning: Reflects on faculty choices of teaching certain texts. A contentious faculty meeting. {PJ}

 Thursday night: Comments on her colleagues, including Daniel Aaron who tries to coax her into staying at Smith. {PJ}

February 28, Friday night: Reading a revision of poems for a book-length collection, her novel seems "too lumbering." {PJ}

March 1, Saturday morning: "I am married to a poet: miracle of my green age. Where breathes in the same body, a poet and a proper man, but in Ted?" {PJ}

March 2: "Dearest mother": "Now that I write 'March' it seems close to real spring and liberation."

 Sunday night: Dissatisfied with her novel: "how does Woolf do it? How does Lawrence do it?" {PJ}

March 3, Monday night: Reads a chapter of Lucas Myers's novel and gets the "itch to emulate." On to the "blinding deluge of Arvins exams." {PJ}

March 4: To Gerald and Joan Hughes: Describes her grading and teaching, her pleasure in taking a modern art course. Praises Ted's new writing and his teaching. "We have good fun: eat fresh steaks & roasts & salads & make a daily ritual of tea, which is somehow most sustaining & relaxing after a day's work."

March 5: "strange what vicarious pleasure I get from Ted's acceptances: pure sheer joy: almost as if he were holding the field open, keeping a foot in the door to the golden world, & thus keeping a place for me." Working on her "art" poems (Gauguin, Klee, and Rousseau). {PJ}

Nearing the end of her teaching year at Smith, Plath seemed to have entirely absorbed Hughes's feeling that his spirit had been incarcerated in an alien land, and that he had become all jammed up in a routinized, conforming culture that deadened creativity. Where she had once thought of America as the land of liberation that would free Ted Hughes to be even greater than he had become in England, she now yearned for a return to an older and yet "spacious" civilization

that would be an antidote to their American confinement. Even Alfred Kazin, whom she had lionized, now seemed a shrunken figure in the Smith College regimen. That Newton Arvin could appear in a dream as "villainous" is another indication of how the campus now seemed to put her in captivity. Her natural inclination to side with Arvin had been stymied by her husband's obvious, visceral distaste for the person and the professor.

March 8: Worries because Ted feels trapped and wonders if the move to Boston will be any better. "What is it that teaching kills? The juice, the sap—the substance of revelation: by making even the insoluble questions & multiple possible answers take on the granite assured stance of dogma." She feels a "forcing to formula the great visions, the great collocations and cadences of words and meanings." She would need more energy than she has to be creative as a teacher. "America wears me, wearies me. I am sick of the Cape, sick of Wellesley: all America seems one line of cars, moving, with people jammed in them, from one-gas-station to one diner and so on." She longs for the moors and the Spanish Mediterranean, the "old history-crusted & still gracious, spacious cities; Paris, Rome." Finishes marking fifty-five Hawthorne exams troubled by the "arbitrary" grading system. {PJ}

March 10: Alfred Kazin to dinner: "he: broken, embittered & unhappy: greying, his resonance diminished." She nearly falls asleep in Newton Arvin's class. Fatigued, nails splitting and chipping, she looks forward to end of May and vacation. {PJ}

March 11: "O how my own life shines, beckons, as if I were caught, revolving, on a wheel, locked in the steel-toothed jaws of my schedule." {PJ}

March 13: Quarreling with Ted as in a Strindberg play. {PJ}

March 14, Friday afternoon: "Deep sleep last night and queer nightmares—fragmented rememberings at breakfast: of Newton Arvin: withered, mysterious, villainous." {PJ}

March 15, Saturday morning: Tempted to be "casual and curt" about her classes and devote more time to writing. {PJ}

Saturday evening: "A gray day: walking to class, snow spitting, half asleep in my lectures, letting the flow of impulse carry the boat, adrift, drifting." {PJ}

March 18, Tuesday morning: A hot bath last night gets the kinks out. "When will I feel my liberty?" An unpleasant party with Mount Holyoke faculty members. {PJ}

March 20, Thursday morning: Working on her poems about Klee and Rousseau, long diatribe against George Abbe,[358] a "poseur." {PJ}

March 22: "To Mother From Sivvy": "I have at last burst into a spell of writing." Writes "Perseus," about "90 lines written in one day," feels she is writing her best poetry so far. "I've discovered my deepest source of inspiration which is art." {PJ}

March 25: To Peter Davison: Looks forward to a visit with Davison, she has "struck a good vein of poem-writing." {PJ}

March 27: Completes "Yadwigha, on a Red Couch, Among Lilies: A Sestina for the Douanier"

March 28, Friday afternoon: A "frenzy" of writing "eight poems in the last eight days, long poems, lyrical poems, thunderous poems: breaking open my real experience of life in the last five years: life which has been shut up, untouchable, in a rococo crystal cage, not to be touched." Vows not to "waste poem-time on people I can't stand." {PJ}

Drinks martinis with Ted to celebrate her creative burst {PA}

c.: March 28: Ted to Olwyn Hughes: "Sylvia is having her holidays, and in 5 days has written more than for the previous 14 months, and better, I think, than ever." {THL}

March 29, Saturday morning: Another "horrid dream of teaching," wonders whether her children will be all right: "Ted's family is full of madness—suicide, idiots & mine has a diabetic father, grandmother died of cancer, mother with ulcers & tumors, aunt unable to conceive after three miscarriages, uncle with heart trouble. Oh glory glory. I live still, and so does Warren." Trusts Ted who is "right, infallibly, when he criticizes my poems & suggests, here, there, the right word. . . . Arrogant, I think I have written lines which qualify me to be The Poetess of America (as Ted will be The Poet of England and her dominions). Who rivals? Well, in history—Sappho, Elizabeth Barrett Browning, Christina Rossetti, Amy Lowell, Emily Dickinson, Edna St. Vincent Millay—all dead. Now: Edith Sitwell & Marianne Moore, the ageing giantesses & poetic godmothers. Phyllis McGinley is out—light verse: she's sold herself. Rather: May Swenson, Isabella Gardner, & most close, Adrienne Cecile Rich—who will soon be eclipsed by these eight poems: I am eager, chafing, sure of my gift, wanting only to train & teach it—I'll count the magazines & money I break open by these best eight poems from now on. We'll see." {PJ}

April 1, Tuesday night: Grumpy about Ted's coarseness: "scratching, nose-picking, with unwashed, unkempt hair."[359] {PJ}

April 6, Sunday night: Reads women's magazine articles and stories, loves the way Ted takes care of her when she is sick, reflects on her mother's observation that she was "too critical" about her dates, "glowing with love like a fire," which is what she had been looking for. "Pored over Beardsley. Felt utterly fin de siècle & fin de moi-měme." {PJ}

April 7: "Good love-making today, morning & afternoon, all hot and hard and lovely." The actress Ellie [Friedman][360] visits—really to see Ted, Sylvia surmises. {PJ}

April 8: Still suffering from a cold, the "left side of my head hardening to unbreatheable concrete." {PJ}

April 10: Still "snuffly." Looking forward to meeting the "long looked-at poetess Adrienne Cecile Rich." Pleased with $140 check for poem published in *Ladies Home Journal.* {PJ}

April 11: In Warren's car, Sylvia accompanies Ted to his reading at Harvard University. {EF}

In attendance: Mrs. Cantor, Olive Higgins Prouty, Marcia Brown and Mike Plummer, Carol Pierson, Peter Davison, Gordon Lameyer, Philip McCurdy, and Aurelia. Meets poet Adrienne Rich for the first and only time. {PA}

April 12: The cold has lingered for a week. {PJ}

April 13: Hopes to win various prizes in product-sponsored poetry contests, remembers renouncing Sassoon two years ago and her resurrection in the Cambridge spring, comes up with Sylvan Hughes, "pleasantly woodsy, colorful—yet sexless & close to my own name: a perfectly euphonious magazine name." Travels home and then to Cambridge for Ted's reading, meeting friends there, including Mrs. Cantor, Peter Davison, Gordon Lameyer, Philip McCurdy, her mother, and Mrs. Prouty. "Adrienne Cecile Rich: little, round & stumpy, all vibrant short black hair, great sparking black eyes and a tulip-red umbrella: honest, frank forthright & even opinionated." {PJ}

April 14: "Still feeling too sogged and groggy, although convalescent, to wash hair and self." Reads Melville preparing for grading Arvin's exams. {PJ}

April 15: "No energy to work." {PJ}

April 17: "I sit on poems richer than any Adrienne Cecile Rich." {PJ}

Travels to Springfield, Massachusetts, to record an interview with Lee Anderson {PA}

April 18: Records a dozen poems for the Woodberry Poetry Room at Harvard {PKS}

April 22: To Peter Davison: Sends him her most recent poems, including "The Disquieting Muses." Ted will send some soon too.

"Dearest Warren": Recounts Ted's public reading of his poetry. Reports Mrs. Prouty saying in "loud clear tones: 'Isn't Ted wonderful?!'" Mentions meeting Adrienne Rich: "she's the girl whose poetry I've followed from her first publication." Records her poems at Harvard. "I do hope to have a poetry book finished sometime this fall!" Wants to hear about his adventures. "Do try to look up Ted's beautiful blonde sister in Paris—she is golden-eyed, golden-haired & very delicate & tall as I am—looks about 18, although 28."

Tuesday morning: Wiped out by "the curse, as it is so aptly named," Sunday "the purge," cleaning the apartment: "How the old maxim must have taken profound root: cleanliness is next to godliness." A quarrel with Ted about throwing away worn out items of clothing and "awful old cuff

links," they both go out, she spots him in a park: "He paused, stared, and if he weren't my husband I would have run from him as a killer." {PJ}

Evening: Miserable about the *New Yorker*'s rejection of her poems, compares herself to Henry James's painful isolation. She has Ted and the expectation of children. "I am made, crudely, for success. Does failure whet my blade?" {PJ}

April 26, Saturday morning: Frets over her teaching and students. {PJ}

April 27: To John Sweeney: "Our year has been much the finer for our knowing you" and his wife, encloses some of her poems.

To Lee Anderson: Encloses copies of the poems she read for his recording of her at Harvard, meeting him "makes us think of you as a friend, not just an acquaintance."

April 28: To Edith and William Hughes: In bed reading poems and Henry James since Newton Arvin's class has been canceled. "Our house is cold—pleasantly reminiscent of England." Ted now has an "increasing following of admirers in America." Looks forward in three weeks' time to visiting New York City to enjoy plays and museums, they take walks in the "lovely green park next door," hopes to have "more publishing news soon."

April 29, Tuesday morning: "Felt, as usual, exhausted this morning & fell back into those horrid dreams of getting up to make a school deadline, waking up & being still in the dream & it being still later." Reflects on the desire to die when she is "blue," fears of childbirth, and how she falls "short from the ideal of Doris Krook." More money would help. {PJ}

April 30: Shops and works on her novel. {PJ}

May 1: Dreams of Warren being blown up by a rocket. Ted, "my saviour," brings her a tall cup of coffee. "This is the man the unsatisfied ladies scan the stories in the Ladies' Home Journal for, the man women read romantic women's novels for." Other men bore her with their "partialness." But how to make him in her novel sound "special" without sentimentality? Describes herself as "between two worlds, one dead, the other dying to be born." {PJ}

May 3: Considers children's names after reading *The White Goddess*, "I only go from less exhausted to more exhausted & back again." {PJ}

May 4: Sylvia and Ted meet Leonard and Esther Baskin for the first time. {EF}

When Plath used the word "superstitious" to express her anxiety over separations from Hughes, she was revealing that his absence resulted in a diminution of her own power. Given their mutual interest in the occult, and the idea of a spirit world that could not be separated from material existence, it is no wonder that Hughes's disappearances (no matter how brief) might excite anxiety and even dread. It would take her a long time to realize that as a poet she could function on her own, and even after that recognition of self-sufficiency, the

effort to summon all of her creativity from herself took an enormous toll on the person and the poet.

May 5: "I am superstitious about separations from Ted, even for an hour. I think I must live in his heat and presence, for his smells and words—as if all my senses fed involuntarily on him and deprived for more than a few hours, I languish, wither, die to the world." Attends an uneven performance of *Finnegan's Wake* at Mt. Holyoke. {PJ}

May 6: Sylvia and Ted meet Robert Lowell at his poetry reading.

May 10: The last classes are now in sight and she vows to make them "good ones," "I need to lie out much in the sun, roast and rest and write. . . . I need to curb my lust for buying dresses ('for New York') only by recalling our budget & keeping it whittled thin." They have saved more than $3,000.[361]

May 11: Mother's Day: "Queer mother—stiff about helping us come to Boston." Her mother worries about their effort to rely on their writing to support them. Thinks of titling her book of poems *Full Fathom Five*: "It relates more richly to my life and imagery than anything else I've dreamed up: has the background of The Tempest,[362] the association of the sea, which is a central metaphor for my childhood, my poems and the artist's subconscious, to the father image—relating to my own father, the buried male muse & god-creator[363] risen to be my mate in Ted, to the sea-father neptune—and the pearls and coral highly-wrought to art: pearls sea-changed from the ubiquitous grit of sorrow and dull routine." {PJ}

May 13: Rejects the "patronizing tone" of George Gibian who asks why she can't just write in the summers. Compares the characters in her novel to those in *The Wings of the Dove*: "I am so crude and loud that his lesson can only serve to make me less crude, not more fine." Dreads the "encouraging, yet inevitable rejection" of her poems. "Why are the Roches so intriguing, though Paul is an obvious, a palpable sham, and Clarissa is simple, even deluded?" Wonders about their motivations. "One can't help wanting to know." {PJ}

Teaching had been both exhilarating and exhausting for Plath, and it took a toll on her marriage as well. She became suspicious when Ted explicitly told her he did not want her to attend his public reading on May 21. She did so anyway. The next day, her last day of teaching, he did not show up at their meeting place. She went looking for him and she saw him walking with a young woman near Paradise Pond, a favorite trysting place at Smith, and Plath became upset. As usual, Hughes acted as though there was nothing to be suspicious about,[364] although it was obvious that women were attracted to him, and on that day, of all days, his failure to meet Plath at their appointed time looked to her like a deliberate rejection.

May 14: Mentions her "highstrung depression." {PJ}

May 21: Sneaks into a Ted Hughes public reading of Paul Roche's translation of *Oedipus*, annoying Ted {PA}

May 22, 9:00: Last day of teaching, Sylvia receives "a spatter of applause" {HC}

11:00: "a thunderous ovation" {HC}

3:00: "medium" applause {HC}

Describes shocking encounter near Paradise Pond with broadly smiling Ted and an adoring young girl he thinks is called Sheila. Sylvia recalls how he had first called her Shirley, and she wonders how she can live with his male vanity and his "fake excuses." Calls Ted a "liar and a vain smiler": "I confided my faith in Ted and why is the wife the last to see her husband's ulcer?" Because of "blind faith." {PJ}

June: *London Magazine* publishes "Spinster" and "Black Rook in Rainy Weather," *Smith Alumnae Quarterly* publishes "Spinster"

Ted to Olwyn Hughes: "Sylvia recorded some poems for the Poetry Library at Harvard. Each one she writes is an advance on the last." {THL}

June 3: Sylvia and Ted depart for New York City

June 10: To Oscar Williams[365]: Describes a New York City trip with Ted and her expectations of the anthology in which she and Ted will appear.

"Dearest mother": Mentions her meetings with Ted's publishers and with anthologist Oscar Williams, and Fifth Avenue party that includes Lionel and Diana Trilling, Ralph Ellison, and other literary figures, a visit to the Bronx Zoo, Greenwich Village for dinner, and a play, Garcia Lorca's *Blood Wedding*. Keeps quiet when she spots Richard Sassoon and passes by. Visits Harlem, Marianne Moore in Brooklyn, sees two Ionesco plays, expects to have dinner with Mrs. Prouty in Brookline.

"Dearest Warren": Hopes they can meet for a picnic, wants to hear all about his work at Harvard, describes her last day of teaching and the responses of the students, saying that "on the whole, my colleagues have depressed me: it is disillusioning to find the people you admired as a student are weak and jealous and petty and vain as people, which many of them are. . . . I can talk to you freely about our plans, if not to mother: she worries so that the most we can do is put up an illusion of security: security to us is in ourselves, & no job, or even money, can give us what we have to develop: faith in our work, & hard hard work which is spartan in many ways." Mentions plans for a book of poetry with the "main difficulty" of "overcoming a clever, too brittle & glossy feminine tone" instead of speaking "straight out." They have met the "mad and very nice poet Robert Lowell. He is quiet, soft-spoken, and we liked him very much. He drove me around Northampton looking for relics of his ancestors, and to the Historical Society & the graveyard." They expect to see him when they move to Boston.

June 11: Describes a physical fight with Ted, but "Air cleared . . . Nothing is worth jeopardizing what I have. . . . I am just getting used to peace: no people, no assignments, no students." Describes her rage at two girls picking flowers in a public park: "I have a violence in me that is hot as death-blood. I can kill myself or—I know it now—even kill another. I could kill a woman, or wound a man. I think I could." {PJ}

To Warren: "Oh we have rousing battles every so often in which I come out with sprained thumbs & Ted with missing earlobes, but we feel so perfectly at one with our work & reactions to life & people that we make our own world to work in which isn't dependent on anyone else's love or admiration, but self-contained: our best pleasure is writing at home, eating & talking & walking in woods to look for animals & birds." Encloses a poem, "Mussel-Hunter at Rock Harbor."

June 16: Aurelia cooks a dinner in Wellesley to celebrate Sylvia and Ted's wedding anniversary, expresses her disappointment that the couple are quitting their teaching jobs. {PA}

June 20: "It is as if my life were magically run by two electric currents: joyous positive and despairing negative—which ever is running at the moment dominates my life, floods it." {PJ}

June 25: To her mother: "Remember, a year ago, we first set foot together on American soil? And the lovely party we had under the great awning in the back yard? Ted & I look back on our party with much pleasure." Announces her first *New Yorker* acceptance for "Mussel-Hunter at Rock Harbor."

To Henry Rago at *Poetry*: Enclosing a "group of recent poems."

To Olive Higgins Prouty: It was a treat for her and Ted to visit Prouty last week, looks forward to entertaining Prouty in Boston. Announces her first *New Yorker* acceptances, which give her "great courage" to continue with her book.

"Dearest Warren": Mentions getting published in the *New Yorker* after ten years of trying, describes the Beacon Hill apartment in Boston ready for move in September 1.

"A starred day" as she runs "yipping upstairs to Ted & jumping about like a Mexican bean." {PJ}

June 26: Completes "Owl"

To Howard Moss, *New Yorker* poetry editor about "Mussel-Hunter at Rock Harbor": "The last two lines of the poem are meant to be read '. . . this relic saved/face, to face the bald-faced sun.' The idiom is 'to save face' here. The crabs in 'mottled mail of browns and greens' are the fiddler-crabs. The dead crabs in the sea may be considered to represent all Crabdom."

Writes "brief poem" in the morning: "Owl over Main Street," thinks: "Could be better. . . . The animal world seems to me more & more

intriguing. Several dreams, one of which is about conception, according to Ted, and another "a musical comedy & a hundred Danny Kayes."[366] {PJ}

June 30: "Dear Olwyn": Describes climbing Mount Holyoke with Ted: "Ted thrives, & so do I, with no jobs. . . . I know he is the great poet of our generation. . . . Our Boston apartment is minute, but aesthetically fine with its light, air, quiet & superb view. The city is a delight to walk in. . . . Ted & I both love getting your letters, especially long ones like the last, so do write soon again. Tell us more about deGaulle."

July 1: "Dear Ted's mother & dad": Describes their writing and mountain climbing. "Both of us are in excellent health & working well. Write soon—Love to you both—Sylvia"

Description of climbing Mount Holyoke. {PJ}

July 2: To Howard Moss: Returns corrected proofs and "these corrections are satisfactory."

July 4: "Independence day: how many people know from what they are free, by what they are imprisoned." Works on her collection of poems, considers "Full Fathom Five," about her "father-sea-god-muse . . . one of my best," wants now to publish a story in the *New Yorker*, studies German two hours a day, translating Grimm's fairy tales, tries to nurse a sick baby bird. {PJ}

July 5: "Dear mother": Tells her mother about the rescued baby bird, a "plucky little thing." Takes the advice of a ouija board about writing certain poems.

c. July 5: Ted to Aurelia: "Dear Sylvia's mother": "Sylvia has a new interest which I suppose she's told you about. We found a little bird at the foot of a very high tree. It looked to be dead, but when we payed attention to it it showed itself quite interested. We brought it back, and now Sylvia feeds it chopped steak every couple of hours or so. . . . Writing is going steadily. Sylvia has written two or three first class poems, as strong as anything she has done, and I think the unbroken practise is necessary—her style and self are changing so rapidly that it is a continuous labour to bring the two together." {THL}

July 7: Can't write, can't sleep, "similar to my two months of hysteria in beginning teaching last fall," stymied at how to write her novel: "My danger, partly, I think, is becoming too dependent on Ted. He is didactic, fanatic—this last I see most when we are with other people who can judge him in a more balanced way than I." She does better when he was "off for a bit," building on her "own inner life . . . without his continuous 'What are you thinking? What are you going to do now'" that prompts her to "stop thinking and doing." They are "amazingly compatible," but he keeps giving her orders on what to read and how to read it. "His fanaticism & complete

lack of balance & moderation is illustrated by his stiff neck got from his 'exercises'—which evidently are strenuous enough to disable him." {PJ}

July 9: Completes "Whiteness I Remember"

"Dear Warren": Wonders about the girls he may have met in Germany. "I am all for foreign relations: it is extremely pleasant to have extended my own affiliations & to feel I have also a permanent home in England, especially in such a beautiful moor-top place." She confesses that she is haunted by the death of a baby bird they had tried to nurse to health but had sickened. "Finally, we figured it would be mercy to put it out of its misery, so we gassed it in a little box. It went to sleep very quietly. But it was a shattering experience. Such a plucky little bit of bird. I can't forget it."

"We hadn't slept for a week, listening for his scrabble in the box, waking at blue dawn & hearing him flutter his pin-feather wings against the cardboard sides." {PJ}

July 10: "Dear mother": Asks her to look over apartment lease, mentions $377 *New Yorker* check for her poems.

c. July 10: Ted to Olwyn Hughes: "She wrote a beauty about Fiddler crabs—very direct & lucid, not so elaborate."[367] {THL}

In spite of finally getting published in the New Yorker *and fulling her dream to become a free-lance writer no longer under obligation to Smith or any other institution, Plath had difficulty adjusting to a writing life that was not defined by a strict schedule of activities and responsibilities.*

July 12, 11:00: Tired. "Yesterday was the nadir," a rejection from *Kenyon Review*. Keeps thinking of stories that will sell, bursts into tears, spoiled by early success, vows to "doggedly work, wait & expect the minimum." {PJ}

July 17: "I feel I could crack open mines of life—in my daily writing sketches, in my reading & planning, if only I could get rid of my absolutist panic." A letter from Marianne Moore responding to "Mussel-Hunter at Rock Harbor," saying "don't be so grisly." {PJ}

July 19: "Dearest mother": Enjoys the fan her mother has sent, asks if she can use Aurelia's Boston University discount to obtain books by Rachel Carson and Robert Lowell. "I am finding it rather difficult to adjust to this sudden having-nothing-to-do."

"Paralysis still with me." I will "try to shut up & not blither to Ted." Tries to write a story about the sickly bird's death. {PJ}

c. July 25: Writes four poems, "two of them about Benidorm" {PA}

July 27: After ten "sterile hysterical" days, produces several poems and is rewriting an old story, reads Thomas Hardy's poems and is revived

Although Plath had accepted Hughes's commitment to a full-time writing life, and thought starting a family would require a delay until she had achieved a great success as poet or novelist, she began to take more seriously the idea of

having children sooner rather than later. At the same time, she began to turn away from staying in the United States, realizing that Ted could not acclimate to a new culture. She never recorded any objection to his plan to return to England even though both had called the country old and decaying with no future they could embrace. His disaffection with America seemed to seep into her own attitudes, fueled by their conviction that they could make a living in the London literary scene.

August 1: "To Mummy From Sivvy": *Poetry* accepts three of her poems for "about $44. . . . I have thought much, & wouldn't have Ted change his citizenship for the world. It is part of his identity, I feel, and will always be so." Considers taking up a "practical skill" like stenography.

To Howard Moss: Accepts his suggestions for changes in her poems. "I have a queer growing hunger for a baby." {PJ}

August 2: "The great fault of America—this part of it—is its air of pressure: expectancy of conformity." Suspects her Aunt Dot and Uncle Frank don't like Ted because he has no job or steady career and "will no doubt be an impractical vagabond." Wants to write "funny & tender women's storys." {PJ}

August 3: Imagines a story set in Trafalgar Square. {PJ}

Aurelia describes Sylvia and Ted's reaction to a visit with friends and their three children. The two-year-old girl latches on to Ted, while Sylvia reverently examines the one-year-old as though discovering some treasure she had been seeking. Aurelia imagines what it would be like to be a fairy godmother waving a wand, producing a home, and greeting her daughter with all she needed to have a family and her writing, too. {LH}

August 8: Receives the *New Yorker* issue with "Mussel Hunter at Rock Harbor": "I am awestruck, excited, smiling inside as a cat. . . . I have the naive idea people all over the world will be reading & marveling at the poem!"

August 9: The *New Yorker* publishes "Mussel Hunter at Rock Harbor."

August 13: To Gerald and Joan Hughes: Telling them Ted is "appearing, it seems, in print every week in England." Wants to hear about their "wonderful" house.

"To Mummy From Sivvy": Looks forward to a "beach-week" at the Cape to fish and swim.

August 14: CSM publishes "Beach Plum Season on Cape Cod," illustrated with two of her drawings {PA}

August 27: Incensed that the landlady accuses them of leaving their Northampton apartment a mess, only four nights until they can enjoy the "elegant" view from their Boston apartment. {PJ}

August 28: Last night she dreamed she had begun her novel. {PJ}

September 1: Moves into sixth floor apartment in the Beacon Hill section of Boston {HC}

September 2: Adjusting to the city sounds in her Boston apartment: "We have an enormous view—the Charles river, sailboats, reflected lights from MIT—the moving stream of car lights on Riverside Drive—the hotels & neons—red, blue, green, yellow, above the city—the John Hancock building, weather tower—flashing—rooftops, chimneypots, gables—even the tree tops of the common from the bedroom—a fine place, dark green & light blue. We have also an aquarium & two goldfish." {PJ}

September 3: To Elinor Friedman: Describes the hectic, fractious process of moving into Boston apartment: "Now that we are here, in our miniscule & marvelously aesthetic two-room furnished flat, I don't know how I stood living in Northampton for a year. Nobody here has heard of Smith, or us, which is magnificent."

September 4: To Lynne Lawner: Happy to be away from the "provincial rounds of professors" at Smith, asks for news about Lawner's novel and poetry.

September 5: Describes a visit from Luke Meyers and their tour of Boston. {PJ}

September 7: Invites Peter Davison to their delightful new flat, describes the poems she and Ted are working on

September 7–8: Ted to Gerald and Joan Hughes and family: "Writing is going steadily. Sylvia has written two or three first class poems, as strong as anything she has done, and I think the unbroken practise is necessary—her style and self are changing so rapidly that it is a continuous labour to bring the two together." Looking forward to their new flat in Boston, an "old city. . . . Rather like the old English cathedral towns, stone, alleys, queer old families, and all life there seems unself-conscious and more European than in these frightful inland executive suburbs . . . endless fresh fish. . . . Sylvia loves fishing." {THL}

September 8: To Smith Vocational Office: Wishes to apply for part-time work: "editing, typing, reception work, and so on" in downtown Boston, in commuting distance of Beacon Hill.[368]

September 11: "I have been tired, feverish, cramped." Considers a part-time job to acquire new experiences: "I would like to squander money on hair styling, clothes. Yet know power is in work and thought. The rest is pleasant frill. I love too much, too wholly, too simply for any cleverness. Use imagination. Write and work to please. No criticism or nagging. Shut eyes to dirty hair, ragged nails. He is a genius. I his wife." {PJ}

September 14: "we both bogged down in a black depression," listening late at night to Beethoven. {PJ}

September 15: "I am too ingrown—as if I no longer knew how to talk to anyone but Ted—sat with my face to a wall, a mirror . . . must keep clear

of confiding in mother: she is a source of Great Depression—a beacon of terrible warning." {PJ}

September 16: Peter Davison visits and observes a "tense and withdrawn" Sylvia. {CR1}

September 18: "Dear Ted's mother & dad": "Ted & I are both extremely happy here in Boston."

"Much happier today."

September 24: To Alice Norma Davis at the Smith Vocational Office: Describes her references and desire for a part-time work in Boston or Cambridge.

September 25: To Dorothea Krook: Homesick for her "magnificent lectures" and supervisions, the "major stimulus of my Cambridge experience," describes teaching at Smith and the Boston flat. "I am, by philosophy, I think, more dictatorial than is proper for an American." Reports on Ted's success.

September 27: Mentions Ted's depression, a depressing call from mother about her "hardships at work," "unspoken nervousness about our futures, my lack of a job. . . . Ted diagnosed my disease of doldrums—& I feel better." {PJ}

October 11: The *New Yorker* publishes "Night Walk" ["Hardcastle Crags"]

October 14: Secures job answering phones and typing records in a psychiatric clinic at Massachusetts General: "my objective daily view of troubled patients through the records objectifies my own view of myself." Undated hospital notes on patients. {PJ}

During her employment at the psychiatric clinic, Plath kept a journal with notes on a secretary's meeting and undated entries describing several patients (Jewish, Italian, young and old), some of whose stories ended up in "Johnny Panic and the Bible of Dreams." Plath's work at the clinic also reflects an abiding interest in abnormal psychology,[369] which she would continue to read about after she quit her employment.

Ethel D.: confused after the death of her husband, mixing up days and nights; a depressed sewing machine salesman feeling listless and unable to sell; fifty-year-old Ida whose cab driver husband thinks she is crazy; Catherine B.: 51, with a suspicious husband constantly accusing her of infidelity; Dominic R.: beset with crying jags; a "twice-married mother" who says she hates her children; Sister Jean Marie: a Catholic nun dizzy and tortured by noises and other sensations; Emily P.: "Invisible person in the house having sexual relations with her at night," thinks her family is trying to poison her; Laura D.: unable to accept her daughter's death and keeps seeing and talking with her; Dorothy S.: nightmare in which her own head is amputated; Mary M.: finds five heads in her closet: "I do feel I have a schizophrenic patient between my hands"; Ferrara: stays home fearing "something might happen"; Philip S.: guilty over his father's death; Francis M.: Shy, alone,

and obsessed with movies; Spero: "Fears asphyxia and death"; Barbara H.: fears she will turn into an animal and have puppies; John M.: everything has to be perfect; Philomena T.: goes crazy while making a cake that left out one ingredient; Lillian J.: obsessed with fears of pregnancy; Martin R.: a plot against him results in his rape while sleeping; William H.: no inner resources. She makes notes on other patients with delusions about being injured and tortured or persecuted. {PJ}

October 26: To Elinor Friedman: Describes her job at Massachusetts General.

November 17: To Esther and Leonard Baskin: Mentions a possible visit to Smith to speak to a creative writing class.

November 25: To Daniel Huws: "We've met Robert Frost once or twice recently. He's very old now, & a bit deaf. But talks continually, & very amusingly." They have also met John Malcolm Brinnin: "monster is no exaggeration either. The glassiest slimiest creature I ever met, just about. Done a rich sun-ray lamp tan, with pale blue eyes, wears an English style blazer & cricket sort of shirt & smiles & smiles. Also, we met Richard Eberhart, who is a sort of bounding rubber ball of a man, very genial, a bit mechanical."[370]

December: *Ladies Home Journal* publishes "Second Winter," *Institute of International Education News Bulletin* publishes "Cambridge Vistas"

December 10: Begins seeing RB for regular therapy sessions {PKS}

December 12: Notes on session with RB: "Better than shock treatment: 'I give you permission to hate your mother.'" {PJ}

December 13: Turning over what happened with Edwin Akutowicz: "Never felt guilty for bedding with one, losing virginity and going to the Emergency Ward in a spurt spurt of blood, playing with this one and that. Why? Why? I didn't have an idea, I had feelings. I had feelings and found out what I wanted and found the one only I wanted and knew it not with my head but with the heat of rightness, salt-sharp and sure as mice in cheese. Graphic story: the deflowering. What it is like. Welcome of pain, experience. Phonecall. Pay bill." Sketches other possibilities for stories. Pleased to learn that John Lehmann of *London Magazine* accepts "Lorelei," "The Disquieting Muses," and "The Snakecharmer." {PJ}

December 16: "My life may at last get into my writing. As it did in the Johnny Panic story." Muses about Truman Capote's success and how men, including Ted, hate the successful homosexual, considers stories based on her early years in Winthrop and work on the farm. {PJ}

December 17: A note for a story to ask RB about "psychological need to fight, express hostility between husband & wife." Suspects RB of changing an appointment because she is not getting paid and so withholds like Aurelia. A fight with Ted: "Just as he tells me, when he wants to manipulate me one way (eg, to stop 'nagging,' which means talking about anything he

doesn't like) that I am like my mother, which is sure to get an emotional reaction, even if it's not true. I hate my mother, therefore his surest triumph and easy-way to get me to do what he wants. . . . I'm just as bad."[371]

December 24: To John Lehman, the *London Magazine*: Brings him up to date on Ted's work and hers. "We are hoping very much to return to England in a year or so."

December 25: Celebrates Christmas in Wellesley with Ted, Aurelia, and Warren {HC}

December 26: Conflicted feelings about her mother, two "acrid fights" with Ted: "I feel his depression[372] . . . only is not articulate about it," admits to jealousy of Ted and her brother. {PJ}

December 27: A long and deep session with RB yesterday: "I dug up things which hurt and made me cry. Why do I cry with her and only with her?" It is over grief that she has not experienced a mother's love. Admits to identifying Ted with her father sometimes. "Images of his faithlessness with women echo my fear of my father's relation with my mother and Lady Death." After reading Freud, interprets her suicide attempt as a transference of hatred for her mother onto herself. RB suggests her inability to write may be to spite her mother. Yet without writing she has no reason to live or feel accepted. Believes her mother avoids responsibility for her life in saying, after Plath turned down a second year at Smith: "I only wish somebody would offer me a job like that." It had been easier communicating with her by letter from England, which provided a safe distance. All her mother cares about is security because of her great fears. {PJ}

December 28: Considers a story with a character based on Dick Norton: "The modern woman: demands as much experience as the modern man." Thinks about a PhD in psychology, a "prodigious prospect." Studying Frank O'Connor's fiction. {PJ}

December 30: "Dear Ted's mother & dad": Describes the wolf mask Ted made for a New Year's Eve masquerade. She is wearing a red cape for Red Riding Hood. "We love every letter we get from you—we can just imagine the Beacon & all the life & country surrounding it."

To Gerald and Joan Hughes: A greeting card for best wishes for "your Merry Christmases and your happy New Years, your long lives and your true prosperities."

Extensive Notes on St. Theresa of Avila {PJ, PKS}

December 31: Broods on a story: "I feel we are as yet directionless (not inside, so much as in a peopled community way—we belong nowhere because we have not given of ourselves to any place wholeheartedly, not committed ourselves)." {PJ}

To Margaret Wendy Christie: Briefly describes her American year with Ted: "We think of you very often & would love to see you when we come back to England which we hope will be in a year or so."

"Dear Olywn": Mentions her "amusing job" at the city hospital, describes the holiday scene in Boston: "Burn a candle for us."

1959

Undated: "The Shadow," photograph of Plath in a boat with fish at Yellowstone

January: *Mademoiselle* publishes "Four Young Poets" featuring Plath and Hughes. They acquire a "tiger-striped kitten" they call Sappho, "said to be a granddaughter of Thomas Mann's cat." {JB}

January 3: Relieved that RB agrees to see her for $5.00 an hour. Feels "emotionally" stood up by those she wanted to rely on, including her father and mother. "Why, after the 'amazingly short' three or so shock treatments did I rocket uphill? Why did I feel I needed to be punished, to punish myself. Why do I feel now I should be guilty, unhappy: and feel guilty if I am not? Why do I feel immediately happy after talking to RB?" {PJ}

January 7: Reads and comments on Joyce Cary's *The Horse's Mouth.* {PJ}

January 8: Thinks about graduate school. "Very bad dreams lately": one about losing a month-old baby, feels passive and "dying of inertia." {PJ}

January 10: Annoyed by the work of electricians, recalls crying yesterday morning, finding it "pleasurable" and "absolutely purged after it," feels blocked, *Yale Review* rejects "Johnny Panic." Ted is worried about her. Talks with RB about Victorian women and their subordination to men. Would pregnancy help or hinder her? Analyzes why she has hated men. {PJ}

c. January 16: Notes for poems "The Bull of Bendylaw," "Point Shirley" {PJ, PKS}

January 17: "Dear Ted's mother & dad": Writes about Ted's success and nearing completion of a second book of poetry and publishing stories, describes trip to Winthrop, the happy site of her first ten years. Ted is set on moving back to England, and she is as fond of it as any place.

To Esther Baskin: Praises her husband's illustrations of Anthony Hecht's book, *The Seven Deadly Sins*, describes Ted's wolf mask for New Year's costume party: "awesomely comfortable to wear, one day it will stick, and his nails will grow."

c. January 17: Ted to Edith and William Hughes: They are taking Vitamin C: "Neither Sylvia nor I have had so much as a sneeze all winter—taking these daily. . . . Mrs Prouty, Sylvia's fairy godmother, sent us tickets for a play the other night, & we sat on the third row among the minks. . . . We decided quite definitely to make our base in England." {THL}

January 20: Describes various friends and events: "How curious one is about these friends committed to other lives, and what they will choose and do." She describes impressions of Elizabeth Hardwick and Robert Lowell. She is resolved to live in England. "Joy: show joy & enjoy: then others will be joyful." {PJ}

January 21: To Esther Baskin: Encloses her poem "The Goatsucker" and describes what went into it.

January 24: *The Nation* publishes "Frog Autumn"

January 27: Compares reading Richard Wilbur and Robert Lowell. "I speak with RB of being little, as if I were a homunculus. . . . Mother with her usual miffed, tragic look, dropped by a book. I didn't ask her up." Disgusted with her one dimensional work. Wishes to consult RB about sifting out her "baby feelings. . . . I am panicked at the separation from Mother Academia." {PJ}

January 28: Reads and criticizes Adrienne Rich's poetry, enjoys Shirley Norton (Perry's wife) and her new baby. "How odd, men don't interest me at all now, only women and womentalk. It is as if Ted were my representative in the world of men. Must read some Sociology, Spock on babies. All questions answered. . . . Must try poems. DO NOT SHOW ANY TO TED. I sometimes feel a paralysis come over me: his opinion is so important to me . . . just use Beuscher to the hilt." {PJ}

January 30: *The Spectator* publishes "The Companionable Ills"

February 11: To Elizabeth Ames, Executive Director of Yaddo[373]: Seeking to apply for a residence.

February 13: "First time I've had the heart to write in here for weeks. . . . Cried with the old stone-drop gloom with RB yesterday." Looking for another job. RB says: "you won't write. This is so, not that I can't, although I say I cant." Reads *Sanctuary*'s "flawless descriptive style" and describes the graphic scenes. "And where are my small incidents, the blood poured from the shoes?" Describes visit to Stanley Kunitz[374] and his dismissal of women poets. {PJ}

The Spectator publishes "Main Street at Midnight" ["Owl"]

February 18: To Lee Anderson[375]: "Ted is completing his second book and within five poems of the close. I am battling a sterner and less bucolic muse."

February 19: Disappointed with draft of "Suicide Off Egg Rock." Wishes to break out of her "glass caul. What am I afraid of? . . . England seems so small and digestible from here." {PJ}

Completes "Watercolor of Grantchester Meadows"

February 22: To Elizabeth Ames: Sends in applications to Yaddo. "I would like to note here that of the thirty-two or so published poems I have listed on my sheet over two-thirds were written while I was an undergraduate and do not form part of my projected book as, in one way or another, I do not consider them sufficiently mature work."

February 25: Their third anniversary: A fight and their "usual gloom. I am ready to blame it all on myself." Describes the "sky a high clear blue bell jar," lousy dreams, one about Gary Haupt. "Got somewhere last week with RB I think." Fear of failure is stopping her from writing. Counsels herself to forget her symbols and myths and concentrate on the "real world. Real situations, behind which the gods play the drama of blood, lust and death." Describes Robert Lowell's class: "O to break out into prose." {PJ}

February 26: "Dear Ted's mother & dad": Describes visit with Ted to the Blue Ship Tearoom where her parents courted and where she and Ted are celebrating their third anniversary. She is having fun braiding a rug and learning to use a sewing machine, hopes they win the football pools.

February 28, 7:30: Pleased with two new poems, "Point Shirley" and "Suicide Off Egg Rock." Reads Faulkner: "The Bear a magnificent story except for the infuriating, confused (deliberately and unneedfully) fourth section, a bumbling apocalyptic rant about landownership and God and Ikkemotubbe and such rot.[376] The rest, a clear, honest recreation of an archetypal image, the great Bear with the man's name, who is, in his way, large as Moby Dick." Tries to "Forget self and give blood to creation." {PJ}

March: *London Magazine* publishes "Snakecharmer," "Lorelei," "The Disquieting Muses"

March 5: CSM publishes "Whiteness I Remember"

March 7: *The Nation* publishes "Departure"

March 9: A "lugubrious session" with RB. Visits her father's grave, "a very depressing sight." Tempted to "dig him up to prove he existed and really was dead." {PJ}

March 11: To Lynne Lawner: Works part time for a Harvard professor. Describes reading William Golding, Tolkien, and other contemporary British fiction. Her cat, Sappho, loves the typewriter, "watching the keys go up and down like dancing snakes. In her more energetic moods she tries to cuff them just before they hit the paper." Describes playgoing, including *Requiem for a Nun*, "concocted by Faulkner, about whom I have great reservations, for his one-time mistress Ruth Ford, now wife of Zachary Scott."[377] Describes Lowell's class and Anne Sexton: "She has the marvelous enviable casualness of the person who is suddenly writing and never thought or dreamed of herself as a born writer: no inhibitions." Wants to hear about what Lawner is writing. "I have been doing some poems this month, as always happens when spring nears, but they are grim, antipoetic (compared to the florid metaphorical things I had in Poetry, Chicago) & I hope, transitional." Thinks it might be easier to publish in England: "they have many companies, small, idiosyncratic . . . And seem to publish vast amounts of unknowns." Feels more akin to the English temperament and

Ted is "very homesick." Still she will feel a "good bit in exile."[378] Wants to know about Lynn's pleasures and bothers: "I feel an odd sisterly bond, partly because I feel, as I think and suspect you may, a dim doppelganger relationship with the few women I know who are very much physically & psychically akin to me."

March 19: Completes "The Ravaged Face"

Plath intuited that in spite of fears of childbirth, pregnancy would pacify her and provide a new focus on the future, the establishment of a family that would enhance her poetic gifts rather than be an interruption of her ambitions. Her desire for children may also be connected to her quest to bring her feelings about her lost father to some kind of resolution that therapy alone could not seem to achieve.

March 20: Her period arrives, disappointed that a suspected pregnancy has not materialized: "I had lulled myself into a fattening calm and this was a blow. . . . I am getting nowhere with RB." What good did it do talking about her father? Lowell pairs her with Anne Sexton: "an honor, I suppose. Well, about time. She has very good things, and they get better, though there is a lot of loose stuff." {PJ}

March 23: CSM publishes "Prologue to Spring"

March 26: CSM publishes "Yadwigha, on a Red Couch Among Lilies (A Sestina for the Douanier)"

March 29: Considering various stories, including one about the "bornwriter who can't write." Another session with RB: "facing dark and terrible things: those dreams of deformity and death. If I really think I killed and castrated my father may all my dreams of deformed and tortured people be my guilty visions of him or fears of punishment for me? And how to lay them? To stop them operating through the rest of my life?" {PJ}

The *New York Herald Tribune* publishes "Prologue to Spring"

March 31: "Dear Ted's mother & dad": Expects Ted to win more prizes for his next book. "This week, for some reason, things are at a standstill. Partly the season, I guess. We should have more news next week."

Spring: *Audience* publishes "Lorelei," "Full Fathom Five," and "The Hermit at Outermost House"

April: *Horn Book Magazine* publishes "The Bull of Bendylaw"

Ted to Olwyn Hughes: Describes Robert Lowell's Boston University class: "Usually he is very quiet, shy, whispers (a real mad whisper) but this time he burst in, flung the tables into a new order, insulted everybody, talked incessantly." {THL}

April 2: The *Warrensburg News* (New York) publishes "Prologue to Spring"

April 3: The *Belleville Times* (New Jersey) publishes "Prologue to Spring"

April 8: To Elizabeth Ames: Pleased to accept an invitation to Yaddo for September 9–November 9.

April 10: To Mary Stetson Clarke[379]: "We have both of us had an excellent and productive year in Boston. . . . We work from 7 to 12 in the morning very hard and then are delighted to indulge in recreation of another sort."

To Monroe K. Spears: Happy to hear the *Sewanee Review* is publishing "Point Shirley," suggests a few changes.

Ted Hughes receives official notification that he has won a Guggenheim Fellowship. {PA}

April 11: The *Lethbridge Herald* (Alberta, Canada) publishes "Prologue to Spring"

April 14: To Ann Davidow: Describes how she came to live in Boston with Ted.

April 23: To Howard Moss, the *New Yorker*: Discusses proposed changes of wording for certain poems, delighted with Ted's Guggenheim grant and her second acceptance from the *New Yorker*, rejects "Electra on Azalea Path" for her book as "forced and rhetorical." Still "blocked about prose. A novel still scares me," works with RB on her suicide, "a knot in which much is caught," thinks of writing a story about Anne Sexton's affair with George Starbuck. {PJ}

April 25: Describes downstairs flat of her invalid neighbor. {PJ}

CSM publishes "Bathtub Battle Scene"

April 28: To Alice Nora Davis at Smith Vocational Office: Looking for a summer job.

To Esther and Leonard Baskin: Ted is working on a children's book, wants to dedicate "Sculptor" to Leonard.

May: The *Grecourt Review* publishes "Sculptor"

May 2: To Emilie McLeod, editor Children's Books, Atlantic Monthly Press: Submits *The Bed Book*, asks for criticism and is willing to make revisions.

May 3: "AS [Anne Sexton] is there ahead of me, with her lover GS [George Starbuck] writing New Yorker odes to her and both of them together: felt our triple martini afternoons at the Ritz breaking up."[380] Happy about completing *The Bed Book* and articles for CSM. "This year, I think, is a year of maturing. I am joyous in affirming my writing at last." {PJ}

May 4: CSM publishes "Above the Oxbow"

May 5: CSM publishes "Kitchen of the Fig Tree"

May 7: To Edward Weeks, *Atlantic Monthly*: "Perhaps 'Alicante Lullaby' might be considered under Light Verse in the 'Accent on Living.' "

Plath and Hughes were about to leave on a car trip West, interrupting Plath's sessions with RB about her "pressure points" including not only her suicide attempt but the strange encounter with Edwin Akutowicz, her ambivalent feelings about her rival—Ted's sister Olwyn—and a certain deracination that the impending trip and her removal to England exacerbated. Starting a family may have occurred to her as a way of grounding herself.

May 13: Reading notebooks on Spain for a magazine article. "Bothered about RB: I seem to want to cover everything up, like a cat its little crappings with sand, perhaps before leaving for California?" A lot of "pressure points: suicide, deflowering, T.'s sister, lack of rooted social life, yet not mind it; lack of children." {PJ}

May 18: Dreams about dolls and dresses and her childhood.[381] {PJ}

c. Spring 1959: "Withens": Describes Brontë memorabilia: Charlotte's bridal gown, Emily's death couch, a beaded napkin ring: "They touched this, wore that, wrote here in a house redolent with ghosts." Describes two different ways to the house: "the furious ghosts nowhere but in the heads of the visitors & the yellow-eyed shag sheep. House of love lasts as long as love in human mind." {PJ, PKS}

May 20: Worries that George Starbuck, Maxine Kumin, Anne Sexton are ahead of her with publishing contracts and prizes. {PJ}

May 22: To William Maxwell, the *New Yorker*: At Alfred Kazin's suggestion sends two stories, "Sweetie Pie and the Gutter Men" and "The Shadow."

Determined to ask RB about what to do with her anger. "Braided violently on rug, which is at cleaner's, and felt anger flow harmlessly away into the cords of bright soft colored wool. It will be not a prayer rug but an anger rug." {PJ}

May 24: "Dear Ted's mother & dad": "The prospect of driving to California and Mexico . . . is making us work harder than ever."

To Gerald and Joan Hughes: "We are thinking at present of getting a big house in the country outside London. As if we could afford it."[382] Looks forward to the cross country camping trip and getting one of her stories into the *New Yorker*, pleased to have Ted's Guggenheim award to live on. "Ted is thriving. He is handsomer than ever. . . . If he has any faults they are not shutting the icebox (a kind of subconscious revenge on American appliances) and knotting his clothes up in unknottable balls and hurling them about the floor of the room every evening before retiring. Oh yes, and the occasional black Moods."

May 25: To Olwyn Hughes: Working on her fifth story of the year, publishing several pieces in CSM, includes a recipe for sponge cake.

"Again, again, the grumpy fruitless cramps." Wishes for a book to be published and a baby, reads Woolf's *The Years*: "Dreamed of catching a very tiny white rabbit last night: a menstruating dream?" {PJ}

May 30: To Seymour Lawrence, *Atlantic Monthly*: Sends him two stories, "The Earth Our Hospital" and "Above the Oxbow," includes biographical notes and appearance of her poems.

May 31: Lists six stories she has written this year. "I feel that this month I have conquered my Panic Bird." Applies for a television writing grant

of $10,000 a year, makes summaries of essays, sketches, and stories she is planning to write. {PJ}

Summer: *Sewanee Review* publishes "Departure of the Ghost" ["The Ghost's Leavetaking"] and "Point Shirley"

June 6: "RB has become my mother." Disconsolate about another rejection of her first book of poetry. {PJ}

Dudley Fitts, editor of Yale Younger Poets series, writes that her manuscript has been chosen as alternate, having lost the award and publication "by a whisper." {PA}

Reads J. D. Salinger's "Seymour: An Introduction," just published in the *New Yorker* {PA}

CSM publishes "A Walk to Withens"

June 10: Reads *The Lonely Crowd*.[383] "What to discuss with RB? Work, desire for work of meaning. To learn German. To write, be a Renaissance woman." {PJ}

June 11: To Emilie McLeod, Editor of Children's Books, Atlantic Monthly Press: Accepts revisions for *The Bed Book*.

June 12: To Ann Davidow: Hopes Ann can visit, describes *The Bed Book* and her choice of illustrators, feels gloomy about her poetry book and failure to win the Yale Younger Poets Contest, hopes her stories will lead to writing a novel.

June 13: Reads two mental health articles in *Cosmopolitan* {HC}

Considers writing an article "about a college girl suicide. THE DAY I DIED . . . Must get out SNAKE PIT.[384] There is an increasing market for mental-hospital stuff. I am a fool if I don't relive, recreate it." Wants to discuss with RB her desire to have a baby. Thinks about how to handle ambition. {PJ}

June 14: *The Observer* publishes "Poem" ["Night Shift"]

June 15: Pleased with plotting of her story, "Courting of Petty Quinett," praises Ted's Yorkshire tales, compares Jean Stafford's and Elizabeth Hardwick's stories, works on reminiscences of the Cantors, rereads an old story, "The Wishing Box," "not bad," but "too much a fable." Thinking of more mental hospital stories, notes for story about George Starbuck and Anne Sexton. {PJ}

June 16: To John Lehmann, *London Magazine*: Encloses poems and mentions they are "working hard now on some stories."

Discovers the name for the heroine of her novel, *Falcon Yard*, Sadie Peregrine, "my initials," hopes to write the novel at Yaddo about Sadie "sadistic," finds her stories set in Spain dull, third wedding anniversary, another *New Yorker* rejection of a story: "Remember: do not feel shut out of your past. Especially the summer of the Mayos. Remember every detail

of that: a story is in that. And in Ilo and the farm summer. My god. God, I think I'll Start on that. Mary Coffee. The damn thing is, I have the goddam subjects, but am thumbs and loose ends trying to realize them, order them. Tell it in third person, for god's sake."{PJ}

June 19: To *Critical Quarterly*: Sends back corrected proofs of several Hughes poems.

June 20: "Everything has gone barren. I am part of the world's ash, something from which nothing can grow, nothing can flower or come to fruit." Dreads being a "career woman," worries about ability to become pregnant: "Barrenness." Intercourse would be a "dead end."[385]{PJ}

June 25: To Ann Davidow: "Am just back from buying sleeping bags, camp stove etc. All we need is a tent and twenty bush natives to carry corn niblets and beer."

June 29: To poetry editor of *Accent*: Includes a batch of poems.

July 1: CSM publishes "Midsummer Mobile"

July 9: "Dear mother": Writes from Algonquin Park camp site in Ontario. Describes their journey through New York, fishing, and nature trail walks.

To Warren: Describes fishing and blueberry picking on Rock Lake in Ontario.

July 11: Leaves Rock Lake {HC}

To Joseph and Dorothy Benoni: Driving through "unspoiled green wilderness" toward Yellowstone Park, describes loon and "reddish deer" that "licked Ted's face!"

July 12: "Dear mother": Pleased with the publication of "Two Views of a Cadaver Room" and "The Hermit at Outermost House" in *Times Literary Supplement*. Ted is reading and writing in a tent. Describes their itinerary, Lake Superior seems like the ocean. They drive long distances alternating every two hours. "We felt the country was being invented before our eyes. . . . I have never seen such masses of untouched land. . . . the peculiar mindlessness of the Canadian scene impressed me: no books, no theaters, no libraries to be seen."

July 13: CSM publishes "Fiesta Melons"

July 14: "Dear mother": They see their first bear in Wisconsin.

July 16: "Dear mother and Warren": "N. Dakota is amazingly flat, straight & yellow-green."

July 17: To Aurelia: Mentions the "marvelous endless prairies, rich with cows & unpeopled" and the Badlands: "In fine health & spirits."

July 18: "Dear Mother": Ted types an essay under the cottonwoods in Billings, Montana. They drive through "yellow wheat & black earth fields stretching in alternate ebony & gold bands to the purple mesas on the horizon."

July 20: "Dear mother": They count nineteen bears at Yellowstone. "Neither of us have seen such wonderful country anywhere in the world. Flowers everywhere, & animals & snow."

July 24: "Dear mother & Warren": A bear wakes them up smashing the car's rear window devouring their food. They catch their limit of six big lake trout and watch the "wonderful geysers."

To Joseph, Dorothy, Robert, and Nancy Benotti and Frank Schober: Postcard from the Teton Range in Grand Teton National Park, elevation 13,766 feet.

"Dear Dotty & Joe & Bobby & Nancy & Grammy": Five exciting days of camping in Yellowstone with elk, moose, and sixty-seven bears.

c. July 24: To Edith and William Hughes: Describes the encounter with the bear.[386] {THL|

July 25: "Dear Mother": Asks to have manuscript submitted to Knopf sent to her.

July 26: Picture postcard to Aurelia: "Salt Lake desert at sunset spectacular!"

July 28: "Dear mother & Warren": Describes their encounter with a bear in Yellowstone and trip through Nevada, the Grand Canyon, camping near Lake Tahoe, and on to Utah, the Salt Lake, Sacramento, San Francisco. "Well, we are fine, and both of us tanned, and have the experience of our lives."

August 2: "Dear mother": Describes lunch with Aunt Frieda. "It is amazing how Frieda resembles daddy—the same clear piercing intelligent bright eyes and face shape."

August 3: Picture postcard: "Dear mother & Warren": "Frieda looks like a feminine version of Daddy."

Picture postcard: "Dear Ted's mother & dad": Enjoyed riding cable cars in San Francisco, on their way to the Grand Canyon, "Ted looks the best I've ever seen him!"

August 6: Picture postcard to Aurelia and Warren: Heading toward Texas. "Grand Canyon was amazing—but we didn't work up energy enough to hike down & up."

August 8: Picture postcard to Aurelia and Warren: A short trip from El Paso into Mexico. "We're in the best of health, & so is the car."

August 9: Picture postcard: "Dear mother & Warren": A "fine afternoon" in Carlsbad Caverns in New Mexico, on the way to New Orleans through "huge Texas."

August 14: The *Decatur Herald* publishes "Fiesta Melons"

Ted to Aurelia and Warren: Ted writes a poem about their travels through Nevada, Louisiana, Tennessee. {THL}

August 17: Editor Emilie McLeod at Little, Brown, rejects *The Bed Book* "as not simple and basic enough" {PA}

August 18: CSM publishes "Song for a Summer's Day"

August 24: To Elizabeth Ames, Executive Director, Yaddo: Expects to arrive on September 9, wishes to extend their stay until early December.

August 25: Editor Monroe Spears accepts "The Fifteen Dollar Eagle" for the *Sewanee Review* {PA}

August 26: CSM publishes "Southern Sunrise"

August 27: Celebrates Ted's twenty-eighth birthday in Eastham on Cape Cod with mother and grandfather {HC}

August 28: Sylvia and Ted arrive in Wellesley {PA}

Fall: *Partisan Review* publishes "I Want, I Want," *Arts in Society* publishes "Aftermath," "The Goring," and "Sculptor"

September: *Poetry* publishes "On the Decline of Oracles," "The Death of Myth-Making," and "A Lesson in Vengeance"

September 1: To John Lehmann, the *London Magazine*: Encloses three of her stories.

September 5: To Elizabeth Ames, Yaddo: Expects to arrive at Yaddo between 7:30 and 8:00 p.m. on September 9.

September 9: Ted Hughes gives a reading of his work at Yaddo {PA}

September 10: "To Warren & Mother": Describes their routine and their large bedroom "about twice as big as our Boston apartment," her writing studio and Ted's, the castle-like house and the grounds: "Very quiet and sumptuous. . . . I have never in my life felt so peaceful and as if I can read and think and write for about 7 hours a day."

Sometime during her stay at Yaddo, Plath realized she was pregnant. She may have suffered from morning sickness.

September 16: Free of the nausea that has troubled her. A "terrible depression yesterday" with a vision of her life "petering out into a kind of soft-brained stupor from lack of use." Bear story seems artificial[387] and "Poems are nowhere." Wondering "where the solid confident purposeful days of my youth vanished." {PJ}

At this point in their careers, Ted Hughes was regarded as the more important poet—an acknowledgement that Plath often made in her letters and public statements, but it heartened her to be recognized in her own right, as she was in being selected for a residency at the famous writer's colony, Yaddo. As in Boston, however, she seemed stymied by having to schedule her own writing routine instead of fitting it around the demands of school and office employment.

September 18: "Dear Mother & Warren": Describes the sumptuous Yaddo meals and the "elegance and peace of the whole mansion." Ted does a reading of his poems. Plans to arrive home day before Thanksgiving.

September 20: To Rachel Mackenzie, the *New Yorker*: Sends in a revision of "A Winter's Tale."

September 23: "Dear mother": Reads her poems at Yaddo, they have been invited for a return trip to Yaddo. They miss their cat Sappho.

September 25: A bad dream about giving birth. "I feel self-repressed again. The old fall disease." {PJ}

September 26: Sees Newton Arvin[388] and recalls her "old teaching nightmares," considers various ideas for stories. {PJ}

September 28: Records her dreams, in one of which her father appears. "Inertia at beginning stories. How to organize them?" {PJ}

September 29: "A weight upon me of the prose solidity of the professional story tellers: something I haven't come near. . . . My feverish dreams are mere figments; I neither write nor work nor study. . . . I write as if an eye were upon me. That is fatal." {PJ}

September 30: "I must leave dreams of money and grandeur alone. If I can only get some horror into this mother story." {PJ}

October: Completes "Magnolia Shoals," *London Magazine* publishes "In Midas' Country" and "The Thin People"

October 3: "The mummy story dubious. Is it simply feminine frills, is there any terror in it?[389] Would be more if it were real? Set with real externals? As it is, it is the monologue of a mad woman." Dreams about packing for Europe with odd appearances of her mother and father. {PJ}

October 4: Dreams of Marilyn Monroe.[390] Reads Jung[391] who confirms images in her mother story. {PJ} Finishes "The Mummy," her mother story. {HC}

October 6: "Yesterday very bad oppressed," seeks inspiration in reading Ezra Pound, "master," aloud, Henry Holt rejects book-length poetry manuscript, Ted advises her to start a new book. Upset with most of her earlier stories, flitting from one subject to another. "Begin begin." {PJ}

The *Selma Times Journal* publishes "Southern Sunrise"

October 7: "To Mother & Warren": Not much news to report from Yaddo. Just writing, misses Boston, Yaddo is like working in a vacuum: "Ted loves it and is getting a lot of work done."

October 10: To Edith and William Hughes: Ted has his usual successes. She is working on short stories, selling a few poems and drawings to CSM.

Describes a walk with Ted. "Feel oddly barren. My sickness is when words draw in their horns and the physical world refuses to be ordered, recreated, arranged and selected. I am a victim of it then, not a master." Reads Elizabeth Bishop who is "juicier" than her godmother Marianne Moore, admires Iris Murdoch's novels: "When will I break into a new line of poetry?" {PJ}

October 12: CSM publishes "Mosaics—An Afternoon of Discovery"

October 13: To Aurelia: Well fed. The *New Yorker* has bought "A Winter's Tale" and CSM has paid her $46, studying German two hours a day.

"Very depressed today. Unable to write a thing" as if in a Greek drama with "Menacing gods." Laments her "inability to lose myself in a character, a situation. Always myself, myself." She thinks of Ted as her salvation, vows to be more like Ted and keep her "sorrows and desires to myself." {PJ}

It may be no surprise that a pregnant Plath is reading fiction about mothers and daughters and dreaming about both her parents.

October 19: After breathing and concentration exercises directed by Ted, she produces two poems, "The Manor Garden" and "The Colossus." Reads Mavis Gallant novel about a "daughter-mother relation, the daughter committing suicide. A novel, brazen, arrogant, would be a solution to my days to a year of life." A rejection from Harcourt. "Ted says: You are so negative." She "gets cross, desperate." {PJ}

CSM publishes "Explorations Lead to Interesting Discoveries"

October 21: "Dear mother": "Ted & I are both in excellent health: I don't know when we've been so rested, getting about 9 hours a night."

CSM publishes "Yaddo: The Grand Manor"

October 22: "Warm in bed with Ted I feel animal solaces. . . . Why should a poet be a novelist? Why not?" Dreams of her father "come to life again" and a confusing scene in which her son is a twin to her mother's son who is an uncle the same age as his nephew, her brother the same age as her child. "O the tangles of that old bed." Drawing remains a "consolation." {PJ}

October 23: Thinks England will offer "new comforts" and the chance to write a novel. "My tempo is British." {PJ}

October 26: CSM publishes "Magnolia Shoals"

October 27: On her twenty-seventh birthday completes "Poem for a Birthday." {PJ}

October 28: "Dear mother": "I loved the gaily decorated birthday telegram. . . . Ted & I are so happy, and healthy—our life together seems to be the whole foundation of my being." Likes the idea of settling in England because the "fastness and expense of America is just about 50 years ahead of me."

October 30: Sends poetry manuscript to Farrar, Straus after rejections from Henry Holt and Viking {HC}

November 1: Dreams of giving birth [she is five months pregnant] to a beautiful and healthy boy: "Ted claims this is a rebirth of my deep soul. Auspicious." Wonders about the depth and complexity of her recent poems, goes to see Bergman's *The Magician*: "Not as gripping and terrifying as the Seventh Seal, but fine, magnificently entertaining." Disappointed that America cannot make such films. Why? "The corruption of the capitalist

civilization? The lack of any knowledge of deep humanity?" Wishes Ted's play were suitable for Broadway. {PJ}

November 4: "Paralysis again. How I waste my days." Will she ever be rid of "Johnny Panic"? Then writes seven poems, including "The Colossus." {PJ}

Completes "Poem for a Birthday"

November 6: *TLS* publishes "Two Views of a Cadaver Room" and "The Hermit at Outermost House"

November 11: Completes "The Burnt-out Spa"

Sylvia and Ted visit editor Peter Davison in Cambridge. They meet Robert Frost and walk with him to his house, with Ted drawing Frost's attention with talk of Edward Thomas, Ezra Pound, and T. S. Eliot, while Sylvia remains mostly silent. {PJ}

Peter Davison recalls Frost "took a shine" to Ted, and Sylvia was very quiet. {BF}

November 12: To John Lehmann, the *London Magazine*: Pleased at the acceptance of her story "The Daughters of Blossom Street" and alerts him to two of Ted's stories he has just sent to the magazine.

November 13: Completes "Mushrooms"

November 19: End of Yaddo residence {HC}

November 23: To Miss Reutlinger: Encloses a poem "Lament" that was published in *New Orleans Poetry Journal*, hopes to publish a volume of poems "in a year or so if fates and editors are willing."

November 28: To Rachel Mackenzie at the *New Yorker*: Suggests subtitles for "The Net Menders," a poem about Benidorm.

To Rachel Mackenzie: Submits several more poems: "I hope it won't lessen the chances of these poems to follow so soon on the heels of the last."

To Robbie Macaulay, *Kenyon Review*: Pleased at the acceptance of "The Colossus" and "The Beekeeper's Daughter," includes notes about her publications.

December 3: Ted to Daniel Huws: "Sylvia is pregnant & should be delivering some time in March." {THL}

December 9: Sails on the SS *United States* from Pier 86 in New York City.

Ted writes to Lucas Myers that Sylvia, six months pregnant, has written a dozen spectacular poems that reflect an entirely new phase—all done as wild monologues: "I've already stolen several things from them." {CR1}

December 12: The *New Yorker* publishes "A Winter's Tale"

December 13: "Dear mother": Writes aboard ship about eating, sleeping, reading, their fellow passengers.

To Joseph, Robert, and Nancy Benotti: In the middle of the Atlantic enjoying "brisk deck-walks," spending Christmas with Ted's parents.

December 14: Arrives in Southampton via Le Havre

December 17: "Dearest mother": A safe arrival at the Beacon, after spending a night in London with Ted's friend Daniel Huws, now "sitting in great armchairs by roaring coal fires, very cosily," in the Hughes home with Olwyn "her hair newly cut & curled looking handsome, chic, extremely nice. I like her a great deal." They are eager to find a flat in London so she can cook. Describes Ted's mother as an "awful cook"—"indigestible pastries, steamed vegetables, overdone meat," an "untidy . . . never quite clean" kitchen. Considers the "critical" Olwyn an "ally," "The main thing is that the family is loving & closeknit."

CSM publishes "Dark Wood, Dark Water"

December 18: To Rachel MacKenzie, the *New Yorker*: Comments on proofs for "The Net Menders."

December 26: "Dearest mother": Rested and preparing to depart for London and flat hunting, playing Tarock, her childhood card game,[392] enjoying her mother's Christmas presents, including the "lovely, very chic" scarf for Olwyn. "Olwyn is very nice, a beautiful blond slim girl, my height & size, with yellow-green eyes and delicate graceful bone structure: looks 21, not 31. I get along with her much better now that she's really accepted me as Ted's wife & like her immensely."[393]

December 27: "Dear Dotty and Joe": "We remember with joy the superlative feast you made for us before we left, & I must say I come from a family of wonderful cooks, a tradition which I hope to keep up as soon as we find a place in London." Investigating maternity plans on socialized medicine: "Luckily Ted will be free to help me through all this & is very strong, sensible and kind, a real support."

December 29: CSM publishes "Memoirs of a Spinach Picker"

1960

Undated: "Candles," with inscription to Olive Higgins Prouty {PM}

January/February: Completes "You're"

January 3: Sylvia and Ted take the train to London to look for an apartment. {PA}

January 10: "Dear Mother": Difficult finding clean, cheerful looking apartments near a city park but are getting help from the Merwins while staying with Daniel and Helga Huws, whose German hausfrau cleanliness and good cooking impress Plath. Dido Merwin has arranged for Sylvia's visit to a doctor who recommends an obstetrician, although midwives handle most of the deliveries at home. "Ted will cook and care for me." Ted has a cold and is "gloomy from this running about," and she has "gone through a very homesick & weary period."

January 11: Ted to Aurelia and Warren: Describes the disheartening search for a flat in London. {THL}

January 16: "Dearest mother": A return to the Beacon after "two grueling weeks in London." Looks forward to the publication of Ted's second book of poetry, the Merwins continue to help out with various items and furniture for a flat they have found near Primrose Hill, which is like "living in a village yet minutes from the center of London."

"Dear mother": Discusses banking matters, mentions maternity clothes "working out beautifully & are very warm," explains the role of the midwife, their child will be named Nicholas or Katharine Frieda, compares Mrs. Hughes unfavorably to Aurelia: "When I'm critical I find it hard to hide it, as you know." Complains about Ted's wealthy Uncle Walter who could do more to help Ted, dreams of owning a London house, praises practical and shrewd Dido Merwin.

To Brian Cox, *Critical Quarterly*: Pleased that "Medallion" has one of the journal's awards.

An affordable London residence that seemed almost out of reach for Sylvia and Ted finally became available in a flat in the Primrose Hill section of London, not far from the zoo and parks. Their cramped quarters would eventually drive them out of the city, but for the nonce they made do with help from fellow poet W. S. Merwin and his wife, Dido.

January 19: The *Selma Times Journal* publishes "Dark Wood, Dark Water"

January 19–22: "Dear mother": Writes from the Beacon to say they now have a lease for an unfurnished London flat in 3 Chalcot Square, using Guggenheim money to purchase a bed, mattress, and gas stove, and perhaps a small refrigerator: "Unfurnished here means literally nothing: not even cupboards." Wrestling with herself not to "hanker after the things I left at home—the iron & board, the kitchen cupboard china set, & most of all my beautiful mixing bowls. . . . Objects do exert such a tyranny over one." Doctor has been reassuring about the baby, stove and bed purchased, with plans to paint and wallpaper parts of the flat, Ted will make bookcases.

January 24: "Dearest mother": Back at the Beacon one more time before settling into the flat on February 1, in London Helga Huws has welcomed Sylvia and Ted and cooked delicious dishes for them, describes the new flat and plans to fix it up, counts on her mother to send along articles from home: "I need a constant flow of America to enrich my blood!"[394] She misses her mother's mothering.

January 27: "Dearest mother": "The smallness of the flat has one advantage in that it will be easy & inexpensive to fix up very prettily." Seeks her mother's advice on appliances, looks forward to some "concentrated writing" after two months of traveling and flat hunting. She is healthy, taking iron

pills, the baby is kicking, avoiding fatigue that makes her feel "homesick & blue." She is an "impressive size," with occasional backaches, heartburn, but with a good appetite. Faber is publishing Ted's children's stories, directs her mother to send out poems to several magazines, Mrs. Prouty's $300 gift has been used to purchase a crib, layette, and to pay for a diaper service.

January 30: *The Nation* publishes "Two Views of a Cadaver Room"

February 1: Sylvia and Ted move to London {PA}

February 2: Typing in the new flat listening to the cries of children in Chalcot Square gardens, repairs made to the plumbing, installation of refrigerator, cupboards, oven, and stove underway, wallpapering and painting soon. "What I like best is the spanking newness of everything. All new fixtures, nobody's old stove to clean or toilet to scrub!" A laundromat is around the corner, Ted will have the use of the Merwins' study while they are in France.

February 7–8: "Dearest mother & Warren": She is delighted with her new stove, freezer, bed, wood bureau, while dealing with workmen doing tiling, paneling, flooring. Ted has already made bookshelves, with a blowup of an Isis engraving on the wall. Describes the delights of the park in Primrose Hill, a visit to her "kind & capable" doctor, attends natural childbirth relaxation classes.

February 8: To Marcia Brown: Recounts the arduous effort to find a decent London flat; "the English are the most secretly dirty race on earth." Appreciates the support of the Merwins and Daniel and Helga Huws as she and Ted fix up their Chalcot Square flat, which she describes in detail: "Day by day things get better as I get the routines under control. . . . in another week I shall feel human again. I may even read a book." Urges Marcia to write her "at least once a month!" She is getting used to the idea of a midwife, "that's the way they do things here."

February 8: To Olwyn Hughes: In recovery: "I don't think either of us has sustained such a prolonged period of crammed exhaustion & despair before—& physical cold, hunger & all the misères. . . . My one prayer is that the saws, nails & sawdust are out of the tub tomorrow, along with the workmen."

February 10: In the York Minster pub on Dean Street in Soho, meets James Michie and signs a Heinemann contract for publication of *The Colossus* {PKS}

Sylvia and Ted celebrate her contract with champagne and Ted brings a copy of D. H. Lawrence's *Complete Poems*, published by Heinemann {HC}

February 11: "Dearest mother & Warren": Describes signing her contract in a pub and celebration at a Soho Italian restaurant, extols all the improvements in the flat, starting to bake, sends regards to the family cat, Sappho.

February 18: "Dear mother & Warren": Praises her midwife, "a surprisingly delicate, yet wiry Irishwoman of about forty with golden hair! A lovely lilting voice: she seemed both kind & warmhearted & extremely practical & capable." Figuring out the details of a diaper service, in good health, sleeping well, good appetite, Dido Merwin continues to help furnishing the apartment, delight in hearing about Sappho's antics: "One Sappho & all other mere flashy copies." Needs her mother's help with banking details.

To Lynne Lawner: "a Dickensianly grim & chilblain³⁹⁵-ridden January hunt for a flat in central London near a big park," finds it amazing that she will deliver a child in five weeks, three weeks of painting, scrubbing, waxing, sandpapers to get their new apartment livable, close enough to the zoo to hear the lions roaring, "blue" about no writing for the past two months, calls her first published book of poetry "a long hard book in coming. . . . I think I shall be a very happy exile & have absolutely no desire to return to the land of milk & honey & spindryers."

February 20: To RB: Describes arriving in England, looking for a flat in London, "bleak and utterly inhospitable," but a flat is found that has to be furnished, describes her doctors and National Health Service care: "I feel I have made the best arrangements for my own odd psychic setup." Baby and first book are "well on the way. . . . I'd love to hear any last minute notes or words of wisdom."

February 21: To W. Roger Smith, Heinemann: Lists the poems in her book that have been unlisted elsewhere or that are forthcoming, and suggests how to write the acknowledgments.

February 22: To Charles B. Cox, the *Critical Quarterly*: A thank you for the check in payment for publication of "Blue Moles," "The Beggars," and "The Manor Garden."

To Monroe K. Spears, the *Sewanee Review*: Sends seven-poem sequence, "Poem for a Birthday," describes working on the new flat: "We're two minutes walk from Primrose Hill and a few minutes more from Regent's Park, a pleasant area."

February 23: First copies of *Lupercal* arrive—"a handsome affair" {HC}

February 25: "Dearest mother": They each get a day in bed, waited on by the other, as part of their recovery from the "strain of the last months & settling in." Describes a trip to Oxford, where Ted gave a poetry reading, wonders if the birth of their child will coincide with publication of his second book, *Lupercal*, hopes to begin writing again soon: "Now we are 'at home,' London is a delight."

Ted inscribes *Lupercal*: "To Sylvia, its true mother, with all My love, Ted" {HC}

February 27: Sylvia and Ted attend a *St. Botolph's Review* reunion. Poet Peter Redgrove finds Sylvia "bright and ebullient but rather false, like Doris Day. She had a Doris Day mask." {EF}

March 1: Lunch with Ted's editors {LWM1}

March 2: Cocktails with John Lehmann, editor of *London Magazine* {LWM1}

March 3: "Dear mother": "I get tired easily & like the house to myself so I can cook, read, write, or rest when I please." Meets with John Lehmann, editor of *London Magazine*, who reminisces about Virginia Woolf, enjoys shopping for baby things at Selfridge's.

March 5: Olwyn visits Chalcot Square flat with a friend, and Lucas Myers observes what he terms Sylvia's "silent animosity."[396] {BF}

March 10: "Dear mother": Homesick for snow, "Ted is, if anything, too nice to his relatives and friends, and I got weary sitting for 8 hours at a stretch in our smokefilled rooms waiting for them to leave—impossible to nap or relax with so many people around." Mentions writing in her diary,[397] cooks for the Merwins, anticipating an imminent delivery: "I have an odd feeling the baby may come any day now, although officially I have 17 days grace."

March 11: To Edith and William Hughes: "We're looking forward to a peaceful spring of working, & the baby, who should be here by the 27th or so."

To W. Roger Smith, Heinemann: "I expect to be resident in England from now on, as far as I know."

March 12: Lucas Myers responds to Olwyn's letter about her March 5 visit to Chalcot Square: "Ted suffers a good deal more than he would ever indicate or admit, but he also loves her and I think it is best to assume he will stay with her. And she evidently loves him in the self-interested and possessive way of which she is capable." {BF}

March 14: The *Selma Times Journal* publishes "Midsummer Mobile"

March 17: "Dear mother": Good checkup with the doctor, still more work to do on the flat, describes the wonderful zoo: free pony rides for children, animals to pet, a reptile house, "monkeys of all sorts."

c. March 17: Doctor predicts arrival of the baby around March 27 {EB}

March 18: Faber and Faber publish *Lupercal* {PA}

March 24: "Dearest mother": Impatient to give birth, "Ted is back at work at his desk, much happier. He gets almost nervously sick when he hasn't written for a long time, & really needs careful handling." During her cold, Ted did the cooking and washing. His prospects for BBC work are excellent. Thanks her mother for sending the *Ladies Home Journal*: "Perfect sickbed reading!" Announces that Ted has won the Somerset Maugham Award for *Lupercal*, over $1,000 is allotted for travel abroad to enlarge his world view.

March 25: To Edith and William Hughes: Asks them to send any clipping they see about Ted's book.

Saturday noon: March 26: Stays home because of her cold, planning to spend three months in France, Italy, and Greece using the Somerset Maugham money, avoiding a "dreary English winter"

March 27: Al Alvarez reviews *Lupercal* in *The Observer* and calls Hughes "a poet of the first importance." {EF}

March 28, noon: Now expecting the baby April 1, a marvelous review of *Lupercal* by A. Alvarez praising the "immensely assured poetic skill . . . profound & important." Thrilled to get her own mention as the "tall trim American wife . . . who is a New Yorker poet in her own right."

March 29: Ted suffers panic attack at the BBC[398] {HC}

March 31: "Dear mother & Warren": They have become very fond of their midwife, who predicts a very early morning Sunday delivery. The doctor says "everything was ripe & ready for my having the baby in the next few days." Still active, washing and waxing the kitchen floor, cooking, a "lovely quiet" evening walk with Ted, writing letters while she still can.

"PS APRIL 1st: 1:15 pm": Describes waking up, groggy from two sleeping pills, twelve hours earlier, for a rapid delivery without anesthesia, fully dilated at five, a half hour later doctor arrives and along with midwife supervises the delivery of Frieda Rebecca "white as flour with the cream that covers new babies, little funny dark squiggles of hair plastered over her head, with big dark eyes. At 5:45 exactly." Ted is there "the whole time," holding her hand, rubbing her back, boiling water, the baby "pink & healthy, sound asleep. We can't imagine now having favored a boy! Ted is delighted. He'd been hypnotizing me to have a short easy delivery— well, it wasn't 'easy,' but the shortness carried me through." Less than five hours labor, the midwife announces "A wonder child! . . . Well, I have never been so happy in my life. The whole American rigamarole of hospitals, doctors' bills, cuts & stitches, anesthesia etc. seems a nightmare well left behind."

April 1, 5:45 a.m.: Frieda Rebecca Hughes is born {PKS}

To Marcia Brown: Describes the circumstances of giving birth and the aftermath: "I am eager to be up, although the sister [the midwife] won't let me set foot on earth till tomorrow. I snuck in the livingroom to call mother when she'd left, though." Contrasts publication of poetry in England with America: "they're much kinder & open to poetry than in America, where loss of money is such a phobia."

April 1–4: To Edith and William Hughes: Describes life after Frieda's birth, how wonderful Ted is with Frieda, the helpful midwife, and urging them to visit "later this spring."

April 2: To Olwyn Hughes: "We loved getting your long letter." Describes the "miraculous" birth, the baby has the "Hughes hands & alas, a Plath nose. . . . Ted's hypnosis, I am sure, made this unusual first labor possible."

To RB: Announces Frieda's birth, describes the delivery: "England is a marvelous country for babies & books & we are happy as we've never been anywhere else."

April 3: A candlelight supper with Ted, eating Dido Merwin's casserole {PA}

April 4: "Dearest mother": Describes the routine of care for mother and child and Ted's role: "You should see him rocking her & singing to her!" Breastfeeding every four hours, napping in between, surrounded by flowers from the Merwins, Ted's parents, and friends.

April 6: W. S. Merwin visits to see the baby and arranges with Ted to meet Merwin's publisher {PA}

Plath's letters home reveal the equilibrium she tried to maintain: affirming her acclimation to an English way of life while sorely missing friends, family, and the conveniences of her American upbringing. She seemed irresponsibly American and that annoyed some of Ted's friends, who did not appreciate how hard she was working to open herself up to this change in culture.

April 7: "Dear mother": "I actually had a dream during my nap yesterday that Ted & I were waiting for you & Warren in the Wellesley kitchen." Longs for her own relatives to "admire the baby in person." Frieda waves her legs when Sylvia changes her diapers. "They put the baby to the breast at birth here, feed it nothing supplementary & the baby obligingly sleeps through the early days & its demand seems magically to produce the right amounts of milk. . . . No more words about hormones & growth-stopping please! I'm surprised at you. Tampering with nature! What an American thing to feel measuring people to ideal heights will make them happier or not interfere with other things. . . . I'm becoming more & more Anglophile—watch out!"

To Gerald and Joan Hughes: "thriving in London air & very happy with all things."

April 9: The *New Yorker* publishes "Man in Black"

April 13: To Peter Davison: Expecting Peter and his wife Jane will visit her in London: "I am now a strong advocate of the British Medical System, which gave me cold shivers when I first came over. . . . A year ago if anyone had told me I'd have my first baby at home, delivered by a five-foot high Indian midwife without any anesthesia I would have called them mad."

April 15: "Dear mother": Describes the daily routine of caring for Frieda: "The midwife says I have enough milk for twins." Beginning to go for walks, describes the new pram, concerned that her mother is working too hard, "eager to begin writing & thinking again."

April 17: Sylvia and Ted take Frieda on her first outing: a ban-the-bomb march.[399] {PA}

April 19: Attends with Ted a lunch with a BBC editor and Karl Miller, editor of the *New Statesman* {PA}

April 21: *Lupercal* second printing ordered for June {PKS}

"Dear mother": Looks forward to her mother's call, enjoys walking past the zoo and Primrose Hill "covered with children," Frieda eats like a "little piglet."

3:15: Sitting on a bench in Regent's Park: "Nothing so beautiful as England in April." Wonderful to feel "hot in the sun," looking forward to cocktails at Faber's with T. S. Eliot, describes the Aldermaston march to Trafalgar Square protesting atomic weapons, "over ten thousand," Frieda sleeping alongside other nursing mothers in a "7-mile-long column" with "Ban the Bomb" banners. "I felt proud that the baby's first real adventure should be as a protest against the insanity of world-annihilation—already a certain percentage of unborn children are doomed by fallout & noone knows the cumulative effects of what is already poisoning the air & sea." Calls Nixon a Machiavelli "of the worst order" and hopes her mother and Warren won't vote for him. She feels "badly to be deprived of however minute a participation in political affairs." {PJ}

Ted speaks with T. S. Eliot at Faber and Faber cocktail party, Sylvia with Janet Burroway, Marshall scholar at Cambridge {HC}

April 22: Ted to Lucas Myers: Describes Sylvia giving birth to Frieda: "the business is like backing a lorry round a tight bend in a narrow alley full of parked cars." {THL}

April 26: "Dear mother & Warren": Happy to have heard their voices on the phone: "You sounded so close," wishes her mother happy birthday and can hardly wait until the summer and her mother's visit. Frieda is sleeping longer at night and behaving as Dr. Spock says is "most common." Believes Peter Davison, fancying himself a poet, is the cause of the rejection of her poems at the *Atlantic Monthly*[400]

April 29: "Dear mother": Encloses snapshots of Frieda, two checks for deposit, describes Frieda's "irritable crying" that Dr. Spock calls "very common," going to see Sir Laurence Olivier in Ionesco's play, *Rhinoceros*, discusses family news. Ted is beginning his BBC work.

May: *London Magazine* publishes "The Daughters of Blossom Street," *Chelsea Review* publishes "The Beggars" and "The Eye-Mote"

May 2: Sylvia and Ted have a tense dinner with Peter Davison {PA}

May 3: Arranges with Janet Burroway to meet for dinner at Chalcot Square

May 4: Babyminders look after Frieda while Sylvia and Ted attend dinner with T. S. and Valerie Eliot, Stephen and Natasha Spender {JB}

Receives a proof copy of *The Colossus* {PKS}

May 5: "Dear mother": "How wonderful Sappho is going to have kittens." Describes proofs of *The Colossus*: "The poems look so beautifully final." Meets Peter Davison who brags about his work in the "most puerile way . . . A very unpleasant person." Describes T. S. Eliot and his wife in their London flat: "I felt to be sitting next to a descended god: he has such a nimbus of greatness about him." Enraptured with "beautiful Frieda."

To Robbie Macaulay, editor of the *Kenyon Review*: Announces publication of her first book in the fall in case it makes a difference in the scheduling of "The Beekeeper's Daughter" and "The Colossus."

c. May 5: Ted describes dinner with T. S. Eliot and Stephen Spender {THL}

May 7: Dinner with Janet Burroway at Chalcot Square {PKS}

May 8: Ted records a BBC program {LWM1}

May 11: "Dear mother": Relieved that Ted can write in the Merwins' study while they are away in France: "I find my first concern is that Ted has peace & quiet. I am happy then, & don't mind that my own taking up of writing comes a few weeks later." Making adjustments in Frieda's feeding schedule: "I don't know what I would do without Ted: he adores the baby & is continually marveling, hanging over her crib, on how beautiful she is." Excited about a Somerset Maugham letter saying he would like to meet Ted in London, enjoys a visit from Ann Davidow and her husband, her paperback copy of Dr. Spock is falling apart.

May 14: Ted to Esther and Leonard Baskin: Describes Chalcot Square flat near the sounds of the zoo, the birth of Frieda: "Visitors comment on her mouth—very delicately & voluptuously formed at this stage—and her eyes which are enormous & stare intently like a bird's. She's just begun to smile—she's generally very good." {THL}

c. May 16: To Olwyn Hughes: Frieda is beginning to smile and interact with them. "London is meat & drink to me in spite of its dirt, & our corner a leafy bower."

May 20: To Myron Lotz: Invites him for a visit: "We're at present enjoying the proverbial English spring. Halcyon greens, flowers sprouting from people's ears, the barking of gay seals in the Zoo next door. Just as I write this it starts to pour rain, & the temperature drops ominously."

Ted records a BBC program. {LWM1}

May 21: "Dearest mother": Already thinking of another name for a second daughter: Gwyneth, reports income from Ted's BBC work and her publications: "I am itching to get writing again & feel I shall do much better now I have a baby. Our life seems to have broadened & deepened wonderfully with her."

May 28: The *New Yorker* publishes "Watercolor of Grantchester Meadows"

May 30: "Dear mother": Congratulates Sappho on triplets, concerned about visitors who take up too much time away from writing, pleased with her new Hoover vacuum.

May 31: To Philip Booth[401]: "I am becoming an Anglophile, what with U-2's,[402] the boom of biological & chemical warfare plants in Maryland, the Chessman execution[403] & Dick Nixon to keep me beating my head for my homeland."

Summer: *Critical Quarterly* publishes "The Manor Garden," "The Beggars," and "Blue Moles,"

Partisan Review publishes "Metaphors for a Pregnant Woman" ["Metaphors"]

June: *London Magazine* publishes "The Sleepers" and "Full Fathom Five"

c. June 1960: Description of Trafalgar Square, National Gallery, Lord Nelson's pillar, the roar of traffic, "hundreds of pigeons wheeling." {PJ}

June 11: To Alan Anderson: Thanks him for making the "lovely leaflet" of her poem "A Winter Ship"

"Dearest mother & Warren": Going through "a rather tired spell," which is why she hasn't written to them "for ages," describes visits from Ted's family, spring cleaning, taking care of Frieda, happy to get clothes from her mother: "You have no idea how much it means to me to dress her partly in American clothes."

June 21: Ted to Mrs. Prouty: Describes Chalcot Square flat, surrounding area, and Frieda: "Sylvia is marvellous with her,—no fuss, very efficient and endlessly patient. We've been taking photographs and if any come out we'll send you one. . . . Sylvia is at last getting back to writing two or three hours a day." {THL}

June 23: Faber and Faber cocktail party: W. H. Auden, Stephen Spender, Louis MacNeice {JB}

June 24: "Dear mother": Encloses photographs of Frieda, ten weeks old, describes Faber party with Ted flanked by W. H. Auden, Louis MacNeice, Stephen Spender, and T. S. Eliot, three generations of Faber poets. "Of course I was immensely proud. Ted looked very at home among the great." Tires easily, trying to take afternoon naps: "I am at the depressing painful stage of trying to start writing after a long spell of silence."

To Dido and W. S. Merwin: "I've at last come out of my little treadmill of domesticity and now spend mornings in the study while Ted works at home, and he spends afternoon there." Describes the Faber party with Auden, Eliot, and the Spenders.

c. June 24: Ted to Olwyn Hughes: At the Faber party: "Sylvia talked quite a lot to McNeice & Spender, and I talked to Eliot." {THL}

June 26: Ted records a BBC program

June 27: Completes "The Hanging Man"

June 29: To Ann Davidow: Expresses her pleasure at meeting Ann's "brilliant" and "very handsome" husband, getting her "nose above crib-level" and beginning to write, feeling "very rusty & superficial," wondering if she will ever write a "good poem again."

June 30: "Dear mother": Frieda is getting her shots. "Something odd happened to me today which both elated & depressed me": She gets her first look at Fitzroy Road where Yeats lived and where she imagines living with Ted in a future home. "Ted, of course, is much more hesitant than I to commit himself."

July: Completes "in Cloud Country"

Harper's publishes "Mushrooms," "On Deck," *Atlantic Monthly* publishes "A Winter Ship"

July 5: Completes "Sleep in the Mohave Desert"

July 9: To Alice Norma Davis, Smith Vocational Office: Looking for work in London and needs documentation of her grades and job references.

"Dear mother": Ted has success with a play on the BBC, which has also asked to see some of her poems.

July 19: "Dear mother": "Both Ted & I are awestruck and immensely proud of your studies & the triple & quadruple life you seem to be leading. Housewife, teacher, student, mother, mistress of four cat-kittens (I do hope this number will diminish): I feel extremely lazy by comparison." Homesick for "days that start out blue & clear & stay that way, and miss being tan, as I have always been in the summer. I am a horrid pale yellow. O England." Vows to disown her mother if she votes for Nixon.

July 23: To Alan Anderson: Delighted with Tragara Press, production of two different pamphlet versions of Plath's *A Winter Ship*, pleased with the cover design

August 2: "Dear mother": Describes a "responsive merry little baby," looks forward to her mother's visit.

Ted and Al Alvarez record a BBC program {LWM1}

August 3: Harper and Brothers publishes *Lupercal*

August 7: To Robert Hemenway, the *New Yorker*: Suggests changes in "On Deck" and "Two Campers in Cloud Country"

August 16–17: "Dear Mother": Getting ready for Ted's birthday, "Ted is a bit homesick for the moors & I think both of us would benefit by a change." Happy with the package her mother has sent with items for Frieda and Ted, reading about Gallipoli, where Ted's father fought, no energy for writing except in her diary.[404] "I do feel sorry no publisher in America seems to want my book, for I am sure it is better than most first books, but I am glad it will come out here."

August 20: The *New Yorker* publishes "The Net Menders: Benidorm, Spain"

August 21: Ted records a BBC program

August 22: "Dear Sylvia's Mother & Warren": Writing from the Beacon, describes their holiday from life in London, "a load on the nerves. . . . We've spent this first 24 hours in bottomless torpor, sucking in the enormous blissful silence." Describes his parents and household, Sylvia has drawn out his father to talk about World War I experiences: "the past is raked up as something intensely interesting & highly amusing. It isn't that they live in the past at all, but the whole past is kept alive & very present. It's the sort of thing I miss very much when we're in London, and now Sylvia's getting addicted to it." {THL}

August 27: "Dear mother": "I do feel sorry no publisher in America seems to want my book, for I am sure it is better than most first books, but I am glad it will come out here." Visits Whitby: "something depressingly mucky about English sea resorts." Dislikes the dirt and litter on the beaches and aches for Nauset, "something clean about New England sand, no matter how crowded."

August 31: "Dear mother": Refreshed after ten days in Yorkshire, hopes Ted will write a successful play so they can buy a London house,[405] worries that her mother is working too hard at her teaching, encourages her to write fiction: "I'll edit anything you do for what it's worth."

September: *Atlantic Monthly* publishes "The Manor Garden"

September 13: "Dear mother": Reports about Frieda and their desire to rent a house on the Cornwall coast: "How I long for Nauset beach! Perhaps Ted will get a lectureship in a few years to finance our going over." They remain undecided where to spend the three months abroad on the Somerset Maugham travel grant.

September 16: "Dear mother": Hopes that Warren will make a good marriage: "Waiting for the right wonderful person is so much more important than getting the outer comforts of marriage at an early age. I feel I know what I'm talking about because I can't imagine being able to remotely stand any one else in the world but Ted." Asks how long her mother can stay for the summer, continues to enjoy nursing Frieda without the bother of "sterilizing bottles & measuring formula."

September 23: "Dear mother": Studying Italian at Berlitz, preparing for a trip to Italy on the Maugham grant, Frieda is "thriving," hopes to make some clothes for Frieda with a borrowed sewing machine.

September 25: Completes "Leaving Early"

September 28: "Dear mother": Ted is working on more plays, on BBC programs, and paid speaking engagements, describes her Berlitz lesson, but her ambition is to "get 3 European languages really well."

To Gerald and Joan Hughes: "I don't think we've ever been as happy as in the last six months." Describes Frieda's adventures and admirers, enthused about Ted's play, encourages them to visit: "Frieda says 'Ga!' which means she sends love."

September 30: To Lynne Lawner: Describes her period of "cabbagey calm" after having a baby and recommends that Lawner have one, including the "primitive homeliness about everything" associated with her childbirth: "Frieda is my answer to the H-bomb."

Autumn: *Hudson Review* publishes "Ouija," "Electra on Azalea Path," "Suicide Off Egg Rock,"and "Moonrise"

Kenyon Review publishes "The Beekeeper's Daughter" and "The Colossus"

Sewanee Review publishes "The Fifteen-Dollar Eagle"

October 8: "Dearest mother": Miserable with a seasonable cold but enjoying Italian lessons, making clothes: "I don't know when anything has given me as much pleasure as putting together the flannel nightie for Frieda."

October 9: To Ann Davidow: Congratulates her on a new book, hopes that Ann and her husband will make a return visit: "I'm awfully fond of this patchy district now and can't really imagine living anywhere else."

October 13: "Dear mother": *London Magazine* has accepted her "rather nondescript story," fictionalizing the bear episode last summer, recovering from her cold.

October 16: Completes "Love Letter"

October 17: Completes "Candles"

Writes a poem for Ted: "Love Letter": "Not easy to state the change you made, / If I'm alive now, then I was dead" {LWM1}

October 19: To George MacBeth, BBC: Sends four poems, "Magi," "Candles," "Love Letter," and "Leaving Early," for a forthcoming program, *The Poet's Voice*. Frieda has discovered a liking for ice cream.

October 20: "Dear mother": Sends checks for deposit, "very mucky weather here" but they have recovered from their colds. Italian lessons are going well. "Do vote for Kennedy!" She is critical of his Cold War defense policy but better than the alternative.

To Owen Leaming, BBC: Enclosing stories, "The Fifteen Dollar Eagle," "Johnny Panic and the Bible of Dreams," "The Fifty-Ninth Bear," describing them as "very slangy" and "Johnny Panic" as a "sort of mental hospital monologue ending up with the religious communion of shock treatment. I'd be very happy to have your criticism of these."

October 26: "Dear mother": Sends her mother copies of *The Colossus and Other Poems*, "touched" that her publisher has them out for her birthday week. Calls it a "nice fat book" handsomely produced. She is sending copies to Mrs. Prouty, Mr. Crockett, and others. Describes a dinner with Stephen

Spender and his important guests, including poet Louis MacNeice and novelist Rosamond Lehmann. They have banked $1600 from their English writing. She has names for their next three children: Megan, Nicholas, and Jacob. "How do you like them?"

October 27: To Olwyn Hughes: "I've been having a lovely birthday week to console me for catapulting so swiftly towards thirty." Calls Ted's hall study a "life saver, reproducing womb-like isolation," happy with her new fat book: "You have a fingerprint in the book—that verse you suggested I omit from 'The Ghost's Leavetaking' being junked to the poem's advantage, I think." Looks forward to Christmas and seeing Olwyn.

c. October 27: Notes on testimony at *Lady Chatterley's Lover* obscenity trial {PJ, PKS}[406]

October 28: "Dear mother": Describes her birthday celebration and gifts, Frieda has had a second polio shot, hopes her mother will get the new book in "good order. Tell me what you think of it."

October 31: Heinemann publishes *The Colossus and Other Poems* {PA}

November 1: Sylvia and Ted attend a champagne party for the Guinness Awards[407] {PA}

November 6: "Dear Mother": Sewing for Frieda on a borrowed machine, mentions *Lady Chatterley's Lover* trial at the Old Bailey, "so Penguin Books can publish the unexpurgated edition—a heartening advance for DH Lawrence's writings!"

November 7: To *Atlantic Monthly*: Submits "Leaving Early," "Candles," "Magi," "Love Letter," "Home Thoughts from London," "Words for a Nursery."

To RB: Encloses a photograph of a "very bouncy, healthy" Frieda, "full of chuckles and a lovely responsive sense of humor," with Ted compiling names for more girls,[408] mentions the "father" poems in *The Colossus* while under RB's treatment, enjoys nursing Frieda, describes Ted's successes, more difficult now to go out with Ted even with babysitters: "I find I don't need a full day—only the first half and a quiet evening—to feel I am leading my own mental & creative life. Then I am absolutely unfazed by domesticalia."

November 17: *The Listener* publishes "Candles"

November 18: Completes "A Life"

To Owen Leaming, BBC: Includes one of Ted's stories and says she wants to come in to see him when she has "another batch of stories to dig into."

November 19: "Dear mother & Warren": Frieda is teething, still nursing her. "Both of us are getting more retiring about blazoning biographies & publication-notices everywhere." Thinks of taking a part-time job and purchasing a house in London when they can afford it, they probably will postpone their trip abroad.

To Joseph and Dorothy Benotti and Frank Schober: Wishes she had a "private jet service so I could get over to see you all for the Christmas holidays!" Mentions how much attention Ted is getting from the critics, and her own reading of two poems on the BBC.

November 20: Reads for BBC program *The Poet's Voice*, dedicated to "New Poetry" {EB}

November 25: "Dear mother": Delighted to hear that Warren has passed his orals, hopes he can come to London: "We would be overwhelmed with joy." Describes Frieda's behavior, "full of giggles, singing, talking and sweet expressions." Mrs. Prouty has sent a $150 to celebrate publication of *The Colossus*. Nursing a cold, working on a sewing machine loaned from Dido Merwin, visits Helga Huws in hospital after birth of a second child. "I would so like a permanent spacious place where I could have as many children as I wanted!"

November 28: "Dearest mother": Writing while Ted is away to see W. S. Merwin's play in Coventry: "I realize how crowded we are here when I am alone for a bit, enjoying every minute of it, feeling inclined to do little secret things I like." Describes her day looking at a house she would like to buy: "Oh mother for the first time I saw us living in a house perfectly suited to our needs! I do so want at least four children & am head over heels in love with London." Calculate they have about half of what is needed for a down payment. Working on women's magazine stories: "Very rusty and awkward on my first, I got into the swing. . . . For the first time I feel I know where I'm going—a couple of American sales could make the house a reality!"

To Olwyn Hughes: "We're suffering late autumn exhaustion & blues & eager for the cowlike peace of Yorks at Christmas."

Winter: *Texas Quarterly* publishes "Flute Notes from a Reedy Pond"

December 7: *Punch* reviews *The Colossus and Other Poems* {PA}

December 14: "Dear mother & Warren": About to depart for Yorkshire, dying to "recharge our batteries," thanks her mother for Christmas gifts, buying furniture to replace Dido Merwin's stuff: "Our relation with her & Bill whom we have large reservations about, has been made false by our living off her second-hand things: she & he feel they can walk in on us any time, expect us (especially Ted) to come over for dinner as domestic 'lions,' and both of us feel the need to free ourselves from this uncomfortable dependency." They have decided to appear on a radio program, *Two of a Kind*.

c. December 17: To Ann Davidow and Leo Goodman: Describes Frieda's progress and asks Ann and Leo to be "godparents-in-absentia."

To Philip Booth: Christmas card from the moors recuperating from London with Frieda "an angel to confound us atheists with the gifts of her humor and rosebud cheeks."

To Wilbury Crockett: Christmas card: Describes her family life in London, attending films, galleries, and theaters with "cheap play tickets." T. S. Eliot has suggested revisions of Ted's light verse for children. "A warm welcome awaits you here anytime you pass through London again!" Frieda is the "sun of our life."

Ted to Aurelia and Warren: Ted describes his reaction to Frieda's birth: "It's not true that only women have children, for instance. I think the general psychological upheaval is quite as severe for the father." Disparages the demands of literary life, and the "art-story" that harmed Sylvia's style, approves of her writing for women's magazines: "stories in which people get killed, get born, get married etc." Explains how they work together on the stories, then describes his own work. "Sylvia has just come back from the B.B.C. where she has been recording her poem A Winter Ship." Frieda is "happy and good" and knows how to entertain herself. {THL}

December 18: A. Alvarez publishes "The Poet and the Poetess" in *The Observer*: "She steers clear of feminine charm, deliciousness, gentility, supersensitivity and the act of being a poetess. She simply writes good poetry. . . ." {PA}

Sylvia listens to Edward Lucie-Smith's positive review of *The Colossus* on the BBC {HC}

December 24: "Dear mother (!) & Warren": A happy Christmas Eve letter from Yorkshire, with a cold and Frieda teething, "a bit haggard, but in good spirits," encouraged by Al Alvarez's review of *The Colossus*, hoping BBC will accept her suggestion of a program about young American woman poets, writing stories, some with plots suggested by Ted, with an agent sending them around, ten-mile moor walks with Ted: "Do plan to stay in England at least a month this summer." Aurelia can babysit while they take a short trip to Ireland or France. She is tired of Mrs. Hughes's repetitive talk. "I wish I had some of my own relatives to admire Frieda. Is there any chance of Warren coming to that conference in London?" Wishes Aurelia would send her favorite children's books

1961

January 1: "Dearest mother": A bad case of the flu after returning from Yorkshire on an unheated train, the baby "waking us for hours every night cutting her top teeth, I have been pretty oppressed. . . . Olwyn made such a painful scene this year that I can never stay under the same roof with her again. She has never hidden her resentment of me, & her relation to Ted is really quite pathological—I think they slept in the same bed till she was 9 years old & probably this is one of the reasons she never married. In any case, she has never spoken to me, asked me one personal question or done

anything but ignore me & make it plain she has come to see Ted. Naturally, this hurt me very much, but I never crossed her, because I knew Ted was fond of her." Full of plans for her mother's summer visit, worried about her painful appendix and an operation.

To Brian Cox at *Critical Quarterly*: Plans for a "supplement of recent American verse."

January 4: To RB: Seeks guidance on how to handle Olwyn, describes their blowup in Yorkshire, her disappointment that Ted did not defend her, and her unwillingness to "forgive & forget," but what attitude should she adopt when meeting Olwyn again? "Generous, I suppose." With Frieda's birth, they have never been happier. She is like a poem they have created. As to the future: "I would appreciate a straightforward word from you."

January 10: "Dearest mother": Still bothered by Olwyn's outburst: "Olwyn has always bossed that house shamefully & as Ted says, her outburst derived from an idiotic jealousy. . . . Do encourage me, I feel the lack of some relative or friend to bolster my morale." Dido Merwin encourages Sylvia to have an operation before going to France because of the danger of sepsis if the appendix should burst. Frieda is doing well, learning to drink from a cup. Looking forward to recording a BBC program, *Two of a Kind*.

January 13: John Wain reviews *The Colossus* in *The Spectator*: "Sylvia Plath writes clever, vivacious poetry, which will be enjoyed most by intelligent people capable of having fun with poetry and not just being holy about it." {PA}

January 18: Sylvia and Ted record "Poets in Partnership" for the BBC {PA}

January 27: Decides on hospitalization in February to remove a painful appendix {PKS}

"Dearest mother": Confesses that her mother's morale-building letters have helped "immensely through a rather glum period." Recovering by eating big breakfasts and taking vitamin and iron pills, getting plenty of sleep, announces she is pregnant and hopes her mother will be there for the birth, enjoys her part-time job copyediting, calculates how much of their savings will be necessary for a down payment on a house.

To Eleanor Ross Taylor: Cancels an appointment.

January 31: BBC broadcasts *Two of Kind*, with Sylvia and Ted

February: *London Magazine* publishes "The Fifty-Ninth Bear," *Encounter* publishes "A Winter Ship"

February 1: Sylvia and Ted attend party for Theodore Roethke[409] {PA}

February 2: "Dear mother": "Thanks a thousand times for your good newsy letters." August 17 is the predicted date for baby's arrival. Doing well on her part-time job: "I get to do all the little rush jobs of typing as my speed is the marvel of the office where the few others hunt-and-peck

& I sound like a steam engine in contrast." Mentions meeting Theodore Roethke, "my Influence," at a party: "Ted and I got on well with him & hope to see him again." In hospital by the end of the month for the appendix operation, mentions Dido Merwin's face lift as an effort to look younger with her younger husband.

February 5: To Anne Sexton: Compliments her on a new book, *To Bedlam and Part Way Back*, singling out "Elegy in the Classroom." "We thrive so in London we'll probably stay forever. . . . Please sit down one day between the poem & the stewpot & write a newsy letter."

February 6: "Dear mother": "I feel awful to write you now after I must have set you to trying to change your plans & probably telling Warren & your friends about our expecting another baby, because I lost the little baby this morning & feel really terrible about it." The doctor could not explain it, except to say that one in four mothers miscarry. Plans to "plunge into work" as a cure for "brooding."

February 9–10: "Dearest mother": Feeling back to normal, "my daily routine with Frieda & Ted keeps me from being too blue." Ted has been making her breakfast all week and has obtained tickets for *The Duchess of Malfi* with Dame Peggy Ashcroft, Yale is making a recording of Ted reading his poems, thanks her mother for sending Frieda new clothes, considering a return to the States sometime in the next five years with Ted teaching on the West Coast or perhaps in New England.

February 11: Completes "Parliament Hill Fields"

February 14: Completes "Zoo Keeper's Wife," "Whitsun"

February 15: Completes "Face Lift"[410]

February 19: Completes "Morning Song"

February 21: Completes "Barren Woman"

February 24: *New Yorker* first reading contract arrives specifying she is to send poems to them first before submitting elsewhere. {SPD}

February 26: Completes "Heavy Women"

"Dear mother": Awaiting her appendix operation, comforted that Ted knows how to take care of Frieda, *Atlantic Monthly* has accepted "Words for a Nursery," and she has been writing several poems and going to several films in Hampstead. "I do love London. I had a gallery-going spree & went to five in one afternoon."

To Anthony Thwaite, BBC: Sends some of her poems "in hopes that you may like something among them." {HR}

BBC rebroadcasts *Two of a Kind*, Sylvia checks into Saint Pancras hospital {PA}

February 27: Describes doctors and patients: "Nobody complains or whines." Details the preparations for her surgery. {PJ}

February 28: Everyone is amiable with "gracious smiles."

Surgery goes smoothly {HC}

7:30: Ted arrives: "felt as excited & infinitely happy as in the early days of our courtship. His face which I daily live with seemed the most kind & beautiful in the world." Notes that the date of the *New Yorker* letter announcing her first reading contract is that same as her first meeting with Ted five years earlier.

10:00: "prepared for slaughter" in a "pink & maroon striped surgical gown, a gauze turban & a strip of adhesive shuts off the sight of my wedding ring." Feels like a "condemned prisoner." {PJ}

11:00: Appendectomy {RH}

March 1: "Dear mother": A day after her operation: "immense relief & pleasant prospects ahead," awful food but Ted, "an absolute angel," brings steak and Tollhouse cookies, excited about her *New Yorker* contract obligating her to send them poems first but giving her the right to send them elsewhere if the magazine rejects them. The contract includes an increase in her base rate and a bonus, to be renewed each year at the magazine's discretion. Her ward is large, pleasant, and the patients at her end are "young & cheerful."

March 3: "I am myself again: the tough, gossipy curious enchanting entity I have not been for so long." Her side hurts when other patients bump into her, lots of noise with vacuuming, bedpan trolleys, tea trolleys, medicine trolleys: "They thump on the floor & rattle." Next to a snorer, nurse refuses to give another sleeping pill, codeine suppresses the sharp pang of her scar. {PJ}

March 5: Thinks of writing a story about her hospital experiences: I am immensely fond of all the nurses in their black & white pin striped dresses, white aprons & hats & black shoes & stockings. . . . I feel more fresh & rested than I have for months." Talks with a patient about her breakdown and "mis-applied shock treatments." {PJ}

7:45: Twilight of low voices, a patient moans, yells, and curses. {PJ}

Receives flowers sent by Theodore Roethke {EB}

March 6: Still in hospital, healing well, and feeling almost on holiday reading Agatha Christie mysteries, walking about "gossiping with everyone," filling her notebook with "impressions & character studies," doctor has declared her "perfectly healthy in every way," Ted eager for her to come home

4:20: Returns to her room after an hour in the sun reading Pasternak's late poems, tired out from the patients complaining all night long, identifies and describes patients in Bed 2 and 3. {PJ}

To Edith Hughes: "Your beautiful spring bouquet. . . . and your nice newsy letter . . cheered me up immensely." Praises the nurses, waiting for

stitches to be taken out, enjoys a visit from Ted and Frieda in a "pretty park in back of the hospital."

March 7: To Dido and W. S. Merwin: Describes her misadventures getting to St. Pancras Hospital for her appendectomy, the anesthesia and pain killing injections that make her feel like she is floating over her "inert body feeling immensely powerful & invulnerable." Notes about patients "piling up. . . . My side hurts like hell but I am so goddam cheerful."

March 17: "Dear mother": She is concerned about Ted's doing all the work for the past month. After nearly three weeks she is "very close to a self I haven't been for some time & full of hope." Now more than ever she feels the need of owning her own house and a car they could take with them on their European travels. Hopes her mother can come to babysit for two weeks while they are abroad.

March 18: In the Merwin's study, completes "Tulips," "In Plaster" {BF}

To Anthony Thwaite, BBC: Sends "Parliament Hill Fields" with a "sort of coda to the other poems I sent." {HR}

March 19: BBC broadcasts extended version of *Two of a Kind* {PA}

March 21: Doctor reports Sylvia is making a good recovery from her operation {PA}

March 27: "Dearest mother": Ted is doing well at the BBC and has won the Hawthornden Prize for *Lupercal*. She is delighted with the sweater Aurelia has sent for Frieda, expects to make some trips to the country and to Cornwall when they purchase a car, encloses check for deposit into the account set aside for earning from publications. A hospital checkup pronounces her "fine."

March 28: Completes "I Am Vertical"

To Marion Freeman: Thanks her for sending a picture book to Frieda, recuperating well from appendectomy, enjoyed hospital stay "quite a sociable time as I was one of the few people who could walk around, and I felt actually sorry to go home."

March 29: To Philip and Margaret Booth: "a manic-depressive winter full of flue miasmas, near bankruptcy, nights full of teething yowls from our changeling, topped off by my grateful departure from my very nasty tempered appendix several weeks ago." She has returned to her "American plateau of fearsome health."

To Dorothy Schober Benotti: All her old energy is back after a restful and happy hospital stay, with Ted faithfully attending to her and Frieda, which her fellow patients say is unusual.

Knopf editor Judith Jones writes to express interest in publishing *The Colossus* {PA}

March 30–April 6: Begins writing *The Bell Jar*[411] {HC}

March 31: The *New Statesman* publishes "Magi"

April: Photograph of Plath and Frieda {PM}

April 1: Frieda's first birthday, with Sylvia and Ted giving a "rousing rendition of 'Happy Birthday'" {HC}

April 2: To Alan Ross: Cannot make "publication day."[412]

April 5: "Dear mother": Thanks her mother for sending Frieda's dress and mentions clothes Aunt Dotty has sent: "I have so many people to thank for things!" She sends another check for bank deposit. Ted is to appear on BBC television and has been offered a commission to write a play for Peter Hall, director of the Royal Shakespeare Theatre. Describes Frieda's birthday celebration.

To Judith Jones at Knopf about *The Colossus*: Agreeing that "Poem for a Birthday" is "too obviously influenced" by Theodore Roethke, but suggests parts of it that are "nothing like Roethke" might be published as separate poems in a Knopf edition of the book. Agrees to cut out other poems leaving forty instead of fifty poems.

April 12: Ted's reaction to "Tulips": "the red tulips—hearts terrifyingly terrible. Organs pulsing something red and uncontrollable" {HC}

April 13: To Theodore Roethke: Sends him a copy of *The Colossus* confessing his influence on the book, noting its forthcoming American publication, and asking if he is willing to write a recommendation for Guggenheim application. She encloses "Tulips," written after her hospital stay.

April 14: "Dear mother": Investigating mortgages that writers might be able to obtain, perhaps with help of Ted's rich uncle, still hoping to buy a car for country jaunts, "Ted's being featured in the Observer this week . . . with 6 poems and a little article by our friend and critic A. Alvarez. We'll send clippings."

April 16: Al Alvarez publishes six new Hughes poems in *The Observer* {HC}

April 22: Birthday card, "Dear mother": Encloses photographs of Frieda and describes outings with her, writing every morning in the Merwins' study, another check to deposit, how marvelous Ted looks on TV: "Our life together is happier than I ever believed possible." Still thinking about a year in America.

"Dear Warren": Wants the details about Warren's involvement with Margaret: "Give me a picture of her. Verbal or actual." Encloses photographs of Frieda, wants to know when he will arrive in England for his conference.

Ted to "Dear Aurelia and Warren": Describes Frieda's "staggering developments. You will just sit & watch her all day long, Aurelia. . . . Frieda is standing up in her pen laughing at everybody. No, now she's thrown her ball out & she's bawling at everybody. Sylvia's been writing at a great pace ever since she's been out of hospital & has really broken through into something

wonderful—one poem about 'Tulips' . . . Her poems are in demand more & more." {THL}

April 26: To Miss Elizabeth Kray, The Poetry Center, New York City: Pleased to get an invitation to do a reading but has no plans to be in the United States next year.

To John Lehmann: Asks him to write on her behalf for a Eugene F. Saxton fellowship.

To Leonard Baskin: Awaiting his arrival with "great joy."

To Alfred Kazin: Asks him to recommend her for a Saxton grant.

Plath's sudden and swift writing of The Bell Jar *has never been explained and perhaps cannot be. It seems to have arisen out of the distance—just enough distance—from her breakdown and suicide attempt that allowed her to look upon those events with some equanimity and cast them into a narrative. Both the physical distance from home, and her sense that she needed a new land in which to release her creativity, may also have contributed to her bold novel that did not temporize about her own feelings or about those who had been close to her in the United States. She had also mused on the possibility that having a child and starting a family would be good for her writer's confidence, establishing her identity, so to speak, on a new front.*

April 27: To Ann Davidow and Leo Goodman: "My mother is flying over in mid-June and we are working like blacks to finish things before she comes so we can take a vacation at W. S. Merwin's farm in mid-France for two weeks while she lives here with Frieda—which will be my first real vacation for too long." Describes her terrible block about writing a novel, and then suddenly, while negotiating for publication of *The Colossus*, the "dykes broke and I stayed awake all night seized by fearsome excitement, saw how it should be done, started the next day." The novel is "chock full of real people. . . . It's probably godawful, but it's so funny, and yet serious, it makes me laugh."

April 28: Judith Jones writes to offer publication of *The Colossus*.

May: Completes "Insomniac"

May 1: "DEAR MOTHER": Overjoyed to announce that Knopf has officially accepted *The Colossus* for publication: "this American acceptance is a great tonic."

May 2: "Dear Anthony Thwaite": Response to her selection as The Living Poet for August. "How about Marvin Kane for a reader? I'll be choosing some poems fitting a male persona, and I think I'd rather have a similarity in accent and a difference in sexes than vice versa. I've done a couple of readings with him before and like his style." {HR}

To Judith Jones: Pleased that "our opinions seem to coincide so closely," discusses merits of various poems for inclusion and exclusion, noting the "trial run" in England has made her "more objective" about her work.

November 14, 1962: Plath to her editor: The mother in *The Bell Jar* is "based on my mother, but what do I say to defame her? She is a dutiful, hard-working woman whose beastly daughter is ungrateful to her." Drawing of Aurelia Plath by Evelyn Mayton.

February 23, 1958: Ruth Beuscher, in Plath's words: a "psychologist-priestess." Drawing by Evelyn Mayton.

March 1, 1958: "I am married to a poet: miracle of my green age. Where breathes in the same body, a poet and a proper man, but in Ted?" Drawing of Sylvia Plath and Ted Hughes by Evelyn Mayton.

January 1, 1961: Plath writes to her mother that Olwyn's "relation to Ted is really quite pathological—I think they slept in the same bed till she was 9 years old & probably this is one of the reasons she never married." Drawing of Ted holding Olwyn's mirrored image by Evelyn Mayton.

March 2, 1955, 5:00: Sees Harry Levin in Sage Hall on Smith campus. Courtesy of Gail Crowther.

March 23, 1955: Lunch at Rahar's with Peter Davison. Rahar's with Sue Weller for Dorrie Licht's wedding shower. Courtesy of Gail Crowther.

April 16, 1955: Sylvia Plath and other aspiring poets meet Marianne Moore at Mount Holyoke College. Courtesy of Mount Holyoke College.

October 2, 1955: Unpacks books, late breakfast, coffee in Whitstead, Cambridge University. Courtesy of Gail Crowther.

October 9, 1955: ADC (Amateur Dramatic Club) meeting in Park Lane "smoke & tour of state & club." Courtesy of Gail Crowther.

February 19, 1956: "I went to the bronze boy whom I love, partly because no one really cares for him, and brushed a clot of snow from his delicate smiling face. He stood there in the moonlight, dark, with snow etching his limbs in white, in the semi-circle of the privet hedge, bearing his undulant dolphin, smiling still, balancing on one dimpled foot." Courtesy of Gail Crowther.

March 25, 1956: Arrives at Richard Sassoon's apartment and is told he will not return until after Easter. Writes him a note "through tears," wanders until she finds the restaurant where they ate her first night in Paris, feeling "growing pride & affirmation at independence." Courtesy of Gail Crowther.

May 1, 1956: At the Anchor for sandwiches and red wine with Ted. Courtesy of Gail Crowther.

May 3, 1956: A walk through Newnham gardens to *Varsity* office. Courtesy of Gail Crowther.

May 11, 1956: Makes love at Rugby Street flat, cleans greasy kitchen. Courtesy of Gail Crowther.

June 16, 1956: "MARRIED TED HUGHES LONDON." The marriage performed at St. George the Martyr in Queens Square in the rain. Sylvia wears a pink dress and a pink rose. Courtesy of Gail Crowther.

August 31, 1956: A long walk to Wuthering Heights watching "wooly gray black-faced sheep" in "lonely winds." Courtesy of Gail Crowther.

June 16, 1956: St. George's door. Aurelia Plath: "To my complete surprise, three days after landing at Southampton on June 13, 1956, I found myself the sole family attendant at Sylvia's and Ted's secret wedding in the Church of St. George the Martyr, London." Courtesy of Gail Crowther.

November 4, 1956: An "itchy" afternoon at the new Eltisley house because of "intolerable chairs & bad light, exhausted and nagged with an urge to paint the house and conquer it." Courtesy of Gail Crowther.

September 30, 1956: A "long windy walk with dear Ted along dark farms, cow fields" and Hardcastle Crags, "dear love." Courtesy of Gail Crowther.

September 1, 1958: Moves into sixth-floor apartment in the Beacon Hill section of Boston. Courtesy of Peter K. Steinberg.

September 2, 1958: Adjusting to the city sounds in her Boston apartment: "We have an enormous view—the Charles river, sailboats, reflected lights from MIT—the moving stream of car lights on Riverside Drive—the hotels & neons—red, blue, green, yellow, above the city—the John Hancock building, weather tower—flashing—rooftops, chimneypots, gables—even the tree tops of the common from the bedroom—a fine place, dark green & light blue." Courtesy of Peter K. Steinberg.

February 19, 1959: Completes "Watercolor of Grantchester Meadows." Courtesy of Gail Crowther.

May 4, 1959: Prospect House at the top of Mount Holyoke in the J. A. Skinner State Park, featured in "Above the Oxbow," published in *Christian Science Monitor*. Courtesy of Gail Crowther.

September 18, 1959: "Dear Mother & Warren": Describes the sumptuous Yaddo meals and the "elegance and peace of the whole mansion." Courtesy of Peter K. Steinberg.

September 23, 1959: Sylvia reads her poems at Yaddo. Courtesy of Peter K. Steinberg.

December 17, 1959: "Dearest mother": A safe arrival at the Beacon, "sitting in great armchairs by roaring coal fires, very cosily," in the Hughes home. Courtesy of Gail Crowther.

January 19–22, 1960: "Dear mother": Writes from the Beacon to say they now have a lease for an unfurnished London flat in 3 Chalcot Square. Courtesy of Peter K. Steinberg.

February 2, 1960: Typing in the new flat listening to the cries of children in Chalcot Square. Courtesy of Peter K. Steinberg.

February 1, 1960: Moving into Chalcot Square: "trunks are much too heavy to get up the narrow winding stair, especially as it is full of workmen's tools," Sylvia writes to her mother and Warren. Courtesy of Peter K. Steinberg.

January 27, 1960: Hallway, Chalcot Square. "Dearest mother": "The smallness of the flat has one advantage in that it will be easy & inexpensive to fix up very prettily." Courtesy of Peter K. Steinberg.

May 14, 1960: Sylvia describes cramped Chalcot Square flat near the sounds of the zoo. Courtesy of Peter K. Steinberg.

April 21, 1960: Faber building. Sylvia looks forward to cocktails at Faber's with T. S. Eliot. Courtesy of Gail Crowther.

June 30, 1960: Sylvia gets her first look at Fitzroy Road where Yeats lived and where she imagines living with Ted in a future home. "Ted, of course, is much more hesitant than I to commit himself." Courtesy of Peter K. Steinberg.

August 22, 1960: "Dear Sylvia's Mother & Warren": Writing from the Beacon, Ted describes their holiday from life in London, "a load on the nerves. . . . We've spent this first 24 hours in bottomless torpor, sucking in the enormous blissful silence." Courtesy of Gail Crowther.

February 22, 1961: A view from Chalcot Square flat. To Lynn Lawner: Describes working on the new flat: "We're two minutes walk from Primrose Hill and a few minutes more from Regent's Park, a pleasant area." Courtesy of Peter K. Steinberg.

March 31, 1961: Chalcot Square kitchen. Sylvia is still active, washing and waxing the kitchen floor, cooking, a "lovely quiet" evening walk with Ted, writing letters while she still can before Frieda's birth. Courtesy of Peter K. Steinberg.

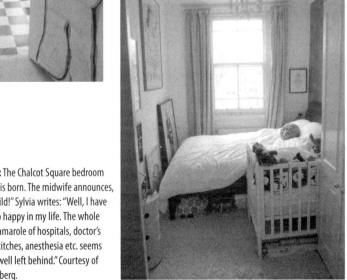

April 1, 1961: The Chalcot Square bedroom where Frieda is born. The midwife announces, "A wonder child!" Sylvia writes: "Well, I have never been so happy in my life. The whole American rigamarole of hospitals, doctor's bills, cuts & stitches, anesthesia etc. seems a nightmare well left behind." Courtesy of Peter K. Steinberg.

August 22, 1961: Sylvia describes Court Green as an "antique thatched house barn, stables, orchard, vegetable garden on 2½ acres of walled land." Courtesy of Gail Crowther.

May 16, 1962: North Tawnton train station. Describes meeting Mrs. Macnamara as their "second entering wedge" into North Tawnton. Courtesy of Gail Crowther.

August 27–November 27, 1962: Fifteen one-hour horseback riding lessons with Miss Redwood, Lower Corscombe Farm, Corscombe Lane, near Okehampton. Courtesy of Gail Crowther.

September 5, 1962: Responds to Marvin and Kathy Kane's postcard of St. Ives in Cornwall: "It must be heaven there." Courtesy of Gail Crowther.

September 21, 1962: To Richard Murphy: Thanks him for his hospitality and allays his concern she was going to write about Connemara, his "literary territory." Courtesy of Gail Crowther.

October 13–14, 1962: Visits Marvin and Kathy Kane living in a house in Hicks Court, Saint Ives, Cornwall, Sylvia gets the flu. Courtesy of Gale Crowther.

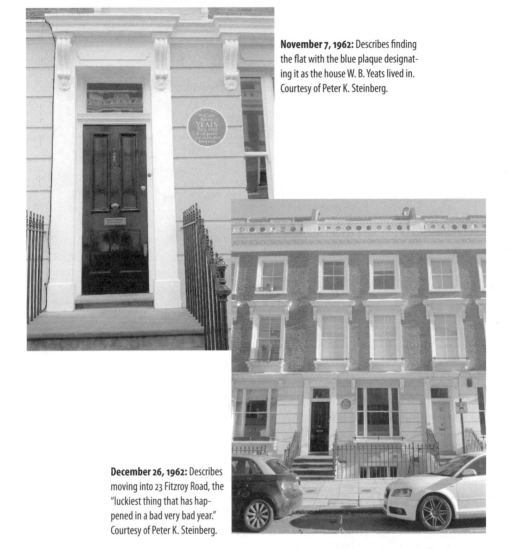

November 7, 1962: Describes finding the flat with the blue plaque designating it as the house W. B. Yeats lived in. Courtesy of Peter K. Steinberg.

December 26, 1962: Describes moving into 23 Fitzroy Road, the "luckiest thing that has happened in a bad very bad year." Courtesy of Peter K. Steinberg.

January 2, 1963: Rear view of 23 Fitzroy Road. To Marcia Brown: "I guess you can imagine what it's like coping with two infants, free lance jobs, painting & decorating acres of floors & haunting sales for curtaining etc. Toute seule!" Courtesy of Peter K. Steinberg.

May 3: To E. Dyson[413]: Encloses a few poems: "I only have these on hand as I'm head over ears in the middle of a long prose thing and not doing anything else right now." Discusses her "sampling . . . by lively American poets of all persuasions."

May 4: *The Listener* publishes "A Life"

May 8: "Dear mother": "We are both working very hard," making arrangements for Aurelia's stay, encloses deposits for their growing bank account.

May 16: Completes "Widow"

To Charles Osborne: "Our baby unearthed this shortly after your departure. I trust it belongs and will come in handy."

May 21: *The Observer* publishes "Morning Song"

May 28: "Dearest mother": Hasn't written because of "huge pile of jobs & harassments," describes Leonard Baskin's ghastly visit, fed up feeding him, "used Ted like a chauffeur," expecting her to do his laundry, looking forward to her mother babysitting, asks her to bring a few things, hoping for good weather for her mother's visit.

May 29: For *The Living Poet* sends "The Disquieting Muses," "Suicide Off Egg Rock," "Parliament Hill Fields," "Tulips," "Sleep in Mojave Desert," "You're," and "Magi"

May 31: Sylvia celebrates Ted's Hawthornden Prize {HC}

June: *Harper's Magazine* publishes "You're"

Summer: *Critical Quarterly* publishes "Private Ground" and "I am Vertical" *During the summer of 1961, Plath became pregnant again.*

June 1: To Anthony Thwaite: Two substitutes for "Tulips": one, "Medallion," for Marvin Kane to read, and one, "The Stones," that she will read. {HR}

June 5: Records for *The Living Poet*, a twenty-five-minute BBC program broadcast of her poems {HC}

June 6: "Dear mother and Warren": So happy Warren will be visiting and that Aurelia will be staying in Dido Merwin's room: "The Merwins get an indefinable something out of knowing us (Ted being a British lion in Dido's eyes) and we have got over feeling we can't repay them in kind, especially as it gives them a certain odd pleasure to see us living on things out of their attic." Worried about passing her British driver's test with their new "small but roadworthy" car, mentions her "interest in working on a novel,"[414] and the "thought of going off alone with Ted for 2 weeks is just heaven." Everything has been arranged for Aurelia's babysitting, including the diaper service.

June 8: The BBC *The Living Poet* broadcast of her poems {HC}

June 17: To Brian Cox: Expects to send him her anthology of poets in a week, "youngish or new . . . the few old poets who are new with first books."

To Howard Moss, the *New Yorker*: Pleased that he likes "Tulips."

June 18: To Olwyn: "I'm very sympathetic to Alvarez's poems, some of them, because I like him & know something about how his wife's knocked him about & gone off."

June 25: To Brian Cox: Enclosing anthology,[415] leaves out her own poems, a reaction to anthologists who use their books as self-promotion, wants to know what "outrages or pleases you."

June 27: "Dear Warren": "Mother is at the moment bathing Frieda, I halfway through making a strawberry chiffon pie & Ted typing a letter to T. S. Eliot." Aurelia has settled into the Merwins' "grand bedroom" and is getting along well with Frieda: "I shall feel relatively easy leaving them." Looks forward to his visit.

June 28: Plath and Hughes travel to France {HC}

June 29: Picture postcard of Rouen: "Dear mother": "We are sitting under an umbrella waiting for our café au lait in Rouen, a wonderful antique town with an open market just beyond this beautiful clock bridge where we have bought a lunch of milk, bread, cheese & fruit for a picnic."

July: Completes "The Rival"

July 2: Picture postcard of Le Mont Saint-Michel: "Dear mother": "We are sitting in a little 'crêperie' in Douarnenez, a lovely fishing port in Finisterre waiting for our crepes—a lacey thin pancake served with butter or jam or honey & cider to drink, for our Sunday supper." Two little presents for Frieda: "I'm dying to hear how our angel is."

July 5: Sylvia and Ted travel to the Merwins' farm in Par Bretenoux {PA}

July 6: "Dear mother": "I am delighted by your 2 good letters so full of Frieda." Now at the "idyllic" Merwin farm, tan from sunbathing, Ted rested, hopes babysitting Frieda is not "too strenuous": "I am so renewed I am dying to take care of Frieda again."

July 10: Picture postcard of Montignac-Sur-Vézère: "Dear mother": Visits prehistoric paintings in "vivid caves. . . . Haven't felt so fine for 5 years."

July 14: Sylvia and Ted return to London {HC}

July 15: Reads a selection of contemporary American poetry on the BBC program *Possum Walked Backwards* {HC}

July 17: Sylvia and Ted read their poems at the "Poetry at the Mermaid" festival at the Mermaid Theatre in London {HC}

July 18: Sylvia, Ted, Frieda, Aurelia drive to Yorkshire in their new Morris station wagon {PA}

July 21: Sylvia sends three poems to Alvarez seeking his opinion: "I am tough enough, so don't be ginger."

July 22: The *New Yorker* publishes "On Deck"

July 26: Sylvia Ted, Frieda, Aurelia, return to London

July 28: Sylvia and Ted drive to Devon in search of a house {HC}

July 29, midnight: Sylvia and Ted drive back to London, after looking at eight houses, with only one, Court Green, that seems suitable {PA}

c. July 30: To Dido Merwin: Sends measurements for a sweater, "returned from a glorious week of bilberrying & moonwalking in Yorkshire & landing to surfeit mother with Stonehenge & the Tower of London before her flight home on Friday."

August: *Atlantic Monthly* publishes "Words for a Nursery," *London Magazine* publishes "Zoo Keeper's Wife," "You're," "Parliament Hill Fields," "Whitsun," "Leaving Early," and "Small Hours" ["Barren Woman"]

August 4: Aurelia departs for America {PA}

August 7: "Dear mother": "London doesn't seem the same with you departed." Plans to move to Court Green, now that they have agreed to purchase the house and land for 3,600 pounds with a 10 percent deposit. "Ted is in seventh heaven." Looks forward to fixing up the new house.

Both Aurelia and Ted's parents contributed to the purchase of Court Green.

August 13: "Dear mother": "A thousand thanks for the $5,880 check which arrived this week, and for your own $1,400 loan." Writes about placing an ad to sublet the Chalcot Square flat and interviewing one couple she and Ted like: "the boy a young Canadian poet, the girl a German-Russian whom we identified with. . . . The couple[416] are coming to supper this week."

The move to Court Green in Devon was momentous, exciting, and disconcerting. Plath had acclimated to London and had to accede to Hughes's wish to live in the country. Yet she took to it with enthusiasm, reveling in the expanded domestic life the house opened up to her. She seems to have had no idea that Hughes was already tiring of family life and looking for outlets, as he would later confess to her. Since the move had been mainly his idea, naturally she supposed he was all for it, and that the move itself was all he wanted—rather than in fact, a freer, open life that home and family precluded. That he made himself the facsimile of a family man fooled her.

August 16: Signs a contract with Knopf for publication of *The Colossus* {PA}

August 18: *TLS* reviews British publication of *The Colossus*: "Miss Plath tends to be elusive and private . . . , as if what the poems were 'about' in a prose sense were very much her own business." {PA}

August 19: To Gerald and Joan Hughes: "We are wild about the Devon place." Describes the house and its history: "white, with a black base-border & this bird-haunted-straw top." She will miss London but expects to get a lot of writing done, "free from entertaining and people-seeing. . . . We'll be good gardeners."

August 22: To Eric Walter White, The Arts Council of Great Britain: Encloses "Insomniac" work sheets, "happy to hear from the Cheltenham Festival. . . . That sleeplessness has its own very pleasant reward."[417]

To John Sweeney: Sends worksheets of "Tulips,"[418] describes Court Green as an "antique thatched house barn, stables, orchard, vegetable garden on 2½ acres of walled land."

Reads a 1958 journal entry asking herself why she doesn't write a novel and comments "I have!"

"She likely finished the novel on this day." {HC}

August 24: To Brian Cox: Approves a new order for the anthology of poems, including extras.

August 25: "Dear mother & Warren": Happy to hear Warren is coming to Devon, probably on September 9, after they move into Court Green on August 31, expects to recoup their expenses with writing income in the next year, they feel a "deep breathing sense of joy" about the "peaceful secluded life opening up for us, and delighted that our children will have such a wonderful place to live and play in." The American edition of *The Colossus* is due out in spring 1962. Wants to get a sewing machine and a Bendix washing machine to rid herself of "lugging great loads to the laundromat each week—usually two a week now," farewell dinners with friends—Helder and Suzette Macedo, Ruth Fainlight, and Alan Sillitoe.

To Frank Schober: "Dear Grampy": Overwhelmed by his housewarming gift of $100, already planning their garden.

What began as Ted's desire to relocate to the country, leaving behind the suffocating literary life he despised, became an exhilarating but also overwhelming change for the couple, as they sought to adjust to caring for two children, repairing their ancient new home, and cultivating their own garden, while remaining caught up in publisher's deadlines and the work of writers in demand but also straining to remain committed to a marriage subject to the vagaries of everyday life, without the reprieve of holidays and time for themselves to enjoy together.

August 31: Sylvia, Ted, and Frieda move into Court Green {PKS}

September: Completes "Wuthering Heights"

September 4: "Dear mother": Describes the Court Green kitchen with coal stove warming the room: "at last I have all the room I could want, and a perfect place for everything." Describes the interior of the home and furnishings, the need to improve the weedy flower gardens, her spirit has expanded and "Frieda loves it here."

To Charles Osborne: Announces the move to Court Green.

September 9: Warren visits {SPD}

September 11: To Howard Moss, the *New Yorker*: Explains "The Rival" and welcomes his suggestions for improving it.

To Ruth Fainlight: Describes work on home improvements, plans for vegetable plots, mentions Alan Sillitoe's "wonderful book," *Key to the Door,*[419] asks if she can stay with them in London if she attends the Guinness Poetry Party, invites them for a weekend.

September 15: "Dear mother": Describes Warren's visit and the elm plank[420] that Warren and Ted made into a desk for her, a trip to Tintagel and Exeter Cathedral with Warren, thanks her mother for the check to be used for the new Bendix, works on recipes her mother has sent, relieved to have a cleaning lady twice a week, Frieda has learned to pick blackberries, the Macedos have visited, Ted is happy with his attic studio and she with hers, the china has arrived with only one broken item, and she has made arrangements with the local doctor and midwife-nurse for delivery of her second child.

Warren departs by train for London {PA}

September 16: To Jennifer Hasssel at A. M. Heath: Encloses manuscript of *The Bed Book* and Ted's *Meet My Folks*.

Helder and Suzette Macedo visit Court Green {PA}

September 23: Completes "Blackberrying"

September 26–29: Tuesday: "Dear mother & Warren": Describes the "pleasant rhythm" of their Court Green days, Frieda is "in her element here" with lots of outdoor activity and a "giant playroom."

Friday: Happy with their seventy-two apple trees, mentions letters from Peg Cantor and Mrs. Prouty, who sends $200, Ted records BBC programs in Plymouth and has taught Frieda to feed herself, but how to get her to pee in her potty chair?

September 29: Completes: "The Surgeon at 2 a.m.," "Finisterre"

To Helder and Suzette Macedo: Offers to help place Suzette's work with her agent, thanks them for a lovely visit. "Write stories about your friends Suzette. Be merciless." Explains how she takes turns during the day taking care of Frieda and writing, they are dreaming up plots for women's magazine stories to write quickly and make money. {HR}

To Ruth Fainlight: Desperate for apple recipes, what to do with stinging nettles: "Surely they have some nutritive value!" Wants news about Alan's work, exhausted after a month of moving in and "feeding my terrifying enormous brother who came for a week." Provides her schedule in London for the Guinness event, mentions missing good movies: "I can barely stand to read the reviews of them, I get so movie-mad." Looks forward to seeing the couple.

September 30: To Margaret Cantor: Mentions the pleasure of getting a letter from her: "You are one of Ted's very favorite American families." Describes their dream home and the beautiful September weather, the working rhythm of their days.

To Peter Davison: Thanks him for his letter to Ted, describes Court Green and the surrounding countryside, encloses a group of Ted's poems, delighted to hear about the birth of his son and welcomes a gossipy letter "someday" from Jane.

Autumn: *Texas Quarterly* publishes "Witch Burning"

October 6: "Dear mother": "Ted and I are dreaming up plots for women's magazine stories." Enjoys her sewing machine, "deluged" with flower and fruit catalogues, "Frieda responds more & more to her life here."

To Ruth Fainlight: Grateful for the "terrific apple recipes," looks forward to visiting London again if it is not inconvenient for Ruth, and invites Ruth and Alan "for a bucolic country weekend" to "live on apples & fat cream."

October 7: To *Hudson Review* copyright department: Asks to assign copyright for three poems to Knopf for book publication.

To Judith Jones, Knopf: Explains she has sent off letters requesting assignment of copyright to Knopf. Heinemann "seemed to know less about copyrights than I did" but claims all will be taken care of, delighted with the contents of the book and "so happy it has been pruned."[421]

To copyright department, *Poetry*: Requesting assignment of copyright for several poems.

October 9: "Dear Edith & Willy": "wonderfully happy here," Ted's "big dream come true." Describes their daily routine and Frieda in "seventh heaven," hoping her women's magazine stories will add to the funds for furnishing the house.

October 10: Submits "Wuthering Heights," "Blackberrying," "Finisterre," and "The Surgeon at 2 a.m." to the *New Yorker* {SPD}

Several references to reaching the age of thirty in Plath's letters suggest that she saw herself as approaching a transitional stage of her life.[422]

October 11: To Roger Smith at Heinemann: Happy that "Medaillion" is to be included in *The London Bridge Book of Verse*, provides her birthdate and asks him to "Guard it well, because after I have reached the ripe age of 30, I shall never mention it again."

Ted's diary: "awake all night . . . my brain by 5 a. m. like a rusted ball & socket joint, creaking & aching." {HC}

October 12: Ted's diary: "Bright day, windy fresh—blue sky, bright yard, but no settled feeling." {HC}

October 13: "Dear mother": "The Bendix has arrived! Huge and beautiful." Awaiting installation, trouble with potty training, decides to attend local Anglican Church to "grow into the community," although she could never "stomach the trinity & all that!" Ted is completing a radio play and she has "a couple of good poems."

Submits two prose pieces, "Shadow Girl" and "The Beggars," to A. M. Heath Agents {SPD}

October 14: Submits "Johnny Panic and the Bible of Dreams" to the *Sewanee Review*. {SPD}

October 17: To Brian Cox: "How about saying simply: AMERICAN POETRY NOW is a selection of poems by new and/or youngish American

poets for the most part unknown in England. I'll let the vigor and variety of these poems speak for themselves."

October 21: Writes "The Moon and the Yew Tree" {PKS}, "Last Words" {SPD}

October 22: Completes "The Moon and the Yew Tree"

"Dear mother": The Bendix is working, Ted has returned to hypnotizing her for a good night's sleep, "the baby is getting perceptibly heavy now," Frieda helps Ted plant strawberries, following him with her little shovel, imitating his gestures. Requests copies of the *Ladies Home Journal* with its "special Americanness, which I feel the need to dip into, now I'm in exile." Attends her first Anglican service in a "sweet little church," plans to send Frieda to Sunday School, although "as she starts thinking for herself she will drift away from the church but I know how incredibly powerful the words of that little Christian prayer 'God is my help in every need' which you taught us has been at odd moments of my life, so think it will do her good to feel part of this spiritual community."

October 23: Writes "Mirror" {SPD}

October 26: To Marion Freeman: Thanks her for gift and housewarming check: Court Green "makes one believe in destiny." The couple's writing is going well and Frieda is "blooming."

To Ruth Fainlight: Wants to stay the night so she can see Edward Albee's *The American Dream* and *The Death of Bessie Smith* at the Royal Court Theatre.

October 26–30: "Dear mother": The *New Statesman* is sending several children's books to review.

Later: October 30, Monday: Travels to London tomorrow to collect a seventy-five-pound poetry prize, attending the theater Wednesday, a "lovely birthday—Ted got me a lot of fancy cans of octopus & caviar at a delicatessen, two poetry books & a Parker pen & a big wicker basket for my laundry." Hopes the Strontium 90 level "doesn't go up too high in milk—I've been very gloomy about the bomb news. . . . The fall out shelter craze in America sounds mad." Prefers to be in Devon.

October 28: *My Weekly* publishes "The Perfect Place"

October 29: Completes "The Babysitters"

October 30: To Helga and Daniel Huws: Happy to get their big "newsy letter," still longing for carpet to relieve the "despair at our acres of bare boards," describes their discovery of Court Green, details plans for improving the house and land, and does not "require the intimacy of other people" to keep her happy, preferring "our family circle . . . very tight and pretty self-sufficient." The villagers are friendly and curious about Ted's employment, wondering how long the couple plan to stay. Admits it "seems odd,

that we should be embedded in such deep country, with cows and sheep herds all the time (Frieda points out the window and goes 'Baaa' when she wakes each day), yet not utterly isolated. It is an ugly town, but I am quite perversely fond of it." Invites them for a visit.

October 31: Departs for London, stays with Ruth Fainlight and Alan Sillitoe, accepts seventy-five-pound Guinness prize {PA}

November 1: Consigns to book dealer original manuscript of *The Colossus* for sale, sees two Edward Albee one-act plays, *The American Dream* and *The Death of Bessie Smith* {PA}

November 2: Ted and Frieda meet Sylvia at the Exeter train station {PA}

November 5: "Dear mother": Describes two days in London, seeing plays, meeting a publisher, but relieved to get home from sooty London, dreading the next five "grim" months. She feels "very ponderous," wonders how much the baby inside her weighs, and is pleased to know her mother has knitted a sweater for the January baby. Attends the peaceful Anglican chapel evensong: "I do love the organ, the bellringing & hymn-singing, & muse on the stained-glass windows during the awful sermons."

November 8: To Howard Moss, the *New Yorker*: Pleased that the magazine is going to publish "Blackberrying," suggests a few emendations.

November 9: To Alan Ross, the *London Magazine*: "Ted and I both" will manage to contribute to the "Poetry number."

Ted wakes up and tells Sylvia: "I dreamed you had won a $25 prize for your story about Johnny Panic." She goes downstairs and reads a letter notifying her that she has won a Saxton grant for $2,080 to write *The Bell Jar*. {HC}

"Dear mother": Announces she has won a Saxon grant for $2000 in quarterly payments, describes a Hunt Meet in town that Frieda enjoyed: "Oddly moving, in spite of our sympathy for foxes." Several household items purchased at an auction, including garden tools, a table, a "lovely china 'biscuit barrel' with pink cherries and green leaves on it, and a wicker handle."

November 10: The *New Statesman* publishes "General Jodpur's Conversion"

November 14: To Brian Cox: Thanks him for the proofs of her anthology, *American Poetry Now*, makes a few corrections.

To James Michie: Discusses libel issues in *The Bell Jar*, describes the background of the novel: "My mother is based on my mother, but what do I say to defame her? She is a dutiful, hard-working woman whose beastly daughter is ungrateful to her." Includes minor corrections.

To Ruth Fainlight: Thanks her and Alan for a fine time in London, happy with the furniture acquired at an auction: "So I sit in comfort for the first time in months, padded all about. Life here is very pleasant in spite of absolutely black weather & huge winds."

November 19: *The Observer* publishes "Mojave Desert" ["Sleep in the Mojave Desert"]

November 20: Plans a carpet-ordering trip to London: "cold with just the boards," ordering two more electric heaters, and has a "batch of stuff" to send for her Saxton report. She is following Ted's example and selling manuscripts to Indiana University.

To Olwyn Hughes: "Our move is a great & pleasant shock to both of us—it happened so fast & seemed such a gigantic thing, sinking our lives & savings into a place chosen from a two-day tour." Describes their living and working arrangements: "I can't imagine living anywhere else now nor can Ted."

December 6: To Gerald and Joan Hughes: Describes the first "awe-inspiring snow," getting Court Green "into shape."

December 7: To Ann Davidow and Leo Goodman: Describes moving into Court Green, encourages them to visit.

To Marcia Brown: Reports home improvements, "quite used to the peaked thatched & love the millions of birds who live in it," only a two-minute walk to shops, chemist, and post office, counting on her visit: "I find I miss London very little." Misses "college-educated" mothers: "nobody like that around here." Complains about the Anglican Rector's sermons and view of the Trinity, which "seems to me a man's notion, substituting the holy ghost where the mother should be in the family circle, almost a burlesque." The minister calls her "an educated pagan." After a miscarriage she is crossing her fingers that the new baby will be fine.

"Dear mother": A bright and "Chrismassy" day, sending out American Christmas cards, concerned about American politics, the John Birch Society, the "repulsive shelter craze," the warlike atmosphere, wondering "if there is any point in trying to bring up children in such a mad self-destructive world." Supports nuclear disarmament: "I just wish all the destructive people could be sent to the moon." Awaits carpets for their bare boards while sewing curtains, thanks her mother for many Christmas presents, details their income and expenditures, looks forward to her mother's summer visit, claims the "cold seems to keep us healthy. . . . Much healthier than the overheating we had in America." She has not written much: "I remember, before Frieda came: quite cowlike & interested suddenly in soppy women's magazines & cooking & sewing. Then a month or so afterwards I did some of my best poems."

December 12: To Brian Cox: Delighted with *American Poetry Now*, "stuffing our cracks against the winter blasts."

To Judith Jones, Knopf: Expects that Heinemann will send her novel to Jones, she does not have an up-to-date author's photograph.

December 15: To Helder and Suzette Macedo: Making preparations for the new baby, "(officially due Jan. 11th)." Ted is arranging a BBC program

for Helder about Portuguese poets. Offers to help Suzette place her stories. {HR}

"Dear mother & Warren": Encloses photographs of Court Green: "I can't tell you how much we like it here." Describes the town, the people, the food for this first Christmas as "heads of a family, & I want to keep all our old traditions alive." Her *New Yorker* contract has been renewed.

December 18: "Dear mother and Warren": Sends color shots of Frieda, a "blue-eyed angel," "piles of presents from everyone," pays off the £600 mortgage: "Isn't that wonderful!" They were allowed to keep the Maugham grant even though they did not travel abroad.

To Howard Moss, the *New Yorker*: Pleased about publication of "The Moon and the Yew Tree," accepts the change of "Mirror Talk" to "Mirror." Thanks him for clippings: "Buried as we are among Devon hedges and livestock, we don't get a chance to keep up on these at all."

December 29: "Dear mother": The temperature in the house in various rooms ranges from forty to sixty degrees with electric heaters. "It all depends on what one gets used to." Believes lack of central heat is actually productive of good health, the "happiest and fullest" Christmas, all homemade, describes unwrapping presents: "Tights are a godsend. I don't know how we'd get through the winter without them!" A Turkey dinner and apple pie "with our last & preciously saved own apples . . . Our house is a perfect 'Christmas' house."

2nd installment: Already planning next Christmas with a piano to play carols on, wants more Christmas recipes, takes sleeping pills because her arms have been "all pins & needles & often so painful I can't lay them anywhere at all: evidently a normal symptom of some pregnancies." Hopes Warren and Maggie, now engaged, will visit. "Ted is an angel—so thoughtful."

December 30: Attends end of year party at George and Majorie Tyrer's flat

December 31: New Year's Eve Party: Describes Dr. Webb[423] and his wife, the Tyrers' sixteen-year-old daughter, Nicola, whom Ted thinks of "educating," enchanted with a Danish architect "turned British farmer": "A curious desperate sense of being locked in among these people, a dream, longing toward London, the big world. Nicola in an "obvious bid for Ted's interest. He wanted to give her 'Orlando.' I groaned and gave her 'The Catcher in the Rye.' Ted's Biblical need to preach." Envies Nicola's "complete flowerlike involvement in self, beautifying, opening to advantage. This is the need I have, in my 30th year—to unclutch the sticky loving fingers of babies & treat myself to myself and my husband alone for a bit. To purge myself of sour milk, urinous nappies, bits of lint and the loving slovenliness of motherhood. A talk with Marjorie Tyrer about childbirth and babies. {PJ, Appendix 15}

Entry (n.d.) on the Webbs: Sees Dr. Webb, tall and lean in his "very modern, clean surgery," at the Tyrers' looks for Joan Webb, "short" with "dark, soft eyes," but they are interrupted by Marjorie Tyrer. Deplores Dr. Webb's delayed circumcision of Nicholas and the doctor's apparent suspicion that Sylvia is "malingering" when she complains of a fever. {PJ, Appendix 15}

1962

Undated: Photographs of Plath with Frieda and Nicholas {PM}

January 8: To Colson's for blankets, gets a grocery order from Day's, an order from the chemist, launders blankets, makes mayonnaise, sand tarts,[424] lemon cake pudding

January 9: 9:45: Nancy Axworthy, the housekeeper, arrives

January 10: Ash cans,[425] washes hair, does laundry, writes thank you notes, bakes cookies & cake pudding[426]

January 11: Nancy Axworthy arrives, Plath asks Dr. Webb for a renewal of pills,[427] washes hair, blankets, writes thank you notes, mentions weighing scales[428]

January 12: Grocery order from Boyd's, checks bank statement, bakes an apple pie, hand washes blankets, notes in calendar payment to "Nat Health"

"Dear mother": Baby officially due yesterday, "no sign," feels "more & more cowlike," lazy, sleeping pills last for ten hours, gets up late, too "ponderous" to work in her study, thinks she weighs, with layers of clothes on, "almost 170!" Her arms feel so heavy it is like "typing through a field of sandy needles . . . always dropping things or running my finger through with pins when trying to sew."

January 13: Bakes an apple pie, writes Saxton report

January 15: Grocery order from Day's

January 16. 9:45: Nancy Axworthy arrives, ashcans, Plath makes meatloaf, pays the bread man 2s.3d, washes hair

The birth of Nicholas confirmed Plath in her plans to have a large family, yet she sensed that her husband did not share her enthusiasm, and in retrospect, at least, he marked this moment as the beginning of his realization that he wanted a different sort of life, less encumbered by the responsibilities that his wife welcomed.

January 17: Sylvia goes into labor

11:55 p.m.: Nicholas is born, Ted sends telegram to Aurelia, on the calendar: bacon, onions, potatoes, eggs

Describes "niggling cramps . . . very calm and excited and eager, but surprised the rhythm of the birth and the order of things was so different from my time with Frieda." Nurse arrives with gas cylinder: "wonderfully

pleasant. Each time a pain came I breathed into the mask . . . until the pain was over." Describes the nurse and her background and is told "'My you're a good pusher, the best pusher I've seen.' I felt very proud." The pain returns and the gas cylinder is empty. Feels the nurse "do something" and her water gushes out and she feels a "black force" that is "too big." She is asked to breathe easily and after a panic-stricken moment "the black thing" hurtles out of her that turns out to be a glistening Nicholas. Dr. Webb arrives. "We had a son. I felt no surge of love. I wasn't sure I liked him." She is disturbed by his "low brow," but she is "immensely proud" and full of "rightness & promise." {PJ}

January 18, 9:45: Nancy Axworthy and an order from Boyd's arrive

5:00 p.m.: "Dear mother": Describes Nicholas at birth "shot out onto the bed in a tidal wave of water that drenched all 4 of us to the skin, howling lustily." Describes Frieda's pride in the baby and how restful it is to give birth at home.

Later: Saturday, January 20: Happy with news from home, and excited about Margaret, "an amiable sister-in-law!"

Now "fond" of Nicholas with his head "shaped up beautifully." Frieda is introduced to the baby. {PJ, undated}

January 21: *The Observer* publishes "The Rival"

January 23, 9:45: Nancy Axworthy arrives

January 24: Ashcans, calls dentist, Nancy Axworthy arrives, Sylvia makes a lemon pie and spaghetti sauce, writes letters, works on a Saxton report

"Dear mother": Recovering from childbirth, cooking again, enjoying "neighborly attentions," asks for advice on an insurance policy.

Saturday: Milk fever, penicillin shots, "cool again . . . Ted's been a saint, minding Frieda all day, making me mushrooms on toast, fresh green salads & chicken broth."

January 25, 9:45: Nancy Axworthy arrives

January 29: Ted to John L. and Máire Sweeney: "This last year hasn't been very good for poetry, or much else either. We made a desperate bid to escape the prime folly—London—& eventually settled in here, a nice old house, biggish, bit of land, orchard etc, quiet. . . . Sylvia's not written much this year but what she's written is her best." {THL}

January 30, 9:45: Nancy Axworthy arrives, grocery order from Day's, Sylvia washes a wool sweater and sorts cleaning, clothes, writes letters, works on income tax, thank yous, Saxton report

To Miss Mary Louis Vincent, Assistant to the Director, Meridian Books: Provides biographical details and names of magazines in which her poems have appeared.

January 31: Ashcans

To Helder and Suzette Macedo: Announces Nicholas's birth: "He looked very blue and angry and dark at first. Now he is pink, with very dark blue eyes I think will change, and darling, with a calm good temper. Frieda can't decide whether she wants to kiss or clout him. Probably both. She is very excited about him & holds him, with help. . . . I am always so broody before a baby is born I say nothing—it is such a miracle to me when they come out perfect." {HR}

"Dearest mother": Describes Frieda's developing stages, includes checks from *New Yorker*, fully recovered from milk fever, delighted with a new radio with three British stations but not all foreign stations: "Now I will be able to hear all sorts of music & plays & language lessons," reviewing "interesting books" the *New Statesman*, asks for advice on a gift for Warren and his fiancé Margaret: "I have got awfully homesick for you since the last baby—and for the Cape & deep snow & such American things. Can't wait for your visit." Knopf is publishing *The Colossus* on April 23 and six of her poems will appear in *New Poets of England & America*.[429]

To Dorothy Benotti: "Now at last things have settled down and I begin to feel my old self." Overwhelmed by the Christmas package, picking out "just what I would myself." Describes all of Dorothy's presents, their traditional Christmas, mentions she is relieved that her mother is done "with all that awful course work. Now maybe she will relax, and knit, and visit more." Describes the job of keeping the house warm, and the boring grey rain with almost no snow, childbirth at home with the assistance of a midwife and a gas cylinder, the "sweet neighbors," her household help, the Bendix, "a real blessing now," but still much to do cooking for two babies: "Well, give my love to the family. Every time I write you, Ted starts remembering those wonderful barbecues in your back yard and the horse & buggy rides. Maybe someday we'll fill our own stable with a pony!"

To James Michie: Passes on a Meridian Books request for permission from Heinemann to reprint "Black Rook in Rainy Weather" for an anthology.

To Marion Freeman: Describes giving birth to Nicholas. Thanks her for sending *Woman's Days*: "There simply are no magazines like this in England." Ted has found a pattern in the How-To section for a "lovely wood cradle." Mentions homesickness.

Turns in tax returns {LWM1}

c. End of January: Writes "New Year on Dartmoor" {SPD}

February: *Harper's Magazine* publishes "Sleep in the Mohave Desert," *London Magazine* publishes "In Plaster" and "Context"

February 1, 9:45: Nancy Axworthy arrives, Sylvia bakes banana bread and stews rhubarb

To Mrs. Olive Clifford Eaton: "Mother tells me you are responsible for making the absolutely beautiful blue blanket with the pink embroidery and the handsome potholders which we received in our wonderful Christmas package from America."

Sylvia and Ted listen to BBC broadcast of his play, *The Wound,* on their new radio {HC}

February 2: Grocery order from Boyd's

To Judith Jones: Sends a few minor corrections in the proofs for *The Colossus:* "I thought the proofs looked very fine."

February 3: Cooks roast beef, "cake-sponge?"

February 4: "Marjorie Tyrer?"[430]

February 5, 3:30: Rose Key comes for tea[431]

February 6: Visits Mrs. Hamilton[432] who wants to see Nicholas and admires his "maleness." Sylvia mentions Ted "seemed to be reluctant it was not another girl." Mrs. Hamilton supposes that he is "jealous for Frieda. . . . She went into the kitchen and bustled about getting a paper bag with a match (for a good match), coal (to light the fire), salt for health, a sixpence for wealth, and an egg for I'm not sure what." {PJ}

February 7: Ashcans, expects Nancy Axworthy between 8 and 9 p.m.

"Dear mother": Appreciates the bra and briefs since shopping is difficult right now until the baby settles to a schedule: "small things still loom very large. I get so impatient with myself, chafing to do a hundred things that have piled up, and barely managing one or two." Nancy is such help doing "mountains of ironing: It is heavenly to lie down upstairs and come down and find the kitchen floors washed, or to bake a cake and go upstairs and find all the rugs clean. Even so I find my hands full. . . . How I envy girls whose mothers can just drop in on them. I long to have a day or two on jaunts with just Ted—we can hardly see each other over the mountains of diapers & demands of babies."

February 8: 9:45: Nancy Axworthy arrives

11:00–12:00: At the birth registrar

11:30: Ted to Exeter, train to London for BBC work

Sylvia sees Marjorie Tyrer, dentist

February 9: Grocery order from Boyd's, trip to chemist, trout and Tollhouse cookies on the menu

February 10: Grocery order from Boyd's, trips to the chemist, hardware store, cooks rhubarb, banana bread, mushrooms, cress[433] sandwiches, airmails Saxton report

February 11: Grocery order from Day's, bakes walnut cupcakes, washes hair

References—some of them undated in her journals[434]—reveal that Plath was getting to know her neighbors in North Tawton and surrounding areas. Hughes had virtually no interest in doing the same.

February 12: Delivers cupcakes to the Watkins, stops off at chemist, hardware store, bank, does mending, listens to Ted on the BBC, works on scrapbooks, notebooks, vacuums the study

February 13, 9:45: Nancy Axworthy arrives, Ted to Exeter

"Dear mother": Describes Nicholas's baby stages and Frieda's frolicking, loves hearing "all these bits of personal detail about the people I used to know."

February 14: Ashcans, prepares Rose Key's franks & baked beans and warms meatloaf, writes letters, pays bills, checks bank statement. Calendar notation: "All The Long Afternoon" (unidentified)

February 15, 9:45: Nancy Axworthy arrives, laundry, banana bread cupcakes

Visits Rose Key who expects Ted to spend the day driving her to see her husband in hospital. {PJ, Appendix 15}

February 16: "A flying visit from Rose," who is worried about Percy's operation." {PJ, Appendix 15}

February 17: Nancy Axworthy arrives

7:10: Ted's play[435]

February 18: Charles Causley,[436] "lamb & rice," reads Ruth Fainlight's "Sapphic Moon" in *Encounter*

February 19: Laundry[437]

February 20, 9:45: Ashcans, Nancy Axworthy arrives

12:30: Ted is on the train to Exeter. Calendar notation: "type ribbons,"[438] "touch & glow,"[439] to do list: walnuts, currant jelly, macaroni, cupcakes, washing hair

February 21: Annoyed at surprise morning visit by Mrs. Hamilton, who has come to see Nicholas before she sets off for two weeks to Beirut and Rome, but Plath feels as though she and her home are being inspected: "As if we could be observed, examined at any moment simply because we were too shy or polite to say Nay." {PJ}

"Popped in on Rose." {PJ, Appendix 15}

February 22, 9:45: Nancy Axworthy arrives, cupcakes, tomato soup cake[440]

Calls on Majorie Tyrer whose husband has had a mild heart attack, describes the decor of the Tyrer home, the clutter, "dull old books," a pottery alligator: "Awful, but compelling. A primitive drollery." Talk turns to cooking, how to make tea, abusive customers at the bank, a peek at George "very dear, tousled grey hair, red cheeks, propped up on pillows, like a young boy. Felt refreshed, enlivened, renewed. Very at home." {PJ, Appendix 15}

Visits Rose Key for news about Percy, who has had part of his lung removed. {PJ, Appendix 15}

February 23: Boyd's grocery order, laundry, mentions seeing the Watkins, reminds herself to pay Rose Key

Plath struggled to manage homemaking and child rearing, and tried to make an effort to make herself presentable. She was bothered by visits from the young Nicola, whom Plath suspected of coveting Hughes, who was only too obliging to cater to the young woman's interests.

February 24, 9:45: Nancy Axworthy arrives, Sylvia cooks chicken, studies Italian

10:30: Nicola Tyrer for tea: The "doorbell rang. I should have answered it. I was in my slippers, without makeup, my hair down on all sides when Nicola came in. 'I'm not too early?' 'Oh no, said Ted.'" He makes tea. "She is shrewd, pushing, absolutely shameless. I shall ask Marjorie when the moment arrives to confine visits to afternoons. I <u>must</u> have my mornings in peace." {PJ}

"Dear mother": "The bitter cold of winter has descended on us again, after a longish lull." Starts spring planting, "feeling in fine shape again," Nicholas no trouble, mentions illnesses of older neighbors, listens to language courses on BBC radio, describes the gift she has in mind for Warren and Margaret, much work to do with house and grounds: "We like our Court Green more & more & more."

At tea manages a "girdle & stockings & heels and felt a new person." Nicola talks on and on about herself, about keeping her figure: "What's wrong with your shape, says Ted. . . . She will of course take anything from him & who doesn't love to have bright young youth listen to pontificatings." {PJ}

February 25: Studies Italian, makes cupcakes, potato soup, rabbit stew, tomato soup cake, chicken tetrazzini with white wine

3:30: To the Watkins

February 26: Takes cupcakes to the Watkins, pays Rose 3s9d [3 shillings, 9 pennies], prepares rabbit stew, and makes or just eats tomato soup cake, rhubarb, potato soup, banana bread, apple cake, cupcakes with frosting

February 27, 9:45: Nancy Axworthy arrives, Ted to Exeter, Sylvia arranges beds and does laundry

February 28: Ashcans

March: Completes "Three Women"

Poetry publishes "Stars Over the Dordogne," "Widow," "Face Lift," "Heavy Woman," and "Love Letter"

March 1, 9:45: Nancy Axworthy arrives, listens to BBC broadcast "Keep Up Your French"

Describes first visit to the Watkins, a disabled couple who reminisce about the war: "I left with Frieda, horribly eager to get out into the fresh air. The smell of age and crippling a real pain to me. Can't stand it." {PJ}

March 2: Rose Key paid 3s9d. Sylvia deposits checks at her bank, goes to post office with air letters,[441] returns to Court Green to work on frosting, potato soup, banana bread

Calls on the Tyrers: "Marjorie popped to the door in her brown cashmere, very neat and fine. Went up, feeling ponderous & clumpy in my suede jacket and big green cord coat. 'I like your coat,' Marjorie said, in a way that made me feel the opposite behind her words." Listens to Marjorie gossip with a friend: "I had the strong intuition Marjorie had peered into our life all she needed to make a judgment, had judged, and now our relation would be quite formal. Mine certainly will be." Feels "shut out." {PJ}

March 3: Nancy Axworthy arrives. Calendar notation: "Novel," finishes a biography of Napoleon's wife, Josephine,[442] studies Italian, German, French

Although Plath was quite aware of the trouble Hughes took to take care of the household routines and responsibilities of Court Green, she assumed he accepted their shared burden and had no idea just how much he was beginning to chafe at what he saw as his confinement. A careful reading of her letters and journals reveals the efforts she made not to confide all her worries to him, since she recognized that he seemed incapable of talking about his own periods of frustration and depression. In the main, their one outlet was arguments that would usually resolve themselves in lovemaking. But as Plath became more involved in motherhood, the romantic side of their lives became attenuated. She understood the problem but was hard put to rectify it since she was so wholly committed to marriage and family and believed her husband felt the same way. Hughes had married a writer and lover, and when Plath could no longer be both all of the time, he felt bereft. His constant train travel from Exeter to London, required to fulfill his BBC commitments, also looks like an effort to escape—at least temporarily—his duties at home.

March 4, 3:10: BBC Italian lesson

"Dear mother": Delighted with her mother's gift of a sweater that has just arrived: "I have just got fed up with winter." She is beginning to write for a few hours in the mornings and work on reviews for the *New Statesman*, thinks she might have the beginning of a novel, looks forward to spring gardening.

To Ruth Fainlight: "post-baby lethargy," describes Nicholas's birth. . . . I thought I must be torn to bits, but not a scratch." Calls the ten days afterward "wicked" for Ted,[443] "cooking & minding Frieda . . . coping with a succession of strange midwives . . . nightly milk fevers," eager to hear Ruth's news and hopes she can visit.

March 5: Pays Rose 3s9d, makes potato soup

10:05: Listens to Bartok

March 6: Nancy Axworthy arrives, Ted departs for Exeter, baking: apple cake banana bread, white cake (made with egg whites only), makes her own mayonnaise, potato soup

8:00: Listens to opera

March 7: Ashcans

 10:25: Listens to Bach

March 8: Nancy Axworthy arrives, Plath bakes white cake

 2:00: Checkup with Dr. Webb

 4:00: Listens to "Famous Singers"

 7:00: BBC French lesson

 Washes hair

 10:15: Listens to e. e. cummings

March 9: Boyd's grocery order, roast chicken, chemist

 9:55: Listens to Stravinsky

An encounter with Marjorie Tyrer in Boyd's that remains enigmatic: "forced myself to try to piece the glancing shields of light to the eyes behind them. Got a headache, continually deflected." {PJ}

March 10: Nancy Axworthy arrives, "GET mushrooms?" writes airletters,[444] prepares "JUG HARE,"[445] reads "Isabelle," writes letters,[446] studies Italian

 10:35: Listens to Haydn

March 11, 3:30: BBC Italian lesson

Works on a *New Statesman* review, bakes banana bread, oatmeal cookies, cooks chicken soup, rabbit stew

March 12: Nancy Axworthy arrives, Day's order of eggs, onions, mushrooms

"Dear mother": "I am getting very sentimental about family things. For instance, someday I hope to be well-off enough to send for grammy's desk. I'd like it to be Frieda's little desk." Describes all the home improvements, deplores the rector's "ghastly H-bomb sermon" that heralded the happy prospect of the Second Coming and condemned the "stupid pacifists & humanists & 'educated pagans' who feared being incinerated, etc. etc." She has stopped attending church, feeling it a sin to "support such insanity even by my presence." Misses the Unitarian church but still plans to send Frieda to Sunday School, awaits the blooming of spring: "I think the most exciting thing to me is owning flowers and trees! . . . I think having babies is really the happiest experience of my life. I would just like to go on and on."[447]

To Clarissa and Paul Roche: Hopes they can visit before returning to America, mentions that "chilblains undid me. . . . I got very grim. . . . I am nearly done with a quite grossly amateur novel [*The Bell Jar*]."

March 13: Nancy Axworthy arrives, laundry, bakes oatmeal bread

March 14: Ashcans

March 15: Nancy Axworthy arrives.

 3:00: Trip to Exeter to dentist, shops for Frieda's dress, baby cot and bureau

 7:00: BBC French lesson

March 16: *New Statesman* publishes "Wuthering Heights"

March 17: Nancy Axworthy arrives, rhubarb banana bread, *New Statesman* review, letters to write, hair to wash, hand washes clothing

March 18, 3:10: "Ted's letters, rhubarb, write James Michie"

March 19: BBC German lesson

March 20: Nancy Axworthy arrives, laundry, meatloaf, oatmeal bread

March 21: Ashcans

March 22: Nancy Axworthy arrives

 3:00: Dental appointment in Exeter

 7:00: BBC French lesson

 Hand washes clothing

March 23: Laundry, including white blanket, washes hair, grocery order from Boyd's

To Elizabeth Schober [aunt]: Thanks her for Nicholas's "darling blue corduroy baby suit," Ted is planning a large vegetable garden and expects to sell "luxury items like asparagus, strawberries & mushroom, plus all sorts of flowers," a very cold winter without serious illnesses, home improvement plans, including a tennis court, looks forward to "another baby Girl" who can wear the dress Aunt Elizabeth sent for Frieda: "blue is really our family color!"

To Marvin Kane: Describes the discovery of Court Green and how they are "rotting ourselves in Devon,"[448] the birth of a second child, battling slugs in the garden, would like to be on his BBC program about Americans who decide to live in England but it would be difficult because of the baby, even though "I miss London a lot more than Ted does!" Invites him and his wife Kathy to visit on their way to Cornwall, and perhaps he can "wangle a tape-recorder" so she can be part of his program.

March 24: Nancy Axworthy arrives. Calendar notation: eggs, lamb, veal, and paddipads[449]

 6:00 Tyrers

 Ted: in Exeter, "black shoes?"

March 25, 3:00: Baptism for Frieda and Nicholas at St. Peter's, an Anglican Church {PKS}

March 26, 7:10: Grocery order from Day's, prepares roast lamb, blanquette de veau[450]

Plath's mention of "March megrims" (low spirits) is telling—not only for her but for Hughes. Notice that in her diary she has so many activities associated not only with home and home improvements but with her efforts at self-improvement and recreation, such as listening to BBC language programs, horseback riding, and music. Nearing the age of thirty, she seemed to think she was beginning a new phase, which she welcomed but perhaps also dreaded. To what extent

Hughes also was entering what has been termed a mid-life crisis is difficult to assess because unlike his wife he remained, for the most part, inarticulate about his anxieties and did not confide his concerns to a therapist.[451]

March 27: Nancy Axworthy arrives, Ted in London, bakes bread, order from Day's arrives. Calendar notation: "BANK"

"Dearest mother": Happy to get her "springy letter . . . suffering from the March megrims," gardening is "soothing," refunds the sum her mother sent for purchase of Court Green, listens to Haydn on the radio and longs for a piano, to practice again, and to play for Frieda, describes the christening for Frieda and Nicholas, relieved to have found a good dentist in Exeter, may begin horseback riding lessons, and wants to be "practically grounded" should Frieda and Nicholas want to learn. "Life begins at 30!"

To RB: Describes finding Court Green after feeling cramped in London and house hunting in Devon: "I have never felt the power of land before." Mentions the grim winter and the "Dickensians disease" of chilblains, Nicholas's birth after a worrisome miscarriage, gardening, cooking, house repairs, finishing a novel in under two months.[452] "It is an immense relief to me to feel I can write you every so often; it heartens me no end to feel you are there, whether I talk to you or not."

March 28: Ashcans

To Ann Davidow and Leo Goodman: A horrible winter, "tombstone skies, sleet, a mean wind set perpetually in the east." Snatches the few nice days to garden: "We dream of a few laying hens, hives, mushrooms." Describes Nicholas's arrival: "a true Hughes—craggy, dark, quiet & smiley, unlike the lively & almost hysterically active Frieda." Surprised at civil rights demonstrations at University of Chicago, which she had considered "the most progressive of places racially."[453]

To Marion Freeman: "They say it is the coldest March since 1909 and I believe it!" Reports on Frieda and Nicholas: "Life is very busy & lots of fun. I so enjoy the Woman's Days. They make me quite homesick, with all the lovely American recipes & how-to-do things!"

March 29: Nancy Axworthy arrives

2:00: "Baby-vaccination?"

7:00: BBC French lesson

Reminder to "get photos." Calendar list: banana bread, meatloaf, tomatoes, oranges

To Helga and Daniel Huws: Recounts Nicholas's arrivals, concluding: "Or have I told you? I am so blank I'm not sure if I've written about him really, or just in my head." Longs to play her childhood piano favorites[454] for Frieda, appalled at chilblains: "the cold had secretly got at me when I thought I was winning out. . . . No real friends here, only nice neighbors"

March 30, 6:10: BBC German lesson

Daffodils to Jim Bennett

March 31: Nancy Axworthy, order from Boyd's arrives, mending, paddipads, painting chair, floors

April: *Encounter* publishes "The Colossus"

April 1: Frieda's second birthday

3:10: BBC Italian lesson

Washes hair, paints a chair, works on letters, poems for the *Sewanee Review*, BBC

To Robert Silvers, *Harper's Magazine*: Mentions publication of her first book of poems.

April 2: Completes "Little Fugue"

Laundry, baths for the children, paints and vacuums study

7:10: BBC German lesson

April 3: Nancy Axworthy and Bolt's men arrive,[455] bakes bread, makes custard, springerle[456]

April 4: Completes "An Appearance," "Crossing the Water"

Ashcans, miscellaneous tasks, wash hair, clean study, eggs, padlock, ovaltine, mending, write letters,[457] Louis MacNeice's play on BBC

To George MacBeth, BBC: Sends unpublished poems, "Blackberrying," "The Surgeon at 2 a.m.," "Mirror," "The Moon & the Yew Tree," "The Babysitters," "Little Fugue," "An Appearance," "Crossing the Water"

April 5: Completes "Among the Narcissi"

Nancy Axworthy arrives, laundry

7:00: BBC French lesson

April 6: "Padlock," "Daffodils,"[458] hand washes clothes, paints table, cleans study

April: 7: Completes "Pheasant," Nancy Axworthy arrives

To Marvin Kane: Plans to meet him at the station for his visit, hopes for better weather: "Gale winds have carried off our lettuces & large spiders are appearing everywhere, most frequently in my coffee cup, before breakfast."

The *New Yorker* publishes "Tulips"

April 8, 3:10: BBC Italian lesson

"Dear mother": Hasn't seen the sun in three weeks, workmen are redoing the floors, pleased with packages of clothing from home, hopes for improving weather and guests from London, looking forward to her mother's summer visit, expecting to sell daffodils at the market once a week.

April 9: "BOLT,"[459] laundry, Day's order

4:00: Marjorie Tyrer

Washes hair, makes banana bread and spaghetti

April 10: Nancy Axworthy arrives, banking, makes lemon meringue pie

 2:40: Marvin Kane arrives at North Tawton Station.

 Calendar notation: a call to the dentist and mentions a Mr. Lacey

April 11: Ashcans

 April 12: Nancy Axworthy arrives, laundry

 7:00: BBC French lesson

 Begins work on "Elm" {HC}

April 13: Boyd's order, two birthday cards, daffodils for Jim Bennett

April 14: Nancy Axworthy's birthday

April 15: Today's menu: beef stew, banana bread; laundry, handwashing, washes hair

 3:10: BBC Italian lesson

April 16: Ted to London, laundry, Day's order, calls the cement man, makes bread, makes or eats beef stew, writes letters

 7:10: BBC German lesson

"Dearest mother": Looks out from her desk at an "acre of shivering daffodils & lilac buds on this black frigid day as if it would make spring come in earnest. . . . Even the local people are very gloomy." Babies are in bed and two hours of "energetic" work, Irish stew awaiting Ted's return from London. "I loved your big fat letter." So grateful for her mother's help in buying the house and land: "We love the place so much our mutual nightmares have been about being forced for some reason to give up Court Green. . . . I never dreamed it was possible to get such joy out of babies. I do think mine are special." It is hard not to have relatives present to "appreciate my babies!"

To Leonard Baskin: Pleased that Leonard asked Ted to write an introduction to his book, apologizes for her behavior when Leonard visited them in London, when she was in a desperate state, in the middle of a first novel, and so was Ted, although "he shows such things less & is of a more open & unfrantic nature." Describes the acquisition of Court Green "a Radical break with our frenzies," hopes he can come to enjoy the Devon spring and "erase those sour memories which grieve us both."

To Ruth Fainlight and Alan Sillitoe: Delighted about the birth of their baby boy: "he and Nicholas should be able to coo & gurgle at each other companionably when you come down." Expects May to be a beautiful month, mentions Fainlight's "Sapphic Moon": "It is a real White Goddess poem, and a voice on its weird fearsome own."[460]

The first reference below is to Elizabeth Compton (later Sigmund), who qualifies as Plath's one close friend in Devon. Plath dedicated The Bell Jar *to Elizabeth and her then husband, David. Elizabeth, a mother and political activist, had the breadth of knowledge and family experience that meant so*

much to Plath. Elizabeth was also in a position to size up Ted Hughes and to deal with him after Plath's death.[461]

April 17: Nancy Axworthy arrives, "Ted: See Jim,"[462] tea with Elizabeth Compton

Rose Key thumps on the door and announces that she thinks Percy has had a stroke. Sylvia follows Ted, saying to herself: "you must see this, you have never seen a stroke or a dead person." She watches Percy "twitching in a fearsome way, utterly gone off, mumbling over what I thought must be his false teeth, his eyes twitching askew, and shaking as if pierced by weak electric shocks." Doctor arrives and walks in "very slowly and ceremoniously, head seriously lowered, to the door. Ready to meet death, I suppose. . . . Ted & I hugged each other. Frieda looked on peacefully from her lunch, her big blue eyes untroubled & clear." Percy had had five strokes that day. "One more, the doctor said, and he would be gone. . . . Everybody, it seems, is going or dying in this cold mean spring." {PJ, Appendix 15}

April 18: Ashcans, Day's order, "Jim,"[463] "Eggs"

Nicola Tyrer visit, asking to take Frieda for a walk but Frieda has gone to sleep after a trauma over a crow bite. Nicola asks if she can help Sylvia: "I saw Marjorie more & more behind this. O I am going to mow the lawn, I said vaguely." Nicola's father, George, visits, apparently assisting Nicola in vying for an invitation to meet people in London: "Nicola left with George, a little defeated." {PJ}

Sylvia spotted Nicola Tyrer as a fetching temptation for Ted, who seemed besotted with her charms. Was it anything more than that?

April 19: Completes "Elm"

Nancy Axworthy arrives, laundry, "TILES"

7:00: BBC French lesson

"Nicola tripped in, in heels and a white silk scarf with large and fashionable black polka dots, to collect the large bunch of 40 daffodils I had arranged to give George for the trip to the grandmother." It is Sylvia's impression that Nicola expects her "to do something." Listens to Ruth Pearson talk about the predatory behavior of priests and monks during her childhood. "My reply, almost continually: 'I didn't know priests would do that, My, my.' The incredible fixed reminiscences of a spinster." The Tyrers announce his retirement and their plans to leave in six weeks for a flat in Richmond. "I felt uncomfortably like bursting out laughing. I managed tears." They offer a list of their things to sell with a price list: "I was astounded. They were letting us have the favor of 'first choice.' The prices were very high. Trust a banker, I thought." They buy an "antique oak drop leaf table" and a few other items. Ted returns home at 7:00[464] and stands with Nicola "at opposite sides of the path under the bare laburnum like kids back from the date, she posed & coy." {PJ}[465]

April 20: Washes floor, paints moulding, notes Marjorie's birthday, harvests daffodils

6:10: BBC German lesson

April 21: Ted's Aunt Hilda and cousin Vicky arrive for two-day visit, Nancy Axworthy arrives, Sylvia mails birthday cards, collects three dozen daffodils

4:00: Tea with Marjorie and Nicola Tyrer

Nicola talks about her idols, Brigitte Bardot and Lolita. "Nicola putting on her stylish white makintosh. Marjorie had worn the usual buff or dun colored cashmere sweater with a pleasant buff & black-squared skirt. Nicola in a navy blue sweater. Her very thick legs." {PJ}

"Dear mother": Picks over forty dozen daffodils to sell at market: "It's like a fairytale here." The rain has turned silvery. Ted is doing more children's book reviews for the *New Statesman.*

To Warren: Wants him to visit soon.

April 22, 3:10: BBC Italian lesson

Easter Sunday picking daffodils with Ted, overhears Rose telling Percy he has to take it easy, Rose asks about the daffodils "Dislike her scrounging to get something out of us. We brought by a bunch." Percy is sitting up and cracks a smile and manages to say, "You can't raise a nation on fish alone." {PJ, Appendix 15}

April 23, 2:10: BBC German lesson

April 24: Day's order, breadman

"A new & fearsome strategy on the Tyrers part." Sylvia is "aghast" that Nicola has asked to read in their garden, as if it were a public park. Sylvia says no since she has company in the garden. Fears that soon neighbors will be dropping in to have free run of the house and grounds. {PJ}

April 25: Ashcans, flowers to Elsie Taylor, hoes garden, writes letters

To Helder and Suzette Macedo: "Nicholas is moaning soulfully at my back. Ted & Frieda are flat out napping upstairs after a week with three of Ted's relatives & we are thinking of camping in the garden—so peaceful." After a bitter winter, a beautiful spring, she supports Suzette's decision to get a job: "I always did this—took a job, after I'd tried writing for a few full days. Couldn't stand it & became a morbid old bitch. Now I squeeze writing into a couple of hours, or rather it is squeezed malgré moi." {HR}

"Dearest mother": "On Easter Sunday the world relented & spring arrived." Excited about her mother's impending visit and mentions a "pompous hotel" where Mrs. Prouty could stay.

"NANCY AXWORTHY & MISCELLANEOUS INTELLIGENCE": Nancy has been called away by the death of her mother. Sylvia hopes to take woodworking this fall from Nancy's husband, head of the North Tawton fire department. {PJ, Appendix 15]

Stops by for a second talk with Rose Tyrer, mentions Nicholas's crying and Rose's response: "Babies are so forward nowadays." {PJ, Appendix 15}

April 26: Laundry, Boyd's order, deposits check, drives Ted to Exeter, washes hair

 7:00: BBC French lesson

April 27: Three dozen daffodils for Jim Bennett

 6:10: BBC German lesson

 The *New Statesman* publishes "Pair of Queens"

April 28: Two dozen daffodils and one narcissi for Georgina[466]

To Alan Sillitoe: Expecting him on May 2 when he will be able to "catch the last marvel of our daffodils," supper will be ready when he arrives.

April 29: Ironing

 3:10: BBC Italian lesson

April 30: Day's order, laundry

 7:10: BBC German lesson

To Marvin and Kathy Kane: "No no we are not dead, nor furious at air motes nor any such thing. Only exhausted": "I am so scatty from my char [Nancy Axworthy] deserting me for two weeks . . . and ironing . . ."

May 1: Nancy Axworthy arrives, Sylvia needs lampshade plugs for Pifco electric heater and lamp; irons, cleans kitchen shelves, writes birthday cards

 Nicola visits to say goodbye and seems huffy at the cold reception. {PJ}

"Dear Aurelia and Warren": Describes the daffodil spring, the differences between Frieda and Nick, Sylvia is writing well: "Since she left America, she's lost the terrible panic pressure of the American poetry world—which keeps them all keeping up on each other." {THL}

May 2: Calendar notation: mushrooms and Devon cream, prepares spaghetti and lemon meringue pie for Ruth Fainlight and Alan Sillitoe

Ruth Fainlight seems to be the first witness to growing estrangement between Plath and Hughes, although nothing in Plath's journals or in her letters up to this point reveals as much. On the contrary, she issues declarations that she has never been happier. Plath's poem, "Elm," seems to voice the darkening mood that Plath could not otherwise articulate: "I know the bottom . . . Love is a shadow . . . I am terrified by this dark thing / That sleeps in me."

May 3: Nancy Axworthy arrives, laundry

 7:00: BBC French lesson

 "Roast pork or Rice & sauce Date nut bars"

Ted drives the Sillitoes to Dartmoor, Ruth stays in the car and later, sensing tension between Ted and Sylvia, dares not mention the lamb's head they find in the grass. {HC}

May 4: Boyd's order

 6:40: BBC German lesson

"Dear mother": Encloses Easter Sunday photographs of Frieda and Nicholas: "You will love the children. Nicholas smiles & laughs & is wonderfully responsive to attention & kind words. Frieda thirsts for knowledge & laps up every word you tell her." She is pleased to hear that Mrs. Prouty would like to visit. "Now it is spring, it is just heaven here. I never dreamed it was possible to be so happy."

May 5: Nancy Axworthy arrives, Sylvia needs two pounds of rice and walnuts, daffodils for Jim Bennett, paints a mirror, plants carnations, mentions a screenstand[467] and "white nasturtiums etc.," mows the lawn

To Judith Jones: Expresses her delight at the cover and jacket for *The Colossus*: "I am so happy with what you have done with it." Remembers that Knopf showed interest in publishing her fiction after her first story appeared in *Mademoiselle*, asks her editor to send clippings: "never see such things here & thrive on criticism of all sorts, especially the adverse sort."

May 6: Reads Dr. Spock,[468] vacuums study rug, types "Three Women," finishes letters[469]

George Tyrer, now retired, visits: "He seemed lessened, deposed, slightly abashed by all his leisure." {PJ}

May 7: Day's order arrives. Calendar notation: "Tyrer's move"

12:30: Lunch with the Comptons

Calls dentist, dinner with the Tyrers at Burton Hall,[470] mentions a "fire extinguisher gas poker"

9:00: Leaves dinner with the Tyrers "with a feeling of immense freedom"

May 8: Nancy Axworthy arrives, Plath writes a *New Statesman* review while Hughes goes to Exeter

May 9: Ashcans

To Gerald and Joan Hughes: Looks forward to joining Ted on his early morning fishing jaunts when her mother arrives, describes her delightful children, and is "thrilled at the possibility of your coming over."

May 10: Calendar notation: a *New Statesman* review due; Nancy Axworthy arrives, laundry

4:00: Appointment with Dr. Webb

7:00: BBC French lesson

Cooks rhubarb, makes tomato soup cake, paints furniture white

May 11: A half pound of Devon cream, Boyd's order

6:40: BBC German lesson

Handwashing

May 12: Nancy Axworthy arrives, Sylvia finishes mowing lawn, plants nasturtium, cleans cottage, paints mirror bar screen white, puts winter clothes away, works on Frieda's chair, mends playroom molding

To Ruth Fainlight: Writes about how much she enjoyed the visit from Ruth and Alan, wants to dedicate her "Elm" poem to Ruth: "I feel very involved & admiring of your imagery."

Visits Mrs. Hamilton, taken to the garden ("immaculate seedless beds"), then tea, talk of Mrs. Hamilton's trip to see the pyramids. {PJ}

May 13: Mayonnaise, banana bread

3:20: BBC Italian lesson

May 14: Laundry, Day's order

3:15: Dental appointment in Exeter

Return homes to "plant nasturtiums, etc"

7:10: BBC German lesson.

"Dear mother": $17 from selling daffodils: "very small in amount, but we are proud of it because it makes it seem as if the place is 'earning.'" Hopes to earn more from apple harvest, bluebells "everywhere, a lovely thundery purple," official publication day for American edition of *The Colossus*, asks her mother to bring various items, expecting a visit from Ted's parents, complains that his mother is "no help at all with babies (they exhaust her) or cooking or anything. Well, she has a good heart, I guess. I'm just glad I have the mother I have!" Asks for advice on canning.

May 15: Nancy Axworthy arrives, corn chowder, plants "nasturtiums, etc."

Hears Percy "with fixed, mad blue eye" using a scythe to attack the "Japanese creeper," a "bambooey plant which had shot up in the alley by the drive," and Ted tells him to stop: "Thought I was doing you a favor he says . . . No sign of Rose." Then she appears and is startled when Sylvia charges her two bob for daffodils, which is what everyone is charged. Rose invites her for tea on Sunday (May 17) and Sylvia feels "sick about going because Percy make me sick." {PJ, Appendix 15}

May 16: Ashcans

1:00: Meets at the Clarence Lounge with "John M"[471]

Describes meeting Mrs. Macnamara as their "second entering wedge" into North Tawnton. She "exudes weal, wellbeing." Describes the decor, family history, the garden, kennel of Pekingese. {PJ}

May 17: Nancy Axworthy arrives, laundry, seed planting, hair washing

7:00: BBC French lesson

Beef stew, gingerbread, corn chowder

Tea at Rose Key's, Percy a little better, Ted arrives to Sylvia's relief. {PJ, Appendix 15}

With the arrival of David and Assia Wevill, the atmosphere at Court Green loured, although to David nothing seemed amiss when he returned to the Chalcot Square flat sublet from Sylvia and Ted. What happened on that visit remains somewhat occluded, with some accounts portraying Assia as pursuing Ted and

others emphasizing that he took the initiative, later showing up at her adver-
tising firm in London. Nothing in Plath's letters or calendar from this period
suggests she was disturbed by the visit. If she kept a diary, it has gone missing.

May 18: Ted picks up David and Assia Wevill at the train station {HC}

David and Assia Wevill arrive at Court Green for a weekend visit. Sylvia serves them gingerbread and beef stew

6:40: BBC German lesson

The *New Statesman* publishes "Oblongs"

May 19: Nancy Axworthy arrives, Assia helps Sylvia in the garden while David and Ted take Frieda to the moors

May 20: Sylvia, silent, drives the Wevills to the train station

3:10: BBC Italian lesson

May 21: Writes "The Rabbit Catcher" and "Event"

3:00: Dental appointment in Exeter

Calendar notation: lampshade, coathangers

7:10: BBC German lesson

To Howard Moss: Encloses "Three Women," "Elm," "The Rabbit Catcher," "Event," pleased to hear that people like "Tulips."

May 22: Nancy Axworthy arrives, rhubarb, Day's order, laundry, gardening, answering letters, banking

"My Dear Sylvia," Assia Wevill writes: "Today I got the tapestry for you, or rather the materials for it. . . . Let me warn you again that you can become seriously addicted to tapestry, and you might find yourself staying up too late at night doing it, or stop eating, or mending and baking and working. Please, please don't let it possess you. . . . But I hope you'll enjoy it." {CAW}

May 23: Ashcans

May 24: Nancy Axworthy arrives

7:00: BBC French lesson

To W. S. and Dido Merwin: He has "written nothing" but claims to be "quite content" to let the design smooth itself out instead of "writing purely out of nerves." {CR1}

Ted works on "Difficulties of a Bridegroom," a play with a moral: "'What you are afraid of overtakes you,' something of a joke." {THL}

May 25: Begins work on "Apprehensions" {SPD}

Bakes banana bread, custard, gingerbread

6:40: BBC German lesson

May 26: Nancy Axworthy arrives, Plath works on playroom floor, Boyd's order

6:40: BBC program on "The American Dream."

May 27, 3:10: BBC Italian lesson.

May 28: Completes "Apprehensions" {SPD}

 7:10: BBC German lesson

 8:30: Marvin Kane

May 29: Nancy Axworthy arrives, Day's order, banana bread, works on tapestry, study curtains, cleans study, weeds, writes letters

May 30: Ashcans

 3:30: Frances Bryant in South Tawton

May 31: Nancy Axworthy arrives, laundry, paints playroom molding, Frieda's chair, mirror frame, victrola, Nicholas's screen

June 1: Sends a telegram to the about-to-be-married Warren and Margaret,[472] works on tapestry, study curtains

 6:10: BBC German lesson

June 2: Nancy Axworthy arrives

 10:00: BBC broadcast: *World of Books*

 Makes molasses crinkles, mayonnaise, white cake, works on tapestry, study curtains, paints playroom molding, Frieda's chair, mirror frame, screen, victrola

 Warren Plath marries Margaret Wetzel {BF}

June 3, 3:10: BBC Italian lesson

June 4, 7:10: BBC German lesson

June 5: Nancy Axworthy arrives, Day's order, trip to the post office

June 6: Ashcans

Plath continued to write letters extolling her family and country life. Yet her poetry suggests an undercurrent of unrest, perhaps surfacing in her comment that working on a tapestry was very "calming." That tapestry had been sent to her by Assia Wevill. What Plath made of Wevill's intentions, and what Wevill herself made of them, is impossible to say—except that for both these women the figure of Ted Hughes loomed as a cynosure of their desires. Wevill may have regarded herself not so much as a rival of Plath's but as a partner in the sharing of that tapestry, and of Hughes, although Plath—as soon as the Hughes-Wevill nexus became clear to her—rejected Wevill as the "other woman," the temptress. Yet right from the beginning, Wevill seems to have been as fascinated with Plath as she was with Hughes, and that fascination with Plath would continue even after Plath's death.[473]

June 7: Nancy Axworthy arrives. Day's order, post office

 6:30: Beekeeping meeting[474]

 7:00: BBC French lesson

 Day's menus: potato soup, molasses crinkles, and "Letters!"[475]

"Dear mother": "Forgive me, forgive me for what must seem a huge silence. The days slide by so fast here that we seem to be living out of Time in a kind of country eternity." Mentions how much time guests have taken up,

including Ted's parents and his Uncle Walt. "This is the richest & happiest time of my life." She mentions working on tapestry as very "calming." Very sorry she could not be at Warren's wedding but she would have squandered their savings on a jet flight. She has been invited to give a short talk on the BBC program *The World of Books.*

"CHARLIE POLLARD & The Beekeepers": They are interested in starting a hive, but they arrive without proper clothing. Mrs. Jenkins offers Sylvia a "boiler suit," a "small, white silk button-down smock, the sort pharmacist's assistants use." Charlie gives Sylvia an Italian straw hat with a "black nylon veil. . . . The donning of the hats had been an odd ceremony. Their ugliness & anonymity very compelling, as if we were all party to a rite. . . . 'Spirit of my dead father, protect me!' I arrogantly prayed." Describes the intricate process of looking for the first new queen. {PJ, Appendix 15}

"Well, Percy Key is dying. That is the verdict. Poor old Percy, says everybody. Rose comes up almost every day, calling "TE-ed" in her "hysterical, throbbing voice." Ted visits Percy and says he is a "bag of bones" and agitated: "Everybody has so easily given him up. Rose looks younger & younger." Sylvia Crawford reports: "cancer went wild if it was exposed to the air. The general sentiment of townsfolk: doctors just experiment on you in hospital. Once you're in, if you're old, you're a goner." {PJ, Appendix 15}

June 8: A Boyd's order, Al Alvarez calls at Court Green on his way to Cornwall and notices nothing amiss {HC}

Dinner: lamb, rice, and peas, rhubarb & cream

They drive to Charlie Pollard's to pick up their hive, he loans them a bee book: "We loaded our creaky old wood hive. He said if we cleaned it and painted it over Whitsun,[476] he'd order a swarm of docile bees." {PJ, Appendix 15}

June 9: Nancy Axworthy arrives

To Marvin and Kathy Kane: Expresses her enthusiasm for gardening and beekeeping

Meets the Rector: "I could feel his professional gravity coming over him." {PJ, Appendix 15}

June 10, 3:30: Winkleigh:[477] meets the Billyealds at Charlie Pollard's bee-meeting, invited to tea, at a house "small as a postage stamp": "Mrs. Bertha Billyeald an amazing & indomitable woman: white short hair, tall, keen blue eyes & pink cheeks. Quite greedy, though fattish, she ate lots of scones & cream & jam for tea."

To Gerald and Joan Hughes: Happily "browning" in a "week of hot blue days," anticipating her mother's six-week visit.

Meets the Billyealds at Charlie Pollard's bee meeting, describes their "cramped, brick house all on one floor like a holiday camp," examines

their pink and white hives, Mrs. Bertha Billyeald shows them her scrap-
book of life in British Guiana: "An astounding document": "Lots of pic-
tures of waterfalls seen from the air in her three-seater plane; her black silk
flying suit, like Amelia Earhart; her handsome pilot; close calls. Pictures
of her with short hair, in pants, handsome herself, ordering a cowering
black to move some dirt, on horseback, driving a locomotive which she
& her engineer built, straightening the 7-mile railway tracks they made
to help get the timber to the river." Describes adventures with a jaguar:
"Very opinionated. Said that these women get multiple sclerosis from
worrying over their husbands' bad health and not accepting what God
has sent them!" Major Billyeald, Bertha's husband, makes "jocular refer-
ences to his wife's expertise (on bees) & domination: 'She has her finger
on my jugular.' "[478] Bertha's father: " 'Three things I'll tell you,' he said:
'There is no sentiment in business. There is no honesty in politics. And
self-interest makes the world go round.' 'All right, I said. I give you those.' "
{PJ, Appendix 15}

June 11: Paints a hive "etc.," plants "odd flower seeds"

7:00: BBC German lesson

Baking and cooking: banana bread, maple custard, potato soup,
beef stew

To Alfred Young Fisher: Announces publication of *The Colossus*, re-
members her senior year "under your office gable. The book is your due.
Those afternoons are at the deep root of it." Describes commitment to
the country life, writing and "balancing babies," gardening, work on BBC
programs: "It is wonderful to discover one's destiny." Her muse is "mad"
for the pink Smith memorandum pads on which she drafts her poems and
would like to buy a dozen of them.

June 12: Nancy Axworthy arrives, Day's order, laundry, weeding, straw-
berry picking, painting, washing hair, pasting photos

6:40: BBC French lesson

9:30: Pinter play[479]

June 13: Ashcans

12:00: Mrs Macnamara

8:00: "New Comment,"[480]finishes painting

11:45: Midwife

Works on hives, washes hair, bakes molasses crinkles, mentions "study
curtains," tapestry, studies French and German

June 14: Nancy Axworthy arrives, laundry, to bank, post office,
butcher, chemist

2:00: Dr. Webb examines Nicholas

Boyd's order, hair washing, makes mayonnaise

Ted records a dream in his diary: "after some lively time in Paris, with attractive girls, back here. Postman comes. I run down, receive from him a note & take it into front room. On it is written the address, in Paris, of the most attractive of the girls—and 'there is a room for you here if you still want it'" {HC}

Inscription in *The Golden Notebook*: "To Ted and Sylvia, with love from Doris Lessing," Sylvia places "three check marks next to passages about single, artistic, bohemian women who live freely." On page twenty, for example, she checked: "Her source of self-respect was that she had not—as she put it—given up and crawled into safety somewhere. Into a safe marriage." On page forty-six: "We've chosen to live a certain way, knowing the penalties, or if we didn't we know now. . . ." {HC}

June 15: Exeter

2:00: Nancy Axworthy arrives

Charlie Pollard delivers Italian hybrid bees to Court Green, Ted is stung six times[481]{PA}

Hair washing, plants seeds, repaints moldings, sews Frieda's dress hems

"Dear mother": "I have been working so hard physically out in the garden that I am inarticulate and ready for bed by evening, hence my long silences. I don't know when I've been so happy or felt so well." They have begun to bee-keep.

To Philippa Pearce, BBC producer of *The World of Books*: Encloses a copy of her talk and asks if it can be recorded on the morning of the 26th.

June 16: Nancy Axworthy arrives. Calendar notation: wedding anniversary; plants seeds, finishes painting victrola and floor, works on Frieda's hems, weeds, cooks roast beef, mushroom, peas, potatoes, a lemon pie, an "*extra bread,*" studies German

June 17: Paints sewing machine, plants seeds

3:30: Adamson's tea

Works on study curtain

The *New Statesman* publishes blurb on *The Big River* by Elizabeth and Gerald Rose

June 18: Day's order, laundry, seed planting

7:10: BBC German lesson

Writes "Cheltenham letters"[482]

"Dear Olwyn": Encloses Nicholas's christening photograph, mentions work on *Three Women* for a BBC production,[483] and gardening labors: "I am working like a black now weeding, mowing, & scything."

June 19: Nancy Axworthy arrives, Exeter trip, Day's order, cleans barn

6:40: BBC French lesson

To George MacBeth, BBC: Delighted that he is using "The Surgeon at 2 a.m." for the BBC program *The Poet's Voice*. Arranging a trip to London:

"I have a very crammed day at the BBC Tuesday 26th and can't really manage to arrange the infinite complications of babysitters, wipers & minders twice in the same week."[484]

June 20: Mows lawn[485]

Noon: Mrs. Macnamara

Washes car, cleans, finishes painting a chair & table, hems Frieda's blue dress, whitens shoes

June 21: Aurelia arrives at Court Green, Sylvia buys sherry and Devon cream, makes a rhubarb pie,[486] mows lawn, arranges flower vases, vacuums carpets, Nancy Axworthy arrives, laundry

June 22: Studies German

To Marvin and Kathy Kane: Describes Mrs. Macnamara: "a minute, fiery white-haired woman with black eyes, two pekinese, a cat, a rose garden, a gardener, the most gorgeous old re-made 19-room rectory in the heart of green stillness."

June 23: Nancy Axworthy arrives, study curtains, gros point,[487] weeding, plants seed, stakes sweet peas

June 25, 11:00: Visits Mrs. Hamilton,[488] confides to her a concern that Ted treats Nicholas coldly,[489] returns home to laundry, Day's order

7:10: BBC German lesson

Rabbit stew

Percy Key dies of lung cancer {PA}

June 26, 10:45: In London, BBC appointment and talk, takes books to sell

June 27: Ashcans, banking, makes spaghetti sauce, works on "Cheltenham poems"

June 28: Works on "Berck-Plage," Nancy Axworthy arrives

12:00–12:30: The Comptons for lunch of spaghetti, salad, lemon pie

June 29: Boyd's order

2:00: Ted's note on Sylvia's calendar: "Mr Key's funeral." Sylvia and Ted attend

6:40: BBC German lesson

10:20: Ted's BBC program

"Ted & I, dressed in hot blacks, passed the church, saw the bowler-hatted men coming out of the gate with a high, spider-wheeled black cart. . . . The awful feeling of great grins coming onto the face, unstoppable. A relief; this is the hostage for death, we are safe for the time-being." {PJ, Appendix 15}

June 30: Nancy Axworthy arrives. Calendar list: oranges, minced shin,[490] carrots, rubber pants, large nipples; completes "Berck-Plage"

To Marvin and Kathy Kane: Wants to know what kind of living arrangements they are looking for and for how long: "At least we can make encouraging gestures after these two places."

July 1: "see piano," calls midwife, mentions study curtains, tapestry, transplanting flowers, sorting clothes, "Novel"

July 2: Completes "The Other"

Day's order, washes hair, laundry

7:10: BBC German lesson

"Percy Key is dead, dying" just at midnight, Monday, June 25, buried Friday, June 29, at 2:30. "It all began with his eye watering, and Rose calling in the doctor, just after the birth of Nicholas. I have written a long poem 'Berck-Plage' about it. Very moved. Several terrible glimpses. His eyes showed through partly open lids like dissolved soaps or a clotted pus. I was very sick at this and had a bad migraine over my left eye for the rest of the day. The end, even of so marginal a man, a horror." Describes Percy in his coffin the next day, she hugs Rose.

Ted writes to his brother Gerald: "It's a good thing every ten years or so to smash your life to bits—whatever's alive in it will survive and you're well rid of the rest."[491] {HC}

July 3: Nancy Axworthy arrives

11:00: Arrives in London to meet George MacBeth

12:00: Lunch with Douglas Cleverdon

July 4: Ashcans

Visits Mr. Ellis to look at his old piano, he talks about how his brother and sister have robbed him of seven fields, so did the Freemasons, and the National Assistance: "He had written to the Queen. . . . The flood of injustice went on, a great apocalyptic melding of perhaps slights or real small grievances." They "edged out, in distress."

Meets Rose Key who tells her about a couple who might want to buy the Key house. {PJ, Appendix 15}

July 5: Nancy Axworthy arrives

3:00: Mrs. Macnamara

Even before the fateful call on July 11, there are indications of Ted's estrangement—perhaps not just from Sylvia but from the whole round of his life, including disengagement on visits to country neighbors and friends.

July 6: Laundry, makes cake, gets wine on way to Comptons

6:40: BBC German lesson

Sylvia and Ted celebrate Elizabeth Compton's thirty-fourth birthday. Elizabeth remembers Ted as "quiet and sullen." {SPD}

July 7: Nancy Axworthy arrives, Aurelia babysits, Sylvia travels with Ted to London, where he makes a recording for *Children's School Hour*, she makes a recording for *World of Books*

July 8: Calls midwife

2:30: "Adamson's—tea"

July 9: Drives with Aurelia to Exeter for shopping, on the way Sylvia says, "I have everything in life I've ever wanted—a wonderful husband, two adorable children, a lovely home, and my writing,"[492] the return home in "high spirits" {HC}

Phone rings, Sylvia answers,[493] decides it is Assia Wevill, disguising her voice

7:00: BBC German lesson

Stays the night with Elizabeth and David Compton telling Elizabeth about Ted's affair {SPD}

The turmoil over Ted's betrayal of their marriage begins as she tries to figure out how to live by herself and remain financially viable.

July 10: "Dentist mother"

3:00: Mrs. Macnamara

Sends Alvarez "The Rabbit Catcher," "Event," and "Elm"

In London, Ted visits the Wevills, and while David is out of the room, asks Assia to see him alone the next day {JB}

Sylvia spends the night with Elizabeth and David Compton, who overhear her weeping {HC}

July 11: Departs from the Compton home, weeping again, but refuses to stay[494] {HC}

Completes "Words heard, by accident, over the phone"

To Clarissa Roche: Preoccupied with the impact of a drought on their plants, "I get homesick for just writing to you."

To RB: "I honestly hope you feel you can answer this letter by return, as I am suddenly, after all that happy stuff I wrote you some while ago, at sea, and a word from you I could carry around with me would sustain me like the Bible sustains others." The buildup to the breakup began when a restless Ted started talking about experiencing "everybody & everything." The Wevills' visit had confirmed her suspicions. She describes Assia's predatory behavior, Ted's constant lying about the affair, her inability to sleep or eat and her worry that she can never trust him again. She considers her marriage the "center of my being." The proofs of her novel "saved the day. . . . I roared and roared, it was so funny and good." Ted seems content to use Court Green as a "home base." She cannot conceive of living without him. Reports his question to her: "Why should I limit myself by your happiness or unhappiness?"[495] It is impossible to speak with her mother about this: "I do need word!"

Ted and Assia make love in Al Alvarez's flat {JB}

July 12: Nancy Axworthy arrives

July 13, 6:40: BBC German lesson

Ted books a room at The Ritz and makes violent love to Assia[496] {JB, HC}

July 14: Nancy Axworthy arrives

 7:15: Listens to BBC production of Ted's play, *The Wound*

July 15: "Study curtains"

To Marvin and Kathy Kane: Still looking for suitable accommodations for the Kanes.

July 16: Sylvia visits Elizabeth Compton, a mother with her own young children, for solace and companionship, with toys and piano music

 7:00: BBC German lesson

July 17, 3:00: Mrs. Macnamara

 BBC's *The World of Books* broadcasts "A Comparison" {PA}

 Aurelia moves in with neighbors {HH}

July 18: Deposits checks, orders and gets groceries, takes out ashcans

July 19: To London: "Reserve mother's ticket"

 11:00: Reads her poems at the poetry festival sponsored by the British Arts Council

Ted tells Assia that Sylvia has been "having hysterics" and has crashed their car[497] {HC}

July 20: Completes "Poppies in July"

To RB: Begins to see this nasty, upsetting shock may also make her "free of so much." Recalls her hysteria when RB said Ted might want to "go off on his own." Feelings for her father have complicated her desire to never let Ted go: "Well, we are 30. We grow up slowly, but, it appears, with a bang." Disparages Assia, listens to Ted's complaints about Assia, and thinks Assia might be a kind of sister-substitute for Ted.[498] Asks for practical advice about toughening herself and keeping up her "woman-morale."

July 21: "Open bank acct," Nancy Axworthy arrives

To Richard Murphy: Informs Murphy his poem has won first prize in the Cheltenham contest, asks about the possibility of a visit with Ted to Murphy in the Irish village of Cleggan. They want to come without the children: "The center of my whole early life was ocean and boats, and because of this, your poems have been of especial interest to me, and I think you would be a very lovely person for us to visit just now."[499]

Submits "Elm," "The Rabbit Catcher," and "Event" to Al Avarez at *The Observer* {PA}

July 23: "Elizabeth's—typewriter,*" a casserole and sweater

July 24: Nancy Axworthy arrives

 11:00: Bow[500]

 2:15: Insurance man

 2:30–4:30: In Okehampton to see about a piano[501]

July 25: "Mother here," Aurelia moves into Court Green to take care of the children {LWM1}

10:00: Attends Bow auction

6:30: "Ted—London"

c. July 25: Burns letters, papers from Ted's study, photographs, her mother's letters, and the manuscript of second novel that had been intended as Ted's birthday present {SPD}

July 26, 3:30–5:30: Frieda attends birthday party at Sylvia Crawford's home, 25 North Street in North Tawton

"*Water new plants twice daily*"[502]

July 27: "*3 pints milk*"

Alvarez writes about the poems Plath has sent him: "the best things you've ever done" {PA}

July 28: Nancy Axworthy arrives, Sylvia travels with Ted to a literary event in Wales to read her work

"*1 loaf Hovis bread*[503]*—owe for it.*"

Assia tells her friend Nathaniel Tarn she does not want to have a "slinking affair" with Ted {HH}

July 30: "*Formula = 1 Feeding 1/2 cup (packed hard) of Ostermilk*[504] *1 teaspoon sugar 8oz boiled water*"

To RB: Works on purging her "father-feelings" for Ted, an "ego-Fascist," identifying with hawks "I kill where I please because it is all mine." But what to do about the "Other Woman" business and her "little girl desires & feelings. . . . My other impulse is to say, 'O fuck off, grab them all.'" She doesn't like being suspicious, doesn't accept his lying or a role as "doll wife," and what to do with his problem: "womb-engulfment." Repeats his claim that "this would either kill me or make me, and i think it might make me. And him too." Expects to take RB's advice about not having more children—although someday she would like "a couple more." Doesn't want to be the "unfucked wife." She needs advice about how to handle Ted's waywardness. Mentions his writing a play "Difficulties of a Bridegroom": He has been asked to rewrite the part about a femme fatale, making clearer what is real and what is not. "A nice parable illustrating your point about the reality of this woman."[505]

July 31: Nancy Axworthy arrives

"*Bread man on Tues, Thurs & Sat from today on*"

August: *Harper's Magazine* publishes "Private Ground"

August 1: "*Formula making = 1) Boil water in tea kettle & cool 2) wash bottles, fill with water, boil in large kettle 3) utensils: 2 cup measure; 1 cup measure & 1/2 cup measure Funnel—wooden spoon: mix 5 portions of Ostermilk & sugar; Beat into a cup*"

August 2: Nancy Axworthy arrives, "*Call Hatherleigh*[506] [in shorthand: "*Her again*"]! *Measure with 8 oz. boiled water; Pour three funnel into Cap with sterilized & eat—cool—then refrigerate*"

August 3: Hatherleigh 270[507]

August 4: Takes Aurelia to Exeter train station, mushrooms from Boyd's, opens a savings account, spaghetti sauce and bread on calendar list

August 5: *The Observer* publishes "Finisterre"

August 7: Nancy Axworthy arrives, grocery order from Day's. Calendar notations: "Sparkes: Crediton,"[508] Joan Webb, post office, note to call "A.A. about reg & tax," washes hair, laundry

August 8: Ashcans, grocery order from Day's

9:00–10:00: To post office, laundry, hair washing, ironing. Calendar notation: "Joan Webb?"[509]

August 9: Nancy Axworthy arrives, Sylvia plans another London trip, pays for groceries: "10 Farex[510] & bottle" and "2 strained broth & bottle," "6 Farex & bottle," "rose hip syrup"[511]

Records "The Surgeon at 2 a.m." for BBC's *The Poet's Voice* {HC}

August 10: Note on calendar: "Start Int. Loaf!!!—"a reminder to herself"[512]

To Marvin and Kathy Kane: Looks forward to their visit, mentions she hopes to resume writing in the morning since she has found a woman to take care of the children five days a week, expecting Mrs. Prouty's visit.

August 11: Calendar notations: Joan Webb, make bank deposit, get photos

August 12: Begins "Burning the Letters" {SPD}

August 13: Completes "Burning the Letters"

Mails letter to Olive Higgins Prouty, sees Joan Webb, makes stew, whitecake, and mayonnaise, Day's grocery order

August 14: Consults with Joan Webb about riding horses, washes hair, pays a tax statement, looks over checking account

August 15: Calendar notations: Prouty, ashcans, "to London, have photographs taken,"[513] get eggs at Fursman's butcher shop, Ted accompanies her to dinner with Mrs. Prouty at the Connaught Hotel, they attend a performance of Agatha Christie's *The Mousetrap* {HC}

To George MacBeth, BBC: Thinks his idea of a book of sick verse is an "inspired idea," sends two poems in case they strike him as "being darker than my other darks, sicker than the old sicks."

August 16: Tomato soup cake, banana bread

August 17: Listens to Marvin Kane's *Sea Fever* program, Boyd's grocery order, ironing, tomato soup cake, "Ted's Friends"

Ted buys for Sylvia and signs a copy of Joseph Heller's *Catch-22* {LWM}

"Dear mother": Encloses photographs she showed to Mrs. Prouty on her visit to London, where she put up Sylvia and Ted in the Connaught Hotel, the "loveliest hotel I've ever stayed in. . . . She asked Ted & me about our work with her usual insight. She means an immense deal to me."[514] Sylvia mentions Mrs. Prouty's servant and family troubles: "I hope

you drop over to see her now and then. Her loneliness must be appalling."
Right now Nancy Axworthy and a new "nice shy woman" who looks after
the children are on holiday, "so you can imagine what a mess the house is &
how little peace I have." Describes the neurotic Marvin and Kathy Kane
who are living in the guest room and are supposed to help with the children,
but Sylvia has her doubts.

To Richard Murphy: Expects to leave Devon on September 10 for a
week-long stay in Ireland: "Do let us know what to do about getting to your
island! . . . I am sick of the bloody British sea with its toffee wrappers &
trippers in pink plastic macs bobbing in the shallows, and caravans piled
one on top of the other like enamel coffins."

Receives Anne Sexton's book, *All My Pretty Ones* {LWM1}

August 19: Orders milk and eggs, BBC broadcasts "Three Women," notes
David Compton's birthday on her calendar, cleans kitchen shelves, roasts
lamb with cauliflower, white cake

August 20, 9:00–1:00: Mrs. Bires minds the children, Sylvia does laundry

 10:00: Gives Nicholas Farex and a bottle

 12:00: Frieda's lunch

 Ironing, orders from Day's and chemist's

 3:00: Meets with midwife, mentions an extractor[515]

August 21: To Anne Sexton: "stunned and delighted" with Sexton's new
book, *All My Pretty Ones*, "superbly masterful, womanly in the greatest sense,
and so blessedly unliterary."[516] Asks for news of mutual friends.

August 22: Ashcans

 9:00–1:00: Mrs Bires

 "Call house lady by 9," get macaroni," "Comptons?"

 Takes out life insurance policy on Ted {HC}

August 23: Nancy Axworthy arrives, laundry

 9:00–10:00: Dr Webb, "to Exeter?"

 Works on income tax, checking account, pays bills

August 25: Nancy Axworthy arrives, Sylvia pays £1 to Council men

 John Malcolm Brinnin visits Court Green to discuss Plath's inclusion
in an anthology *The Modern Poets* {HC}

August 27: Miss Redwood[517]

 "Dear mother": Describes Marvin Kane as "depressive" and Kathy
Kane as "manic," but they have nonetheless been a good source of support.
She is considering a winter in Spain, having recovered from the flu, which
the children have also caught. She has lost weight during "this worrisome
summer." Her beekeeping has produced "delectable" honey. Her first riding
lesson is this afternoon. She hopes her mother is not "too shocked" that she
is seeking a legal separation from Ted. She doesn't believe in divorce, but

"I simply cannot go on living the degraded and agonized life." She cannot have the children living with a father who is a liar and adulterer. He is living most of the week in London. She visits the Comptons weekly and has written to Ted's parents about the separation.

August 28: Nancy Axworthy arrives, tomato soup cake, handwashing clothes

August 29: Ashcans, "potatoes, onions, etc,"

3:00: The Comptons

August 30: Nancy Axworthy arrives, £4 paid to Marvin and Kathy Kane

August 31: To Howard Moss, the *New Yorker*: Sending "Elm" again, "Berck-Plage," "The Other," "Words heard, by accident, over the phone," "Poppies in July," "Burning the Letters":

"I thought your comments perfectly good and well taken." Explains the speaker in "Elm."

The Kanes depart from Court Green and Ted returns {HC}

Late summer: Ted to Olwyn Hughes: "the awful intimate interference that marriage is . . . I'm aghast when I see how incredibly I've confined & stunted my existence, when I compare my feeling of what I could be with what I am[518]. . . . I'm trying to fix Sylvia up in Spain for the winter . . . as soon as I clear out, she'll start making a life of her own, friends of her own, interests of her own. If she wants to buy her half of the house gradually, fair enough. {THL}

Ted to Vicky Watling: "Marriage, of course, is a bloody monster, but it eats up many little snakes." {THL}

September 1: Nancy Axworthy arrives

6:00: Visits Mrs. Macnamara

September 3, 2:30: Horseback riding with Miss Redwood

To Eric Walter White: Recovering from the flu, feels "about as strong as a dead codfish."

September 4: Nancy Axworthy arrives, tea with Betty Barker

To RB: Reports that Ted calls Court Green a prison and that "I am an Institution."

September 5: Ashcans

To Judith Jones: Comments on Marianne Moore's response to her poetry: "I am sorry Miss Moore eschews the dark side of life to the extent that she feels neither good nor enjoyable poetry can be made out of it. She also, as I know, eschews the sexual side of life, and made my husband take out every poem in his first book with a sexual reference before she would put her name to endorse it." Mentions her novel is "as good as done."[519]

To Marvin and Kathy Kane: Relieved to have found a nanny while she is with Ted in Ireland.

Sylvia is fined five pounds for a traffic offense (driving off the road) {LWM1}

September 6: Asks Nancy Axworthy to babysit, fixes playroom shelf, padlock for door desk, "See Winifred" [Davies]

September 7, 3:30: Marvin Kane's BBC American series, Sylvia buys nipples, dishcloths, copper, razors, fixes a beehive

September 8: £1 for Nancy Axworthy, nipples and razors are put back on the list, a trip to the bank, "Mrs. Weare?"[520]

To Elizabeth Compton: Recovering from a flu that has been her worst illness, "very wobbly, but better." She wants Elizabeth to send her David's new mystery novel: "I'm dying to read it, it looks just the thing to cheer me up, all about murder."

To Richard Murphy: Describes travel arrangements: "We would love to stay in your cottage. I don't know when I have looked so forward to anything."

To Ruth Fainlight: A "ghastly summer," hopes Ted will set them up for three months in Spain, beginning in December, wants Ruth's practical advice on what to pack, worries that Ted never touches Nicholas, eager to write a second novel but with no time to do it, hopes Ruth can visit: "I miss you so much, all 3."[521]

September 9: Sylvia has Mrs. Prouty to dinner at Court Green {HC}

September 11: Sylvia and Ted leave by train for Ireland and arrive in Dublin {PKS}

September 12: Sylvia and Ted arrive at Richard Murphy's Cleggan cottage, spending the night in twin beds in the guest room {PA}

September 13: Murphy sails with the couple {PA}

September 15: Murphy takes the couple "cottage-hunting," Ted departs without informing Sylvia {PKS}

The *New Yorker* publishes "Blackberrying"

c. September 15: To Olwyn Hughes: Describes his time with Sylvia in Ireland: "You're right, she'll have to grow up—it won't do her any harm." {THL}

September 16: Calendar notation: "New Poetry"[522]

September 17: RB writes to ask if she is being consulted as a "woman (mother) (witch) (earth goddess), or as a mere psychiatrist?"[523] She criticizes Ted for acting like a child and advises Sylvia to concentrate on her "oneness." {CR1}

September 18: "Nancy/upstairs"

Sylvia returns to Court Green {PA}

September 19: Ashcans

September 20: "Nancy/downstairs"

2:00: Takes Nicholas to Dr. Webb, vacuums study

The *Listener* publishes "The Surgeon at 2 a.m."

September 21: Pays butcher's and Boyd's bills

12:00: Calls Miss Cartwright[524]

2:00: Nancy Axworthy arrives and is given £1

2:30: Horseback riding with Miss Redwood

"See Mrs Weare to Okehampton," deposits checks, calls her solicitor

To Kathy Kane: The nanny has worked out well, admits "the end has come.[525] It is like amputating a gangrenous limb—horrible, but one feels it is the only thing to do to survive."

To Richard Murphy: Thanks him for his hospitality and allays his concern she was going to write about Connemara, his "literary territory." Retracts her invitation since Ted is no longer at Court Green: "My town is as small & watchful as yours."[526]

September 22: Nancy Axworthy arrives, Sylvia writes to the Comptons, goes to Lloyds to deposit checks, baking: apple cake, banana bread, meatloaf, works again on tax statement and checkbook, sews playroom and study curtains and a dress for Frieda

To RB: Calls her the "midwife to my spirit," hopes RB can provide at least brief, practical responses about starting a new life even as Ted taunts her with becoming like her mother, describes his desertion of her in Ireland, his fits of fury, attributes his beating of her before her miscarriage to his declaration that he did not want children, explains that she has always taken care of their business because he is incompetent at it,[527] now she plans on renting Court Green for the winter months. Rejects the idea of living with her mother: "Her notion of self-sacrifice is deadly—the lethal deluge of frustrated love which will lay down its life if it can live through the loved one on the loved one, like a hideous parasite." Deplores Ted's "infantilism. . . . I think when I am free of him my own sweet life will come back to me."

Winifred Davies to Aurelia: The news from Court Green is "not good." Sylvia "in distress" when Ted did not return. "Ted has never grown up, he is not mature enough to accept his responsibilities, paying bills, doing income tax looking after his wife & children, so Sylvia has taken over all that practical side of the partnership of necessity & no man really likes that. He wants to be free for parties, travelling etc." Success has "gone to his head." Sylvia seems "calmer" after they talk over her situation. "I made her eat supper & we had some good laughs as well as some tears." {HC}

September 23: Works on a tax statement checkbook balance, pays bills

12:15: Winifred Davies comes for a sherry

"Dear mother": "The nanny I had was wonderful, a whiz. She brought a little dog & Frieda still talks of 'Miss Cartwright & the liddle doggie.'" Describes visit to Ireland: "Ted was there, but had no part in my happiness, which was compounded of the sailing, the fishing, the sea and the kind people & wonderful cooking of an Irish woman from whom I bought a

beautiful handknit sweater for $10 which would be $50 in America." Hopes to settle in Ireland for a few months since Ted has been spending their money and can't afford Spain. Explains he abandoned her in Ireland. "I want to be where no possessions remind me of the past & by the sea, which is for me the great healer. . . . Your telling Winifred I had a nervous breakdown has had disastrous consequences for me. Any ordinary doctor treats a former 'mental case' as a 50% exaggerater. So I have had no treatment." Describes Ted's carelessness with Nicholas, allowing him to fall on a concrete floor. Ted confesses he did not have the courage to say he did not want children. Sylvia asks her mother to tell Mrs. Prouty that Ted had deserted her. She did not want her mother to visit again: "I shall never come to America again."

The Observer publishes "Crossing the Water"

September 24: Miss Cartwright arrives

2:30 An hour of horseback riding with Miss Redwood, takes Frieda with her to to Exeter, washes her hair, a coat, and bathrobe slippers

"Dear mother": "I feel I owe you a happier letter than my last ones. I begin to see that life is not over for me." She canvasses various possible temporary moves—Ireland or perhaps a London flat, saying she would "starve intellectually" if she stayed at Court Green.

RB writes advising a divorce and recommends reading Erich Fromm's The Art of Loving {CR1}

September 25: "to London"

9:45—12:45: Nancy Axworthy

11:00: "life ins."

2:30: Mr. Mazillius[528]

6:30–10:30: Nancy Axworthy

September 26: Returns to Court Green

Completes "For a Fatherless Son" {PKS}

9:00–12:00: Mrs. Weare, to the chemist "for pills," ashcans

"Dear mother": Describes meeting with solicitor who advises her that Ted is "worthless & to get clear." Calls Ted a "vampire on my life, killing and destroying all. We had all the world on tap, were even well off, now this insanity on his part will cost us everything. . . . He had it in him to be the finest & kindest & best father & husband alive, & now thinks all feeling is sentimental & womanish."

RB to Sylvia: "Glad to get your letter today and to find that you are still fighting, not moping." {CR2}

September 27, 9:00–12:00: Mrs. Weare

9:45–12:45: Nancy Axworthy

Calendar notations: deposit check, make banana bread, apple cake, corn chowder, maple custard

244

September 28: Writes three pages of her novel {HC}

 9:00–10:00: "Joan Webb?"

 Orders from Boyd's and butcher

September 29, 10:00–12:00: Nancy Axworthy

 12:00: Horseback riding with Miss Redwood

 Bakes bread, to bank for cash, picks apples

"Dearest mother": Feels good in the morning and works on her novel with Winifred's encouragement, soothed by the company of the Comptons, taking sleeping pills, "a necessary evil," feels humiliated to be deserted, and takes solicitor's advice to withdraw money from joint accounts. The nanny helps: "I don't break down with someone else around."

To Kathy Kane: Announces Ted's desertion, Frieda is miserable, "I am going potty with no one to talk to. . . . Every day I try to go to tea with someone. The evenings are hell."

To Olive Higgins Prouty: Describes Ted's desertion and the "beautiful and barren" other woman: "that time we spoke of unfaithful men that evening at the Connaught for instance it was as if you intuitively grasped what our situation was." Affirms her decision to stay in England: "The hard thing is realising that Ted has gone for good." What she has learned from RB will help her to realize the life that is possible for her.

To RB: Hasn't seen Ted for two weeks and does not have his London address: "I am just desperate. Ted has deserted me." Discovers his erotic love poems to Assia, acknowledges they are "fine" and make her feel "haggish" and without anyone to help her or confide in, terrible evenings when she longs for her love for the old Ted, worried about the settlement terms with him, even though RB has suggested Sylvia might as well divorce him, so she can be her own person, and near the end of the letter she agrees: "The divorce like a clean knife. I am ripe for it now."

September 30, c. 5:00–8:00 a.m.: Completes "A Birthday Present"

 The day's menu: roast beef, potatoes, corn, apple cake, banana bread; a Day's order

 RB advises Sylvia to get a divorce: "You can certainly get the goods on him now while he is in such a reckless mood." She advises Sylvia to keep Ted out of her bed and to cut contact with his family. {HC}

October 1: BBC German for beginners, baking banana bread, withdrawal £10 from bank

 4:00: Mrs. Daniel brings a friend to tea

 Completes "The Detective"

 Assia and Ted return to London after ten days in Spain {JB}

 Assia phones her friend, Nathaniel Tarn to tell him about her ten days in Spain with Ted {SPD}

October 2, c. 5:00–8:00 a.m.: Completes "The Courage of Shutting-Up"
 9:45–12:45: Nancy Axworthy
 9:00–12:00: Mrs. Weare
 Buys bread, does laundry
October 3, c. 5:00–8:00 a.m.: Completes "The Bee Meeting"
 Ashcans
 9:00–12:00: Mrs. Weare
 Calendar notations: "get meat," "make milk"
 3:00: Mrs. Macnamara brings two kittens for Frieda
October 4, c. 5:00–8:00 a.m.: Completes "The Arrival of the Bee Box"
 9:45–12:45: Nancy Axworthy
 9:00–12:00: Mrs. Weare
 Calendar notations: "get pork," "lamb leg"
 Ted returns to collect his belongings {PKS}
October 6, c. 5:00–8:00 a.m.: Completes "Sting"
 Nancy Axworthy, lamb leg, oranges, short breads
With her decision to get a divorce, Plath experienced an exhilaration that translated into writing several great poems, in spite of her severe flu and slow recovery.
October 7, c. 5:00–8:00 a.m.: Completes "The Swarm"
 To Richard Murphy: "I am getting a divorce, and you are right, it is freeing. am writing for the first time in years, a real self, long smothered. I get up at 4 a.m. when I wake, & it is black, & write till the babes wake. It is like writing in a train tunnel, or God's intestine."
October 9, c. 5:00–8:00 a.m.: Completes "Wintering"
 "Dear mother": Tells her mother not to worry about finances, just sold "Elm" to the *New Yorker*: "I'll get by." Worries about the "Yorkshire-Jew miserliness" of Ted's parents who will want to screw her.[529] Ted is packing up to live with his lover: "He laughs at me, insults me, says my luck is over, etc. He goes tomorrow." She dreads going to court but is determined to get a divorce, starting a new life is the "hardest 30th birthday present I could envision. I am fighting on all fronts, I have to stand my ground." It is a matter of honor and self-preservation. Going to America would seem like running away, and she cannot face her mother after what Aurelia witnessed at Court Green. "Everybody in town leering and peering." Wishes Warren and Margaret could join her for a holiday in Austria and Germany next spring or summer, or accompany her to court—all she wants to do otherwise is "write at home. I hate teaching jobs. . . . And be with my kids, and see movies, plays, exhibits, meet people, make a new life."
 To RB: Ted has agreed to a settlement but still bedevils her saying she is sentimental: "he switches on and off like an electrode. . . . Right now I hate men."

One of the great mysteries of Plath biography is the sudden emergence of anti-Semitism. It is puzzling because the Hughes family had been hospitable to Plath and were not, in any case, Yorkshire Jews. Why Plath would think her mother would want to read such a hostile and prejudiced attack is puzzling. The coarseness of Plath's expressions is shocking, especially given her identification with Jews in "Daddy" and at other times in her life.

October 10, c. 5:00–8:00 a.m.: Completes "A Secret"

To Howard Moss, the *New Yorker*: Pleased about the publication of "Elm," submits several poems; "A Birthday Present," "The Courage of Quietness," "A Secret," "For a Fatherless Son," "Bees"

Assia Wevill reports that Plath has named her in a divorce suit and set detectives on her {HC}

October 11, c. 5:00–8:00 a.m.: Completes "The Applicant"

Ted moves out of Court Green {LWM1}

Drives Ted to Exeter train station {PA}

Plath's telling her mother to tear up her last letter (Aurelia did not) is instructive. In her childhood diary, she mentions that she often writes down feelings that reflect a momentary mood, not necessarily what she would stand by even a day later. Her diaries and letters are valuable, of course, because the urgency with which she writes is so compelling. But to take what she might say at any particular time as revealing a settled opinion or feeling has to be gauged against the overall pattern of remarks. Another factor, as the next letter shows, is Plath's manic-depressive cycles that could result in sudden switches of mood.[530]

October 12, c. 5:00–8:00 a.m.: Completes "Daddy"

"Dear mother": Tells Aurelia to tear up the last letter because it was written at "probably my all-time low and I have an incredible change of spirit, I am joyous—happier than I have been for ages." Ted has left and now, finally, "everything was definite." Calls him a coward and a crook, but she has recovered from illness and is "full of fantastic energy, now it is released from the problem of him,"[531] drives him to the train station and returns to eat a hearty meal. But she misses friends and relatives. Expects to keep Court Green as a summer place while living in London with access to great minds and art, still rising at 5:00 a.m. to write "like mad," managing a poem a day before breakfast: "Terrific stuff, as if domesticity had choked me." Expects to finish her novel, still hopes Warren and Maggie can join her for a holiday, enjoys horseback riding, but looks forward to having a salon in London,[532] feels she has become famous, refers to an article by Elizabeth Jennings[533] in *The Listener* (September 13, 1962): "Memorable English or American women poets can be numbered on less than two hands; one thinks of Emily Brontë, Emily Dickinson, Marianne Moore, Edith Sitwell's early work, Anne Ridler, Kathleen Raine, Elizabeth Bishop, Sylvia Plath, and scarcely anyone else."

To Howard Moss, the *New Yorker*: Hopes he will consider "Daddy" and "The Applicant."

To Warren and Margaret Plath: Tells them she has gone through hell but now feels "wonderful. . . . The good, kind, domestic person he has been these six years was a terrible strain on him & I believe he has made this experience so awful & hurtful as a kind of revenge on me for having 'reformed' him."[534] She remains a believer in his genius as a poet and that she discovered him and he has "ditched" her. "The loneliness here now is appalling." Finds it ironic that Ted wanted to move to the country because London was "dead," and now he is living it up in London. Proposes they holiday together in Germany or Austria, promises to be "cheerful & entertaining": "Your letters are like glühwein[535] to me. I must really learn German."

October 13–14: Visits friends in Saint Ives, Cornwall, Sylvia gets the flu {PA}

October 15–December 31: "Eavesdropper"

c. Mid-October: Olwyn writes to Ted voicing her family's discontent with the way he has ended his marriage {SPD}

October 16, c. 4:00–8:00 a.m.: Completes "Medusa"

9:00–12:00: Mrs. Weare irons

9:45–12:45: Nancy Axworthy cleans guest room. On the menu: custard, bread, banana bread Sylvia wires nanny, does a grocery order, washes hair, cleans study

"Dear mother": Writing with a fever and chills, interprets letters from the Hughes family as saying she is on her own, still thinking of a refuge in Ireland by December: "Ted has said how convenient it would be if I were dead, then he could sell the house & take the children whom he likes." She needs someone from her family to be with her: "I am fighting now against hard odds & alone. . . . Please have a family powwow & answer this as soon as possible!"

"Dear mother": Coming home for Christmas is "impossible from every angle," proposes Maggie come to her instead: "Do I sound mad? Taking or wanting to take Warren's fiancé? Just for a few weeks! How I need a free sister!" She needs a defender from home, since she dreads dealing with Ted, a man without honor, and the hired nanny sounds (on the phone) "such a bitch."

October 17, c. 4:00–8:00 a.m.: Completes "The Jailor"

Ashcans, Miss Hutchins (the bitch)[536]

9:00–12:00: Mrs. Weare

Ted's mother writes to Aurelia saying she is upset about what has happened and that she will always "be there for Sylvia." {SPD}[537]

October 18, c: 4:00–8:00 a.m.: Completes "Lesbos"

9:45–12:45: Nancy Axworthy

Calendar list: tomatoes, sweet corn, custard, banana bread, apple sauce, apful kuchen, trip to the bank

"Dear mother": Apologizes for suggesting she can uproot Margaret's life to "poultice my own," looking forward to arrival of a nurse recommended by her midwife, trying to work out an agreement with Ted through her lawyer: "I am myself, proud, and full of plans. Mentions a letter from Clement Moore, "very fond of him, like a second brother." She expects to expose Ted's sadism and venom in a novel.

To George MacBeth, BBC: Pleased that he has accepted "Berck-Plage" for "The Poets Voice": "I sort of had you in mind when I wrote it and did hope you might like it."

To Olive Higgins Prouty: "Thank you a thousand times for your dear, intuitive letter and the wonderfully helpful check." Provides the details of Ted's desertion: "he was furious I had not committed suicide—evidently he and his new flame had discussed this, in view of my old nervous breakdown." She paints a grim picture of Ted and Assia plotting against her, with his family "behind him. . . . Like a true genius, he will live only for himself and his pleasures, and I wish him joy." She hopes soon to have enough poems to make a second book. She has to rebuild her health and spirit—helped by horseback riding.

To Warren: Describes her domestic trials and asks him not to tell their mother, repeats that Ted says he does not understand why she does not kill herself,[538] asks Warren to convince mother that the decision to stay in England is the right one, worries about what kind of financial settlement she can expect from Ted, mentions that the novel she has completed is a secret, urges him to keep writing to her: "I live on letters & have no other source of contact with relatives & friends just now! Even a paragraph from you is a great tonic!"[539]

October 19, c. 4:00–8:00 a.m.: Completes "Stopped Dead"

Calendar notations: "Dr. Webb?" "See Mrs. Weare: 15s"

To Clarissa Roche: "You have no idea how much your sweet letter meant to me, which came today." Announces she is divorcing Ted and needs her friends: "I would just adore to see you & Paul." She is trying to arrange for better domestic help and child care. Asks if Clarissa knows anyone who might rent Court Green while Sylvia recuperates in Ireland and looks for a London flat.

October 20, c. 4:00–8:00 a.m.: Completes "Fever 103°"

10:15–12:15: Nancy Axworthy

11:00–12:00: Horseback riding with Miss Redwood

12:00: Mrs. Weare

October 21, c. 4:00–8:00 a.m.: Completes "Amnesiac," "Lyonnesse"
Banana bread, roast beef, potatoes, "Loin"[540]

"Dear mother": Asks Aurelia to stop writing to Winifred Davies[541] who is busy and doing enough to help Sylvia, Aurelia's interference is one of the reasons why she finds her mother's presence "so difficult": "Don't talk to me about the world needing cheerful stuff! What the person out of Belsen—physical or psychological—wants is nobody saying the birdies still go tweet-tweet but the full knowledge that somebody else has been there & knows the worst, just what it is like." She now believes Ted was frightened by her creating babies and writing a novel. Mentions visit from the bank manager's "handsome 14 year-old son & a schoolfriend," readers of Ted Hughes: "They were charming. I dearly love the people I know in town, but they are no life. I am itching for museums, language study, intellectual & artistic friends. I am well-liked here, in spite of my weirdness, I think, though of course everybody eventually comes round to 'Where is Mr. Hughes.'"

To RB: "Since I last wrote you, everything has blown up, blown apart, and settled in a new and startling places. . . . I understand now what you mean about being in my own womb, my own primal cave." She feels liberated: "I was my own woman." Doing a poem a day and feels she can use "everything." She now regards her marriage as "sick." Ted has reverted to his premarriage self when he was known as the "greatest seducer in Cambridge." Dismisses Assia as his "twin sister." Ted has told her Assia adores her work. Realizes that "domesticity was a fake cloak for me," but she did it all so well: the cooking and housework, bee keeping, riding horses, and now does not want a "safe, dull sweet reliable husband to take Ted's place." She wants to pursue an active life alone: "I have become a verb, instead of an adjective." Despises her mother's "cravenness. Her wincing fear, her martyr's smile. Never has she taken a bold move, she has always stuck quietly in one place, hoping no one would notice." With a nanny and household help, life will be possible. "I love you for listening. Each of your letters is so rich, they last like parables."

Heinemann contract states novel is "finished and submitted" {HC}

October 22, 8:00: Susan Roe begins work

To Ruth Fainlight: "I write you in confidence, and as a sister-mother-muse-friend." She expects all her friends while married to Ted will become just his friends. Provides the "unsavoury details" of what led to the decision to divorce, her plight in "cow land," her 4:00 a.m. schedule of writing poems, plans to recuperate in Ireland, to be followed by securing a London flat: "Psychologically, Ruth, I am fascinated by the polarities of muse-poet and mother-housewife. When I was 'happy' domestically I felt a gag down

my throat. Now that my domestic life, until I get a permanent live-in girl, is chaos, I am living like a spartan, writing through huge fevers & producing free stuff I had locked in me for years. I feel astounded & very lucky. I kept telling myself I was the sort that could only write when peaceful at heart, but that is not so, the muse has come to live, now Ted is gone, and my God! what a sweeter companion." Wants to know what Alan is writing and what Ruth is doing.

Rereads D. H. Lawrence's *Complete Poems*: "She underlined much of 'The Mess of Love' and wrote 'Oct. 22, 1962,' in the margin. ('We've made a great mess of love / Since we made an ideal of it.') She dated and starred several other poems, including 'Lies' ('Lies are not a question of false fact / but of false feeling and perverted justice'), 'Poison' ('What has killed mankind . . . is lies'), 'Commandments' ('faked love has rotted our marrow'), 'Laughter' ('Listen to people laughing / and you will hear what liars they are / or cowards'), and 'Retort to Jesus' ('And whoever forces himself to love anybody / begets a murderer in his own body'). Lawrence's poems, with their images of love, truth, lies, poison, Lucifer, moons, knife edges, and rising phoenixes, gave Plath plenty of material to consider the day before she wrote the first drafts of 'Lady Lazarus.'" {HC}

Submits seven poems to the *New Yorker* {SPD}

October 23, 9:45–12:45: Nancy Axworthy

On the menu: apples, banana bread, bread, lemon cake, tomatoes; errands: bank, post office, and Blogg[542]; laundry

October 23: "Dear mother": Apologizes for "grumpy letters," following more fever and a "hideous nanny" who has been sacked and replaced with Winifred Davies's help by a sweet twenty-two-year-old children's nurse [Susan Roe]. Anticipates life in London with a new hairdo and salon: "Ted may be a genius, but I'm an intelligence."

To Eric Walter White: Asks if he and his wife could put her up on October 29 when she is recording a long poem at the BBC.

To Father Michael Carey: Agrees to look at his poem, but it will be up to him to decide to go on writing.

October 23–29, c. 4:00–8:00 a.m.: Works on "Purdah," "Lady Lazarus"

October 24, c. 4:00–8:00 a.m.: Completes "Cut," "By Candlelight"

Ashcans, lemon cake, banana bread, hash and cabbages, Leonard Moore arrives

As Plath wrote poem after poem, her confidence rose, and she no longer thought it urgent that someone from home should come to support her, although that longing for her family would return.

October 25: c. 4:00–8:00 a.m.: Completes "The Tour"

9:45–12:45: Nancy Axworthy

9:00–1:00, 3:30–5:30: "Mrs. Weare?" apples and bread

"Dear mother": Mentions her trip to London to read poems to Al Alvarez, recording at the BBC, a meeting at the Royal Court Theatre about American Poetry Night, with Susan Roe taking care of the children: "For goodness sake, stop being so frightened of everything, Mother! Almost every other word in your letter is 'frightened'! One thing I want my children to have is a bold sense of adventure,[543] not the fear of trying something new." No cough, no fever, feeling better, planning to spend winters in London, summers at Court Green, horseback riding on her birthday: "I'm 'rising to the trot' very well now. . . . My riding mistress thinks I'm very good. Forget about the novel & tell no-one of it. It's a pot-boiler & just practice."[544] She expresses her content with Warren and Maggie visiting her in the spring. "It's too bad my poems frighten you—but you've always been afraid of reading or seeing the world's hardest things—like Hiroshima, the Inquisition or Belsen. I believe in going through & facing the worst, not hiding from it. That is why I am going to London this week, partly, to face all the people we know & tell them happily & squarely I am divorcing Ted, so they won't picture me as a poor, deceived country wife." She is confident of a financial settlement with Ted.

To Clarissa Roche: Reports "things are calming down here." Mentions how Ted has been "running down the novel as a form" now that she has written one which he has not bothered to read. Still expects a visit from Clarissa and her husband Paul.

To Mrs. Prouty: "How I appreciate your great kindness and concern!" Explains the improving conditions at home, her success with the *New Yorker*, her impending visit to Al Alvarez in London, where she will read her poems to him at his home: "He is a great opinion-maker & says I am the first woman poet he has taken seriously since Emily Dickinson!" She has found her "real self" in her study writing poems: "I shall forge my writing out of these difficult experiences—to have known the bottom, whether mental or emotional is a great trial, but also a great gift." As her literary godmother Mrs. Prouty "will feel as proud of my independence as I am. Do keep writing! I love your letters."

To Warren and Maggie: She is grateful that they were willing to come to Court Green, but it is no longer so urgent since the domestic routine has been sorted, her forthcoming London trip has already served as a "tonic," so tell mother to stop worrying, still expects to winter over in Ireland, but looks forward to a spring holiday on the continent with them.

October 26, 8:30: Post office and grocery order

4:00: Tea at Dr. Webb's house

Takes apples to Mrs. Daniel[545]

To Eric Walter White: Thanks them for putting her up in London "after my more or less enforced purdah in the West Country."

Sends five poems to the *New Yorker* {SPD}

October 27, c. 4:00–8:00 a.m.: Completes "Ariel," "Poppies in October"

Turns thirty

10:15–12:15: Nancy Axworthy

Irons and washes sweater, "bread"

11:00–12:00: Horseback riding with Miss Redwood

Calendar notation: pick apples

8:30: Susan Roe

Mrs. Prouty writes to Aurelia agreeing with her that the Ireland trip is a "bad idea." {SPD}

October 28, c. 4:00–8:00 a.m.: Completes "Lady Lazarus" {PA}

Ashcans, menu: meatloaf, apple pie, finishes a book review, packs, Susan Roe stays until 7:30

October 29, 4:00–8:00 a.m.: Completes "Nick and the Candlestick," "Purdah"

Travels to London

10:45: BBC appointment, records "Berck-Plage" {SPD}

Sees Al Alvarez, attends PEN[546] party

October 30, 11:00: Appointment with Patric Dickinson about her interest in the American evening of poets at the Royal Court Theatre in July 1963

9:45–12:45: Nancy Axworthy at Court Green

12:30 Meets Peter Orr of the British Council for lunchtime interviews of her for a series, "The Poet Speaks," records "The Rabbit Catcher," "Ariel," "Poppies in October," "The Applicant," "Lady Lazarus," "A Secret," "Cut," "Stopped Dead," "Nick and the Candlestick," "Medusa," "Purdah," "A Birthday Present," "Amnesiac," "Daddy," and "Fever 103°"

Meets Al Alvarez {CR1}

Returns to Court Green {PA}

October 31: Ashcans, sends four poems to *London Magazine*, errands to bank and post office

November 1, 9:45–12:45: Nancy Axworthy

9:00–1:00: Mrs Weare

Trips to butcher, grocer, bank (£10 withdrawal)

3:30–5:30 Pays Mrs. Weare 15s

Mentions a movie at 7:15 and the White Hart[547]

Ted meets Susan Alliston in a pub. He says, "Marriage is not for me—nor you, I think." {JB}

Alliston describes first meeting Hughes: "blue-chinned, a little stooped, young, and with some enormous strength extending from him, difficult to say how much is pure physical." {CR2}

Plath abandons plans to winter in Ireland and decides, instead, to resume a London life, believing it is best to rejoin the literary world and a new independent life as a single mother.

November 2: On the menu: apple cake, banana bread, white and brown bread

4:00: Joan Webb for tea with her daughters Holly & Clare

To Mrs. Prouty: "went to a literary party and faced everybody, all the malicious questions, the gloating nastiness that is part of the gossip world. . . . You are absolutely right about the need for me to strike London now. Ireland was an evasion."

November 3, 4:00–8:00 a.m.: Begins writing "Getting There" and "Gulliver" {SPD}

9:30: Hair appointment in Winkleigh[548]

11:00–12:00: Horseback riding with Miss Redwood, pays her £2.6

2:00: Sees Winifred Davies

Shopping list: plastic pants (for Nicholas), sleeping pills at chemist, rusks,[549] butcher, grocer

Winifred Davies writes to Aurelia, relieved that the Ireland trip has been canceled. {SPD}

November 4, 4:00–8:00 a.m.: Completes "The Couriers," "The Night Dances," "Thalidomide" {SPD}

Meets Ted who helps her look for a London flat {RH}

November 5: A single calendar notation: "London"

Reads a Carolyn Kizer poem, "The Great Blue Heron," for George MacBeth's BBC program *The Weird Ones*. "The nostalgic poem about ephemeral childhood summers at the seashore sounded like something Plath herself might have written about Winthrop or Nauset." {HC}

Stays overnight with the Macedos {HC}

November 6, 9:45–12:45: Nancy Axworthy

Discovers the Yeats home on 23 Fitzroy Road,[550] returns to Court Green

Completes "Getting There," "The Night Dances," "Gulliver"

November 7: Ashcans

Calendar notation: "Winifred: bandage"[551]

"Dear mother": Describes finding the flat with the blue plaque designating it as the house W. B. Yeats lived in, with a new hairdo she makes a stunning appearance in London with men staring and truck drivers whistling. She is no longer living in Ted's "shadow."

It distressed Plath that the Merwins had taken Hughes's side, even though she had predicted that many of his friends would drop her. Evidently, Plath had not realized how much Dido actually detested her, which is made plain in Dido's memoir appended to Anne Stevenson's biography of Plath.

November 8, 4:00–8:00 a.m.: Completes "Thailidomide"

"Susan [Roe] off."

9:00–1:00: Mrs. Weare

9:45–12:45: Nancy Axworthy

11:00: Horseback riding with Miss Redwood

To W. S. Merwin: Explains her dire situation when Ted first announced he was leaving her, disturbed that Dido refuses to speak with her, although Sylvia is not asking anyone to take sides, professes her respect for Ted as the "best living poet," feels she is an "idiot to think either of you ever cared for me and my work at all": "Ted has told me to give Dido up. Must I give you up? . . . Please just say straight out."[552]

November 9, 9:00–1:00: Mrs. Weare

Meat and bread are on the calendar, a reminder to call Nancy Axworthy about supper on Friday

The *New Statesman* publishes "Oregonian Original"

Inscribes her copy of *The Art of Loving* by Erich Fromm {HC}

November 10, 8:30: Susan Roe comes to care for the children

11:00: Horseback riding with Miss Redwood

Calendar reminder to pay Nancy Axworthy and withdraw £10 from bank, errands: to butcher for chicken, and bread at grocer

November 11, c. 4:00–8:00 a.m.: Completes "Letter in November"

8:30–10:00: Susan Roe

On the menu: spaghetti and apple cake

November 12, c. 4:00–8:00 a.m.: Starts writing "Death & Co" {SPD}

Calls dentist, Mrs. Macnamara, a "Health visitor," Exeter on the calendar

1:30: Winifred Davies

2:00: Winkleigh hairdresser

Tomato soup cake

Ted meets Susan Allison at a pub, The Lamb. She tries to "beautify myself up a little." {CR2}

November 13: Nancy Axworthy arrives, Sylvia feeds the cats and cleans up, feeds the bees, works on grocery order, opens Yeats's *Collected Plays*, reads "Get wine & food to give you strength & courage I will get the house ready." She writes the date, November 13, 1962, in the margin, commenting, "The prophecy—true?" {HC}

November 14, c. 4:00–8:00 a.m.: Completes "Death & Co"

Ashcans, calendar notations: laundry, grocery order, £10 from the bank, apple cake, banana bread, date nut bars

11:00: Horseback riding with Miss Redwood

6:00: Susan Roe

To Eric Walter White: A thank you for her stay with him and his wife Dodo in London, looks forward to planning the American Poetry night for next July.

November 15: Susan Roe on holiday

 9:00–1:00: Mrs Weare

 To Exeter for watch repair and the cleaners

 Menu: wine & sherry, cider, frankfurters, sour cream; glasses

 To Howard Moss, the *New Yorker*: Sends revisions of "Amnesiac."

November 16, c. 4:00–8:00 a.m.: Completes "Years," "The Fearful"

 9:00–1:00: Mrs. Weare

 3:00: bread

 To Peter Davison, the *Atlantic Monthly*: Sends a "wad of stuff": "Fever 103°," "Nick and the Candlestick," "Purdah," "A Birthday Present," "The Jailer," "The Detective," "The Courage of Quietness" ["The Courage of Shutting-up"], "Lesbos," "Eavesdropper," five bee poems. She is "hard up at the moment, I'd be awfully grateful if you could get a rapid hearing for these!"

November 17: Paul and Clarissa Roche arrive

 11:00: Horseback riding with Miss Redwood

 5:25: "butcher- mince"

 To the baker

 7:10: Listens to "Berck-Plage," recorded for BBC program, *The Poet's Voice*

 Serves chicken and rice and perhaps pork chops, which are on her list

November 18, c. 4:00–8:00 a.m.: Begins "Mary's Song" {SPD}

 Works on *New Statesman* review, serves lamb, rice, and peas

November 19, 4:00–8:00 a.m.: Completes "Mary's Song"

 Mrs. Macnamara, laundry, grocery, bank withdrawal: £10, apple cake and banana bread

 7:00: Dinner with Alan and Nancy Jenkins

 "Dear mother": Describes how busy she has been with correspondence and how happy she is: "I realize now that all my married life I have sacrificed everything to Ted & his work, putting his work first, going to get part-time jobs, with great faith in his future wealth & fame. I never even got a new dress or went to a hairdresser!"[553] Mentions visit from Clarissa Roche, meeting Mark Bonham-Carter, Liberal candidate and director of a London publishing house, still in an agony of suspense over acquiring her new flat, feels she has been in touch with Yeats's spirit, reviewing historical biographies for the *New Statesman*.[554]

 To Douglas Cleverdon, BBC: Requests a copy of the script for "Three Women" for an Australian gynecologist, and six copies for her, expects to finish a second novel.

 To Stevie Smith: Having a "lovely time" listening to recordings of Stevie Smith and reading her novel, hopes that Smith can come for tea or coffee as soon as Sylvia in settled in London to "cheer me on a bit. I've wanted to meet you for a long time."[555]

To W. Roger Smith, Heinemann: Pleased to hear that "Mushrooms" is wanted for a recording, which has her permission, hopes he can increase the permission fee.

November 20, 9:45–12:45: Nancy Axworthy

9:00–12:00: Mrs. Weare

10:00: Eye clinic

11:30: Horseback riding with Miss Redwood

3:15: Okehampton, Winkleigh hairdresser

To Leonie Cohn, BBC: Inquires about a program, *Landscape on Childhood*, that she might contribute to.[556]

To Mrs. Prouty: Still in a "state of almost unbearable excitement" about the Yeats flat, getting it would be a miracle as she sorts through the "complicated process" of acquiring a lease: "My dream is selling a novel to the movies and eventually buying the house from the present owner. I am applying for a 5 year lease, the longest I can get." Hopes to take possession by Christmas, which she seems destined to do after she opened a copy of his plays and read: "Get wine and food to give you strength and courage and I will get the house ready." Describes how she will furnish the flat and let it out when she is at Court Green, believes she has a good business plan, thrilled at the idea of once again enjoying the culture of London, shopping for a new wardrobe: "When I met Ted at the train in London he didn't even recognize me. I am going to leave all my old Smith clothes in Devon & just take these new ones to London. I want my life to begin over from the skin out." Enjoys reviewing children's books and historical biographies for *New Statesman*. Mentions her second novel, "Doubletake" . . . semi-autobiographical about a wife whose husband turns out to be deserter and philanderer although she had thought he was wonderful & perfect."[557]

To Ruth Fainlight: "I have been up to my neck in pragmatics. You can imagine how easy it is hunting for a flat in London from down here!" Two recent trips to London to remedy her "culture-less, movie-less" life, describes discovering the Yeats flat and plans to eventually purchase it: "My life seems to be spent furnishing a new place every year!"[558] Urges Ruth to visit Court Green while her husband is in Russia.

November 21: Ashcans, £10 bank withdrawal

7:30: Winifred Davies for dinner

Tarot cards, chicken soup and white cake

To Michael Carey: Explains her delay in responding to his poems, which she critiques, recommending he read poets like Thomas Wyatt, Gerard Manley Hopkins, Eliot, Pound, Emily Dickinson, calls herself an atheist, encloses a copy of her poem "Mary's Song."

November 22, 9:45–12:45: Nancy Axworthy

Calendar notation: "fix flashlamps,"[559] Susan Roe expected

"Dear mother": Reviews *Lord Byron's Wife* for *New Statesman* but finds it difficult to read and write in the country without proper help, still hopes for the London flat but worried about the next year's finances, now that Ted, "a coward & a bastard," has left her, and is now seeing Susan Alliston who wants to meet her: "that is a pleasure she'll have to forgo."[560]

November 23: Dentist, to Exeter to pick up repaired watch

11:30: Cleaners and bread

November 24: Bread

11:00: Horseback riding with Miss Redwood

Alan & Nancy Jenkins, chicken and macaroni on the menu, shops for macaroni, almonds, Mazola, and baby food

November 25: Calendar notations: "4 tea?" "Fosters" "Afternoon off"

November 26: Completes "Winter Trees"

November 27, 11:15: Horseback riding with Miss Redwood

Makes apple pie, hash, chicken and rice, fried bananas, "pear salad?"

7:15: Dinner with Winifred Davies and her son Garnett

November 28: Works on *New Statesman* review

9:00: Hairdresser

Note to see Gregory,[561] ashcans, Susan Roe has the afternoon off, Sylvia reminds herself to call the Macedos

There is a rising tone of exasperation in Plath's letters to her mother. More than at any other time in her life, Plath allowed herself to express such annoyance. She wanted her mother's support, but not at the cost of maudlin expressions of sympathy. Since Plath did not retain her mother's letters, however, it is difficult to say if Plath might have been overreacting to her mother's concerns, which may have made Plath's burdens seem all the more unbearable.

November 29: Susan Roe, another off day; bank deposits and withdrawals: £200 and £10; to the grocer

7:45: The Film Society in London.

"Dear mother": Expects to move into her new flat by December 17, with Aurelia as the "guarantor" since Sylvia has no regular employment, a year's rent in advance sealed the deal: "for goodness sake don't say 'unless you are safe & reasonably happy, I can't live anyway'! One's life should never depend on another's in that way. Why do you identify so with me? That sort of statement only makes one chary of confiding any difficulties in you whatsoever, as I am sure you will see if you think of it." She has engaged a "local truck man" to move her stuff for only $50, expects to be the "happiest person in the world" when she moves into her flat, immensely grateful for the $700 Aunt Dot has sent her, looks forward to getting speaking engagements after her appearance at the Royal Court Theatre for American

Poetry night, sees parallels between Byron's sister and Olwyn, Ted is being "cooperative" about the divorce.

To Harriet Cooke: Mentions she is divorcing Ted for desertion, expects to finish in London her second novel about a painter: "I pray I can manage a holiday in Ireland (West) next fall again. I loved it so there I never want to go anywhere else!"

To Karl Miller, *New Statesman*: Finds *Lord Byron's Wife* the "finest of that bunch you sent."

To Father Michael Carey: "The blessing was lovely & I do feel better for it. . . . Please could you bless Yeats' house as well! i think it is coming through, & Lord knows I need it!"

November 30: Calls gas company for 23 Fitzroy Road

Shopping list: stew meat, pork roast, macaroni, liver, bread; sews curtains

December: *Harper's Magazine* publishes "Leaving Early"

December: Ted to Gerald Hughes: "All this business has been terrible—especially for Sylvia, but it was inevitable, and now the storm-center of it recedes into the distance, I can only be relieved that I've done it. The one factor that nobody but quite close friends can comprehend, is Sylvia's particular death-ray quality. . . . Now we're separated, we're better friends than we've been since we first met. . . . Sylvia's stories of all the women in London are an exaggeration, of course . . ."[562]{THL}

Ted to Olwyn Hughes: "Sylvia has finally, by a series of extraordinary flukes—which she calls her witchcraft—acquired the top two floors of the house in which Yeats lived as a child." {THL}

December 1: Completes "Brasilia," "Childless Woman"

December 2: Packs car radio

3:30: Tea with Alan and Marion Foster

Begins work on "Sheep in Fog"

December 3: Calendar notation: "to London?"

Takes train to sign lease and pay first year's rent {PA}

Stays with the Macedos and leaves them an inscribed copy of *The Colossus* {HC}

December 3 or 4: Meets Ted for dinner at L'Epicure: He questions her about the children and where she is staying. He accedes to her request to join him at Dido Merwin's flat, where he is staying. Their quarrel disturbs the downstairs neighbors. They depart, in Ted's words "cold-mouthed" as "flood victims" {SPD}

December 4, 12:30: Stevenage Arts Center in London, invited to give a reading, goes to vegetarian restaurant in Leicester Square

Aurelia writes a letter to Sylvia full of practical advice about furnishing a flat and what to bring with her from Court Green. Provides news from

home and concludes, "Your plans sound well thought out. . . . I salute you, my dear!" {CR2}

December 6: Back in Devon: meets Charlie Pollard, Gregory, notation about Frieda's and Sylvia's hair, speaks to her mother on the phone[563]

December 7: Calendar notation: bank, umbrella, grocer

8:15: Webbs

New Statesman publishes "Suffering Angel," review of *Lord Byron's Wife*

December 8, 9:30: Hair appointment in Winkleigh

Writes letters,[564] shops for bread, light bulbs, light plugs,[565] "See Nancy [Axworthy]"

Knopf rejects *The Bell Jar* {HC}

Aurelia writes to Sylvia about how much she enjoyed their conversations last Thursday, provides advice about housekeeping and husbanding. {CR2}

December 9: Washes car, pays paperman[566]

Closes up Court Green {HC}

The move to London marked a new era in Plath's life, or so she thought, having abandoned plans to winter in Ireland, and projecting a salon and a cultural renaissance in her life.

December 10: To London with Frieda and Nicholas: "trash bins down," turns off gas, Mr. Bennett fixes a window, she picks holly. Calendar notations: "let out water," "key and cat to Fosters"

December 11: At 23 Fitzroy Road: "au pair" and "baby's room"

December 12, 10:00: Meets Ted at zoo, calls estate agents, Morton-Smith, about 23 Fitzroy Road rental, contacts gas board, irons

Receives the first copy of *The Bell Jar*, inscribes it "Christmas 1962" {HC}

December 13: Contacts nappy service, shops for groceries, calls Morton-Smith, the gas board, out to Camden Town,[567] orders straw mats, Indian rug, blue glasses, red rug for babies' room; ironing, painting of au pair's room, babies' room, floor, and hall

The first days of moving into 23 Fitzroy Road were heady, with Plath sounding as exuberant as during her first days at Court Green, although the range of her activities seems exhausting and, ultimately, enervating.

December 14: Kitchen cabinet delivered from Co-op; three chairs from Selfridge's; one white wood bureau for baby items. Settles on chicken stew but has to get a frying pan, paints her room and the au pair's room

"Dear mother": Describes the "immensity of the move": "And I can truly say I have never been so happy in my life." It all seems like an adventure: writing a poem, painting a floor, hugging a baby." "Blessed" Susan Roe has helped with the move. Pleased at how many people in the neighborhood remembered her, she feels Yeats's spirit blessing her, works on commissions from the BBC, Al Alvarez says her second book of poetry will win a

Pulitzer Prize, works on potboilers under a pseudonym: "For goodness sake, remember no news is good news & my work is so constant I barely have a second to fry a steak. Don't make me worry about you."

To Dorothy Benotti: Children are enjoying the nearby zoo, busy with BBC work, describes London smog: "thick white for 5 days, you couldn't see your hand before your face & you can imagine what it was like to get round!" Describes "heavenly rides under the moors" just before moving to London, eating like a horse, hoping to get off sleeping pills as soon as she is fully moved in, asks her aunt to talk to Aurelia about not worrying. Self-reliance has made Sylvia happier: "You have no notion of how much your cheery letters mean!"

December 15: To the Co-op to "see about rug"

To Douglas Cleverdon, BBC: She has written a broadcast for her new selection of poems. "We will be camping out a bit till I get my ancient Yeatsy floors painted & a mother's help lured to live in and a phone, all of which I hope to accomplish by the New Year."[568]

To Gilbert and Marian Foster: Describes moving in, checks on details for wintering Court Green, thanks them for looking after her cats.

To Mary Coyne: Asks for a sweater she has left behind in Ireland and mentions she is now living in a Yeats house.

To Mrs. Prouty: "The miracle has happened." Even her solicitor was surprised that she obtained a lease. "It is heaven for me to be among people. To be anonymous, in myself."[569] Describes moving in, her happy children, her BBC work, the high praise from Al Alvarez, plans for finishing her second novel: "Having to close up that big house & open this flat has given me an immense pleasure in businesslike dealings, I feel to have grown up a great deal in the process." Pleased with her lead review of *Lord Byron's Wife*, notes the resemblances to Ted's life, does not like the terms of divorce settlements in England, but Ted has agreed to pay a thousand pounds a year and she hopes he will agree to putting Court Green and the car in her name. "This woman, who is still dangling her 3rd husband, has brutalized Ted beyond belief—taught him it is 'clever' & 'sophisticated' to lie & deceive people and so on."[570] She wants to dedicate her second novel, "Doubletake," to Mrs. Prouty.

December 16: Orders *The Observer* and *Radio Times*, paints bureau, bed, irons, washes bathroom floor

To Douglas Cleverdon, BBC: Tells him she has used his name as a reference for a "priority phone," which she needs for her freelancing. "I hope this isn't too much of a bother!"

To Father Michael Carey: "The various blessings have triumphed & the babies & I installed over the Yeats plaque. . . . Do drop by for a cup of tea."

The Observer publishes "Event"

December 17: Work by carpenter and painter on kitchen shelf and book shelves, picks up linoleum for kitchen, notes the walls will be white. Calendar notation: "see Doris."[571] Mentions two straw mats and one Indian rug, purchases a Jaeger dress, calls Al Alvarez, goes to the bank, washes her hair, takes a black sweater to cleaners, still no arrangements for babysitting

December 18: Calls babyminders, paints lounge on second floor, bureau, au pair's room, second floor and downstairs hall, picks up laundry and grey paint, washes hair

December 19: Calendar notation: "Painter's wall." To do list: butcher, wash hair, make spaghetti; paints bureau, downstairs hall, nursery, calls baby minders, to cleaners for black sweater

December 20: Calendar notation: "whitewood bureaus"

6:45: Doris

9:00–1:00: "Babyminders?"

4:00: Katherine Frankfort comes for tea

Goes to see Ingmar Bergman's film *Through a Glass Darkly*[572]

December 21: Bakes apple cake, banana bread, shops for nappies, blue candles, to the butcher and cleaners, paints bureaus, babies' room, au pair's room. At Dickins & Jones[573] buys fur pants

"Dear mother": Extols her new life, furnishings in the flat, new clothing, socializing: "You should see me nipping round London in the car! . . . Now I am out of Ted's shadow everybody tells me their life story & warms up to me & the babies right away. Life is such fun." The weather "blue & springlike & I out every day with the babies." Blue is her new royal color, a color Ted never liked.

December 22: Susan's Roe's birthday. On the menu: banana bread and pancakes, shops at Camden Town market

4:00: Tea with Corin Hughes-Stanton, Susan Roe's boyfriend

To the bank, pays Doris 7s.6d, paints three bureaus, uses yellow for her bedroom and kitchen, red and blue for babies' room, pink for au pair's room

A "fine white snow begins to fall" {HC}

December 23: Baking, cooking, banana bread, pancakes, ironing, child care, nappies, paints bureau

4:00: Tea with Lorna Secker-Walker

December 24: Shops, washes her hair and kitchen floor

Invites Al Alvarez for dinner {RH}

Al Alvarez stops by her flat for drinks on way to dinner with friends {RH}

December 25: Helder and Suzette Macedo visit, paints au pair's room and hallway, calls Doris, Elizabeth Jennings

The holiday season of joy is also one of depression for some people, which Plath acknowledges simply as homesickness. She did not tell her mother

just how devastating it felt to be without a sense of home at Christmas, although her mention of cheering letters from home tells part of the story of her last days.

December 26: It begins to snow {RH}

Calendar note: "Frankforts"

"Dear mother": "I wish you could see me sitting here in my gorgeous front room." Mentions various friends she has seen for tea, lunches, dinner, Christmas dinner with the Macedos, enrolling Frieda in nursery school, Nick is "wonderfully happy and strong," mentions homesickness, missing holidays at home.

To Helga and Daniel Huws: "You have no idea how your two good letters cheered me, & how Frieda loves the little toy village you sent." Describes moving into 23 Fitzroy Road, the "luckiest thing that has happened in a bad very bad year." Relieved to be away from the gossip concerning Court Green and Ted's departure. Mentions an addiction to sleeping pills, which she would like to end, and smoking,[574] which she is beginning "alas" to like. Frieda is slowly "coming out of the regression she went into after Ted's desertion—she was always his little pet." Agrees with Daniel about Ted: "His guilt alas makes him very hard & cross & hurtful, and you can imagine the public humiliations one has to face, being in the same work & Ted being so famous." Expects him to visit once a week and take the children to the zoo. She hopes Daniel and Helga will visit her at Court Green in the summer.

To Ruth Fainlight: "I am now sitting in the first floor lounge with the snuffly babies, who both have Xmas colds, watching a beautiful frosty snow fall on the 18th-century-engraving housefronts opposite & thanking God & Yeats & whoever that I got out of the Devon pig fields before the real cold set in. . . . the Yeats 'aura' is very calm & benevolent." But she admits: "Christmas was a bit of a large gap & I very glad to get rid of it."

December 27, 10:00: Meets Ted at the zoo, then heads to Camden Town, makes spaghetti for a dinner with Corin Hughes-Stanton, calls the poet and critic John Wain and his wife, does laundry

December 28, 11:15: Appointment with Dr. Horder to treat Nick's eye and to obtain sleeping pills

Nappies, laundry, grocery shopping

December 29: To Camden Town, grocery shopping, banking, ironing, hand washing, paints bureau and the au pair's floor

December 30, 1:00: Lunch with Winifred's son, Garnett Davies

December 31, c. 4:00–8:00 a.m.: Completes "Eavesdropper" {PKS}

Calls from a phone box to arrange for installation of home phone, takes Frieda to Dibby's,[575] laundry, shampoo, bath

1963

January: *London Magazine* publishes "Stopped Dead" and "The Applicant"

January 1, 1:30: Calls baby minders

2:30: X-ray at the University College Hospital, cooking and baking: maple custard, apple cake, works on statement for solicitor, paints three bureaus

The snow, which at first seemed so picturesque, began to seem sinister as it paralyzed London and resulted in power cuts, busted pipes, and the kind of lowering cold that always depressed Plath, although in the early days of the freeze, she seemed able to thrive, even if having to do it, as she said, all alone, took a tremendous toll on her spirits.

January 2: Paints bureaus, irons, bakes apple cake, maple custard, deals with nappies, reads *Contemporary American Poetry*, edited by Donald Hall, and sends off poems to *Encounter*

"Dear mother": Urges Aurelia to tell people about the separation and divorce to avoid receiving cards to both her and Ted, mentions the first big snow with the city immobilized and the streets frozen, and the car "snowed up," enjoys the presents from home for the children. She is under Dr. Horder's care, who sent her for a chest x-ray, "so I am in the best of hands." Wants news about Aurelia's teaching and when Warren and Maggie can visit, asks her mother's help advertising Court Green for scholars on sabbatical leave, while she stays there in the summers.

To Marcia Brown: Describes the situation with Ted who has absolved himself of family responsibilities and "left me with the lot, after I almost died of flue this summer at Court Green." Rescued by her Devon midwife and a children's nurse, the plan to stay in Ireland scrapped for the London Yeats flat, her BBC work: "I guess you can imagine what it's like coping with two infants, free lance jobs, painting & decorating acres of floors & haunting sales for curtaining etc. Toute seule!" After six months of "unique hell," she is "fine now." She had to take care of all the business of their lives as "businesswoman, farmer."

To Mrs. Prouty: Thanks her for financial support, describes all she has done in three weeks fixing up her flat, her plans to make a "business proposition" out of Court Green, plans to finish a novel, BBC work, English ineptitude in dealing with snowfall.

January 3, 10:00: Meets Ted at zoo

 1:00: Clarissa and Paul Roche arrive for apple cake and corn chowder

 Irons, paints table and sled, shops at Hamley's[576]

January 4, 9:30–12:30: Laundry, nappies, sends Frieda to school, calls au pair

 6:40: BBC German lesson

Works on poems for *Encounter*, continues reading Donald Hall's anthology of American poetry

The onset of another case of flu, which had resulted in Plath losing twenty pounds when she had it at Court Green, depleted her reserves of energy, and the exhaustion of coping with the last six months began to erode her determination to prevail over her troubles.

January 4–8: To George MacBeth, BBC: "down with the flue & so have the children." No phone yet.

January 5: Works on review of Donald Hall's book for the BBC *New Comment* program, does laundry, wonders if she needs some codeine for her cough, mentions paddipads

7:00: Meets Ted

Plath, never entirely happy without the sun in her life, began to reckon with the grim weather that gripped her soul.

January 9: To Charles Osborne: "I am at present writing by candlelight with cold fingers a sinister return to Dickensian conditions thanks to the Electricity Board." Encourages him to visit if "you are not a childphobe."

To Gilbert and Marian Foster: Reports ten days of flu: "all of us flat out with a day-nurse through this ghastly weather." Asks if Nancy Axworthy[577] has recovered from illness so she can take care of Court Green.

January 10: Sylvia records her review of Donald Hall's *Penguin Anthology of Contemporary American Poetry* for the BBC {HC}

January 13: *The Observer* publishes "Winter Trees"

January 14: Heinemann publishes *The Bell Jar*

Compounding Plath's painful period of flu and low spirits, Hughes's sporadic visits and his fitful moods made her days seem erratic and out of control and filled with the mess she had sought to escape when she resumed life in London.

January 16: "Dear mother": Tired and "cross," still recovering from the flu, children with "high fevers," Frieda with a "ghastly rash," filthy weather, "heaped snow freezing so the roads are narrow ruts & I have been gloomy with the long wait for a phone," still waiting after two months. Ted's visits are problematic, sometimes "nice" and sometimes "awful." Power cuts interrupt dinners and are followed by the rush for candles when the lights go out.

The live-in nurse recommended by Dr. Horder leaves {LWM1}

January 17: *Time & Tide* publishes excerpts from *The Bell Jar*

Nicholas's birthday with apparently no celebration {HC}

Susan Alliston's journal: "he talks so much, so personally about himself and S[ylvia] and Assia and his plans. He said the exclusivity of the relationship killed something—the keeping always on the same plane, and that she is an absolutist—will not accept a compromise."[578] {HC}

Aurelia asked Patricia Goodall, living in London and a cousin of Perry Norton's wife, to visit Sylvia and report back on her state of mind and surroundings. Goodall caught Plath at a good moment, or Plath, as she often did with her mother, put on a good show.

January 19: Patricia Goodall visits 23 Fitzroy Road. Sylvia greets her with a "bright smile and eager American expression." The children look "healthy, in good humor, and well tended, in a 'warm and cheery' flat." {HC}

It was not only Plath who was undone by the deadly winter, as Ted Hughes noted in his letters.

January 21: Hughes writes to the Merwins about the cold "freezing people dead." Preparing his finances so he can permanently separate from Plath. Writes in his journal: " "I am completely responsible for S's fixation on me, I demanded it." Acknowledges his "weakness with women," and how hard it is to be "rational & disciplined" about them, his "yielding to whatever I may think is their whim is ruining—has probably already ruined my life. And in the end it leads to disaster for them too, meshed in my falsity. . . . My unwillingness to hurt women, my incredible indulgence toward them is simple reflection of the same attitude toward myself. My fear of rebuffing & feeling: ends in the utter callousness of my dealings with S." {HC}

BBC broadcasts Ted's play *Difficulties of a Bridegroom*[579] featuring "visions of two women: one represents lust; the other chastity." {HC}

The tone of Plath's letters begins to change as she emphasizes the difficulty of her struggle rather than her excitement at beginning life anew. It is significant that Plath writes to the two people who helped her survive her first suicide attempt: Olive Higgins Prouty and Ruth Beuscher.

January 22: To Leonie Cohn, Talks Department, BBC: Planning a twenty-minute talk about childhood.

To Olive Higgins Prouty: "How good to get your letters! They are like soul letters to me." Describes how difficult it is to start her life anew, how spiritually deprived she feels, how she misses the conversations with RB in her winter of struggle.

January 23: Invites Ted to Fitzroy Road for sherry to celebrate January 14 publication of *The Bell Jar* {HC}

Reviews of The Bell Jar *were respectable, even laudatory, but what they meant to Plath is unclear, although it seems certain that the reviews did not mean enough to overcome her increasing despair.*

January 25: *TLS* review praises the "dry wit" of *The Bell Jar*, calls the novel a "considerable achievement." *New Statesman* deems the book "clever," the first "feminine novel . . . in the Salinger mode."

Meets Philip French, producer in BBC Talks Department, to sign a contract {HC}

January 25–26: *The Observer* reports the "worst power crisis" in the country's history {HC}

January 27: Anthony Burgess reviews *The Bell Jar* in *The Observer*: "We've met the situation before, but rarely so mature a fictional approach to it. Where (especially in the asylum scenes) there might have been sensationalism, there is sensitivity and decorum; also, the characterisation is economical but full, and the style is careful without being labored or pretentious." {HC}

Al Alvarez reviews *Difficulties of a Bridegroom* on the BBC, calling it "extraordinarily vivid, imaginative, and original." {HC}

Knocks on door of downstairs tenant Trevor Thomas and in sobs says, "I am going to die. . . . And who will take care of my children? . . . We were so happy. I don't want to die. There's so much I want to do." Launches into a diatribe against Ted and Assia. She says Thomas reminds her of her father. {HC}

Ted publishes "Full Moon and Little Frieda" in *The Observer*

January 28, c. 4:00–8:00 a.m.: Completes "Sheep in Fog," "The Munich Mannequins," "Totem," "Child"

To Leonie Cohn, BBC: Encloses the script for her program on childhood: "do let me know if you think it is all right."

January 29, 4:00–8:00 a.m.: Completes "Paralytic," "Gigolo"

January 30: David Manchin, Heinemann editor of *The Bell Jar*, writes to congratulate Sylvia on the "excellent reviews that are coming your way." He asks if they can meet, and they agree on February 12. {CR2}

January 31: *The Listener* review of *The Bell Jar*: "There are criticisms of American society that the neurotic can make as well as anyone, perhaps better, and Miss Lucas[580] makes them triumphantly. . . . This is a brilliant and moving book." {PA}

In a Euphoria*, Elin Cullhed's novel about Plath, Ted Hughes says: "You always get sick in February . . . Broke your leg in February, sinus infection, in the psych ward all the way until February, miscarriage and appendicitis at the same time—in February . . . February is your month, my love. . . . Mastitis in February." Plath muses: "There was something about February. Something about the frozen stillness. Something about the rebirth that had to occur in February, as with the purification of the year which had passed. Something about the fact that I was surely CONCEIVED in February, I who was born late in October. It was my fate, February."*

February 1. 4:00–8:00: Completes "Mystic," "Kindness," "Words"

February 2–3: In Devon, to retrieve some belongings {HC}

Like one of Plath's most famous poems, "Edge," she was on the border between life and death, still capable, as Hughes's diary shows, of tremendous resiliency and creativity and almost in the same moment of despair. Hughes's diary suggests

that his very presence, after so much effort on her part, unnerved her, as if he were drawing away the very power that she had just put in her life and poetry. Some of what happened to Plath seems a matter of timing—like the delay in Ruth Fainlight's return to London, which, in Fainlight's later musings, made her wonder if her presence might have made enough of a difference to save Plath's life.

February 3: Calls Ted and invites him to lunch {CR1}

From Ted's diary: "We had meat-loaf. We had the pleasantest most friendly open time since last July. She read me her most recent poems—stronger, calmer. She seemed more whole and in better shape than at any time since she came to London. Yes, we planned. We conspired. When I played with Frieda, she wept. I held them both and she wept. She kept repeating that I would want somebody else and I kept denying it absolutely. For the last few days I have been calling everybody Sylvia. Wanting to turn back but not knowing how to stay out of the old trap. Letting her know that I wanted to take up our old life but that it had to be different. I couldn't be a prisoner, also, the feeling that she was strengthening in her independent life, that she seemed so pleased with, and starting to write again. And the feeling that my seeing so much of her disabled this effort of hers. The feeling that her centre of gravity was coming back into me. The feeling that I wanted that and encouraged it. She promised to visit me Thursday night." {HC}

Ruth Fainlight writes to Sylvia that she will return to London in early March. {CR2}

February 4, 2:00 a.m.: Ted leaves 23 Fitzroy Road {CR1}

c. 4:00–8:00 a.m.: Completes "Contusion"

To Elizabeth Compton: Sends a copy of *The Bell Jar*, misses Elizabeth, saying how hard it is to live alone: "I get quite black & hollow feeling about bringing up the babies without a father." Ted's weekly visits are difficult: "one keeps wishing for lost Edens." {HC} Begins seeing Dr. Horder daily {PA}

"Dear mother": "I just haven't written anybody because I have been feeling a bit grim—the upheaval over, I am seeing the finality of it all, and being catapulted from the cowlike happiness of maternity into loneliness & grim problems is no fun." She has to stay in London for work that will support her, and so that Ted can be made to see he must contribute his fair share to the family. Returning home would "uproot" Frieda upset by her father's fitful visits, and Sylvia herself has no desire to return to stifling Wellesley. "I shall have to fight it out on my own."

To Marcia Brown: "Your letter was like a shot of brandy or shot in the arm. . . . Everything has blown & bubbled & warped & split."

To Father Michael Carey: Counsels him not to "worry about critiques or harshness, I enjoy both. I've been silenced by everybody's having flue & fevers & am just now creeping enough out of my post-coma flu."

To RB: Diagnoses herself as suffering the consequences of "idolatrous love," making Ted both husband and lover, so that the fear of losing him has grown, although she recognizes that his departure has liberated her as well. Fears the return of "madness, a "vision of the worst" leading to a "cowardly withdrawal" and to "a mental hospital, lobotomies." She keeps slipping into a "panic" and "deep freeze," writing great poems that verge on the "edge of madness."

Calls Ted, according to his diary, and demands that he leave England {CR1}

Susan Alliston writes to Sylvia expressing the hope they can meet: "Do ring me, if ever you feel like it."[581] {CR2}

February 5, c. 4:00–8:00 a.m.: Completes "Balloons," "Edge"

Sees Dr. Horder who prescribes antidepressants[582]{HC}

February 6: Ted sees Assia, who tells him Sylvia has told the Beckers that Ted deserted her in Devon {JB}

Ted writes angry note to Sylvia about her friends spreading tales about his ill treatment of her. He threatens to consult a solicitor. His diary reports she is very upset and asks him if he has faith in her, which seems to him "new & odd." {CR1}

Meets art historian John Richardson to discuss the Saint Pancras Arts Festival {HC}

Sees Dr. Horder {HC}

February 7: John Richardson writes to invite her to a Spike Milligan reading in early March and accepts her invitation to visit her. He expects to "drop round on you." {HC}

Sees Dr. Horder {HC}

Fires au pair, calls Jillian Becker and asks to stay with Jillian {PA}

Phones Ted "freshly upset" and visits him at his flat {JB}

2:00 p.m.: Arrives at Jillian Becker's flat {CR1}

4:00 p.m.: Sylvia declares she would rather not go home {CR1}

Sylvia's phone conversation with Ted settles nothing. Ted notes in his diary that she briefly considers a reconciliation but then reverts to her demand that he depart England. {CR1}

February 8, 3:30 a.m.: Sylvia awakens Jillian, "crying for help" {PA}

Dr. Horder plans to hospitalize Sylvia {CR1}

5:30 a.m.: Sylvia dozes off after a tirade against Ted and Assia

Eats a hearty breakfast, Dr. Horder calls, Jillian says Sylvia is depressed, Dr. Horder asks Jillian to make sure Sylvia takes her pills and that Sylvia remain with her children {CR1}

3:30 p.m.: Ted receives a note, calling it in his diary a "farewell love letter." She announces she is leaving the country and will never see him again. {CR1}

Meets Ted at night but refuses to explain the note and burns it {CR1}
Returns to the Beckers

Leonie Cohn from BBC Talks Department writes to thank Sylvia for her "splendid script," "Ocean 1212-W" about her childhood by the sea. {HC}

Sees Dr. Horder {HC}

February 8–10: Ted spends the weekend with Susan Alliston {JB}

Sylvia sees Dr. Horder several times {LWM1, HC}

Calls Lorna Secker-Walker to say she is feeling better and has resolved her problems {TMA}

Although much emphasis has been placed on Plath's fraught state of mind, Hughes seems to have been worried about his own mental capacities, given what he tells Susan Alliston on February 9.[583]

February 9: Listens to Beethoven with a student whom the Beckers ask to sit with her {PA}

Phones Ted twice at night. Susan Alliston overhears him telling Sylvia, "Take it easy." He tells Susan that Sylvia sounds "drugged or drunk" and says, "If I go back, I die." {JB}

BBC rebroadcasts *Difficulties of a Bridegroom*[584] {HC}

February 10: Enjoys a hearty breakfast at the Beckers, "a little more cheerful" {CR1}

An outing to the zoo, Sylvia naps, decides to return to 23 Fitzroy Road {PA}

7:00 p.m.: Jillian's husband, Gerry, leaves Sylvia at her home[585] {CR1}

11:45 p.m.: Rings the bell of Trevor Thomas, asking for airmail stamps for letters sent to America[586]

Ted and Susan Alliston spend the night at 18 Rugby Street {JB}

February 11, 5:00 a.m.: Trevor Thomas hears Sylvia pacing overhead {CR1}

6:00 a.m.: Sylvia leaves a plate of bread and butter and two mugs of milk in the children's room upstairs. Seals their room with towels to prevent the seepage of oven gas. {EB}

9:30: Nurse Myra Norris arrives as expected but no one answers the door. After gaining entrance Sylvia is discovered sprawled on the kitchen floor, her head still in the oven. {PA}

Later in the day Ted sends telegrams announcing Sylvia's death. {JB}

ACKNOWLEDGMENTS

Peter K. Steinberg's assistance has been invaluable. I'm deeply indebted to his many, many responses to my queries, and to his wonderful collection of photographs. His extensive work on Plath is available in the Preservica Digital Preservation System at https://te992faff27c68c1d.starter1ua.preser vica.com/portal/en-US. I can't seem to do a book on Plath without Gail Crowther's wonderful photographs and her encouraging comments and helpful criticism. I wanted some original, evocative drawings for this book, and Evelyn Mayton, as usual, has made a wonderful contribution to my work. My copy editor, Kerri Jordan, made excellent suggestions and rectified errors and inconsistencies. Mistakes and infelicities that remain are entirely of my devising.

NOTES

1. John Ford (1586–1639) was a Jacobean dramatist.

2. Smith College historian Eleanor Duckett was Mary Ellen Chase's partner.

3. Lameyer was in the Navy.

4. Alvina is not otherwise identified.

5. Dorothy Wrinch Hubbard is not otherwise identified.

6. Dr. Chang is not otherwise identified.

7. Profesor Gray was a blind Smith professor. See CR3.

8. "A Smith tradition since 1876, when it commemorated the birthday of George Washington, Rally Day is highlighted by a festive all-college gathering at which distinguished alumnae are awarded Smith College Medals by the president," from Smith College website, https://www .smith.edu/about-smith/college-events/rally-day.

9. Rahar's was a college hangout. See Ivy-Style.com, "Golden Years: Road Trip to Rahar's," January 5, 2017, http://www.ivy-style.com/golden-years-road-trip-to-rahars.html.

10. Ruth probably refers to Ruth Freeman.

11. Harry Levin was a distinguished American literary critic.

12. Webster's *Duchess of Malfi* is a Jacobean revenge tragedy.

13. Ruthie probably refers to Ruth Freeman.

14. Chris Buxton was a Cambridge University graduate.

15. D. was Dorrie Licht, Smith student.

16. Alpha Phi Kappa is an arts society.

17. Joan Bennett was a Cambridge University professor giving a lecture at Smith.

18. *Saint of Bleeker Street* is a Gina Carlo Menotti opera and was performed at the Broadway Theatre in NYC.

19. Stefan Wolpe was a German American composer. See Encyclopedia.com, "Stefan Wolpe," June 8, 2018, https://www.encyclopedia.com/people/literature-and-arts/music-history -composers-and-performers-biographies/stefan-wolpe.

20. Clement Moore was not only Warren's friend and best man at Warren's wedding but also the husband of Susan Alliston, who later became involved with Ted Hughes. Clement's mother was a writer.

21. The Poetry Reading Contest was the Glascock Poetry Prize, given by Mount Holyoke College. The judges were John Ciardi and Marianne Moore.

22. Frank Newhall Look Memorial Park is in Florence, Massachusetts. See Look Park, https:// www.lookpark.org.

23. Wiggins Tavern is in Northampton, Massachusetts. See The Hotel Northampton, "Wiggins Tavern," http://www.hotelnorthampton.com/dining/wiggins-tavern/.

24. Carol perhaps refers to Carol Pierson, a Haven House friend of Plath's.

25. Mrs. P. perhaps refers to Mrs. Prouty.

26. Professor Joyce Horner was organizer of the Glascock Poetry Prize event at Mount Holyoke.

27. The letters to Carol, Mrs. P., and Sassoon are lost or in private hands.

28. On the advisory board of *The Lyric*, a poetry magazine. Plath's letter to her is lost or in private hands.

29. Dr. Booth was a Smith College psychiatrist.

30. Professor Page was Plath's creative writing teacher.

31. Miss Fitch is not otherwise identified.

32. Longinus was a first-century AD Greek writer.

33. Sidney Lanier (1843–1881) was a Southern poet.

34. According to an email from Judy Denison, a Plath classmate in Lawrence House, to Carl Rollyson, June 20, 2022: "Pinning is an event signaling you are thinking of getting engaged. The guy gives the girl his fraternity pin. (I don't know what happens if he is not in a fraternity.) The girl wears it on her sweater . . . nearly at the point of her boob (which is very pointy because that's how bras were). So I guess there's a party with her friends to celebrate. I never went to one." See also Jon E. Gorgosz's 2014 paper, "The Practice of Pinning and Its Production of Gendered, Idealized Images for Women on College Campus in the 1940s, 50s and 60s," https://opensiuc.lib .siu.edu/cgi/viewcontent.cgi?article=1001&context=esh_2014.

35. See entry for May 6, 1955.

36. The correlation questions are not otherwise identified.

37. The major event of the evening is the senior Step Sing, where the senior class gathers at the front of Neilson Library as members of Sophomore Push sing to them." See Smithipedia, "Ivy Day and Commencement Weekend," https://sophia.smith.edu/blog/smithipedia/traditions/ivy -day-and-commencement-weekend/.

38. See entry for May 5, 1955.

39. Dachine Rainer (1929–2000) was an English writer.

40. Mickey Spillane (1918–2006) was an American crime novelist and friend of Bob Thornell.

41. Bob Thornell was husband of Emma Thornell, host of the Onteora literary festival. The letters to the Thornells and Sassoon are lost or in private hands.

42. "Theory of Beauty" perhaps refers to a book by E. F. Carrit published in 1914.

43. *Paris Incident* involves the adventures of a telegraph messenger who loses and tries to retrieve the telegrams he is supposed to deliver. See the IMDb website at https://www.imdb.com/ for more information about this film and about most of the other films Plath mentions.

44. George & Harry's was a New Haven restaurant. See Mark Alden Branch's "Throwback Thursday: Remember George & Harry's?" March 26, 2020, https://yalealumnimagazine.com/blog _posts/3341-throwback-thursday-remember-george-harry-s.

45. Estella Kelsey was Lawrence House Mother.

46. Thomas De Quincey (1785–1859) authored *Confessions of an English Opium Addict* (1821).

47. Steuben's Tavern was located at 47th Street and Broadway. See Lost City, "Another Lost Restaurant Search," February 2, 2010, http://lostnewyorkcity.blogspot.com/2010/02/another-lost -restaurant-search.html.

48. The Plaza Promenade is located at Rockefeller Center.

49. Cafe Francais is a mixed drink. See J. Steiger and John McCarten's "Mixed Drink," in the *New Yorker's* "Talk of the Town," October 8, 1955. https://www.newyorker.com/magazine/1955/10/08/mixed-drink.

50. Hamburger Heaven remains a popular mid-town restaurant. See BarryPopik.com, "The Gates of Heaven—Never Closed," April 23, 2006, https://www.barrypopik.com/index.php/new_york_city/entry/the_gates_of_heaven_never_closed_hamburg_heaven.

51. Toffenetti's was a popular New York restaurant at the corner of 43rd Street and Broadway. See Greg Morabito's "A Trip to Toffenetti, Times Square's 1000 Seat Restaurant," August 28, 2012, https://ny.eater.com/2012/8/28/6558333/a-trip-to-toffenetti-times-squares-1000-seat-restaurant.

52. For the history of The Colony Club, see Big Apple Secrets, "The Colony Club—The Only Club, Created Only for Women," http://www.bigapplesecrets.com/2015/06/the-colony-club-only-clubcreated-only.html.

53. For details on Ivy Day, see Smithipedia, "Ivy Day and Commencement Weekend," https://sophia.smith.edu/blog/smithipedia/traditions/ivy-day-and-commencement-weekend/

54. The alumnae parade is described on the "Commencement & Ivy Day Traditions" page of the Smith College website, https://www.smith.edu/about-smith/college-events/commencement/commencement-and-ivy-day-traditions.

55. For the history of the Quabbin Reservoir, see Mass.gov, "Quabbin Reservoir," n.d., https://www.mass.gov/locations/quabbin-reservoir.

56. These letters are lost or in private hands.

57. For more on The Belmont, see Jack Sheedy's "Grand Hotels of the Past. . . and Present," 2018, https://capecodlife.com/grand-hotels-past-present/2/.

58. Kathy perhaps refers to Kathy Cantor, Mrs. Cantor's oldest daughter.

59. Stan is not otherwise identified.

60. These letters are lost or in private hands.

61. Angelo Bertoccis was a professor at Boston University.

62. According to the Babson College website, "The Globe was meant to 'impress upon students and other viewers an appreciation of the world as a whole . . . stimulating an interest in world geography, history, economics, transportation, and trade.' . . . When it was dedicated in 1955, the Globe measured 28 feet in diameter and weighed 25 tons. It was engineered to rotate on its own axis (though notably, it did not rotate on an oak tree trunk as Roger Babson had originally envisioned). The Globe was the largest of its kind at the time and drew tens of thousands of visitors to campus each year" (first ellipsis in original). See "Babson Centennial," https://centennial.babson.edu/past/babson-world-globe/.

63. Bill Cruikshank was a neighbor.

64. Pixie is a cousin.

65. "Black Prince" presumably refers to a book about the son of Edward III famous for his exploits in the Hundred Years' War with France.

66. These letters are lost or in private hands.

67. These letters are lost or in private hands.

68. Mrs. Gaery was a Wellesley neighbor.

69. These letters are lost or in private hands.

70. Hunnewell Courts are in Wellesley, Massachusetts. See Global Tennis Network, "Hunnewell Field," n.d., https://www.globaltennisnetwork.com/tennis-courts/courts/tennis-court-page/court/6326-hunnewell-field.

71. Robert Shea was at the US Consulate in Tangier, Morocco. Plath considered teaching there until she was awarded a Fulbright.

72. These letters are lost or in private hands.

73. Ruth Cohen was principal of Newnham College at Cambridge.

74. Christine Abbott was secretary of Newnham College at Cambridge.

75. Irene Victoria Morris was one of Plath's tutors at Cambridge.

76. Gertrude Claytor served on the advisory board of *Lyric*, a poetry magazine.

77. These letters are lost or in private hands.

78. Rhoda Dorsey was a Smith College graduate at Newnham College, Cambridge.

79. These letters are lost or in private hands.

80. This letter is lost or in private hands.

81. These letters are lost or in private hands.

82. These letters are lost or in private hands.

83. Vincent Cliffs was an iconic part of Lucy Vincent Beach. See Noah Asimov's "Iconic Martha's Vineyard Landmark, Cliff at Lucy Vincent Beach Collapses," May 2, 2020, https://vineyardgazette.com/news/2020/05/02/iconic-landmark-cliff-lucy-vincent-beach-collapses.

84. The article was Lucinda Baker's "No Literary Slump for Lucinda."

85. Claudio Spies (1925–2020) was a Chilean American composer. See Wikipedia, "Claudio Spies," n.d., https://en.wikipedia.org/wiki/Claudio_Spies.

86. These letters are lost or in private hands. Sassoon to AW: "Sylvia and I did correspond a lot and, long ago, visiting my parents' house, I looked in the attic in a trunk where I kept her letters and they were not there, which is a total mystery."

87. These letters are lost or in private hands.

88. These letters are lost or in private hands.

89. Robin Hood's Ten Acres was in Wayland, Massachusetts. See CardCow.com, "Robin Hood's Ten Acres, Route 20 - The Old Boston Post Road," n.d., https://www.cardcow.com/174146/wayland-massachusetts-robin-hoods-ten-acres-route-20-old-boston-post-road/.

90. "RR Express" perhaps refers to a trunk sent to England.

91. Arden perhaps refers to Arden Tapley.

92. Asti's was popular with opera goers. See Museum of the City of New York, "Asti's Restaurant," n.d., https://collections.mcny.org/CS.aspx?VP3=SearchResult&VBID=24UAYWE591A6Q&PN=8&IID=24UAKVTIIGG.

93. Anthony Wedgwood Benn was a prominent Labour politician, a Labour member of parliament in 1955, and later a Cabinet minister in Harold Wilson's government. Benn later became known as Tony Benn, after he gave up his peerage and shifted to a far left position in his party. For the importance of Plath's talk with Benn: CR4.

94. Pete is not otherwise identified.

95. Charles Percy Snow (1905–1980) was an important novelist whose book *The Two Cultures and the Scientific Revolution* (1959) explores the divide between literature and science in modern life.

96. Released in 1943, *Shadow of a Doubt* is about a teenager's involvement with her Uncle Charlie, a murderer.

97. For an image of Chez Auguste, c. 1947, see Mary Evans Picture Library, "Chez Auguste on Old Compton Street, Soho," n.d., https://www.prints-online.com/chez-auguste-old-compton-street-soho-7187593.html.

98. Mr. Ray and Mr. Christie are not otherwise identified.

99. Scott Hamilton is not otherwise identified.

100. Winthrop W. Aldrich (1885–1974) was American ambassador to the UK. See "Winthrop Aldrich Dead; Banker and Diplomat, 88," *New York Times*, Feb. 26, 1974, https://www.nytimes.com /1974/02/26/archives/winthrop-aldrich-dead-banker-and-diplomat-88-chase-national.html.

101. *Riffi* is about the perfect crime.

102. These letters are lost or in private hands.

103. These letters are lost or in private hands.

104. John Clark was one of Sue Weller's friends.

105. A busby is a tall fur hat.

106. This letter is lost or in private hands.

107. This letter is lost or in private hands.

108. Lesley Davison was Peter Davison's sister living in London.

109. These letters are lost or in private hands.

110. Smith is not otherwise identified.

111. This letter is lost or in private hands.

112. *The King and I* is a popular musical about a king of Siam and a governess.

113. *The Doves* possibly refers to *Good Morning, Miss Dove*.

114. John perhaps refers to John Clark or John Whiteside. See entries for September 25 and 28, 1955.

115. For an image of Sa Tortuga from September, 1959, see Ray Moreton's "Trendy Coffee Bar," available at https://www.gettyimages.com/detail/news-photo/patrons-outside-sa-tortuga-a -fashionable-caribbean-style-news-photo/1205526587.

116. This letter is lost or in private hands.

117. Jean Pollard was a South African student.

118. David is not otherwise identified.

119. The Bridge of Sighs is an iconic feature of St. John's College. See the St. John's College website, "Bridge of Sighs," n.d., https://www.joh.cam.ac.uk/bridge-sighs.

120. For information about the River Cam, see Creating My Cambridge, "The River Cam," n.d., http://www.creatingmycambridge.com/history-stories/the-river-cam/.

121. Plath's room was in Whitstead. In "Sylvia Plath's Cambridge," Di Beddow provides a succinct description: "a large, draughty, white house just off the Barton Road and across the playing fields and gardens from the main college." See *The Bloomsbury Handbook to Sylvia Plath*, ed. Anita Helle, Amanda Golden, and Maeve O'Brien (New York: Bloomsbury Academic, 2002).

122. Elizabeth Kimber was an American student studying history.

123. These letters are lost or in private hands.

124. Margaret Roberts was a South African student.

125. Barry Edward Sales was a Cambridge student.

126. Lois Marshall was a Fulbright scholar.

127. These letters are lost or in private hands.

128. Dr. Bevan was an English doctor who gave her nose drops for her sinuses.

129. Evelyn Sladdin was an English Cambridge student.

130. Isabel Murray was a Scottish Cambridge student.

131. F. R Leavis was a distinguished and astringent critic of modern literature who had a large following—even disciples who were called Leavisites.

132. Haupt would later commit suicide. New information about his role in Plath's life is explored in CR4.

133. The Queen and Prince Philip were coming to open the new Cambridge Veterinary School.

134. Luigi Pirandello's famous play *Six Characters in Search of an Author* explores the nexus between illusion and reality. See Britannica, "Six Characters in Search of an Author," last updated February 6, 2022, https://www.britannica.com/topic/Six-Characters-in-Search-of-an-Author.

135. Richards pioneered the close reading of literary texts without regard to the authors who wrote them. Plath attended Cambridge tutorials using Richards's methods of dealing with literary texts.

136. Christine Abbott was Newnham College secretary.

137. Founded in 1871, Newnham College is the oldest Cambridge College run by women for women. See the Newnham College website, n.d., https://newn.cam.ac.uk.

138. John is not otherwise identified.

139. *Varsity* is one of Cambridge University's main student magazines.

140. Webster's *The White Devil* was first performed in 1612.

141. *Camino Real* by Tennessee Williams was one of Plath's favorite plays. The impact of *Camino Real* on Plath's sensibility is explored in CR4.

142. For more on Plath's participation in the play, see CR4.

143. Ken Frater was a South African student Plath called "sweet, if prosaic" in an October 29, 1955, letter to her mother.

144. Dick Mansfield was a Cambridge student studying history mentioned in an October 18, 1955, letter.

145. Camille Prior was an actress and boarding house proprietor mentioned in an October 18, 1955, letter.

146. Grantchester is a village not far from Cambridge beside the river Cam with a medieval church and several pubs.

147. Dick Gilling is described in a letter to her mother (October 29, 1955) as "our tall, skinny, utterly delightful producer."

148. Of the Royal visit, Plath notes "she was amazed to find herself in a receiving line for Queen Elizabeth, 'within touching distance,' at Newnham" {HC}. See also entry for October 24, 1955.

149. Brian Corkery was a Cambridge student Plath describes in an October 29, 1955, letter as "very correct, and looks like the young t. s. eliot."

150. John Oddey is not otherwise identified but presumably a Cambridge student.

151. Martin Duckett was a Cambridge student Plath dated.

152. To her mother (October 29, 1955), Plath writes about a visit to Market Hill: "where the open booths spilled over with red tomatoes and apples, translucent green grapes, and armfuls of hot yellow and orange dahlias. I love just walking around that place, feasting my eyes on the colors and shapes like a glutton."

153. These letters are lost or in private hands.

154. Heffer's is a bookshop in Cambridge since 1876.

155. Brian perhaps refers to Brian Corkery.

156. *New Faces* and *Little World of Don Camillo* were shown at the Rex Cinema, then on Magrath Avenue, Cambridge.

157. For more on LaMar and the impact of his writing on Plath, see CR4.

158. Martin Deckett was a Cambridge student and ADC member.

159. Yvonne Zeffert is not otherwise identified.

160. "Lady Tansley & apples" is a reference to the orchard at John Lythgoe's grandparents.

161. Louis MacNeice (1907–1963) was an important Irish poet Plath would later meet in London in the company of Ted Hughes.

162. *I Am a Camera* is an adaptation of Christopher Isherwood's novel *Goodbye to Berlin*.

163. Mark and Joyce are not otherwise identified.

164. Thomas Otway (1652–1685) was a Restoration English dramatist.

165. Derrick A. Moore was editor of *Chequer*, a Cambridge University poetry magazine.

166. John Dryden (1631–1700) was a poet, critic, and playwright.

167. David Buck was one of the ADC actors.

168. Plath presumably was listening to a recording of sultry Eartha Kitt (1927–2008), famous for singing "C'est si bon." See Eartha Kitt's website, https://earthakitt.com.

169. PA: "Around November 20, Sylvia had tea with Dick Wertz" and "realized she missed Sassoon." But this entry suggests a physical relationship with Wober. Or is talk about love? Or both?

170. Plath may have been writing to friends she missed. If so, such letters are lost or in private hands.

171. Ben Jonson's *Bartholomew Fair* is available as a Project Gutenberg eBook at. https://www.gutenberg.org/files/49461/49461-h/49461-h.htm. Regarding Plath's acting in this play and in others, see CR4.

172. Is this an allusion to C. S. Lewis's autobiographical *Surprised by Joy*, published in 1955?

173. See entries for December 11 and 12, 1955.

174. Gregor Samsa is a character in Kafka's "Metamorphosis."

175. How many Jews Plath knew is not clear, and so far as is known, her one important friendship with an African American was with Nat LaMar.

176. See entry for August 21, 1955, for mention of *Psychology and the Promethean Will*. The importance of this book is explored in CR4.

177. Alan Patillo is not otherwise identified.

178. Sylvia and Jane Baltzell make a seasick crossing in the English Channel to France.

179. Café Deux Magos is famous in Paris as the haunt of writers and artists such as Picasso, Hemingway, Jean-Paul Sartre, and Simone de Beauvoir.

180. See entry for December 30, 1955.

181. Bernice is not otherwise identified.

182. Jean Cocteau's play *Machine Infernal* is a version of the Oedipus myth. See Playwrights and Their Stage Works, "The Infernal Machine," n.d., http://www.4-wall.com/authors/authors_c/cocteau/infernal.html.

183. For instructions on playing Belote, see Fournier, "Belote," n.d., https://www.nhfournier.es/en/como-jugar/belote/.

184. Only the Faber paperback edition of LP1 includes this letter.

185. The impact of *Bird's Nest* on Plath is described in CR4.

186. *Granta* was a student magazine, now a literary quarterly, founded in Cambridge in 1889.

187. These cards are lost or in private hands.

188. The film *Odd Man Out*, first released in 1947 and directed by Carol Reed, is about a wounded Irish Nationalist leader.

189. Chris Levenson was editor of Cambridge magazine *Delta*.

190. Professor Joyce Reynolds was a classicist.

191. *L'age D'Or* is a surrealistic film by Luis Buñuel.

192. The Vence story's title is "The Matisse Chapel."

193. Freddy Mayer was an Amherst College friend.

194. *Beauty and the Beast* (1946), a Jean Cocteau film, is discussed in CR4.

195. Donald Lehmkuhl was a Columbia University student.

196. Iko Meshoulem was a friend of Mallory Wober's.

197. These letters are lost or in private hands.

198. "Chris: Downing" refers to Christopher Levenson at Downing College.

199. Richard presumably refers to Richard Sassoon.

200. Gary presumably refers to Gary Haupt, a Fulbright student from Yale.

201. Jeremy Trafford is not otherwise identified.

202. "R or C" most likely refers to Richard Sassoon and Chris Levenson.

203. *Darkling Child* is a verse play by William Stanley Merwin.

204. See PJ for a passage on Plath's response to hypnotism.

205. Win is Winthrop Dickinson, a Harvard graduate and Fulbright Fellow.

206. R. McClaren & Dark Dick are not otherwise identified.

207. Derek Strahan was studying medieval language and literature at Queens College, Cambridge.

208. Keith Middlemass was studying history at Pembroke College, Cambridge.

209. Cambridge had curfews and climbing the locked gates became a sort of sport for males, but Plath accepted Hamish Stewart's challenge to get over the gates and accompany him to his room where they had sex. See HC for a full account.

210. "Pursuit" is a poem written about Ted Hughes—although Richard Sassoon thought the poem was about him. More discussion of this poem appears in CR4.

211. For "radiant panther," see "Pursuit."

212. Maryan Jeffrey is not otherwise identified.

213. Heurtebise is a character in *Orphee*. The impact of Cocteau on Plath is explored in CR4.

214. "Two American girls who write" is presumably a reference to Jane Baltzell.

215. In her letters, Plath acknowledged Huxley as one of her important influences. But at Cambridge, she longed for something more than lectures *about* tragedy, as she wrote to her mother on March 6, 1956:

Dr. Redpath, former lawyer, brilliant in discussion classes in aspects of tragedy, a real challenge . . . But these people are all removed to the lecture platform, and there is no personal interplay, which I savored so much in my units at Smith where one could literally "imbibe" the genius of a Patch, a Kazin, a Fisher, a Drew, and, although one's mind was ignorant, it was receptive, and there was a reciprocal current of ideas: our papers received comment, we did not just drink in the lecturer's words in notes.

216. It is difficult not to see these last words as Plath's own fashioning of her life into an Elizabethan/Shakespearean tragedy.

217. Jane presumably refers to Jane Baltzell.

218. D. Wilson presumably refers to David Wilson, a Cambridge student.

219. Brian Adams is not otherwise identified.

220. For the impact of D. H. Lawrence's novel on Plath, see CR1.

221. Presumably John Lythgoe.

222. A frustrated Sylvia learns that Hughes and two others had thrown clods against the wrong window, expecting to rouse her. {CR1} See entry for 8:00.

223. Valeria Stevens is not otherwise identified.

224. CTBlackwell is Constance Taylor Blackwell, a Smith alumnus at Cambridge.

225. Peter Andrews is not otherwise identified.

226. "Ted has girl!" is presumably a reference to Shirley, whom Ted was seeing.

227. Gordy is presumably Gordon Lameyer.

228. Marian Frisch is a Swiss friend.

229. The postcard presumably depicted Carcassonne, a famous French medieval citadel. See UNESCO, "Historic Fortified City of Carcassonne," n.d., https://whc.unesco.org/en/list/345/.

230. Plath and Haupt are discussing the ending of George Eliot's novel, *Mill on the Floss*, in which Maggie Tulliver and her brother drown in the mill race. Haupt would commit suicide many years after Plath's death. For more on Haupt, see CR4.

231. Who is J? And who is jealous? Gary is presumably Gary Haupt.

232. See entry for March 18, 1956.

233. Plath met Blakey, studying economics and law, during her eye treatment.

234. The Backs is an area along the banks of the Cam. See Cambridge River Tours, "The Cambridge Backs," n.d., https://puntcambridge.co.uk/cambridge-backs/.

235. Jennifer Platt is not otherwise identified.

236. These letters are lost or in private hands.

237. These cards are lost or in private hands.

238. Margaret presumably refers to Margaret Roberts, a South African Cambridge student.

239. Emmet Larkin was a student at the London School of Economics.

240. James Martin is not otherwise identified.

241. Ted called her Shirley, the name of the woman who had accompanied him to the St. Boltoph's party. For more on Shirley, see CR2 and JB.

242. Emmet Larkin was a Columbia University graduate student studying at London School of Economics.

243. R. Diderot is not otherwise identified.

244. *Dreams That Money Can Buy* (1947) is a surrealist film with seven dream sequences exploring a man's ability to look into the minds of others as he looks into his own.

245. *To Catch a Thief* stars Cary Grant and Grace Kelly in a romantic melodrama on the Riviera.

246. Assiette anglaise refers to assorted cold meats.

247. *Blanche Neige* is a French opera of Snow White.

248. See entry for March 26, 1956.

249. Boul Mich refers to Boulevard St. Michel in the Latin Quarter of Paris.

250. I did not knock.

251. Carl Shakin was Plath's romantic partner on her voyage to England.

252. The Verlaine quotation translates as "Tears fall in my heart / As rain falls on the town."

253. Don Cheney is an old Wellesley friend who attended Choate with Gordon Lameyer.

254. Bulganin was Soviet premier under Khrushchev, First Secretary of the Communist Party.

255. Higgins (1920–1966) was a famous war correspondent.

256. Isabel is possibly Isabel Murray, a Scottish student at Cambridge.

257. Jean is South African student Jean Pollard.

258. These letters are lost or in private hands.

259. Frayn, later to become an important playwright, worked on the editorial board of *Varsity*.

260. Gorgias was a pre-Socratic philosopher and subject of one of Plato's dialogues.

261. Evelyn Sladdin was an English Cambridge student.

262. Barry Edward Sales was studying French and German at Corpus Christi College, Cambridge.

263. Anthony Eden was British prime minister.

264. Clement Attlee was former leader of the Labour Party.

265. Bob Byerly is not otherwise identified.

266. Michael France is not otherwise identified.

267. Margaret Roberts was a South African student.

268. Michael Butcher was a South African student.

269. Campbell Page is not otherwise identified.

270. Ben Nash was a Cambridge English student.

271. Walter Elthis is not otherwise identified.

272. A few months before Sylvia's first encounter with Ted, she asked Michael Frayn to introduce her to Nash, editor of *Granta*, who had "a formidable reputation as a seducer of women." Sylvia seemed "aware of this." Frayn took her to Nash's room at King's College, but he was out. Plath met Nash eventually, and, according to Frayn, they became romantically involved. {HC}

273. For more on the antipathy of the Hughes circle to Plath, see CR2.

274. Callicles was a Greek political philosopher. See Stanford Encyclopedia of Philosophy, "Callicles and Thrasymachus," updated August 31, 2017, https://plato.stanford.edu/entries/callicles -thrasymachus/.

275. Christine Abbot was Newnham College secretary.

276. An exeat is a permit for a temporary absence from college.

277. Mrs. Milne was Whitstead House Mother.

278. Martin Buber's *I and Thou*, first published in 1923, described what it was like to have a fully developed understanding of another person, to have a profound empathy for another person so as to be able to put yourself in that person's place. Plath imagined she shared with Hughes this highly sought after communion of two selves.

279. Plath's childhood reading is detailed in CR3.

280. A scholar at Cambridge in the natural sciences and medicine (neurology), Miller went on to an illustrious career in the theater as performer, director, and author.

281. Valerie is not otherwise identified.

282. Karl Popper's book *The Open Society and Its Enemies*, first published in 1945, attacks Plato, Hegel, and Marx for promoting the idea of universal laws of history.

283. This letter is lost or in private hands.

284. The film was *Duck Soup*.

285. Sheila Hardy was a Newnham, Cambridge University student. Plath consistently misspells her first name.

286. See entry for May 26, 1956.

287. These letters are lost or in private hands.

288. See entry for May 26, 1956.

289. This letter is lost or in private hands.

290. Peter Durlacher is not otherwise identified.

291. Merrydown is cider.

292. She is working on the poem "Crystal Gazer."

293. For the context of this incident, see CR1.

294. Elizabeth Zeeman was a Middle English scholar assigned to tutor Plath on Chaucer.

295. This letter is lost or in private hands.

296. *Waltz of Toreadors* is a sex comedy by Jean Anouilh.

297. Aurelia was staying at the Clifford Inn.

298. In "Your Paris," included in *Birthday Letters*, Hughes provides a strikingly different account of the days right after their marriage and their time in Paris.

299. There is no diary entry for the previous day.

300. "O'Kelly's Angel" is a Ted Hughes story.

301. Jeff is not otherwise identified.

302. For more on Jean Babilée, see "Jean Babilée, Rebel of World Ballet, Dies at 90," *New York Times*, February 2, 2014, https://www.nytimes.com/2014/02/04/arts/dance/jean-babilee-dies-at-90-ballets-acrobatic-star.html.

303. Olwyn had borrowed money from Ted.

304. The Galeries Lafayette is a famous shopping mall in Paris. See the Galeries Lafayette website at https://www.galerieslafayette.com.

305. Mozambo is a Latin American musical genre.

306. This letter has been lost or is in private hands.

307. See THL for a detailed and very different account of the bull fight.

308. Ted had still not told his parents that he married Sylvia on June 16.

309. Merluza is a cod-like fish.

310. "Black zucchini" probably refers to eggplant.

311. Hughes provides his version of this period in "You Hated Spain," in *Birthday Letters*.

312. Horchata is a Spanish plant-based drink.

313. Axel Hoffer is not otherwise identified.

314. "Sketchbook of a Spanish Summer" was perhaps written in September.

315. Bishop Farrar was a sixteenth-century Hughes ancestor burned for heresy. Hughes later wrote a vivid poem, "The Martyrdom of Bishop Farrar": "Hear him crack in the fire's mouth."

316. Ted's girlfriends had trouble on visits to the Hughes home, especially with Olwyn. See JB.

317. One of Fisher's wives wrote a novel, *The Horizontal Man*, about Smith College that provides an important insight into what it was like for Plath to teach at Smith. CR4 includes a discussion of the novel.

318. The Brontës produced miniature books. Plath's published journals include drawings she made of many objects in the museum.

319. Redgrove and Hughes were contemporaries and rivals at Cambridge, which perhaps accounts for Plath's "ghastly." For Redgrove's work, see Poetry Foundation, "Peter Redgrove," n.d., https://www.poetryfoundation.org/poets/peter-redgrove.

320. Dina Ferran was a newly arrived American Fulbright scholar.

321. Jess Ivy Brown Bishop was a South African Cambridge student.

322. Edna Janeen Walsh was a Newnham student.

323. Plath's reading in abnormal psychology is explored in CR4.

324. Cows make many appearances in Plath's letters and journals, and it may be that they had the same calming impact on her as they did on Rebecca West. See Carl Rollyson, *Rebecca West: A Modern Sibyl* (iUniverse, 2009).

325. Certain ambitious women of Plath's generation grew up with Marie Curie representing their ideal of having a career and a genius husband. See CR3 for Plath's childhood fascination

with Curie, and Carl Rollyson and Lisa Paddock: *Susan Sontag: The Making of an Icon*, revised and updated (Jackson: University Press of Mississippi, 2015) for another example of a young woman's identification with Marie Curie.

326. *Granta* published "The Day Mr. Prescott Died."

327. There was a mixup about where she was to meet Hughes.

328. On the significance of *Painted Caravan*, see the beginning of Chapter 8 in CR1; see also Julia Gordon-Bramer, *Decoding Plath's "Daddy"* (Magi Press, 2017).

329. The letter to Ellie Friedman is lost or in private hands.

330. See Julia Gordon-Bramer, *Decoding "Lady Lazarus": Freedom's Feminine Fire* (Magi Press, 2017).

331. Ira presumably refers to Ira Scott. See entry for September 7, 1955.

332. This would be possible—imaginable—I suppose, since Christian Scientists believed in mind over matter.

333. See entry for October 18, 1956.

334. Wendy Christie was a South African friend of Dorothea Krook's who sat in on some of Plath's supervisions.

335. Ann Hopkins was Peter Davison's friend.

336. Grace is not otherwise identified.

337. Edna Jeanean Walsh was a Newnham student.

338. Plath refers here to the Soviet invasion that put down the Hungarian uprising.

339. S. O. perhaps refers to Olwyn Hughes. See entry for November 16, 1956.

340. Boots is a drugstore chain.

341. An image of *Senate House Passage* by Joseph Murray Ince is available at Art UK, "Senate House Passage," n.d., https://artuk.org/discover/artworks/senate-house-passage-134732.

342. All day of week and "morning," "noon," and "night" designations are Plath's.

343. Plath will change her mind about England and about where to raise her children.

344. Plath would continue to characterize the cold in England as a menacing force that she wanted to conquer.

345. Joyce Cary's *The Horse's Mouth* is a novel about an artist.

346. These letters are lost or in private hands.

347. Julian Jen is not otherwise identified.

348. This is a revealing example of Plath's thank you notes for wedding gifts. Many of these notes have been lost or have not yet been discovered.

349. Mrs. Spaulding was the cottage caretaker. For details on the Cape stay, see HC.

350. For Plath's syllabus, see HC.

351. The poem is a response to *The Dream* by French painter Henri Rousseau (1844–1910).

352. For entries on Plath's awareness of England and what it was like to live there, see CR3.

353. Arvin becomes a significant figure in CR4.

354. She is grading papers for Newton Arvin.

355. Plath's reaction to the Roches seems to be colored by the campus setting. Later, away from Smith, she would find them more appealing, especially Clarissa, whom Plath welcomed to Court Green with much enthusiasm.

356. The Hughes coterie is thoroughly canvassed in CR2.

357. See CR3 for documentation of what Plath refers to as the "cocoon" of her childhood and adolescence.

358. George Abbe was a poet and friend of the Roches.

359. See CR3 for Plath's many references to washing her hair and other matters of hygiene. But there is also a passage in her journals about the sensual enjoyment of nose picking.

360. Plath thought her friend Ellie Friedman had an actress's personality.

361. Shopping was a therapeutic activity for Plath (see CR3 for many examples) and was associated with being a successful person rewarded for her success. Married to Hughes, Plath had to restrain her desire to shop, not only for pecuniary reasons, but to appease his disapproval of what he considered frivolous activity. Occasionally, he would relent and graciously accept clothing she purchased for him, but in the main he regarded her materialistic side with scorn.

362. For the importance of *The Tempest* in Plath's childhood, see CR3.

363. It is remarkable how few references there are to Plath's father in her early diaries, and how she came to look upon the diary entries as her effort to bury his influence and her acknowledgment of his power over her , which will become a theme in poems like "The Colossus" and "Daddy."

364. Hughes's reaction may be an example of gaslighting, which is discussed in CR4.

365. Oscar Williams was editor of several influential poetry anthologies.

366. See CR3 for Plath's comments on Danny Kaye's films.

367. The "beauty about Fiddler crabs" is "Mussel Hunter at Rock Harbor."

368. Only the Faber paperback edition of LP2 contains this letter.

369. For more about Plath's reading of abnormal psychology, see CR4.

370. Brinnin wrote a controversial biography of Dylan Thomas. Richard Eberhart was a well-known poet.

371. This is another possible example of gaslighting; see CR4.

372. Most accounts of Plath emphasize her depression and overlook Hughes's dark moods that Plath mentions often, while observing that he never talks about his mental state, which is perhaps why his own depressions gets so little attention. See CR2 for discussion of Hughes's psychology.

373. Yaddo is an important writer's refuge offering bucolic surroundings, meals, and rooms for temporary stays.

374. Stanley Kunitz was an important poet.

375. Plath recorded her poems for him in Springfield, Massachusetts, for the Library of Congress.

376. Plath seems to be unaware that the fourth section of "The Bear" was meant only for the novel *Go Down, Moses* and was not meant to be read as just part of a separate story.

377. Ford was not Faulkner's one-time mistress. See Carl Rollyson, *The Life of William Faulkner: This Alarming Paradox* (Charlottesville, University of Virginia Press, 2020).

378. Plath's experience as an exile is explored in CR4.

379. Mary Stetson Clarke was a close friend of Plath's.

380. See Gail Crowther, *Three-Martini Afternoons at the Ritz: The Rebellion of Sylvia Plath & Anne Sexton* (New York: Gallery Books, 2021).

381. CR3 contains extensive references to Plath's making and playing with dolls.

382. The couple could not afford a house outside of London, but Plath's mention of the possibility helps to explain why Hughes, in particular, regarded their flat in Chalcot Square as only a temporary residence on the way to their purchase of a country home.

383. The impact of *The Lonely Crowd* on Plath is discussed in CR4.

384. *Snake Pit* is a popular novel and film with considerable impact on Plath, as discussed in CR4.

385. What Ted was thinking right then is perhaps lost somewhere in the ellipses of THL.

386. See also Plath's story "The Fifty-Ninth Bear" in *Johnny Panic in the Bible of Dreams*, and discussions of story in CR1 and JB.

387. See entry for c. July 24, 1959.

388. Arvin had a long association with Yaddo. See CR4.

389. Plath would later turn to Shirley Jackson's work to immerse herself in narratives of terror. See CR4.

390. For an interpretation of Plath's Marilyn Monroe dream, see CR1 and Carl Rollyson, *Marilyn Monroe: A Life of the Actress*, revised and updated (Jackson: University Press of Mississippi, 2014).

391. For more on Plath and Jung, see the appendix in CR1.

392. See the references to the game as "Turock" in CR3.

393. Was the comment on Olwyn wishful thinking, or was Olwyn on her best behavior? Or was Sylvia performing the role of good wife by making nice comments? See for example her "resolutions" of April 1, 1956.

394. Compare to the comment in October 23, 1959 entry.

395. Chilblains is an inflammatory response to the cold, manifesting in red or purplish lesions. See HealthPrep, "Treating and Preventing Chilblains," n.d. https://healthprep.com/skin-problems /treating-preventing-chilblains.

396. In this small flat, Plath surely sensed that neither Myers nor Olwyn liked her, and Olwyn made matters worse, so far as Plath was concerned, by wanting to stay over in the cramped quarters. See entry for the next day, March 10 and March 12.

397. The diary is lost or in private hands.

398. This panic attack is never explained. Unlike Plath, Hughes, as she knew, was not open about his worries, misgivings, and depressions. Perhaps the imminent birth of a child, Hughes's admirable if taxing efforts to make his wife comfortable and to take on as much of the day-to-day management of their affairs, contributed to a sudden sense of being overwhelmed.

399. The ban-the-bomb march was organized by the CND (Campaign for Nuclear Disarmament) as part of a series of protests that included prominent intellectuals and politicians such as the historian A. J. P. Taylor and Labour Party MP Michael Foot. See Campaign for Nuclear Disarmament, "The history of CND," n.d., https://cnduk.org/who/the-history-of-cnd/. See also entry for April 21, 1960.

400. Davison's memoir about Plath is *The Fading Smile: Poets in Boston, From Robert Frost to Robert Lowell to Sylvia Plath* (New York: Knopf, 1994). See entries for May 2 and 5, 1960.

401. Philip Booth (1925–2007) was an American poet.

402. A U-2 spy plane was shot down over the Soviet Union on May 1.

403. In the months leading up to the execution on May 2 of Caryl Chessman, in prison for robbery and rape, a widespread protest against capital punishment arose that involved many public figures.

404. This diary is lost or in private hands.

405. What happened to the idea of a country house is not clear.

406. The obscenity trial took place between October 20 and November 2, 1960. For more, see the British Library website, https://www.bl.uk/learning/timeline/item105907.html. See also entry for November 6, 1960.

407. Hughes won one of the Guinness poetry awards.

408. Later Hughes would tell Plath that after Frieda's birth he really did not want more children.

409. Roethke was a major influence on Plath's poetry. See entry for February 2, 1961.

410. See entry for February 2, 1961.

411. HC notes that Ted Hughes claimed *The Bell Jar* was begun in late February.

412. "Publication day" is perhaps a reference to Ted Hughes's *London Magazine* publication. See LP2.

413. Anthony E. Dyson, literary critic and lecturer, was employed at Bangor University in Wales.

414. June 6, 1961, is the first time Plath alludes to *The Bell Jar* in a letter to her mother and brother.

415. See footnote 1237 in LP2 for a listing of the poems Plath included.

416. The potential tenants were David and Assia Wevill.

417. "Insomniac" won the 1961 Guinness Poetry Award and first prize at the 1961 Cheltenham Festival of Art and Literature.

418. See footnote 1266, LP2: "The Poetry at the Mermaid Festival. On 27 July 1961, Sweeney wrote to Stephen Fassett, 'And it was for me very moving to hear and see Sylvia—the only woman on the stage that evening and the only American on the stage! She read with great grace and clarity and command and the poems she read is a humdinger. . . . And Sylvia has promised to lend the Poetry Room the worksheets of the poems she read'; held by Houghton Library. Sweeney displayed 'Tulips' in the Woodberry Poetry Room from October to December 1961."

419. Emory University has a copy of Sillitoe's *Key to the Door* inscribed: "To Sylvia and Ted, for their new house! Love, Alan & Ruth."

420. The elm plank is now on display in Special Collections, Smith College.

421. The American edition contained forty poems, ten fewer than the Heinemann book.

422. The nature of this transition is explored in CR4.

423. In her journal, Plath describes Dr. Webb: "Tall, lean, blondish hair, blue eyes, and a habit of smiling a 'shy' Perry Norton sort of smile to one side."

424. Sand tarts are thin, crispy butter cookies.

425. Presumably Sylvia carried out metal bins or trash cans of ashes from the stove and fireplaces and other refuse to be picked up weekly by what were colloquially called "bin men" or "dustmen" because they were dusty. Sylvia had a Rayburn cast iron range (stove), also called an Aga. "Out of the ash I rise with my red hair"—"Lady Lazarus," October 23–29, 1962.

426. Cake pudding tends to have a richer flavor and moister texture than cake.

427. What kind of pills is not specified, but see entry for January 12.

428. Weighing scales were for recording her weight.

429. *New Poets of England & America* was edited by Donald Hall (Meridian Press, 1962).

430. This is the first mention of Marjorie Tyrer, bank manager George Tyrer's wife. Sometime in the spring Plath left a sketch of them in her journal (Appendix 15).

431. Undated journal entry (Appendix 15) describes Rose and Percy Key: "Retired Londoners, our nearest neighbors," descriptions of their home's decor, Rose "full of gabble," Percy, a former pub keeper, in poor health, in their "cramped, steamy cosy place." Rose is so anxious about her husband's hospital stay that Sylvia puts her arms around her.

432. Plath described Mrs. Hamilton in her journal entry for May 16, 1962: "A tall, imposing white-haired woman . . . a sense of her measuring, judging. Invited me to coffee with Frieda. She lives across the street at an angle to the right in a handsome white house with black trim, and a wattle fence protecting her garden beautifully groomed by a retired gardener." {PJ}

433. Cress is also called garden cress, garden pepper cress, pepperwort, or pepper grass. The crisp and succulent leaves are a bit spicy and taste something like mustard greens.

434. See Appendix 15 in PJ.

435. Ted's play was *The Wound*.

436. Charles Causley was a local writer. See SPD for more details.

437. See entry for April 16, 1962.

438. "Type ribbons" are typewriter ribbons.

439. "Touch & glow" are fabric ribbons.

440. Tomato soup cake was a Depression-era recipe and one of Sylvia's favorites.

441. Also known as an aerogramme, an air letter was a thin piece of blue letter paper folded and sealed as an envelope to save on postage. Plath sent many letters this way as the cheapest way to communicate with friends and family.

442. Hubert Cole's *Josephine* (London: Heinemann, 1962) was reviewed by Sylvia in the *New Statesman*, April 27, 1962.

443. Hughes would later say during his involvements with other women "no more nappies." For details on his aversion to a conventional, domestic life, see CR2.

444. These airletters are lost or in private hands.

445. Jug hare is usually cut into pieces, marinated, stewed, and cooked with red wine.

446. These letters are lost or in private hands.

447. This is exactly what Hughes dreaded: that Plath would go on and on having children and making their lives all the more tied to the home that seemed to him no longer a refuge from London but a drag on his spirit.

448. "Rotting" seems to reflect for Plath a rich, relishing sensibility.

449. Paddipads are diapers.

450. Blanquette de veau is creamy veal stew.

451. This passage into mid-life is one of the main concerns of CR4.

452. Exactly how long it took Plath to complete *The Bell Jar* is uncertain, but it was probably more than six weeks. All the same, she wrote the novel quite rapidly after years of false starts and misgivings. The sudden outpouring may be related to her thinking of the book as a pot boiler, a term which absolved her of her high art aspirations and allowed her to just let loose, without apology.

453. Plath does not seem to have ever explored race issues in much depth, but what she did know and think about is discussed in CR4.

454. For extensive references to Plath's playing the piano, see CR3.

455. Bolt's men were probably builders replacing old wooden floors with linoleum in the playroom and hall. See entry for April 8, 1962.

456. Springerle are German biscuits with an embossed design.

457. These letters are lost or in private hands.

458. Plath was probably harvesting the flowers—see entry for April 8, 1962.

459. See entry for April 4, 1962.

460. The line is a reference to Robert Graves's book *The White Goddess*, which had a tremendous impact on Ted Hughes, who seemed to believe in the myth of a goddess that inspired a primordial sense of poetry and the poetic that had been suppressed by a male dominated tradition.

461. For more on Elizabeth Compton Sigmund, see CR1, CR2, and Gail Crowther and Elizabeth Sigmund, *Sylvia Plath in Devon: A Year's Turning* (Fonthill Media, 2015).

462. Jim probably refers to Jim Bennett.

463. Jim probably refers to Jim Bennett.

464. Ted had been having tea with the Tyrers. {BF}

465. This scene is reminiscent of the episode when Sylvia spotted Ted with a young woman near Paradise Pond on the Smith College campus, although Plath does not seem to have expressed any objections to Hughes. See entry for May 21, 1958.

466. Georgina is not otherwise identified.

467. The screenstand was perhaps for growing plants and flowers.

468. Dr. Benjamin Spock is author of *Baby and Child Care* (1946).

469. The letters are lost or in private hands.

470. Burton Hall was a hotel close to Court Green.

471. The Clarence Lounge was perhaps in the Royal Clarence Hotel in Exeter, and John M was perhaps John Montague, an Irish poet who corresponded with Ted Hughes.

472. The telegram is lost or in private hands.

473. CR4 explores the Plath–Wevill nexus, as does my review of *The Collected Writings of Assia Wevill* in *Plath Profiles* 14 (2022), 36–41, https://scholarworks.iu.edu/journals/index.php/plath/article/view/33819.

474. Plath's interest in beekeeping is irrevocably connected to her father's scholarly pursuit of bees and their ways, as he put it, exploring bees as a kind of society that could be both studied and managed. Whatever else beekeeping may have meant to Plath in the series of poems she wrote about it, taking up beekeeping at this point in her life seemed another way of exercising control over herself and her environment that became part of the "calming" she mentioned when working on a tapestry.

475. If the letters were sent, they have been lost or are in private hands.

476. Whitsun is the Christian festival of Pentecost celebrating fifty days after the appearance of the Holy Spirit to Christ's disciples.

477. Winkleigh is a town near North Tawton where Sylvia attended bee-keeping meetings.

478. Was beekeeping a form of domination that Plath associated with her father but also perhaps with her marriage, sensing that Hughes was about to hie from the hive? His dream (see entry for June 14) suggests as much.

479. The Pinter play was most likely a BBC broadcast.

480. *New Comment* was a BBC program that later featured Plath's review of *Contemporary American Poetry*, edited by Donald Hall.

481. This incident is so evocative of divide between Plath and Hughes that Kate Moses could not resist creating a scene out of it in her novel *Wintering* (St. Martin Press, 2003). See also CR2.

482. The letters were presumably part of her work as a judge at annual Cheltenham literary festival.

483. For the origins of *Three Women*, see SPD.

484. Unlike Hughes, with his frequent untrammeled trips to Exeter, for Plath to leave home involved quite an organizational plan.

485. See CR3 for frequent references to mowing the lawn, an activity that Plath enjoyed as a child and that may have had a calming impact on her life at Court Green and been part of her happy exhaustion.

486. Rhubarb and rhubarb dishes are often mentioned in CR3.

487. Gros point is a stitched canvas or possibly a carpet—perhaps the tapestry that Assia Wevill sent her.

488. A note in LP2 mentions "Sybil Merton Hamilton (d. 1963), widow of Francis Monteith Hamilton (d. 1935). According to SP's journals, Mrs Hamilton lived a Crispens, a cottage at 5 Market Street, North Tawton."

489. For Ted's treatment of Nicholas, see CR2.

490. Shin is beef cut from the leg and usually slow cooked, braised, and put into casseroles.

491. Ten years? In Hughes's case, he needed only about six years. His letter is written a week before the fateful phone call. See entries for July 9 and 11.

492. Aurelia senses otherwise.

493. See entry for July 11 and accounts of the phone call in CR1 and CR2.

494. Sylvia will reenact a similar pattern during the last weekend of her life, staying a few nights with Jillian Becker, then deciding to return home, even though she is weeping, and the Beckers urge her to stay with them.

495. This is perhaps the first time Hughes articulated a long-held feeling that Plath was holding him back from expressing his whole self. In retrospect, Hughes would claim that he began to chafe at the restraints of marriage after about two years living with Plath.

496. Assia reported to friends that Ted raped her. See CAW.

497. There are conflicting accounts of the car accident, some suggesting it may have been suicidal.

498. Sylvia long had suspicions about what she regarded as an unusual intimacy between Ted and Olwyn. See entry for January 1, 1961.

499. "Murphy, whose cottage was let until the first week in September, replied by telegram: 'Do hope you can come after 8 September stay with me and sail.'" {BF} For more on Murphy's role in the Plath-Hughes breakup, see CR2.

500. Bow is about four miles from Court Green.

501. This may be a reference to a toy piano for Frieda, who liked a similar toy she saw at Elizabeth Compton's home. Or Plath may still have been considering the purchase of a piano to play her favorite music for Frieda.

502. Items in italics were written by Aurelia.

503. Hovis is brown bread baked with various ingredients.

504. Ostermilk is dried milk for infant feeding.

505. Hughes's play presents his own confusion about what was real and what was imagined. It is a work that justifies Plath's view that Assia Wevill—whatever her physical charms—was also a figment or projection of Hughes's imagination, and a counterpoint to the reality of life at Court Green. For more on the play, see CR2.

506. Hatherleigh possibly refers to a poetry reading for a local arts group. {SPD}

507. Is this a phone number?

508. Sparkes: Crediton refers to a law firm in a town near Court Green.

509. Joan had said she could arrange for Sylvia to take horseback riding lessons.

510. Farex is baby cereal.

511. Rose hip syrup was often for medicinal use to treat colds and a variety of other ailments.

512. In *Sylvia Plath in Devon*, Gail Crowther explains that the reminder was "to seriously start work on her novel. Whether this was the day she began, we cannot know for sure."

513. Plath and Hughes put on a show of contentment for the meeting with Mrs. Prouty.

514. Plath satirized Mrs. Prouty in *The Bell Jar* but remained grateful for her kindness and support.

515. An extractor is used for removing honey from hives.

516. For the impact of Sexton's work on Plath, see CR 2, TMA, and Carl Rollyson's podcast interview with Gail Crowther, "Talking with Gail Crowther about Her New Book on Plath and

Sexton," on *A Life in Biography*, May 8, 2021, https://podcasters.spotify.com/pod/show/carl-rollyson /episodes/Talking-with-Gail-Crowther-about-her-new-book-on-Plath-Sexton-Three-Martini -Afternoons-at-the-Ritz-e10gg5e/a-a5giukl.

517. Horseback riding lessons begin.

518. Compare this statement to Plath's account of his state of mind in the entry for July 11, 1962.

519. This is presumably a reference to *The Bell Jar*.

520. See entry for September 26, 1962.

521. Plath persisted in her belief that Hughes had not been affectionate with his son. The reasons for her belief are canvassed in CR2.

522. See entry for July 9, 1962.

523. See entry for October 22, 1956.

524. Miss Cartwright was the nanny who looked after the children while Sylvia and Ted were in Ireland.

525. "The end has come" refers to the end of Plath's marriage.

526. Plath was miffed that Murphy thought she was coming onto him. See CR4 for a critique of Murphy's reactions to Plath.

527. The evidence that Plath handled the business of their home and literary lives is overwhelming.

528. Mr. Mazillius is a lawyer whom she consults about how to handle separation from Ted.

529. Olwyn Hughes, on a brief visit to Yorkshire in November, saw the vituperative letters Sylvia wrote to Mrs. Hughes . . . and was appalled that Sylvia could have sent them to a "woman who had always been kind and generous to her daughter-in-law." Nonetheless, Mrs. Hughes urged her husband to visit Court Green and help Sylvia, but shocked at Sylvia's letters, he declined to "become involved." {BF}

530. Plath was aware of these cycles, which are discussed in CR1, CR2, and CR4.

531. The "problem of him" would not be so easily overcome, as subsequent letters and journal entries demonstrate.

532. The idea of a salon always intrigued Plath. See, for example, the entry for October 22, 1955.

533. Elizabeth Jennings was a Catholic poet and a companionable London contact.

534. Hughes said as much about his rebellion against his own reform, but see also the entry for May 6, 1956. During Jane Anderson's visit, she also received the impression that Sylvia believed in her power to reform Ted Hughes. See CR2.

535. Gluhwein is mulled wine.

536. Miss Hutchins was a nanny who proved unsatisfactory.

537. SPD notes: What Hughes was thinking at this time is not really known. His selected letters have a gap between September and December 1962, and the poems in *Birthday Letters* are oblique.

538. Plath's repeated statements that Hughes expected and even wanted her to kill herself is reminiscent of the "gaslight" phenomenon, which is explored in CR4.

539. The gnawing need for her American family becomes reiterative in her last letters.

540. "Loin" was perhaps in connection with a visit from the son of Mr. Daniels, the bank manager.

541. In Appendix 15 of PJ, Plath leaves an account of her first meeting with Davies: "I felt she would judge, kindly, but without great mercy." But she and Ted made a good impression on her, and Sylvia imagines her thinking, "There was some hope for us!" Davies would later provide her account of the marriage breakup. See CR1.

542. Blogg is a car repair shop still in business in North Tawton, where Plath had a heater installed.

543. That sense of adventure derived, in part, from her childhood reading of Richard Halliburton. See CR3.

544. Plath had still not told her mother what the novel was about or that Aurelia and many friends were satirized in *The Bell Jar*.

545. Mrs. Daniel was presumably a neighbor.

546. PEN is a writer's organization. For more information, see the PEN website at https://www.pen-international.org.

547. The reference is perhaps to The White Hart Hotel in Okehampton or The White Hart Hotel in North Tawton, where films may have been shown in the town hall.

548. Winkleigh is about five miles from Court Green.

549. A rusk is a light dry biscuit, sometimes with a sausage filling.

550. See entry for June 30, 1960.

551. The bandage was perhaps for Sylvia's cut thumb.

552. The surviving evidence suggests that Merwin did not tell Plath "straight out" what he thought of her.

553. Plath does not mention the ways Hughes contributed to her own welfare and work, but she is accurate about foregoing many of her own pleasures, which he regarded as superficial and extraneous.

554. Plath found in historical biographies a way to gain some perspective on her own life and her husband's behavior. See CR1.

555. Plath and Stevie Smith never met. It may be that Plath hoped Smith would form part of a salon. Plath was looking for some kind of counterweight to the imposing presence of her estranged husband.

556. This became "Ocean 12-12-W," Plath's memoir of childhood, which verges on the fictional. See CR1.

557. Exactly what happened to this second novel, and how much of it may have survived, is still a mystery. See entry for c. July 25, 1962.

558. This is no exaggeration since by this time Plath had furnished and decorated six flats in Cambridge, Northampton, Boston, London, Devon, and again in London.

559. Flashlamps are electric arc lamps with unfiltered white light often used for photography.

560. Like Assia Wevill, Alliston was fascinated with Plath.

561. Gregory is not otherwise identified.

562. Hughes was involved in affairs with Assia Wevill and Susan Alliston, and perhaps others, so it is not clear whether Plath was exaggerating.

563. See entry for December 8, 1962.

564. These letters are lost or in private hands.

565. Light plugs are electrical connectors for appliances and lamps.

566. The paperman was the newspaper delivery man.

567. Camden Town is a district in Northwest London.

568. Obtaining home phone service would prove to be a trial in a country still recovering from the austerity following World War II.

569. Plath's journals reveal that while she was sometimes heartened by her Devon neighbors, she also resented their prying and welcomed the move to London where she had to answer only for herself.

570. For Wevill's point of view, see CAW. Wevill did not feel any more in control of Ted Hughes than Plath did.

571. Doris was from the baby agency and "loved the children," Sylvia said on a December postcard to her mother.

572. Bergman's and Cocteau's films had a powerful impact on Plath. See CR4.

573. Dickins & Jones is a department store.

574. Plath did not take up smoking until after Hughes left her.

575. Dibby's was a child care/nursery school on Regents Park Road in Primrose Hill, near 23 Fitzroy Road.

576. Hamley's is a London toy and game shop.

577. Although Plath had only a flat to take care and not the house that Nancy Axworthy cleaned, the frequent visits of Nancy to Court Green provided a steady level of support that Plath found it hard to maintain in London.

578. What Hughes meant by "compromise" is not clear, except for his desire to come and go as he pleased.

579. For more on the significance of *Difficulties of a Bridegroom* see CR2.

580. Plath published the novel using a pseudonym: Victoria Lucas.

581. Plath never did "feel like it."

582. As HC points out, Dr. Horder mentioned two drugs: Nardil and Parnate, "part of the amphetamine family," that could have caused insomnia. She was also taking a sleeping pill, Drinamyl, a barbiturate and amphetamine combination, as well as codeine (an opiate). For the impact of Parnate, see CR2.

583. For more about Hughes's state of mind and how it complemented and exacerbated Plath's, see CR2.

584. Plath may have listened to the rebroadcast of her husband's play, which deals with his predatory nature and his willingness to sacrifice one woman for another. See CR2.

585. In Jillian Becker's memoir, *The Last Days of Sylvia Plath*, Plath is depicted as insistent on returning to her Fitzroy Road flat even as she is weeping and Gerry Becker tries to persuade her to return to the Becker home.

586. Those letters, if they were written or posted, have never been found.

INDEX

ABOUT THE AUTHOR

Self-portrait courtesy of the author

Carl Rollyson is professor emeritus of journalism at Baruch College, CUNY. He has published fifteen biographies: *A Real American Character: The Life of Walter Brennan*; *A Private Life of Michael Foot*; *To Be a Woman: The Life of Jill Craigie*; *Amy Lowell Anew: A Biography*; *American Isis: The Life and Art of Sylvia Plath*; *Hollywood Enigma: Dana Andrews*; *Marilyn Monroe: A Life of the Actress*; *Lillian Hellman: Her Life and Legend*; *Beautiful Exile: The Life of Martha Gellhorn*; *Norman Mailer: The Last Romantic*; *Rebecca West: A Modern Sibyl*; *Susan Sontag: The Making of an Icon* (coauthored with Lisa Paddock); *The Life of William Faulkner*; *The Last Days of Sylvia Plath*; and *Ronald Colman: Hollywood's Gentleman Hero*; and three studies of biography, *A Higher Form of Cannibalism? Adventures in the Art and Politics of Biography*; *Biography: A User's Guide*; and *Confessions of a Serial Biographer*. His reviews of biography have been collected in *Reading Biography, American Biography, Lives of the Novelists*, and *Essays in Biography*. He reviews biography twice a week for the *New York Sun*. His reviews have also appeared in the *Wall Street Journal*, the *Weekly Standard*, the *New Criterion*, and other newspapers and periodicals. He has also published four biographies for young adults on Pablo Picasso, Marie Curie, Emily Dickinson, and Thurgood Marshall.